FAKING DEATH

FAKING DEATH

Canadian Art Photography and the Canadian Imagination

Penny Cousineau-Levine

McGill-Queen's University Press
Montreal & Kingston • London • Ithaca

Legal deposit first quarter 2003
Bibliothèque nationale du Québec

First paperback edition 2004

This book was first published with the help of a grant from the Humanities and Social
Sciences Federation of Canada, using funds provided by the Social Sciences and
Humanities Research Council of Canada. Grants were also received from the Canada
Council for the Arts through their Visual Arts and Writing and Publishing programs;
from the Department of Canadian Heritage through the Canadian Studies Program;
from Concordia University through the Office of the Dean, the Rector's Cabinet,
and the Office of Research Services; and from the Phyllis Lambert Foundation.

Portions of this manuscript dealing with the photographs of Charles Gagnon appeared
in the 1998 Musée du Québec exhibition catalogue *Charles Gagnon: Observations*.

McGill-Queen's University Press acknowledges the support of the Canada Council
for the Arts for our publishing program. We also acknowledge the financial support of
the Government of Canada through the Book Publishing Industry Development
Program (BPIDP) for our publishing activities.

National Library of Canada Cataloguing in Publication

Cousineau-Levine, Penny
Faking death: Canadian art photography and the Canadian imagination /
Penny Cousineau-Levine.
Includes bibliographical references and index.
ISBN 0-7735-2526-2 (bnd)
ISBN 0-7735-2826-1 (pbk)
1. Photography—Canada. 2. Photography, Artistic. I. Title.
TR26.C68 2003 770'.971 C2003-900295-0

This book was designed by Mantz/Eiser graphic design and typeset in
10.5 /13 Filosofia

Printed in Canada

For my parents.

*And in memory of
my brother, Tony Vickers,
and Susan Schouten Levine,
most wonderful teacher
and friend.*

CONTENTS

ACKNOWLEDGMENTS

The contributions of countless individuals and institutions are woven into every fibre of this book, which was so long in the making. I am immensely grateful to them all.

I want to thank Phyllis Lambert, the Canada Council for the Arts, and the Social Sciences and Humanities Research Council of Canada for their generous financial aid, as well as P.E., B.P., and F.J. of a corporation that, although wishing to remain anonymous, gave a substantial gift to offset publishing costs. Dean Christopher Jackson of the Faculty of Fine Arts of Concordia University, as well as the Rector's Cabinet and the Office of Research Services, provided financial grants. The confidence of these individuals and agencies in this project has meant a great deal to me. Also at Concordia, Fine Arts Advancement Officer Philippe Turp; Dean Claude Bédard of the School of Graduate Studies; and Garry Milton, executive director of the Rector's Cabinet helped in locating funding, as did staff members Natalie Michel and Enza De Cubellis.

At McGill-Queen's University Press, it has been my great good fortune to work with editor Aurèle Parisien. Aurèle's commitment to this book never wavered, and without that mainstay, I doubt I could have carried this undertaking through its many stages to completion. As copyeditor, Lesley Barry's input has been both incisive and respectful. A book with as many reproductions and design challenges as this one demanded unusual expertise and care on the part of the publishing team, and these were very ably provided by production manager

Susanne McAdam, coordinating editor Joan McGilvray, editorial assistant Joanne Pisano, and designer Christine Mantzavrakos of McGill-Queen's.

The isolation of writing was mitigated by my remarkable assistants. Anna Carlevaris gave editorial help at every step of the way. Without the dedication of Anna, Marisa Portolese, and Mackenzie Stroh I could not have gathered together the many images that appear in these pages. Many a footnote was rescued thanks to the computer expertise of Daniel LeComte. Colleen Ovenden directed me to an important article by David Howes. I thank wholeheartedly the anonymous readers who offered their very thoughtful commentary on the manuscript in its early stages.

Martha Hanna, Linda Fish, Sue Lagassi, Denise Marchand, and Robert Bernier at the Canadian Museum of Contemporary Photography were always ready to supply access to photographic archives, books, and slides. Lorraine Monk and Av Issacs shared their memories of Michel Lambeth when I thought I might be writing a book only about that signal Canadian photographer. Raven Amiro and Martha King of the National Gallery of Canada were exceedingly helpful as I gathered together copy images, and Director Pierre Théberge, where possible, waived fees for reproduction rights. Assistance in procuring images for the book also came from Martha Langford, Lily Koltun of the Public Archives of Canada, Galerie René Blouin in Montreal, Stephen Bulger Gallery in Toronto, Barbara Terfloth of the Canadian Artists Representation, Katia Macia-Valadez of Société de droits d'auteur en arts visuels, Catherine Crowston of the Edmonton Art Gallery, Viviane Gray at the Indian and Inuit Art Centres, Mario Doré and Michel Ménard of Litho-Acmé in Quebec City, Dorothy Lambeth, Mark Wilson, Mike Schulman of Magnum Photos in New York, Shannon Anderson at Oakville Art Galleries, Jennifer Woodbury of The Banff Centre for the Arts, the Catriona Jeffries Gallery in Vancouver, Linda Spohr, Colette Perron-Sharp, Loretta Yarlow at the York University Art Gallery, Lori Ellis of The Whyte Museum of the Canadian Rockies, James Patten of the Winnipeg Art Gallery, Jan Allen of the Agnes Etherington Gallery, Michael Torosian, Faye Van Horne of the Art Gallery of Ontario, Patricia and Earl Green, Pace/McGill Gallery in New York, Megan Lewis at the Fraenkel Gallery in San Francisco, and the Centre for Creative Photography in Tucson. Christine Freedman at Artexte in Montreal and staff at the Visual Studies Workshop in Rochester helped in locating references.

The desire on the part of so many of my students to have a book on Canadian photography has sustained me more than they could have known during the many years it took to complete this book. I thank them all for their infectious enthusiasm and insightful feedback on my class lectures, especially Geoff Brown, Julie Bélanger, Nicola Feldman, Louise Perry, Thomas Kneubühler, Denis Redmond, Pierre LeBlanc, Tom Hawthornewaite, Michelle Graznack, Marie-France Lepage, Christian Liboiron, Carol Corey Phillips, David Newland, Phillip Hannan, Priscilla Cowan, Chloe Davis, Colin Mackenzie, Lucie Poirier, Grace Tsurumaru, Shannon

Walsh, Sharon Harper, France Choinière, Pierre Dorion, Susan Close, Elsie Wood, Nicholas Amberg, Pierre Arpin, and the past students, now practising photographers, whose photographs are discussed in this text. I'm grateful as well for the very useful commentary I received when speaking about Canadian photography in museums and art departments across the country.

The abiding concern with Canadian culture of Lon Dubinsky, Peter Harcourt, Mel Watkins, and John Metcalf, and their conversations with me, have been an important inspiration. Equally inspiring has been my memory of the integrity that informed the seminal Canadian art spaces run for many years by Michiko Yajima and Brenda Wallace, respectively.

My colleagues during the late 1970s and through the 1980s in the Visual Arts Department at the University of Ottawa, particularly Suzanne Rivard-LeMoyne, Philip Fry, the late Jacqueline Fry, and Leslie Reid offered a lively and intellectually challenging academic family. As Dean, Marcel Hamelin waited patiently for this work to come to fruition, and Mireille Lavigne made the resources of the slide library available to me long after I had left that institution. At Concordia University, my fellow photography teachers Tom Gibson, Gabor Szilasi, Evergon, Raymonde April, Katherine Tweedie, Geneviève Cadieux, and Joanne Biffi have given me a valuable context in which to think about and discuss Canadian photography. Tony Patricio, Javier Lee, Kathleen Wiggan, and Mary Tsakalis held down the fort in the Studio Arts Department Office at Concordia when I had to be away.

The unwavering presence of friends during this writing has been crucial. I owe much to Karen Oxorn, Simon Finn, Susan Palmer, Steve Luxton, Gail Stockburn, Batia Winer, Kate McGregor, Sharon Katz, Susan Geraldine Taylor, Abby Nedik, Irene Angelico, Viviane Elnécavé, Maurie Alioff, Jan Bauer, Ioulia Zaitseva, Candis Graham, David Levine, Robert Boffa, Jessica Raimi, Werner Grosspeitsch, Julie Lefebvre, Herménégilde Chiasson, Nicholas Holownia, Tammy Anderson, Susan Card, Rob Buckland, Maeve Hancey, Marilyn Healy, Robin Johnson, Megan Murtagh, Monique Bélanger, and my step-grandmother, Marjorie Powys. Some of the most affecting moments of this writing came about when women friends, unbidden, offered to be with my children so that I could write. Although I didn't take you up on your offers, Mary Clifford, Nancy Froehlich, and Madeline Aubrey, I was touched by your kindness. Missing from this list are the many important friends who are also Canadian photographers, writers, and filmmakers, whose works I have been privileged to consider herein.

To my son, Dylan, who said to me recently that this book was like another brother or sister he grew up with, and my daughter, Zoë, goes my gratitude for always sharing their mother with this demanding "sibling." To Marielle, Naomi, and Julia, the children who came into my life later, thank you for your belief in me, your editorial help, and all those times you brought me coffee.

Finally, the greatest debt is owed to my husband, Norman Bethune Levine, whose support to me in this endeavour has known no bounds.

FAKING DEATH

In the nineteenth century the equation of Canadian identity to Canadian images was very literal. A painting that failed to be Canadian in character failed either because it did not contain Canadian subject matter, or because it did not contain Canadian "technique."

In other words, it was not *attitudes* toward subject matter or directions toward a certain way of seeing and thinking, or a particular vision of life, that was seen as being Canadian. This led to some very curious and confused critical attitudes in the nineteenth century. What professed to be a nationalistic spirit was often an attitude of the most appalling colonial servitude in disguise ... it is not the painter's talents or his or her works *per se* that are being judged or reviewed, it is the Canadian landscape — and it is found wanting ... These critics were then giving an inventory of what did *not* exist in Canada — an excessively negative start. This gives us the impression that all that lay between the Canadian painter and great Canadian painting was a matter of a few castles, preferably ruined, stormy skies, etc. — in short, everything might have worked out *if only* Canada had been Europe.

Ann THOMAS

"Canadian Nationalism and Canadian Imagery"

Not to have any story to live out is to experience nothingness: the primal formlessness of human life below the threshold of narrative structuring. Why become anything at all? Does anything make any difference? Why not simply die?

Michael NOVAK

Ascent of the Mountain, Flight of the Dove

INTRODUCTION

Although I didn't know it at the time, I think that I resolved to write this book one autumn evening years ago as I returned from a lecture given at the Montreal Museum of Fine Arts by John Szarkowski, the Museum of Modern Art's curator of Photography and the *éminence grise* of the American photographic world. Szarkowski had spoken eloquently about American photography to a house packed with eager Canadian listeners. I was driving home with a friend, a photographer who had also attended the lecture, and he seemed barely able to contain himself as he extolled the virtues of Szarkowski's speaking style and bemoaned Canadian photography's "lack of tradition." Why, Szarkowski could quote Emerson and Thoreau, but what could *we* refer to in any attempt to situate our photographic imagery within a larger cultural context? Nothing. Unlike the Americans, he seemed to be saying, we had no tradition and no culture. Years later, the Canadian philosopher and essayist John Ralston Saul would address this self-demeaning Canadian attitude, writing that "[c]olonial élites have always put their emotional dependence on a single foreign model down to sophisticated internationalism. Tribal leaders spoke that way of Rome; Indian rajahs that way of London; Vietnamese princes that way of Paris. In other words, the essential references of our élites indicate a strong inferiority complex."[1] Edward Said and others have also written of this colonial phenomenon, Said stating that as a Palestinian sent to colonial schools he was taught that "the only representations that counted were

the representations of English ... culture that I was acceding to by virtue of an education."[2]

This conversation left me angry and frustrated, emotions that had most obviously to do with a sense that our cultural situation, as a country, must be desperate. When I discussed this evening later with other Canadian photographers, what became clear was their feeling of impotence in the face of our culture's perpetual fascination with imagery and discourse produced anywhere but here, a fascination shared by many Canadian curators and critics, as well as photographers. But what was also certain was that I would not have been left feeling nearly as upset myself if, in fact, I had been able to counter my doubting friend's propositions with any of my own. I didn't know either what our photographic tradition was, or how it might relate to a larger constellation of Canadian cultural assumptions. All I knew was that I wasn't willing to admit this tradition didn't exist.

That I had no idea what, if anything, might characterize Canadian photographic imagery was already becoming painfully apparent to me in the university History of Photography course I was teaching at the time. More disturbing than the attitude of my friend was that of my students, who were themselves to become the next generation of Canadian photographers. When shown Canadian photographs alongside those made in Britain, the United States, and elsewhere, whether documentary photographs or portraits or landscapes, the almost universal response of these students was that they could see "nothing" in these images, that there was "nothing there." What perturbed me, of course, was that again I had no reply. And the fact that these students had absolutely no sense of the significance of the products of their own people, and hence by extrapolation of their own artistic work, that they could look forward only to making images they themselves would view as valueless, and that would fall invisible into a critical void – all of this was enough to make me call into question what I was doing as a teacher. It seemed to me then, as it does now, that inundated as they and I were by the cultural "noise" of elsewhere, "noise" to which I had contributed by teaching at that point a fairly standardized Anglo-American version of photographic history, we were deafened to the content and worth of our own voice. Peering through the veil of received notions of what "straight," "topographic," and other kinds of photographs ought to look like, indeed handicapped by concepts like these, which had been formulated to apply to works made in other places at other times, neither my students nor I were able to see what was going on in the Canadian photographs we looked at on any but the most superficial levels. Above all, it has been the desire to present Canadian students of art and culture with an appreciation of the richness of Canadian photography that has given impetus to the writing of this book.

If I was drawn to find another way of looking at Canadian photography it was not merely because it seemed impossible that in all of this imagery there really was nothing of any interest or importance. Nor was it only because I felt it my duty to my students to find something to say about these pictures, or because of a then

vague, and barely able to be articulated, sense of what those images might be about, and how intriguing that sense was.

I don't believe that the recurrent and persistent terms in the discussion going on around me concerning Canadian photography, terms like "nothing," words having to do with lack and invisibility, concepts like "no history," would have impressed me so deeply had they not resonated with certain precepts taking form within feminism at the time. Theologian Carol P. Christ has pointed out, for instance, that the "ordinary experience of women in patriarchy is akin to the experience of nothingness," that women "may need only to strip away the ideology of patriarchy ... in order to come face to face with the nothingness they know as lack of self, lack of power, and lack of value for women in a male-centered world." [3] What literary theorist Toril Moi has to say about Freud might be extended to patriarchal culture in general: "when he looks at the woman," writes Moi, "Freud apparently sees nothing. The female difference is perceived as an absence or negation of the male norm."[4]

Concurrent with the beginning of my search for an understanding of Canadian photography was a burgeoning awareness of how women had for so long been defined, and defined themselves, in terms of what they were not. For me the struggle to dig out from under patriarchal perceptions of what constitutes female experience became a paradigm for the attempt to find meaning in the imagery of a culture that has been seen, and has seen itself, almost solely in negative terms. While I would never suggest that fifteen years ago only a woman would have been interested in Canadian photography, I do think that it was easier for someone used to living in the realm of "the Other" to become conscious of the kind of cultural self-abnegation the views of my students and that friend expressed. Although it will be obvious to anyone reading this book that my understanding of Canadian imagery is largely informed by psychoanalysis, without the grounding of feminist discourse it would have been impossible for me to have even begun to approach the study of Canadian photography in the way that I have. But if I was propelled by feminist consciousness and methodologies when I began this investigation, I was utterly surprised to encounter the relationship which Canadian photography bears to what I will call the "feminine principle." The distinction between feminism and "the feminine" is an important one, which I hope will become apparent to the reader as he or she proceeds through the book.

Of course it is now no longer the 1980s, and as I write, Canada, photography, and feminism, if not my friend's ideas, have profoundly changed from what they were that evening of John Szarkowski's lecture. Canada itself is in question, and so, in many ways, is photography. In some quarters at least, not only the documentary mode but all of straight photography appears irrelevant as a means of expression, its traditional role as purveyor of information usurped by television and the Internet, and within the world of museums and galleries, by the multimedia installation; faith in its verisimilitude has been undermined by the possi-

bility of digital image manipulation. What could be the purpose now of attempting to "hear" what Canadian photography is "saying"?

For years I regretted the fact that the demands of teaching and motherhood were prolonging, seemingly indefinitely, the completion of this book. What I have come to believe is that the ideas expressed here see the light of day at precisely the time they were meant to do so. For as much as we may have been blind to the message that repeats itself again and again in our images, in our collective dream as it were, that message is nonetheless present. It is clear to me, for example, that the images of Québécois photographers and those of photographers working in other parts of Canada have more in common with each other than either has with photography produced anywhere else. And while an in-depth study of Canadian film and literature is outside the scope of this book, I hope I will show that the world view that undergirds Canadian photography is evident in our movies and writing as well. The fact is that we have, apparently unconsciously and almost in spite of ourselves, given expression to a thoroughly consistent *Weltanschauung*. Before we allow this country to be thrown away as if it had no value whatsoever, it might be useful to become cognizant of the vision of things we so unwittingly share.

In writing this book I do not intend to produce an encyclopedic overview of Canadian photography since the 1950s, nor am I seeking to establish a canon of excellence in Canadian photography. Rather, I am interested in setting forth what I have observed to be the predominant concerns and ways of presenting the world of Canadian art photographers working since 1955, and examining these in relation to historical and contemporary discourse around Canadian cultural production. I begin with 1955 because this was the year Toronto photographer Michel Lambeth began producing the exceptional images that make up the mature body of his work. It can be argued that Lambeth was the first post-war Canadian photographer to produce a substantial and consistently sustained body of art photography. His photographs, for me, comprise the quintessentially Canadian *oeuvre*. They demonstrate, in an entirely cohesive and evocative manner, almost every one of the characteristics I associate with Canadian photography.

It needs to be said as well that while Canadian photographic production of the last half-century also includes photojournalistic, fashion, scientific, medical, sports, editorial, advertising, family snapshot, and many other subspecies of photography, here I give attention for the most part to images that were expressly created to enter into the art arena. In order to focus on Canadian art photography, I have left the study of more instrumental photographic genres to other researchers.

As a critic I am acutely aware that my perception of Canadian photography, as outlined in this book, is only one of many possible perspectives on a particular (national) body of work. Like any general theory applied to a vast array of phenomena, it can be seen to be subjective, and even reductionist. But the test

of a theory, whether scientific or other, is surely its usefulness, and I have found the framework I propose here to be rich in its capacity to contain, and explain, otherwise widely divergent trends and tendencies in the work of Canadian art photographers. There are at this time no other comprehensive theories of Canadian art photography, so by default this discussion becomes a kind of monologue, and one with which the reader might disagree. This is not, however, because I wouldn't wish for a conversation. I do hope that the vision I have articulated here will encourage other theories to emerge.

Part 1 of this book, entitled "Dislocation," provides an overview of writings on the nature of photography and shows how the ideas contained in these books and essays differ from the typical Canadian use and understanding of the medium. I also review the traditions of American and European photography, and discuss the philosophical and aesthetic assumptions underlying the artistic use of the medium within these cultures. Part 2, "Inside and Outside," questions the commonly held notion that the predominant Canadian photographic tradition is a documentary one, and examines the ways in which Canadian photographers have adapted the documentary idiom and the stylistic devices of other traditional photographic genres to their own very singular ends. Part 2 also reviews texts that discuss the historical relationship of photography to death, and distinguishes this general tendency from the overriding preoccupation Canadian photographers have with death and dying. In this section I discuss those features that, from my observations over almost thirty years, I have found to be characteristic of, and particular to, Canadian photographic production. Foremost among these is a persistently dualistic presentation of reality, the world seen as divided into the realms of "here" and "elsewhere." I examine what these characteristics might mean in terms of the Canadian collective unconscious, and how my observations compare with other commentaries on Canadian literature, film, painting, music and political life. Here I argue that the Canadian psychic landscape, as revealed in our photographs, is psychologically akin to that of an anorexic adolescent, and that Canadians unconsciously consider themselves to be both "feminine" and stalled in a rite of passage toward autonomy as a nation.

In part 3, "Rehearsal," I suggest that death, which Canadian photographers are so preoccupied with, is portrayed in our photographs as something far more positive than the final annihilation of physical demise. It seems that Canadians, like the subject of the 1977 work by Vancouver photographer Jeff Wall, have been only "Faking Death." In part 4, "Entering and Leaving," I discuss what our photographs have to say about the Canadian relationship to the wilderness outside the "fence" of civilization and to the transformative realm of the underworld. Throughout the book, I give representative examples of works that reflect what I consider to be characteristic tendencies of Canadian photography. Further instances of the attribute under discussion are given in sections of text set off by the symbol ¶.

The manner in which I pursued the research and writing of this book betrays my allegiance to a deeply held Canadian article of faith. This is the belief in a realm of discourse, free of outside influence, where we will finally locate ourselves and our "true" identity. Lawren Harris and the Group of Seven, for instance, also felt the need "to express the experience of Canada 'free from all preconceived ideas.'"[5] Dermot McCarthy points out that a "central feature of nationalist literary discourse" in Canada, initiated by E.H. Dewart in his 1864 *Introduction to Selections from Canadian Poets*, was the notion that "[c]olonialism retards the development of the nation by allowing foreign images of cultural identity to fill up the mirror of art, which should reflect the native reality." From Dewart on, writes McCarthy, each "new anthology or literary history thus claims to be a new mirror of the nation, its novelty defined in terms of the diminishing presence of foreign cultural models, forms, or images, and the burgeoning fullness of native self-presentation."[6] I clearly have not been immune to this search for Canadian cultural authenticity. In the service of this principle, I avoided as much as possible reading other writers on Canadian art and imagination until the final stages of this writing, so as to not to "contaminate" my own process of discovery. By the time I began writing it was too late not to have read Margaret Atwood and Northrop Frye, but I did manage to leave the writings of Ian Angus, Linda Hutcheon, Gaile McGregor, Patricia Smart, and John Ralston Saul until I had formulated my own thesis; my response to their findings has been "layered into" the text during the book's final stages. Nonetheless, ideas about Canadian culture are part of the air we breathe, and this atmosphere undoubtedly affected my putatively pure reading of Canadian photography. Within this Canadian "garrison," to borrow a term from Frye, the insights and vocabularies of both Jungian and Freudian feminist psychoanalysts, as well as post-structuralist thought, were helpful to me in my interpretation of the many Canadian photographs I examined for this study.

The Canadian dynamic of "here" and "there," which I identify as a predominant element in Canadian photographic images, is in evidence in this work as well, in that the book presents the representative features of Canadian photography by comparing them to those found in the photography of other cultures, primarily that of the United States. Elucidating a Canadian reality in terms of an American one would hitherto have been unacceptable to me for many reasons, and while this is not quite what I have ended up doing, I did find that the "here" of Canadian image-making can be seen more clearly for what it is when held up against the "there" of American photographic imagery, which dominated the art for most of the last century. The notion that meaning takes place for the Canadian photographer in the space "in-between" two zones of reality is key to my argument, and it has turned out that I, too, am best able to explicate my own ideas while attempting to hold in place simultaneously the visions of both our own photographic imagery and that produced outside the country.

I have been asked many times who I think qualifies as a Canadian photographer. For the purposes of this inquiry, I have considered a photographer to be Canadian where most or all of her or his career as an artist has been spent in this country. This includes photographers who immigrated to Canada in their youth – Gabor Szilasi, Geoffrey James, Tom Gibson, Lynne Cohen, Clara Gutsche, and others – and who then went on to establish a photographic practice and to enter maturity as photographers here. An analogy within literature would be the common agreement to deem Carol Shields a Canadian writer, even though she emigrated from the United States as an adult. In several cases I point out elements of these photographers' vocabularies that owe something to their upbringing within another culture, even though the work has taken on a predominantly Canadian vision. In a couple of instances, I discuss work by a photographer born in Canada but no longer based here. One of these photographers had not been living outside the country for long when she produced the work I examine; and in all cases, the body of work under discussion has received critical attention almost entirely within the Canadian context.

I have also been asked if our lack of an articulated tradition within photography might have to do with a conscious eschewing of nationalism on the part of Canadians, particularly those who came of age during the sixties and seventies. For me, the answer to that question would depend on whether or not one is referring to a rejection of the search for a particularly Canadian photographic tradition on the part of critics and theoreticians or on the part of photographers. For reasons I discuss in chapter 1, I don't think writers about art in Canada have been encouraged to seek out the specifically national aspects of work made in Canada. As for the conscious embracing of nationalism on the part of Canadian artists, I'm not sure the question does justice to the often contradictory impulses, not all or even most of them conscious, that come into play during the creation of a work of art. A major tenet of this work is that Canadian art photographers, collectively, have produced a cohesive world view, although they have not consciously attempted to do so. Therefore a *conscious* decision to reject nationalism (by which is meant a homogeneous national vision? an attention to issues of national concern? patriotic propoganda?) would be irrelevant in this context. It also needs to be said that only sporadically did American photographers, for instance, try to create a specifically American photographic viewpoint or vocabulary, and yet such a characteristic vision can be observed throughout the history of American photography. The same is true for the art of many other cultures.

What are the cultural assumptions about who we are that link together a photographic installation by Stéphanie Beaudoin entitled *Je suis morte*, displayed in a store window on Ste Catherine Street in Montreal and featuring images of the photographer posing as if she were dead, and Mina Shum's 1994 movie *Double Happiness*, in which a young Canadian Chinese woman struggles to reconcile the

traditional ways of her immigrant family with her own contemporary reality? This book proposes possible answers to this question. What is the significance for the Canadian imagination of the fact that at the end of Patricia Rozema's 1995 film, *When Night is Falling*, a dog that was dead and buried comes to life and exuberantly runs free? To me, the release of Rozema's dog from death – the same "death" to which Canadians in their photography, as well as their literature and film, consistently consign not only animals but themselves – represents a radical shift in paradigm, the import of which I hope this book will help to elucidate.

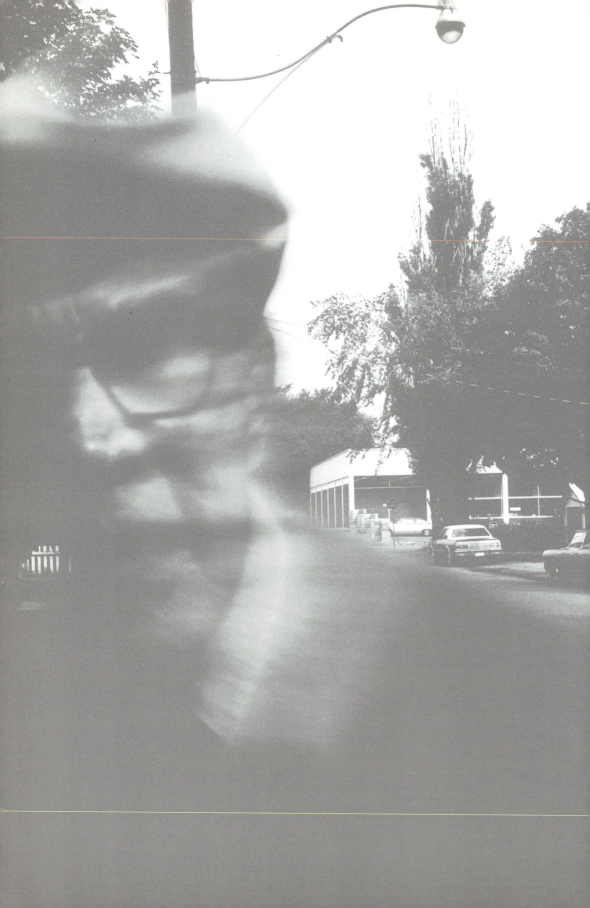

PART ONE - Dislocation

Women's stories … have not been told. And without stories there is no articulation of experience. Without stories a woman is lost when she comes to make the important decisions of her life. She does not learn to value her struggles, to celebrate her strengths, to comprehend her pain. Without stories she cannot understand herself … If women's stories are not told, the depth of women's souls will not be known.

If there are no stories of women … What will she do? She may with some incredible effort "slide herself sidewise" into the stories of men.

Carol P. CHRIST

Diving Deep and Surfacing

An important question: What do you do with a tradition once you discover you have one? The answer in terms of the Canadian tradition can get rather complicated, but I'll make two simple initial suggestions: If you're a writer, you need not discard the tradition, nor do you have to succumb to it. That is, you don't have to say, "The Canadian tradition is all about victims and failures, so I won't have anything to do with it"; nor need you decide that in order to be truly Canadian you have to give in and squash your hero under a tree. Instead, you can explore the tradition – and in the course of the exploration you may find some new ways of writing.

If you're a reader, you can learn to read the products of the tradition *in terms of the tradition itself*. You don't knock Faulkner for not being Jane Austen, and those who do reveal their own obtuseness; the terms of reference are completely different. Recognizing your own tradition won't make you less critical; on the contrary, it ought to make you a better critic.

Margaret ATWOOD

Survival

CHAPTER ONE

Between the Lines

In a 1974 *New York Times* review of John Max's book of photographs, *Open Passport*, photography critic A.D. Coleman, while praising the book's photographs for their distinctive vision, takes Max to task for his "frequent abuse of the snapshot mode."[1] In the same year, reviewing the National Film Board's publication of Judith Eglington's *Earth Visions* in *Afterimage*,[2] I wrote that if the photographer had sought to underline the beauty of the natural landscape, she might have done better to use a large format camera.

These two statements share a misunderstanding of Canadian photography. Both betray the reviewer's presumption that there was no reason *not* to apply established critical precepts like the "snapshot" aesthetic and the "appropriate" use of a view camera to the work under consideration just because that work happened to be made by a Canadian photographer. And on one level this attitude may have been correct, if one assumes that criticism is about applying a standardized (which is to say, "international") system of evaluation that ascertains how a given product "measures up" to abstract, idealized, and currently fashionable notions of what constitutes an acceptable work of art. Similar critical blind spots have been evident in evaluations of Canadian literature. Writing about a conference organized around the search for a Canadian literary canon, Donna Bennett observed that in "seeking to develop 'a more secure sense of what is really first-class in our fiction,'" criteria were applied "that lie outside [the] culture and its own writing and point to standards that are extra-national and extra-generic. Such a perspec-

tive assumes that evaluative standards are already understood and that internally derived 'national' characteristics are secondary in canonical evaluation to universal 'literary' ideals. A national canon from this viewpoint is 'good' writing produced by writers from a particular country but evaluated by standards that are extra-national."[3]

The problem is, of course, that this monolithic approach almost guarantees that enormous chunks of the work under consideration will slip through the critical cracks, that whatever exists in the work that cannot be mediated through the "universal" terms of discourse the critic employs risks being missed altogether. And if not much in the work does lend itself to being discussed in these critical terms, the work may be barely seen at all, with the conclusion that nothing exists in the work to *be* seen.

The French feminist psychoanalyst and writer Luce Irigaray has said that because women have always written in the language of the patriarchy, in essence attempting to adapt a foreign language to their own expressive ends, one must read "between the lines" of women's writing in order to get at what is really being addressed. Something akin to this has happened in Canadian photography. It is not particularly surprising that critics would proceed blithely along, taking for granted that Canadian photographs of any particular stylistic category are coming out of roughly the same construct of aesthetic and philosophical assumptions as, say, American photography of the same genre. Canadian photographs of a particular period, for instance the 1970s, *look* a lot like photographic images created in the United States at the same time.

Many of the photographs made in the streets of Toronto, Montreal, or Halifax in the late 1960s and the 1970s, for example, display characteristics until then usually associated with the amateur's snapshot – "multiple exposures, distortions, unusual perspectives, foreshortening of planes, imbalance."[4] These are characteristics, along with a "directness of ... commentary" on "people and people things,"[5] that Nathan Lyons, in writing about the images of Americans Garry Winogrand, Lee Friedlander, Bruce Davidson, Danny Lyon, and Duane Michaels, saw as earmarks of what he called "social landscape" photography. Why would it not then be useful to view the Canadian photographs in terms of the "social landscape" as well?

It might not be very useful because to do so would, I think, only obscure, rather than illuminate, what is really going on in the Canadian works. After following Canadian photography closely over many years, I have concluded that while it may from decade to decade and from genre to genre resemble very closely photography made elsewhere, these resemblances can be highly misleading. That Canadians have been exceedingly masterful in their appropriation of stylistic veneer has meant that their photographs have been judged, understandably, as if they were meant to be concerned with the kinds of issues these aesthetic devices are most often used to address. And when the "syntax from elsewhere" is employed

in Canadian photographs in the sort of colonial fashion Irigaray says women employ men's language, when it is in fact *not* being used to say the same kinds of things that syntax is ordinarily associated with, then the Canadian photographs are deemed wanting, as being "merely derivative," "like" something else but not "as good as" the "original," to be saying nothing at all. Yet even categorizing Canadian photographs into the classically accepted genres may, in many cases, only cloak their meaning.

To "read between the lines" of a Canadian photograph might mean, for example, recognizing that in many instances a Canadian photograph made on the street is not "about" what is actually happening on that street in the way that it most probably would be in a similar English or American photograph of the same period. A Canadian photographer of the 1950s, for instance Michel Lambeth, may have adopted the look of "social documentary" photography, an idiom in which, as photographer and critic Geoffrey James once remarked to me, large grain in an image seemed to stenographically signal Truth. In American photography the use of the particular visual vocabulary that came to be associated with a 1950s social documentary image will indicate almost without exception that the photograph is indeed meant as a *social* document, and should be understood on those terms. The use of the same vocabulary and content by a Canadian photographer very nearly always indicates something else altogether. For example, within the structure of symbolism developed in the work of several Canadian photographers whose images have been deemed "documentary," a recurrent window or rectangular opening becomes a metaphoric portal into another world, or establishes a dialectic between a reality that is "here" and one that is "elsewhere."

In discussing "intellectual life in peripheral societies" with particular attention to Canada, sociologist Ian Angus has observed that "[e]ven when concepts are taken over from dominant formations, they may be used in a way that surpasses their original formation and thereby changes their meaning."[6] To Angus, any "defence of distinctiveness" contains a paradox: "if something is unique to Canada, then it must exist nowhere else on the planet; if something is not unique, then its existence in Canada seems to be of no importance for the national identity." This approach "will marginalize any definition of Canadian identity to parochialism." However, says Angus, "the paradox can be dissolved … if we pose the problem in another way, if what is inside is separated from the outside, not by a unique content, but by a *distinctive relation between contents*," a different "arrangement or pattern."[7] Instead of "the paradox between local parochiality and foreign universality, we may then discover an interest in the distinctiveness of our arrangement of contents." Angus writes that although an idea may indeed be "imported" (as in some cases photographic styles and approaches have been), in the receiving culture the idea "takes on a different use, is applied to different issues, and is crafted in a different manner. For the question of national identity this difference becomes more interesting than origin."[8] In Canadian photog-

raphy what may be observed is not so much a distinctive arrangement of contents in our use of visual syntax that is shared with other cultures but rather the use of these visual syntax to singularly different ends.

If, then, Canadian street photographs since 1955 are not really about the social context in which they were taken, though they may portray that context in a way we are used to if we have looked at American and European photographic imagery of the same period, what *are* they about? And what are the clues in the Canadian images indicating that some other way of reading them may be possible, indeed necessary, if we are to penetrate their meaning at all?

The answer to this question didn't, for me, come after looking at five or ten or a hundred photographs made by Canadians. It took years of looking at the work of dozens of Canadian photographers to begin to see a characteristic vision emerge. It took several more to come to some sense of what the significance of these recurrent configurations and subjects might be. But that was the case, I believe, because I had so few guidelines with which to approach these images. I was, in a very real sense, hobbled by the baggage of my American photographic education, and more severely by my immersion in a world view that presumed a specifically Canadian experience of reality didn't exist, or if it did, was really "only" a hybrid one, and a not very exciting hybrid at that. As Said writes, "we can read ourselves against another people's pattern, but since it is not ours we emerge as its effects, its errata ... Whenever we try to narrate ourselves, we appear as dislocations in *their* discourse."[9]

Once we have looked beyond the ways in which Canadian photography resembles (and shares some obvious preoccupations with) other photography, it is possible to readily recognize that certain kinds of subject matter, treated in very particular kinds of ways, appear again and again. Not only do Canadian photographers seem particularly preoccupied with death as subject matter, for example, but it is significant that in Canadian photographic imagery there is frequently a kind of undertow, a persistent awareness of death in life, even in photographs that on the face of it have nothing to do with death at all.

At one point all of this ceased to be invisible to me, because I was seeing it repeat itself so often in the Canadian work that I was looking at. That it has remained for so long unseen may have something to do with a phenomenon described to me by a psychotherapist who uses a good deal of hypnotherapy in her work. If a subject is told under hypnosis that something doesn't exist, the bowl on the table in front of him for instance, when he leaves the hypnotic trance he will believe when he looks at the table that there is nothing on it. He "sees" nothing where in fact something is. Effort *is* required to penetrate to the level at which Canadian photography and other means of expression begin to reveal themselves as pertaining to something that is uniquely Canadian. That by and large we have not felt this effort to be worthwhile may only indicate the degree to which we have been

mesmerized into believing that our search for a particularly Canadian mythology will be fruitless.

It is perhaps unnecessary to point out that Canadian artists, too, are caught in a quagmire of borrowed cultural suppositions, and can be as unable as the rest of us to decipher the particularly Canadian subtexts of what they have created. An analogy might be the dreamer whose unconscious has manifested a rich and complex dream narrative, yet who is unaware of the dream's implications. Most of us would agree that the artist, in terms of intention and effort, is implicated in a work of art in a way that the dreamer is not in the dream. But it is still entirely possible that the artist will be cognizant of certain levels of signification and not of others within his or her own artistic production. Many conversations over the years with Canadian photographers about their work have only served to confirm that, with respect to the kind of "Canadian content" I will be discussing here, this is undoubtably the case. As I have pointed out, the fact that aspects of Canadian work have remained inaccessible to Canadian viewers and artists alike is not surprising. I believe that what I call the "real" content of Canadian photography, and most Canadian art, has been created on an almost entirely unconscious level. One can only begin to imagine what Canadian photographers and other artists might accomplish once these layers and subtexts are brought into conscious awareness.

This does not imply, however, that the characteristics I identify as Canadian are only transitional, to be followed by work that will be somehow better once we become conscious of our own photographic tradition. As Canadian artists do become aware of the idiom they have helped to create, the choice becomes available to work within that characteristic mode of expression, to play with it, question it, to work against it, or even to feel burdened by it. But not to say that we have no tradition at all.

Every natural fact is a symbol
of some spiritual fact. Every appearance
in nature corresponds to some state of
mind, and that state of mind can only
be described by presenting that natural
appearance as its picture.

Ralph Waldo EMERSON

Nature

referenceless world
i do take refuge in

bpNICOL

Martyrology

CHAPTER TWO

The Missing Referent

Spectral Images In discussing the nature of photography as a medium, commentators of different stripes have tended to agree about what defines photography and sets it apart from other visual means of expression. At the medium's inception, photography was seen as a chemical and physical process that "gives Nature the ability to reproduce herself."[1] Toronto critic Marta Braun has aptly referred to this quality as photography's "privileged ontological relationship to reality." Curiously, in ways we will examine, Canadian photographers appear to eschew the very qualities these theorists identify as the defining features of the art.

"Photography affects us like a phenomenon in nature, like a flower or a snowflake whose vegetable or earthly origins are an inseparable part of their beauty,"[2] wrote film critic André Bazin in 1945. Bazin thought that "[o]nly a photographic lens can give us the kind of image of the object that is capable of satisfying the deep need man has to substitute for [that object] something more than a mere approximation, a kind of decal or transfer."[3] He went so far as to assert that the "photographic image is the object itself, the object freed from the conditions of time and space that govern it ... no matter how 'lacking in documentary value' or how unclear the image may be," to Bazin "it shares, by virtue of the very process of its becoming, the being of the model of which it is the reproduction, it *is* the model."[4]

Nearly thirty years later the perceptual psychologist Rudolf Arnheim remarked that a "different attitude toward time is characteristic" of our response to a photograph. "'When was this painted?' means mostly that we want to know to which stage of the artist's life the work belongs. 'When was this taken?' means typically that we are concerned with the historical locus of the subject."[5] As Arnheim says, when we see a painting in a museum of, say, a Flemish tavern, we are interested in the kinds of artistic decisions the painter made by introducing particular objects and characters into the work. "Only indirectly do we use his picture as a documentary testimony on what life was like in the seventeenth century." But our attitude is strikingly different when we approach a photograph of a modern lunch counter. "'Where was this taken?,' we want to know," and we use the photograph as evidence regarding the nature of actual lunch counters; we explore the scene depicted with the "delighted curiosity of the tourist."[6]

Here Arnheim echoes the German essayist Walter Benjamin, who in the 1930s alluded to the "new and strange phenomenon"[7] one encounters with photography. Of a photographic portrait made in the mid-nineteenth century by the Edinburgh photographers Hill and Adamson, Benjamin writes that "in that fishwife from Newhaven, who casts her eyes down with such casual seductive shame," there is something "that does not merely testify to the art of Hill the photographer, but something that cannot be silenced, that impudently demands the name of the person who lived at the time and who, remaining real even now, will never yield herself up entirely into art."[8]

"The painter constructs, the photographer discloses,"[9] wrote Susan Sontag in *On Photography* in 1977. "That is, the identification of the subject of a photograph always dominates our perception of it – as it does not, necessarily, in a painting."[10] To Sontag the formal issues that are always a central issue in painting "are, at most, of secondary importance in photography, while what a photograph is *of* is always of primary importance." The assumption that underlies all uses of photography, "that each photograph is a piece of the world," means that "we don't know how to react to a photograph (if the image is visually ambiguous: say too closely seen or too distant) until we know *what* piece of the world it is."[11]

Photographic images are even "able to usurp reality," says Sontag, "because first of all a photograph is not only an image (as a painting is an image), an interpretation of the real; it is also a trace, something directly stenciled off the real, like a footprint or a death mask."[12] Even a hyperrealist painting "is never more than the stating of an interpretation," while a photograph "is never less than the registering of an emanation (light waves reflected by objects) – a material vestige of its subject in a way that no painting can be."[13] Sontag believes that "it is in the nature of a photograph that it can never entirely transcend its subject, as a painting can. Nor can a photograph ever transcend the visual itself, which is in some sense the ultimate aim of modernist painting."[14]

In his seminal *Camera Lucida*, published in 1980, Roland Barthes writes that "overcome by an 'ontological desire,'" he set out "to learn at all costs what Photography was 'in itself,' by what essential feature it was to be distinguished from the community of images."[15] His search for this "essential feature" produced perhaps the most elegant and poetic of all expressions of photography's nature.

"In the Photograph, the event is never transcended for the sake of something else,"[16] says Barthes. Rather, a photograph is "wholly ballasted by the contingency of which it is the weightless, transparent envelope." For him "a specific photograph ... is never distinguished from its referent (from what it represents), or at least it is not *immediately* or *generally* distinguished from its referent,"[17] which he says is true for every other kind of image.

By its very nature the photograph "has something tautological about it: a pipe, here, is always and intractably a pipe. It is as if the Photograph always carries its referent with itself,"[18] and both are affected "by the same amorous or funereal immobility, at the very heart of the moving world: they are glued together, limb by limb, like the condemned man and the corpse in certain tortures; or even like those pairs of fish (sharks, I think, according to Michelet) which navigate in convoy, as though united by an eternal coitus."[19] A photograph "belongs to that class of laminated objects whose two leaves cannot be separated without destroying them both: the windowpane and the landscape, and why not: Good and Evil, desire and its object: dualities we can conceive but not perceive."[20]

The photograph, to Barthes, "is always invisible: it is not it that we see." This is because "the referent adheres." And this makes it "difficult to focus on Photography."[21] Because the photograph is "pure contingency and can be nothing else (it is always *something* that is represented) ... it immediately yields up those 'details' which constitute the very raw material of ethnological knowledge."[22] What he persists in seeing when he looks at any photograph is the referent, and it is in this respect that the photograph "really transcends itself: is this not the sole proof of its art?" he asks, to "annihilate itself as *medium*, to be no longer a sign but the thing itself?"[23]

"In Photography," writes Barthes, "the presence of the thing (at a certain past moment) is never metaphoric."[24] In photography "the fact was established *without method*."[25] Barthes, like Sontag, believes that "[t]he photograph is literally an emanation of the referent." Like others before him, he is amazed that "[f]rom a real body, which was there, proceed radiations which ultimately touch me, who am here."[26]

Barthes returns to the referent as a kind of photographic Holy Grail: "in Photography I can never deny that *the thing has been there*. There is a superimposition here: of reality and of the past."[27] And because "this constraint exists only for Photography, we must consider it, by reduction, as the very essence, the *noeme* of Photography. What I intentionalize in a photograph (we are not yet speaking

of film) is neither Art nor Communication, it is Reference, which is the founding order of Photography."[28] The "stubbornness of the Referent in always being there"[29] proves to be the essence he was looking for.

The inextricable relationship of the photographic image to the object or persons photographed is, in the opinion of these and virtually all writers on the subject, photography's most intractable and definitive feature. What is quite astonishing then is the degree to which Canadian photographers, in their use of this most realist of all media, work to pry the photographic image from the physical fact that it refers to. The *sine qua non* of photography, its unique capacity for verisimilitude, is the very trait that many Canadian photographers seem distinctly ill at ease with. In an earlier essay,[30] Barthes distinguishes between photography's "denotative" and "connotative" functions; it is the "denotative" aspect of photography that the Canadian photographer would appear to be happy to eliminate altogether.

This Canadian attempt to rend asunder image and referent, in a medium that distinguishes itself by its absolute identification with that which it represents, makes itself apparent in a variety of ways. Not the least of these is that Canadian photographs, in contrast to photographs made almost anywhere else, aren't primarily about what it is they point to. One can become lost very quickly in a body of Canadian images if one attempts to read them as the analyses of Barthes, Sontag and others suggest photographs cannot help but *be* read. Barthes may feel, with good reason, that the "presence of the thing" in a photograph is "never metaphorical," and yet somehow, in Canadian photography, it almost always is. A pipe in a Canadian photograph *isn't* usually a pipe. It's probably a crucifix.

The Canadian street photograph, while showing us, say, the visit of Queen Elizabeth to Canada in 1957, or a sideshow at the Canadian National Exhibition, is likely not to be about the occurrence it describes but to point to some metaphysical or symbolic, rather than social, dimension. (Here and throughout this text I use the term "metaphysical" to denote a register that is beyond or apart from the physical, as in the philosophical use of the word "metaphysician" to describe one who "propound[s] theories about the overall structure of the world."[31] Given the post-structuralist and, often, feminist mistrust of binary oppositions, such as male and female, which are perceived as being both false and grounded in a Western system of "metaphysics," I would have preferred to use another term in this context. But after much reflection, I have found that no other will do as well – Canadian photographers do use photography to expound on "the overall structure of the world," as opposed to the anecdotal particularities of a specific time and place. In a catalogue essay written to accompany an exhibition she organized at the 49th Parallel Centre for Contemporary Canadian Art in New York in 1987, curator Frances Morin wrote that her criteria for the inclusion of artists in the show was "not that they were born in Canada or that

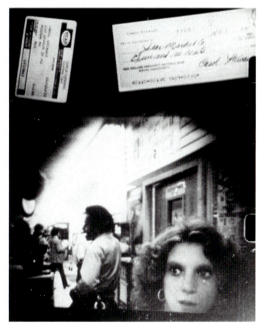

**2.1 Karen SMILEY
(now Rowantree)**
Detail from *Check
Cashing Identification
Photographs, Star
Market Co., Boston.*
A series of 17 pairs
of photographs
1976
40.64 x 50.8 cm each

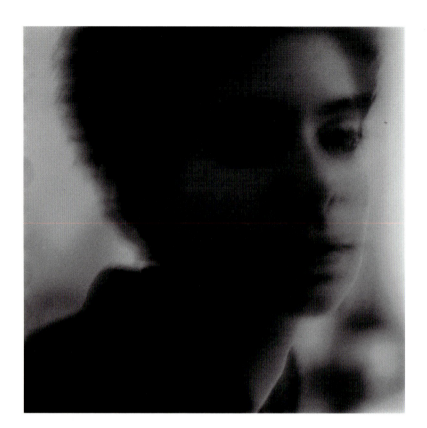

2.2 Angela GRAUERHOLZ
Anne Delson
1984
50.8 x 60.96 cm

they lived there … so much as their personal understanding and interest in Glenn Gould's metaphysical 'idea of North' and of Canada in general."[32] Morin's use of "metaphysical" here is consonant with my own. Still, I want to signal that I use the word with caution, conscious that it may be problematic for some readers.)

Canadian photographers, particularly in their use of the portrait, attempt to remove the image itself from the context in which it was embedded, and then treat that image as if it had very little to do with the subject matter of which it is, to borrow a nineteenth-century term, the "shadow." The Canadian photographic image floats overhead, as it were, disconnected to the physical reality that engendered it and which we have been conditioned to assume every photographic image is created to reflect.

A series of portraits made by Karen Smiley in 1976 are in this respect quintessentially Canadian. Noticing the surveillance camera used to take identification photographs of people wanting to pay by cheque at a supermarket, Smiley obtained negatives produced by this machine and made blow-ups of a selected few. The resulting head and shoulder portraits of anonymous individuals, shown with the contents of their wallets spread before them, are dark, grainy, and eerily disconcerting. The persons in them seem like anxious shades floating homeless

in some unidentified and vaguely threatening nether region. This impression is exacerbated by our sense of the bureaucratic no man's land in which cheque verification pictures are likely to end up.

Montreal photographer Anne-Marie Zeppetelli's large-scale colour photographs are "layered" over time – objects, flashes of light, and sometimes Zeppetelli herself pass before the camera while the lens remains open, leaving the trace of phantom-like presences in the photographer's elaborately constructed environments. Zeppetelli's works and Smiley's portraits, like the vaporous-looking images Angela Grauerholz made of her women friends in the early 1980s, bring to mind the story told by nineteenth-century French photographer Nadar about Honoré de Balzac's highly superstitious reaction to photography. Balzac believed, wrote Nadar, that "all physical objects are made up entirely of layers of ghostlike images, an infinite number of leaflike skins laid one on top of the other." Balzac "concluded that every time someone had his photograph taken, one of the spectral layers was removed from the body and transferred to the photograph. Repeated exposures entailed the unavoidable loss of subsequent ghostly layers, that is, the very essence of life."[33] Looking at Canadian portrait photography, one could begin to believe that Balzac was correct: the work of a significant number of Canadian portrait photographers present disembodied, spectre-like "skins," ghostly images that appear autonomous, to have a life of their own, independent of the individual whom they apparently represent.

Within portraiture in general, including what is often called "environmental" portraiture, Canadian photographers use several different devices to achieve the same end – the distancing of the resultant image from the original subject of the photograph, and often, of the subject from his or her environment. Nina Raginsky's full-length frontal portraits made in the 1970s of Victoria eccentrics might have functioned as a quasi-ethnological record of a particular community of persons at a specific point in history. But Raginsky's sepia toning and hand-colouring undermine the social content of the portraits, distance the subjects from their actual surroundings, and situate them in a zone of representation that is somewhere between prototype and caricature.

Nina Raginsky has said[34] that her photographs are inspired by those of the German photographer August Sander, who sought to photograph representative German professions "according to their essential archetype."[35] What distinguishes Sander's straightforward images of ordinary Germans – a pastry chef, members of a village band, a radio station worker, lawyers, and many others – are not only the dress and demeanour that were characteristic of these professions within a particular historical context but the specificity of unique physical details, what Barthes called "punctum." The cowlick and crookedly arranged tie of the writer, the shadows under the eyes of the unemployed actor – these lend Sander's subjects an individuality that is beyond typology. The posing of Sander and Raginsky

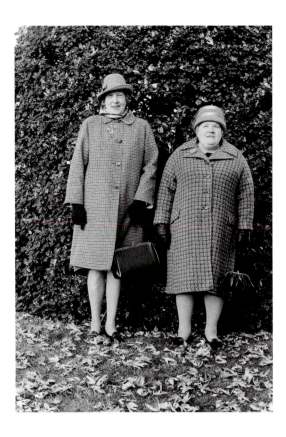

2.3 Nina RAGINSKY
*The Kirkpatrick Sisters in front of
the Empress Hotel, Victoria, British
Columbia*
1974
17.1 x 11.4 cm
Original in colour
(See also plate I)

is similar – both present their subjects as if they are specimens of a type – but Sander's subjects are allowed to emerge from beneath their archetypal representation, while the personalities of Raginsky's personages recede behind her toning and hand-colouring, and finally collapse into caricature.

By throwing the individuals he photographed in the streets of Ottawa and elsewhere out of focus, while leaving their suburban environs sharply delineated, Sylvain Cousineau in 1978 created a series of phantom-like presences who seem to hover over, rather than inhabit, the landscape in which they were found. Michael Schreier put sheets of Cibachrome direct positive photographic paper, instead of negative film, into the 8 x 10 inch view camera he used to photograph the tourists and others he encountered in the public spaces of Ottawa in 1980 and 1981. The result is the opposite of Cousineau's: the people are seen in bold relief, while their environment drops off like a kind of hazy rear-projection version of the "nation's capital." But the effect is the same: the wrenching of the subject from the landscape.

The dissociation of image from referent is made explicit by the seam that cuts across some of the large-scale photographic works of Jeff Wall and Geneviève Cadieux; this cut, like the one that dissects the closed eyes of the woman in Cadieux's

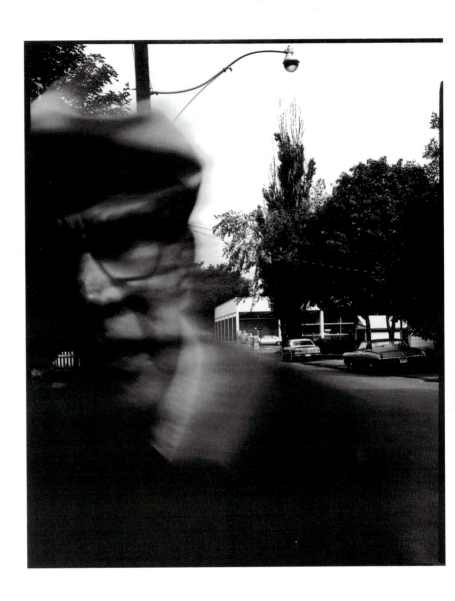

2.4 Sylvain P. COUSINEAU
Mr. Fraser, Ottawa
1978
20.32 x 25.4 cm

2.5 Michael SCHREIER
Street Portraits: The Anonymous Individual, 1981
Diptych; 25.2 x 20.1 cm each. Original in colour

1989 triptych, *Hear Me with Your Eyes*, functions to move the viewer one step away from the enticing verisimilitude of these photographers' images. This same sense of dissociation links artists with goals as seemingly incompatible as those of Yousuf Karsh and Donigan Cumming. Within the parameters of his project of creating admiring portraits of men and women he deems heroic, Karsh employs pose, retouching, and what used to be called "Rembrandt" lighting in a manner so extreme as to propel his subjects into a stratosphere of the canonized to which mere humans could never hope to gain access. Cumming's photographs of working-class Montrealers displaying the scars of surgery or amputation, vacuuming their beds dressed in jockey shorts and bemedalled World War II army jackets, or surrounded by Elvis memorabilia, would seem to be worlds away from the Karsh portraits of Churchill and others that graced the covers of *Life* magazine in its heyday. Cumming's pictures have been read as either exploitative and stereotype-reinforcing caricatures or as clever deconstructions of classic documentary practice.[36] But his exaggerated use of commercial display techniques, his obtrusive lighting, and obvious personal intervention function to place the subjects of his photographs in a realm as unreal, as unconnected to the here-and-now of their actual lives, as that created by the more conventional and romanticized portraits of Karsh.

During the latter part of the nineteenth century, Canada's most well-known portraitist was William Notman. Notman produced many straightforward por-

traits of the country's wealthy and powerful citizens, but he was known internationally for his seamlessly collaged and often hand-painted photographic *mises-en-scène*. In an era when the technology was sufficiently advanced to allow a photographer to photograph his or her subject out in the actual landscape, Notman preferred instead to go to elaborate lengths to recreate snowy tableaux of Canadians in nature in his Montreal studio. A family might be photographed in full winter regalia in the month of June, under studio lighting, perched on a wooden incline. With the help of his staff of painters, Notman then transformed this image into one showing the family sliding on a toboggan down the icy slopes of what could be Mount Royal.

In all these cases, and in many more within Canadian photography, what is really happening is that the photographic image is being severed from the body of the world; an escape hatch is being fashioned by which the images of the persons photographed, if not the persons themselves, are able to flee their attachment to the physical realm. Even in a film about Canadian photography, the same dissociation is apparent. *Les images des autres*, a film made by art critic Nicole Gingras in 1993, is composed almost entirely of photographs by Canadian photographers Raymonde April, Johnide, Brian Piitz, and Sandra Semchuk. (The remaining footage shows the photographers speaking, although the interviewer herself never appears.) Narration is provided solely by the photographers talking about their work. The poetic power of the film, which is considerable, resides in the particular way in which the still photographic images are made to inhabit the cinematic space. In Gingras's film this space becomes a kind of world apart where the photographic images seem to float, almost palpably transparent, existing only *as* images, with no reference to anything outside themselves, and yet nonetheless infused with energy.

Contemplating this aspect of Canadian photographic imagery always reminds me of the time I saw Marshall McLuhan on the ill-fated Peter Gzowski late-night talk show. McLuhan was attempting to convince his fellow guest, a Las Vegas entertainer, that what the television audience reacted to was not her, but her image, and that this was an absolutely crucial difference. The medium's being the message seemed to disturb the singer no end, and the resulting interchange, at least to me, was hilarious. The American's inability to fathom how her image could *not* be identical to her and McLuhan's insistence that image and physical reality had little or nothing to do with one another seem in retrospect to represent quite succinctly how our two cultures understand representation in general. Before discussing further the Canadian portrait photographer's rejection of the literal dimension of photography, and what that might be about, it will be useful to focus on the use of photography by a nation that wholeheartedly embraces the medium's capacity for the faithful witnessing of reality. In contrast, the Canadian attempt to sabotage much of what is photographic about photography appears all the more remarkable.

Intractable Fact From the moment of photography's arrival within American culture in 1840, in the form of the silver-plated daguerreotype, the monolithic, frontally posed subject, human or object, has dominated American photographic imagery. The predominance of this visual configuration and the American photographer's intimate involvement with the physicality of the world were apparent in the millions of daguerreotype portraits produced prior to the beginning of the American Civil War in 1860.

It "is possible to suggest that without prior conditioning by the daguerreotype, America would not have been intuitively ready to experience the Civil War."[37] So writes Richard Rudisill in *Mirror Image*, an analysis of the effects of the daguerreotype, the first photographic process available to the public, on American society. "The [American] people... had developed a sense of national character through the agency of the daguerreotype," says Rudisill; the medium prepared Americans to face the challenge of a civil war "because its pictures had helped produce a symbolic certainty of what the American nation was."[38] Rudisill's study concentrates only on that period of American history, from about 1840 until the beginning of the war in 1860, when the daguerreotype reigned supreme and millions of the silver-plated images were produced in the United States alone, but the insights he provides regarding the relationship of the American use of the daguerreotype to the culture as a whole afford useful underpinnings for an examination of American photography up to the present day. They offer as well a basis for comparison with an utterly dissimilar Canadian use of the medium. Rudisill contrasts the European disdain for a picture-making device such as the daguerreotype, which recorded everything on which it was focused without discrimination, with the extremely positive American response to the identical technology. The European artist and public alike lamented that use of the daguerreotype did not allow for the intervention of the artist, who saw his or her role as that of suppressing certain details and highlighting others in order to produce a pictorially harmonious whole.

Because, Rudisill says, Americans were overwhelmingly concerned with the truthfulness of images even prior to the introduction of photography into their culture, the daguerreotype's accuracy was seen as a positive feature. American genre painters of the era, who might paint government figures, entertainers, or farm workers, realized that ordinary people would take them to task if they found details in the paintings that failed to correspond to their own experience of reality. A stage act consisting of the unfurling of a canvas on which was painted in accurate detail the entire length of the Mississippi River and shoreline, with accompanying lecture, was a popular diversion of the day. To the Americans, who were looking for accurate reflections of their emerging national character, a picture was "good" if it was "true," whereas for the European, with an artistic tradition already securely in place, the recognizable mark of the artist's hand was the predominant concern. The silvered surface of the daguerreotype image, what writer

Oliver Wendell Holmes called "the mirror with a memory,"[39] literally gave Americans the reflection of themselves they so avidly sought at that point in their development as a nation.

What also prepared American culture for its acceptance of the machine-made image, according to Rudisill, was the prevalence in mid-nineteenth-century America of the Transcendentalist ideas of Ralph Waldo Emerson and Henry David Thoreau. To the Transcendentalist the visual was primordial, and this preoccupation filtered its way down to even the most pedestrian examples of artistic and literary expression.

Emerson's essay "Nature," published in 1836, "spoke of the physical eye as the means to spiritual perception."[40] If only one could see clearly enough, one could go beyond surface appearances to the "underlying truth of the universe";[41] if one could observe nature in a clear and sensitive manner, the unity underlying all life in the Oversoul would be revealed. Sight could become Insight.

Thoreau felt that memory prolonged nature's benefit beyond the moment of visual insight. How much more effective would such a trace image be, says Rudisill, if the entire impression could be permanently retained, as is the case with photography. Photography provided "an otherwise unattainable source of insight into events or objects too transitory to allow thorough perception."[42] Emerson's "philosophical ideal of physical sight becoming spiritual insight by keen observation of nature became a practical activity," says Rudisill, "once the medium of the daguerreotype became available for use in the definition of American society."[43]

Rudisill writes that Americans, at the point of the photograph's entry into their culture, had a deep-seated belief that physical seeing was the route to spiritual perception, that observation that was as accurate and "scientific" as possible was the pathway to communion with the spiritual essence informing all of physical reality. There is every evidence that this belief has persisted within the American imagination, and understanding this presumption helps to contextualize a predilection that has dominated American photographic practice to the present day.

Americans have always used the camera to describe the surface appearance of the world with as much veracity as the medium is able to muster, and this impulse has fuelled that most enduring of American photographic traditions, the school of "Straight" or "Purist" photography. From the works of art photographers Alfred Stieglitz, Paul Strand, Edward Weston, and Ansel Adams up to the present, the exploitation of photography's denotative function – in crisply rendered, pristine prints whose predominant quality is their faithful rendering of reality – has been an abiding American passion. The metaphysical moment for American Purist photographs occurs when the photograph is taken; the belief in a greater truth beyond the facts of surface reality, and the concomitant belief that the way to this truth is through the clearest possible description of physical fact, underlies virtually all of American photography, including that which could be termed "socially

concerned" rather than "artistic." Emerson's conception of himself as becoming a "transparent eyeball" in order to achieve unity with God is not in the least ideologically incompatible, for instance, with Minor White's celebration, decades later, of the way in which the objectivity of the camera allowed for a transcendent, Zen-like experience on the part of the photographer.

According to Rudisill, because Americans in the middle of the nineteenth century tended to understand history as the "lengthened shadows of great men"[44] who embodied the definitive characteristics of their nation, the more accurate a portrait of these men one had available, the more easily one could respond to the ideals they symbolized, as if to reality itself. Ordinary American faces and the American landscape were seen as symbolizing abstract principles that distinguished the American nation from all others, just as public figures symbolized national ideals of character. Great effort was hence made to obtain likenesses of America's most well-known citizens, who defined and summarized what was noble and noteworthy about their culture. Exhibits like Anthony's National Daguerreotype Miniature Gallery, P.T. Barnum's American Gallery of Female Beauty (surely a precursor to later pin-ups and beauty pageants), and publications like Mathew Brady's "Gallery of Illustrious Americans" gave Americans a chance to participate in the process of collectively deciding who embodied the most valued aspects of their national character.

Photographers like Brady, says Rudisill, were conscious of the need to portray, for posterity, the innermost nature of the sitter by means of the "searching objectivity"[45] of their pictures. Precisely because of photography's scientific accuracy the symbolic message of such images would be the same for everyone, and the further melding of a unified group consciousness made possible.

American daguerreotype portraits, from those by the famous Brady or the Boston society photographers Southworth and Hawes to the cheapest products of itinerant operators, were largely unadorned, frontal head and shoulders shots, with the sitter posed against a neutral background and including only those personal objects that would help to define his or her character. Rudisill's description and analysis of these portraits might well be applied to American portraiture in general, even allowing for the obviously singular preoccupations found in the work of a photographer like Diane Arbus. In the straightforward portraits of Arbus, Richard Avedon, Irving Penn, Judy Dater, Nicolas Nixon, and scores of others – Dater's influential 1970s pictures of "sexually liberated" San Fransisco women, for example, or Nixon's *The Brown Sisters*, photographs he has made annually since 1975 of his wife and her three sisters, frontally posed in an unvarying line-up – it is obvious that as in the earliest decades of photography's existence, the American portrait photographer believes that an extremely clear and detailed likeness of the sitter's features will reveal the inner character, and that this, rather than aesthetic considerations, is of primary importance. As we have seen, even when a Canadian photographer adopts a frontal composition that isolates the

subject, as do, for example, Nina Raginsky and Michael Schreier, the effect is entirely different. What is most evident is not the personality of the person who is posing but rather their estrangement from their surroundings.

In contrast, European photographic portraiture has tended to treat the sitter as if she or he were only one of many visual elements within the frame, all of which need to be appropriately placed in order to create a dynamic visual balance. In the 1930s era portraits of the British photographer Bill Brandt, or the Europeans Brassai and André Kertesz, for example, it is evident that the interplay of light and shade and of volume and line, and the feeling these create around the subjects of the photograph, are of more import than a precise copying of surface reality. In Brandt's 1963 portrait of Iris Murdoch the writer is almost engulfed by the flowering vines and the garden that grows up to the door of her cottage, and up to her knees. Despite the strength of character expressed in her face, Murdoch is merely one element in a visually rich field of texture. Similarly, in an image Brandt made during the 1930s, the coal-blackened face, arms, and torso of an East Durham coal miner, enjoying a smoke after arriving home from the pit, merge with the smudged pattern of the paper on the wall behind him. The woman in the foreground of the audience at Her Majesty's Theatre, in a Brandt photograph from the same decade, is a bold mass of light and shade against a sea of other spectators.

It is instructive to compare portraits made by the Canadian photographer Cal Bailey – frontal, from the waist up images of individuals and groups taken against grey backgrounds – with the American photographs of Richard Avedon or Irving Penn they so closely resemble. What is immediately noticeable about Bailey's images of Manitoba waitresses, lawyers, middle-class families, and others, is how *dépaysé*, how uprooted, they all appear to be. By stepping into the neutral space in front of Bailey's backdrop, whether wearing a security guard's uniform, a Brandon University jacket, or a well-cut suit, these persons have taken on, to the viewer, a vulnerable sense of disconnection, of not being where they normally belong.

Many of Bailey's subjects are laughing or smiling, and in the catalogue of an exhibition of his portraits held in 1978, the photographer provided capsule descriptions of the persons photographed, as for example: "Bob Krohn is working with his father and brothers building the Roseisle Pentacostal Assembly. Bob is the eldest of three sons." Nevertheless, the ethnically and economically diverse group of persons who appear in Bailey's portraits all look as if they have had their habitual surroundings suddenly cut away, surroundings that would allow us to place them, both psychologically and in terms of social circumstance, and which would, more importantly, allow them to place themselves.

For reasons that aren't fully explained in the catalogue, Bailey called his exhibit "Waiting," a title that underlines the atmosphere of dislocation the series conveys. In the studio shots of Penn, Avedon, and other American photographers,

2.6 Clayton BAILEY
Dorothy, Joy and Judith
1978
27.94 x 35.56 cm

individuals in working uniform and costume appear against plain backdrops just as they do in Cal Bailey's images. But what is significant is that never do they appear as lost as do the persons in Bailey's ostensibly very similar portraits. Between 1967 and 1971 Irving Penn produced a series of "ethnographic" essays for *Vogue* magazine, portraits that might uncharitably be read as exoticizing his subjects and reducing their attire to inspiration for the fashion industry. Although the persons who posed for Penn in Nepal, Cameroon, New Guinea, and Morocco have obviously been displaced from their habitual surroundings and catapulted into the force-field of his makeshift studio, these persons – the "Four Unggai of New Guinea," or "Three Asaro Mud Men" – are presented exactly as the "Patissiers" Penn photographed nineteen years earlier in Paris. No matter where he photographs them, Penn's subjects merge with the mottled paper of his travelling backdrop that covers wall and floor in a seamless sweep; they are visually grounded in their studio surroundings. Even when an American portrait amounts to a mild

36 Dislocation

case of character assassination, as can happen in an image by Avedon or Arbus, the revelation of the "inner being" of the sitter remains the photographer's primary motivation. Cal Bailey and other Canadian photographers use studio set-ups that are almost identical to those of Avedon, but the results are not so much portraits of individuals as they are a description of those persons' estrangement from any environment in which they might potentially feel at home.

The anonymous individuals photographed by Joel Sternfeld between 1985 and 2000 for his *American Prospect* series (shown in a one-person exhibit entitled *Stranger Passing* in 2001) seem unequivocally rooted in their surroundings when set side by side with portraits from a comparable Canadian photographic project. A man who might have been a drifter was photographed by Sternfeld on the banks of the Mississippi in Louisiana in 1985 wearing a one-piece outfit that could be a leisure suit, a mechanic's overall, or a prison uniform. The man's expression seems worried, even paranoid. Despite these signifiers of disconnection, this man, who may be only passing through the landscape, is seen as anchored in it nonetheless. His feet seem to grow from the earth like the stalks of a plant, just as the farmer taking a break in Iowa in 1987, her feet embedded in a pile of corn, her hand holding a cigarette, appears almost organically grounded in the landscape surrounding her. In Michael Schreier's deceptively similar portraits, the *Street Portraits: The Anonymous Individual*, what catches our attention is not so much the physical details of the subject, as interesting as these may sometimes be (the pink coat and Dominion shopping bag of a wistful middle-aged woman, the cinnamon suit of a slender, dapper man), but the tentative relationship they have to their physical context. Not only are they not firmly situated in their physical environment, that environment threatens to fall away entirely.

The Canadian tendency to see the subject as somehow removed from its surroundings persists when photographing architecture. The "portraits" of Orthodox churches Orest Semchishen made in Western Canada over several years in the 1970s, like the "Ukrainian Orthodox Church, Stry, Alberta, 1975," or "St. Elia's Ukrainian Orthodox Church, Spirit River, Alberta, 1975," present these buildings as if they are tiny, jewel-like toys that have been indiscriminately tossed on to the vast and empty plains. The ornate churches with their onion-shaped domes take on the aura of hallucinations, mirages on the deserted prairie. In short, they do not seem to belong where they are, and convey a sense of profound cultural dislocation and dissociation from the land. One might juxtapose Semchishen's images to similar studies of vernacular architecture by that most seminal of American documentary photographers, Walker Evans. Both men photographed indigenous churches; in Semchishen's photographs, like that made in Stry, or an image of a Ukranian Catholic Church photographed the same year in Craigend, Alberta, the churches are the only buildings in sight, surrounded by otherwise empty fields. Evans's South Carolina "Wooden Church" or his "Negro Church," both from 1936 and seen in his *American Photographs*, may or may not have been

situated in sparsely developed areas. What is significant is that they were pho-tographed in a closely cropped manner, with the hint of other buildings close by, so as to emphasize their containment in the landscape and not their isolation. The point is not whether the rural southern United States of the 1930s was more populated than the Canadian prairies of 1970s but how each photographer chose to represent the architectural artifacts that reflect their respective cultures.

A similar difference within the genre of landscape photography may be seen by juxtaposing Humphrey Lloyd Hime's small, unprepossessing collodion plate images of the Canadian West in the mid-1850s (Hime was part of the Assiniboine and Saskatchewan Exploring Expedition, sent west by the Province of Canada to establish a route for emigration) with those made by American Western land-scape photographers of the same era. Flat prairie and bare sky, with only a lone house, church, or skull as visual relief, compare with the mammoth plate images of natural grandeur – Yosemite Valley, Mount Agassiz, the Grand Canyon.

Rudisill says that one of the first existing American daguerreotypes is of "a simple view of a tree in a meadow made in the summer of 1840, which still car-

2.10 Edward WESTON
Shell
1927
24.6 x 19 cm

ries a sense of perception beyond the visible facts – a transcendental experience recorded in permanent form," and he notes that, over and over, in the transcendent experiences American photographers were wont to encounter in the landscape, the culminating moment was the creation of a permanent image of that "truth" by photographic means. "In the American view, the spiritual insight arising from such an experience ultimately depended on the objective recording accuracy of the photographic machine," writes Rudisill.[46]

Rudisill notes the American public's fascination with objects, particularly machinery, in the era of the daguerreotype, and links this fascination to the need for reassurance regarding machine technology in a culture that, up to that point, had been largely agrarian. The tendency to stress a central object rather than the overall pictorial composition in portraiture meant that, in fact, a person was literally treated as an object and seen by the camera in the way a machine, a tree, or a monument might be.

Bram Dijkstra, too, has noted the importance of the object to American art in general, as exemplified in the poems of William Carlos Williams, the paint-

2.11 Alison ROSSITER
Pink Soap Bottle. From the series
Bridal Satin
1983
40.64 x 50.8 cm
Original in colour

ings of Georgia O'Keefe, and the photographs of Alfred Stieglitz. Dijkstra also relates this American obsession with the visual properties of "the thing itself" to the abiding influence of Transcendentalist philosophy. American artists of Stieglitz's time, he says, sought to focus on the objects around them with absolute precision as a way of grounding themselves in a truly American reality. "For Stieglitz and his followers the immediate task was to restore the integrity of the American object, to perceive it free from metaphor, to see it as it actually existed, within its own experimental framework." They sought "to free the American object from the impositions of alien consciousness, from the metaphoric vision which forces the object to become other than itself, and hence to be continually misapprehended."[47] This parallels the wish of the Group of Seven to give expression to Canadian experience free of preconceived ideas.

It was Edward Weston, photographing in the Purist mode from the 1920s on, and his exact renderings of smokestacks, bed-pans, shells, vegetables, and female nudes, placed against neutral backgrounds – in other words, photographed in the same way American daguerreotypists had seen their rubber machines, trees, and

Presidents – who made explicit the American photographer's preoccupation with the *Ding an sich*. Weston wrote often of the need of the photographer to "re-create his subject in terms of its basic reality"[48]: "I want the stark beauty that a lens can so exactly render, presented without interference of 'artistic' effect. Now all reactions on every plane must come directly from the original seeing of the thing, no secondhand emotion from exquisite paper surfaces or color. Honestly unembellished – first conceptions coming straight through unadulterated – no suggestion, no allegiance to any other medium."[49] For Weston, the real issue was "significant presentation of the Thing Itself with photographic quality."[50] Writing in 1939, he felt that "the penetrating power of the camera-eye [could] be used to produce a heightened sense of reality – a kind of super realism that reveals the vital essences of things."[51]

The relationship between landscape photography and a transcendent experience of nature can be seen to underlie the imagery and public statements of American Straight photographers like Minor White and Paul Caponigro. The Canadian landscape photographer Robert Bourdeau has been a particularly accomplished adept of the American Purist school. Bourdeau's large camera studies, made from the 1960s on, of the British and Ontario countryside, the South Western American desert, Sri Lankan sacred architecture, and more recently, abandoned industrial sites in the United States and Western Europe, are lush formal studies replete with detail; Bourdeau has said, reminiscent of Weston, that he wishes "to photograph things for what they really are, in the strongest possible manner."[52]

This search for the essential within the reality of the object may be detected in American work created with radically different ends in mind. One might liken, for example, Paul Strand's elegant 1923 examination of a drilling machine, or the tools Walker Evans photographed in close-up around 1955 for *Fortune* magazine – pliers, tin-snips, and wrenches that appear to float in mid-air against seamless, neutral-coloured backdrops – to the equally isolated objects photographed by the American photographer Alison Rossiter, who lived and exhibited in Canada for several years during the 1970s and 1980s. While living in Banff, Rossiter photographed centrally placed household objects – toasters, irons, and fans – with an Instamatic camera in black and white. She also made images in colour, of the flaming burners of a kitchen gas range, and of plastic bottles of dish detergent and "Beauty Aids" such as tweezers, eyelash curlers, and electric shavers, all set against satin backgrounds. Many of these objects evoke a sense of malevolence lurking dangerously close to the surface within apparently innocuous domestic settings. Neither these images nor Rossiter's more recent, humorous, head and shoulder colour portraits of horses have much in common with the Evans or Strand pictures in terms of emotional resonance. But Rossiter's isolation of the object or creature within the frame, and the importance she assigns to these elements by her attentive delineation of them, is consistent with the approach that has been apparent in American photography from its beginnings.

Along with portraiture and the Purist preoccupation with objects, nudes, and the landscape, the other equally predominant vein within American photography is that of the documentary, and here as well attention to the faithful copying of reality is evident. William Stott, writing about America and the documentary expression of the 1930s, distinguishes between the dictionary definitions of documentary or document and what he calls a "human document." "Documentary proof" refers to "'presenting facts objectively and without editorializing and inserting fictional matter, as in a book, newspaper account or film,'"[53] and "document" to a "'written or printed paper bearing the original, official, or legal form of something, and which can be used to furnish decisive evidence or information.'"[54]

The human document, to Stott, "is the opposite of the official kind; it is not objective but thoroughly personal. Far from being dispassionate, it may be 'a document that is shattering in its impact and infinitely moving' ... Even when temperate, a human document carries and communicates feeling, the raw material of drama." A human document gives some information that is found in the official, more impersonal one, and "may be read as a historical document is – for the facts it gives about public events and social customs." But to read a human document in this way "overlooks what is unique and primary: the glimpse it offers of an inner existence, a private self."[55] Stott feels that we understand a historical document intellectually and a human document emotionally.

And, he says, while human documentaries show man "undergoing the perennial and unpreventable in experience, what happens to all men everywhere: death, work, chance, rapture, hurricane, and maddened dogs,"[56] what he calls "social" documentaries accomplish this and something else as well. The social documentary "educates one's feelings as human documents do," but it "shows man at grips with conditions neither permanent nor necessary, conditions of a certain time and place,"[57] such as racial discrimination or unemployment. Social documentary "encourages social improvement," and "works through the emotions of the members of its audience to shape their attitude toward certain public facts."[58]

The thread running through all of American social documentary photography is irony. This can be seen in the Walker Evans photograph of the dilapidated interior of a sharecropper's home, on the wall of which a sampler promises that "The Lord Will Provide," or the famous Margaret Bourke-White image, "At the time of the Louisville flood," made in 1937. In the Bourke-White picture a bread line of Afro-Americans holding empty pails, baskets, and shopping bags spans the entire length of a billboard. The huge announcement behind them features a cosy white family, complete with adorable pooch, in a new model car, topped by a banner that reads "World's Highest Standard of Living." The billboard also tells us, and the blacks in the food line, that "There's no way like the American Way." Similarly, the American flag and other symbols of American democratic ideals are consistently used as counterpoints to American inequalities in Robert Frank's 1958 book of photographs, *The Americans*.

This ironical juxtaposition, of emblems of the American dream against glaring evidence that the dream has failed to come to pass, occurs throughout the kind of American documentary practice that seeks to effect social change. Even when such juxtaposition does not occur on a visual level within the photographic image itself, there is an implicit weighing of the social facts being shown against American standards of what is right and just. The tacit understanding in the work of the earliest American social documentarians like Jacob Riis and Lewis Hine is that the things they photographed – child labour, slum living conditions – ought not to be happening in a country with the professed social ideals of the United States.

This American impulse to reform is in contrast to British photography of social reality, where although inequalities are alluded to – as they quite certainly are in Bill Brandt's 1930s images of North England coal miners and Mayfair aristocrats, for example – there is an inevitable resigned acceptance of social circumstances. From the nineteenth-century photographers Sir Benjamin Stone and Paul Martin through to Tony Ray-Jones, whose work became known in the 1970s, British photographers of the social scene prefer to concentrate, in an often humorous way, on the ceremonial and leisure activities of their fellow citizens, rather than on social ills. George Orwell wrote of the characteristic "*privateness of English life,*" of the British "addiction to hobbies and spare-time occupations." In England, said Orwell, the "liberty of the individual is still believed in … But this has nothing to do with economic liberty." It is rather a freedom to "have a home of your own, to do what you like in your spare time, to choose your own amusements instead of having them chosen for you from above."[59]

It is interesting, in light of Orwell's comments, to consider the work produced by the young Tony Ray-Jones when he returned to England in 1966 after studying in the U.S., where, he said, he was inspired by the work of Robert Frank. After travelling around England for five years, the collection of images he produced stopped short of condemning the social injustices of his native country, the influence of Frank notwithstanding. Published posthumously as *A Day Off: An English Journal*, his pictures of May queens in Sittingbourne and Maidstone, Bacup coconut dancers, and celebrants at the Broadstairs Dickens Festival are reminiscent of the "Ancient Neptune Festival" and the commemoration of an 845 AD attack by the Danes recorded eighty years earlier by his fellow countryman Sir Benjamin Stone, and also of the witty snapshots of holiday fun – groups of couples necking on the beach – made in the 1890s by Londoner Paul Martin. More recently, Martin Parr's 1985 book, *The Last Resort*, documented the activities of vacationers in the cut-rate beach town of New Brighton, and Richard Billingham's mid-1990s *Ray's a Laugh* showed, in non-judgmental fashion, the vicissitudes of his dysfunctional family. Unlike their American counterparts, British documentary photographers are unlikely to criticize, in any overt manner, the social situation they describe.

2.12 Henri CARTIER-BRESSON
Sunday on the Banks of the Marne
1938
16.4 x 24.5 cm

In his now-famous description of the "decisive moment," the French pho-
tographer Henri Cartier-Bresson wrote that after taking a certain picture, one
may depart from the scene feeling that a particularly good image has been obtained.
This feeling can be substantiated, he says, and suggests that to do so a photogra-
pher make a print of the picture and "trace on it the geometric figures which come
under analysis." It will then be possible to observe that "if the shutter was released
at the decisive moment, you have instinctively fixed a geometric pattern without
which the photo would have been both formless and lifeless." He believed that
"inside movement there is one moment at which the elements in motion are in
balance. Photography must seize upon this moment and hold immobile the equi-
librium of it."[60]

Cartier-Bresson's preoccupation with composition reveals itself in the careful
choreography of movement within the documentary images he began producing
in 1930. His bold, pictorially conscious way of constructing images had an enor-
mous effect on several generations of documentary photographers, including
Canadian photographers of the 1960s and 1970s like Lutz Dille, John Max, and

2.13 Walker EVANS
General Store, Selma, Ala.
1936
20.2 x 25.2 cm

Michael Semak. The European photographers' concern with formal issues is as
evident within documentary practice as it was in their construction of daguerreo-
type portraits. While the subject matter and social consciousness of Robert Frank's
pictures from *The Americans* are very American, for example, Frank is true to his
European roots in his disdain for the finely detailed print and in the provocative
configurations of his images.

There is much documentation within American photographic history that
William Stott might deem "human," as opposed to "social," like the *Life* magazine
photo-stories of W. Eugene Smith and the work of other 1950s photographers
who, feeling the pressures of a politically repressive climate, shied away from
potentially controversial social content. But the bulk of American documentary
practice, including Smith's later investigation of mercury poisoning in Japan, has
been bound up with a search for social wrongs and a plea for change. Several
American photographers, including Martha Rosler and Allan Sekula, have in
recent years questioned traditional documentary methodologies, but the photo-
graphic approaches they suggest as alternatives have ideals that correspond closely
to those of the more traditional "concerned" photographers whose methods they
deplore. The so-called "postmodern" American photography of the 1980s,
including that of Cindy Sherman, Laurie Simmons, and Barbara Kruger, with its

appropriation of stereotypical modes of representation from media imagery, manifested an agenda curiously compatible with that of Stieglitz, who believed that if regrettable social conditions were shown to the public clearly enough, change was inevitable.

The quintessential American documentary photographer is considered by many to be Walker Evans, whose Depression era pictures of indigenous American architecture, commercial signs, and sharecroppers and the interiors of their homes were published in 1938 as *American Photographs*. Although clearly social documents, the photographs of Evans and of those up to the present who have adopted what Alan Trachtenberg calls Evans's "calm, intransigent style, the open and direct frontality, of the vernacular itself,"[61] are first and foremost, like a Weston pepper, or the simple daguerreotype of a tree, "pictures of things-in-the-world."[62] Their "transparency," writes Trachtenberg, "invites the viewer to acute attention of detail, of disclosure of fact." In an Evans photograph, "the intractable sensuous fact is always there."[63]

As, indeed, it is in all of American photography. It is this "intractable, sensuous fact" that Canadian photographers, as we shall see, have gone to such lengths to avoid.

PART TWO – Inside and Outside

I like to think that
the subconscious Canada is even more
important than conscious Canada and
that there is growing up swiftly in this
country, under the surface, the sense
of a great future and of a separate des-
tiny — as Canada.

John GRIERSON

Grierson on Documentary

CHAPTER THREE

Subconscious Canada

Documentary Dialectic Perhaps because of Canadian art photography's long association with the Still Photography Division of the National Film Board, Canadian critics and photographers – when they pronounce themselves at all on the matter – conclude that if we do have a photographic tradition, it is a documentary one. National Gallery of Canada photography curator Ann Thomas has written that "looking back at Canadian photography from 1940 to 1967 – from the inception of the National Film Board with its strong nationalistic and documentary program to 1967 – the year during which the *Camera as Witness* exhibition was organized at Expo '67 and the National Film Board began publishing the *Image* series and commenced on an intensive program of exhibitions of Canadian photography – the strongest directional pull has been toward what I will loosely term the documentary approach."[1]

Without question many examples of what was referred to in the last chapter as "human" documentary, as opposed to "social" documentary, have been created in this country under the sponsorship of the NFB. The photographer as social critic has not been a strong force in Canada. In her introduction to an anthology of photographs from the collection of the National Film Board,[2] Martha Langford mentions several documentary projects that have become major NFB exhibits: Robert Minden's work on Doukhobor Canadians in British Columbia, photographs of miners by James Stadnick, Fred Cattroll's boxers, Pierre Gaudard's *Les Ouvriers.* Ann Thomas, in the text referred to above, points to the work of

3.1 Lorraine GILBERT
Logging Roads on Coyote Ridge Rd., Invermere, B.C.
From the series *Shaping the New West,* 1989
Panoramic Diptych, 101.6 x 157.48 cm overall

photographers Lutz Dille, Michel Lambeth, Sam Tata, Michael Semak, Gabor Szilasi, Pierre Gaudard, and "a later generation of younger photographers: Orest Semchishen, John Paskievich, Spiteri, Cal Bailey and James Lisitiza, Sandra Semchuk" as belonging to a "broad general category of documentary."[3]

Many other Canadian photographers and photographic projects that could be said to fall within the parameters of documentary photography might be mentioned as well – the landmark 1972 study of Disraeli, Quebec by Claire Beaugrand-Champagne, Michel Campeau, Roger Charbonneau, and Cedric Pearson; the long-term investigation of Quebec in transition by Gabor Szilasi; David Miller and Clara Gutsche's *The Destruction of Milton Park, 1970–1975,* a photographic essay on the attempt to save a row of Montreal Victorian houses from the developer's axe, and their 1985–86 series commissioned by the Canadian Centre for Architecture on abandoned industrial sites on the banks of Montreal's Lachine Canal; the images of groups of women from Western Canada, including nurses and church groups, produced by Frances Robson in 1983 and 1984; Raphael Goldchain's work in Latin America during the 1980s; Larry Towell's studies, beginning in 1985, of communities in Palestine and Central America, and of Mennonite seasonal workers; Lorraine Gilbert's photographs, made between 1988 and 1994, of reforestation activity in British Columbia; Robert del Tredici's images, from the Soviet Union, Japan, and the United States, of nuclear sites, and persons involved

in, or directly affected by, the nuclear industry in *At Work in the Fields of the Bomb*; Brenda Pelkey's 1988–90 photographs of decorated suburban yards, *... the great effect of the imagination on the world*; Yves Arcand's mid-1990s explorations of the effect of human transformations on the landscape in the Gaspésie, Bas St Laurent and Côte-Nord regions of Quebec.

Yet something that is not about documentary at all emerges once we begin to discuss those Canadian photographers who have produced bodies of work of more than one or two photographic assignments, and this includes several photographers referred to in the lists above. The *modus operandi* of the Still Photography Division sometimes meant that photographers who produced generic documentary-style images after minimal exposure to the social situation they were purporting to study were given equal billing in exhibitions and publications with those who had developed, and sustained over time, more personal and distinct ways of looking at the world. If we are to locate a Canadian specificity of image, I believe that we have to look beyond the plentiful stock documentary imagery available in the archives of this country to the work one is tempted to call "serious," but which might be better termed "inspired." Even when the syntax of the documentary genre is in evidence in such work, as it surely is in the case of Sandra Semchuk or Michel Lambeth, for example, what reveals itself to be of primary significance is attention to a metaphysical order of things, expressed symbolically, as opposed to the reflection of a social reality. This tendency is particularly recognizable, for instance, in Charles Gagnon's transposition of his suburban Montreal environs into a symbolic universe shot through with portends of death and transcendence.

Various literary critics have adopted the metaphor of the NFB film documentary in order to elucidate some aspect of Canadian writing. However, they have employed this metaphor in a decidedly more qualified manner than have commentators on Canadian photography, using "documentary" as one term in a dialectic that attempts to describe the dualistic nature of the work they are examining. Linda Hutcheon locates a "double pull" in a whole category of regional novels of the 1970s and 1980s that includes Rudy Wiebe's *The Scorched-Wood People* and David Williams' *The River Horsemen*. "On the one hand, there was the clear attraction to an almost National Film Board-like documentary realism. On the other hand, there was a pull toward the presentation of the local and the natural as symbolic or metaphoric."[4] Hutcheon sees in urban novels of the same period "the same double pull ... between the documentary impulse and the drive toward symbolic universalization."[5] This can be seen as parallel to the Canadian tendency to want to portray a symbolic dimension of reality within photographs that employ a straightforward documentary or social landscape photographic idiom, like the many diptychs and polytychs of Montreal photographer Claude-Philippe Benoit that show, for example, a conference room at the United Nations, or the workroom of a tailor, and yet also allude to some metaphysical state of being.

Manina Jones writes that "[i]t has become a critical commonplace to say that the documentary is the quintessential Canadian form of representation, perhaps partly because the term itself was first added to the vocabulary of film analysis in 1926 by John Grierson."[6] Jones is commenting on poet Dorothy Livesay's well-known 1969 article, "The Documentary Poem: A Canadian Genre," in which Livesay seeks to "identify an impulse that she sees as the impetus for a genre of Canadian literature that is analogous to documentary film and radio."[7] Livesay's paper "announces the existence of a class of Canadian 'documentary' poetry that is marked by its use of particularized historical and geographical data, as well as its basis in research." What interests Livesay in these developments "'is the evidence they present of a conscious attempt to create a dialectic between the objective facts and the subjective feelings of the poet.'"[8] Expanding on this, Jones argues that "a common formal strategy of a body of contemporary Canadian works is a 'collage' technique that self-consciously transcribes documents into the literary text, registering them as 'outside' writings that readers recognize both as taken from a spatial or temporal 'elsewhere' and as participating in a historical-referential discourse of 'non-fiction.' The works both invoke and undermine the oppositions between categories such as textual/referential, intratextual/extratextual, literary/non-literary, or fiction/non-fiction, and thus stage a kind of documentary dialogue."[9] To Jones, this amounts to a "doubleness of citation"; she refers to Stephen Scobie, who remarks that "[d]oubling is the fundamental gesture of the documentary poem."[10] Jones interprets Livesay's argument to mean that documentary "may be situated in a dialectic not simply between two forms of writing (factual and poetic), but between two conventions of reading: the 'objective' or 'literal' reading of the document and its 'subjective' interpretation *as poetry*."[11]

Analogous to this Canadian literary "dialectic" between "documentary" objectivity and "poetic" subjectivity, or realism and symbolism, is the "doubling" tendency I have long observed in Canadian photography, and which I alluded to earlier. The Canadian photographer typically adopts a social documentary or some other established mode of photographic expression, and then attempts to bend this realist syntax to a particularly non-social, metaphysical, or metaphorical end. And what I identify in a subsequent chapter as the most predominant Canadian photographic characteristic, the consistent delineating within the photographic image of two zones of reality, one that is "here" and another that is "out there" or "elsewhere," finds a parallel in Jones's recognition that a class of Canadian poets uses found documents within literary texts in order to point to an "elsewhere" that partakes of an "outside," non-fictional reality.

The appeal to what I term "metaphysical" reality within Canadian photography, even when the genre of photography employed is the documentary one, may relate as well to an aspect of Canadian writing identified by Leon Surette. In a 1991 article entitled "Creating the Canadian Canon," Surette writes of "the unsuitability of the bourgeois realistic novel to the task of forging an indigenous

culture," adding that "[s]ymbolic, allegorical, and mythopoeic or romance forms of prose fiction are much more suitable to the task." Thus, he finds that "realistic novelists like Hugh MacLennan, Morley Callaghan and Mordecai Richler are the exception rather than the rule among canonized Canadian novelists," while "Sheila Watson, Robertson Davies, Robert Kroetsch, Leonard Cohen, and Margaret Atwood all permit fantasy, magic, mysticism, or the uncanny in their fiction."[12] Similarly, as the reader will see, photographs by many Canadian photographers operate on a symbolic level even while working within the constraints of accepted, "universal" photographic codes and conventions, in ways not usually seen in the photography produced in other cultures.

Funeral Designs　　Jungian analysts are fond of saying that women's lives, or the "feminine" aspects of both women and men's lives, are likely to follow the trajectory of a spiral, as opposed to the more linear path that is the "masculine" way. It has been my experience that the "inner consciousness" of Canadian photography reveals itself in a spiral-like manner as well. Canadian photographic imagery seems initially to suggest one reading, and then other, quite unexpected readings present themselves as we encounter the same bodies of work a second and twelfth and hundredth time. What occurs as we go round this spiral might be characterized as a process of depathologizing, for what Canadian photographic images appear to be about at first sight – death, bondage, and entrapment – is disturbing indeed.

The relationship between death and photography has long intrigued both writers and photographers, but even given this fact, the Canadian photographic preoccupation with death is glaring. The medium itself is intimately linked to death: "To take a photograph is to participate in another person's (or thing's) mortality, vulnerability, mutability. Precisely by slicing out this moment and freezing it, all photographs testify to time's relentless melt,"[13] writes Susan Sontag. This is because "[p]hotographs state the innocence, the vulnerability of lives heading toward their own destruction,"[14] and "this link between photography and death haunts all photographs of people."[15] To Roland Barthes "photography is a kind of primitive theater, a kind of *Tableau Vivant*, a figuration of the motionless and made-up face beneath which we see the dead."[16] He can "never see or see again in a film certain actors" whom he knows to be dead, "without a kind of melancholy: the melancholy of Photography itself," and writes that he experiences "this same emotion listening to the recorded voices of dead singers."[17]

It is because of this dimension of the medium, says André Bazin, that we are drawn to the "charm of family albums." The "shadows, phantomlike and almost indecipherable" we find there "are no longer traditional family portraits but rather the disturbing presence of lives halted at a set moment in their duration,

freed from their destiny; not, however, by the prestige of art but by the power of an impassive mechanical process: for photography does not create eternity, as art does, it embalms time, rescuing it simply from its proper corruption."[18] Canadian photographers take as a given this intrinsic relationship of photography to death, and then, by so often taking death as their subject matter, they compound it.

As Sontag says, the capacity of photography to throw into bold and inescapable relief the vicissitudes of time becomes particularly apparent in portrait photography. Because we have available to us photographs that span the entire adult lives of certain well-known and relentlessly photographed individuals, Picasso, for example, or Georgia O'Keefe, as well as those of our families and friends, the impact of the aging process is impressed upon us now in a way it could never have been in pre-photographic times. It seems little wonder then that those nineteenth-century photographers whose work consisted mainly of portraiture, like the American daguerreotypists Southworth and Hawes, the Scottish calotypists Hill and Adamson, or the French Nadar, should have each in their own way, and perhaps not unconsciously, underlined the poignant connection of photography to death.

Southworth and Hawes, in addition to producing portraits of the Boston "Who's Who," also spent considerable time photographing funerary statues in the Mount Auburn graveyard. Their social counterparts in Edinburgh, Hill and Adamson, posed many of their subjects in the Greyfriars Cemetery. The natural extension of the portraits Nadar took of Baudelaire, Sarah Bernhardt, the Brothers Goncourt, and Monet in all their vitality was not only a deathbed portrait of Victor Hugo but the piles of skeletons he photographed in the catacombs of Paris. This is where the portrait ends, they seem to be saying, the way of all flesh that photography is able to track so well.

Peter Hujar, in his 1976 book, *Portraits in Life and Death*, made this connection explicit by juxtaposing a series of pictures of his well-known friends to a sequence of petrified Sicilian corpses. And Richard Avedon, whose portraits of vulnerable, crumbling flesh have always stood in stark contrast to the images of eternal youth, frivolity, and beauty that are his fashion photographs, merely made overt what portrait photography is always doing when he photographed, over a period of several years, his dying father.

Photography *is* capable of rendering excruciatingly apparent the fact that all of life is a march forward to death, and as such it is an often trenchant reminder of the inescapable reality of death itself. But this doesn't mean that death has become the sole preoccupation of most, or even many, photographers. Psychoanalyst Gregory Zilboorg has observed that while "the fear of death must be present behind all our normal functioning, in order for the organism to be armed toward self-preservation"[19] this consciousness of death cannot be constantly present in mind or "'the organism could not function'"[20] normally. Zilboorg goes on to say

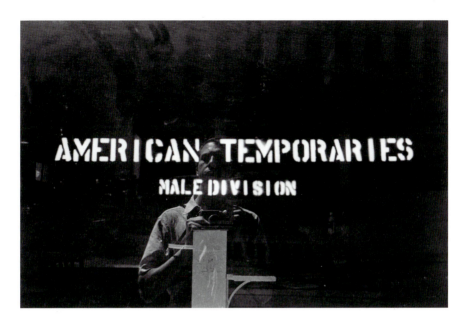

3.2 Lee FRIEDLANDER
Industrial Northern United States
1968
27.94 x 35.56 cm

that the awareness of death "'must be properly repressed to keep us living with
any modicum of comfort.'"Canadian photographers, however, *do* appear to be
able to sustain a constant awareness of death, though whether they do so in com-
fort is another matter. In their treatment and choice of subject matter, photog-
raphers in this country betray a fascination with the phenomenon of death that
goes far beyond that of any other group. I have mentioned that Canadian photo-
graphs that look as if they are about social reality usually aren't about that at all,
but point instead to some metaphysical dimension. That dimension is often death.
The "decisive moment" in photography in Canada is very often a moment having
to do with death.

　　In Lee Friedlander's well-known series of self-portraits made in the 1960s,
the photographer imposes his shadow or reflection on to the urban landscape in
such a way that these spectres of himself become queries, and the question being
asked is "How do I, as an American male, measure up?" To the image of a cultural
icon like John F. Kennedy, to the level of accomplishment represented by the
winged trophy in a store window, to the demand for "American Temporaries/Male
Division" stenciled across the window of an employment agency? Where does he
situate himself in terms of the women on whose body parts and photographs he

imposes his shadowy alter-ego? Friedlander tests himself against a network of societal expectations; his witty visual investigations have to do with his search for a meaningful place within a particular cultural context.

When we turn to Canadian photographs made at about the same time in which the photographer has also used his reflection or shadow or face as a reference point within the urban landscape, we find a crucial difference. The Canadian photographer, unlike Friedlander or others, doesn't seem interested in asserting his presence within the social domain. Rather, the Canadian consistently juxtaposes him or herself to images of death, whether it be Charles Gagnon's reflection in a Laura Secord store window featuring what looks like a Remembrance Day display, or Tom Gibson's shadow against a row of tombstones. Or Michel Campeau turning his camera around on the street so that we see his face centred in front of a Hare Krishna diorama illustrating, in graphic detail, the gruesome voyage of the human body from infant to skeleton. When Charles Gagnon photographs that index of cultural reality the highway billboard, as beloved by generations of American photographers as the store window, he chooses an announcement alluding to the lives sacrificed by members of the Marines.

3.3 Michel CAMPEAU
*Autoportrait, Fête pour la
paix, Montréal, mai 1983.*
From the series *La Mémoire
du corps*
1984
40.6 x 50.8 cm

Facing page

3.4 Tom GIBSON
My Shadow at Comber
1970
27.94 x 35.56 cm

3.5 Michel LAMBETH
Tchuantepec, Mexico
1969
5.4 x 17.2 cm

3.6 Michel LAMBETH
St. Lawrence Market,
Toronto, Ontario
1957
35.3 x 27 cm

In situations in which Cartier-Bresson or Eugene Smith might have found a touching and life-affirming "human" anecdote, Michel Lambeth, photographing in Toronto in the 1950s and 1960s in a stylistic manner not unlike theirs, managed to find instead reminders of death. It didn't seem to matter if Lambeth was photographing a mother and her children waiting to see Queen Elizabeth drive by, a woman posing as an advertisement for a sideshow at the Canadian National Exhibition, or a child on the beach in Mexico. The result was always the same: at the moment Lambeth pressed the shutter release, the figures in the image took on the configuration of a crucifixion. Like the William Kurelek painting in which a Canadian golf course is haunted by spectral images of starving persons from the Third World, Canadian photography that at first appears to be quite straightforward documentation is often haunted with images of death. A Lambeth store front covered with commercial signage might almost be mistaken for a Walker Evans image but for the skull-like head that appears through one window. Lambeth, who, as I stated in the introduction, can be considered to have produced the quintessential body of Canadian art photography, saw death everywhere. A pensive girl of ten or twelve stands with her shopping bags against a brick wall of the St Lawrence Market in Toronto, and behind her is a sign reading "Funeral Designs."

3.7 Michel LAMBETH
Toronto, Ontario
1959
25.4 x 17.2 cm

Another girl, or perhaps the same one, looks through a rectangular opening in a market building and stares at a bundle of burlap sacks and flowers that has taken on the appearance of a wrapped corpse.

When American photographers take death as subject matter, they tend to do so in a straightforward manner that is consistent with the Purist formal agenda and the Transcendentalist underpinnings of that tradition. The black and white post-autopsy portraits made by Jeffrey Silverthorne of bodies lying in the drawers of a morgue include the 1972 portrait "The Woman Who Died in her Sleep," in which the head and torso of a young woman whose chest has been crudely sewn up after an autopsy is photographed with a directness and power reminiscent of Stieglitz's portraits of Georgia O'Keefe. Silverthorne's images, Andres Serrano's large colour close-ups of cadavers from his 1992 series, *The Morgue (Cause of Death)*, Frederick Sommer's highly detailed 1939 study of an amputated foot – all these American photographic images attest to an interest in the materiality and aesthetic seduction of death and decay. These photographs are of a piece with other American investigations of "significant fact" in the physical world. British curators Val Williams and Greg Hobson's 1995 exhibition of photographs, *The Dead*, included the work of Serrano, as well as the Drensteinfurt photographer Annet van der Voort's images of preserved heads taken in medical museums, Louis Jammes' victims of war made in Sarajevo morgues, and Franco Zecchin's documents of Mafia killings in Sicily. In a text written to accompany the exhibit, Williams notes that many of the photographs in the show were "intimate studies of the human body," but that "[r]ather than reflecting on the nature of death in a metaphysical way, they have looked unflinchingly on its physicality, in the mortuary at the end of the street, at the hospital round the corner."[21] Williams' descriptions of the works of the photographers in *The Dead* exhibition correspond to my own characterizations of American and European photographic traditions. Serrano's images are "literal,"[22] while the Swiss Hans Danuser, in his 1984 autopsy series, "looks at form and surface. Rubber overalls hang neatly on racks, pale floor tiles glimmer and the exposed muscle and tissue of a corpse is merely another system of forms."[23]

In the Canadian photograph death is imbricated in almost everything. Canadian photographers don't typically study the physical traces of death as do American and other photographers; they reveal the degree to which death is braided into any situation they might encounter. Death stalks utterly prosaic Montreal neighbourhoods in the photographs of Charles Gagnon and the St Lawrence Market in the images of Michel Lambeth, and this is revealed through the symbolic codes they construct in their work. The narrative sequence Vancouver photographer Marion Penner Bancroft made around the terminal illness of her brother-in-law, Dennis; the book of images and text Montreal photographer Mark Leslie produced as he was dying of AIDS; the series Sandra Semchuk made with her father, "Seeing My Father See His Own Death, Yuma, Arizona, 1983" and "Death is a

3.8 Jeff WALL
Dead Troops Talk (A Vision After an Ambush of a Red Army Patrol Near Moqor, Afghanistan, Winter 1986)
1992 229 x 417 cm. Original in colour

Natural Thing, Sweetheart"; and Montreal photographer Nicole Doucet's projects that address the process of dying – in all these works Canadian photography reveals a persistent interest in the transition from life to death. The American, European, or British photographer trains his or her camera on the actual remains of death, and then turns to photograph something else. Animating the Canadian photograph, of every conceivable situation or thing, is the constant parsing of what is seen into two dimensions – here and there, and very often, life and death.

The only instance I know of a contemporary Canadian photographer producing a portrait made after death is "Felix, June 5, 1994," the monumental colour photograph AA Bronson made of the body of fellow General Idea member Felix Partz, lying in bed, dressed and surrounded by his favourite objects. In a public lecture, Bronson spoke of noticing how the faces of those viewing this image initially light up, as they respond to the bright colours and lively patterns of his deceased partner's clothing and bed coverings, and how they then suddenly register horror at the sight the skeletal head at the centre of the mural-sized photograph.[24] The text Bronson wrote to hang with the image underscores, in characteristic Canadian fashion, the interpenetration of the realms of life and death; it reads, in part: "We need to remember that the diseased, the disabled

and, yes, even the dead walk among us. They are part of our community, our history, our continuity. They are our coinhabitants in this dream city."[25] This interpenetrability appears to macabre effect in Jeff Wall's lightbox transparencies of the digitally manipulated photographic images "The Vampires' Picnic" and "Dead Troops Talk (A Vision After An Ambush of a Red Army Patrol Near Moqor, Afghanistan, Winter 1986)," made in 1991 and 1992 respectively. In the first, the viewer sees an outdoor, nocturnal gathering of individuals, including a geriatric woman dressed in a ski jacket, a security guard, and a college-age young man in a leather jacket; these persons cavort with vampires who are both naked and clothed. In "Dead Troops Talk," white-faced, disembowelled soldiers laugh or appear to be waking from some kind of trance. Recently a *National Post* article discussed a Wall photograph entitled "The Flooded Grave," which was featured in the National Gallery of Canada's millennium exhibit. Describing the work when it was still in process, Wall said that it was made up of "hundreds of computer-generated images superimposed on to a 10-foot photo of a grave," in which would appear fish, an octopus, and sea anemones. "The Flooded Grave" takes place on a typical, rainy Vancouver day," the article quotes Wall as saying. "The rain has just stopped. An open hole dug in the ground has been flooded, and for the moment, the grave has turned into the sea. I wanted it to be as if someone was walking their dog in the cemetery, gazed into the water and had a daydream that would disappear in a moment. It's a purely imaginary vision that could never actually be photographed."[26] What is significant is that Wall's grave image doesn't highlight the putrification of physical death, but rather presents death as another dimension, and one that is both dazzling and, paradoxically, very alive.

The opening scenes of Allan Moyle's 1999 film, *New Waterford Girl*, provide the perfect filmic illustration of the Canadian interweaving of life and death within a visual image: wedding vows are being spoken next to a casket; a family wake is being held at the same time as a wedding. Family members move from one room, what they call the "wedding room," to another, the room of death, just as the living and the dead drink together in a pub in Canadian Matt Cohen's 1996 novel, *Last Seen*.

As the reader moves through this book, he or she will notice that almost every Canadian photographic work one might mention refers to death or entrapment, and very often both. In the 1992 Jeff Wall photograph "Adrian Walker, artist, drawing from a specimen in a laboratory in the Dept. of Anatomy at the University of British Columbia, Vancouver," the wizened human hand that the artist is attempting, with intense concentration, to capture on paper, is the most vital element in the room. This image of death as the artist's singular preoccupation provides a metaphor of Canadian photography that is entirely apt. Yet, as we shall see, Wall's 1977 installation "Faking Death," in which the photographer lies in bed as if dead in two images of a triptych, and another shot shows the lighting and make-up crew preparing Wall for this tableau, is even more so.v

3.9 Jeff WALL
The Flooded Grave
1998-2000
228.6 x 282 cm
Original in colour
(See also plate XVI)

3.10 Jeff WALL
Adrian Walker, artist,
drawing from a specimen
in a laboratory in the
Dept. of Anatomy at the
University of British
Columbia, Vancouver
1992
119 x 164 cm
Original in colour

Caged When Canadians aren't photographing their shadows or reflections juxtaposed to images of death, they are photographing them against images of bondage and entrapment. French and American photographers, from Eugène Atget on through to Nathan Lyons and beyond, have used the contents of store windows as indicators of a culture's values; in Lyons' images the store window becomes a kind of altar, housing the icons of a materially obsessed and war-mongering civilization. What Canadian photographers see in commercial window displays and through car windows, on restaurant walls and behind glass in museums, is life – in whatever form, human, animal, or plant – that is bound, or caged, or both. When a glass cage or other trap isn't available in the situation they are photographing, Canadian photographers create one.

The central image of a photographic construction produced in the late 1980s by Arthur Renwick is almost entirely black; the word "cage" that is embedded there is barely decipherable. Framing this are colour photographs of glass-enclosed First Nations artifacts housed in a British Columbia museum of anthropology. The colour Xerox *Bondage Scapes* made by Evergon around 1976 show nude, mostly male figures tied up and holding or surrounded by animals, birds, or vegetables. Evergon placed Saran Wrap over these collaged images before photocopying them,

3.11 Arthur RENWICK
Cage
1989
152.4 x 182.88 cm
Original in colour
(See also plate IV)

Facing page

3.12 EVERGON
Horrific Portrait
1983
50.8 x 60.96 cm
Original in colour
(See also plate V)

so that the entire set-up appears to be seen from behind glass. In the later *Interlocking Polaroid* series, Evergon mimicked the photocopy process by placing his subjects, along with accompanying props, on sheets of plexiglass held six feet above the floor. He then photographed his models from below — using light that aped the scanning red beam of a copy machine — in sx-70 colour Polaroid, the draped bodies squashed against the clear plastic glass as if on a giant Xerox machine. A devilish-looking man, with a red pepper tongue flashing from his mouth, a man with his ankles and wrists bound, a woman holding a fish — all float in some prenatal, or perhaps post-mortem, state of limbo; these persons were photographed one section of their body at a time and the truncated images mounted and presented together as a vertical strip. An Evergon series of 20 x 24 colour Polaroids entitled *Horrific Portraits* show close-ups of the artist's face contorted by the thick, painfully constricting elastics he has bound around his face. The figures in the tortured images of Diana Thorneycroft are consistently bound with ropes, bandages, or leather straps; in "Untitled (Skull Lake Sanatorium)," made in 1997, two people face each other; their eyes are covered with gauze, their mouths are gagged, and they are tied by rope both to metal, quasi-medical contraptions, and to one another. In "Untitled (Snare)," from 1994, a nude woman, whose head is covered

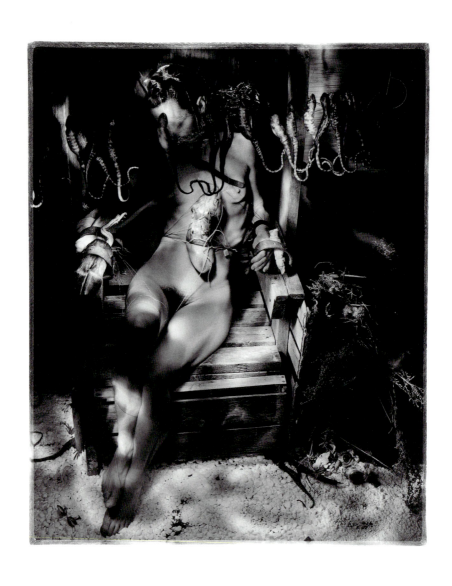

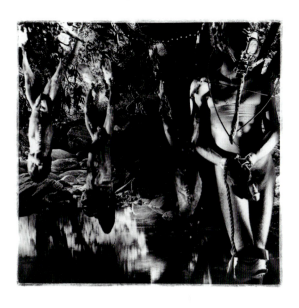

3.14 Diana THORNEYCROFT
Untitled (Snared)
1997
81.28 x 81.28 cmv

in some transparent wrap, is tethered by leather straps to a wooden seat that is suggestive of a primitive electric chair; a cloven hoof extends from one arm-strap, a large animal tongue is tied across her waist, and creatures that look like snakes swollen with prey dangle in front of her. A naked female body is bound to a primitive wheelchair, animal bones sitting on her knees, in the 1995 triptych "Pièta (For Yvette)," and another naked figure with gauze around her head and eyes is tied to a metal device in the 1998 "Untitled (Patient/Prisoner)." Three skinned rabbits whose bodies have been eviscerated and then stitched back together hang in front of trees and a pond in "Untitled (Snared)," 1997; next to them is a bound and masked human figure whose bandaged torso also bears the same rough stitching as that of the rabbits. Suzy Lake's large-scale photographs, like the grouping of four images from 1978 called *ImPositions* and 1977's *Against the Wall*, have often featured images of the photographer full-length and bound with ropes.

¶ While some of Evergon's images of bondage might be taken as affirmations of a particular sexual preference, not all of them can, and none can be said to pertain only to the sexual arena. Rather, they, like the photographs of Lake, are of a piece with many other Canadian images of **ENTRAPMENT**: the bound woman in Sylvain Cousineau's

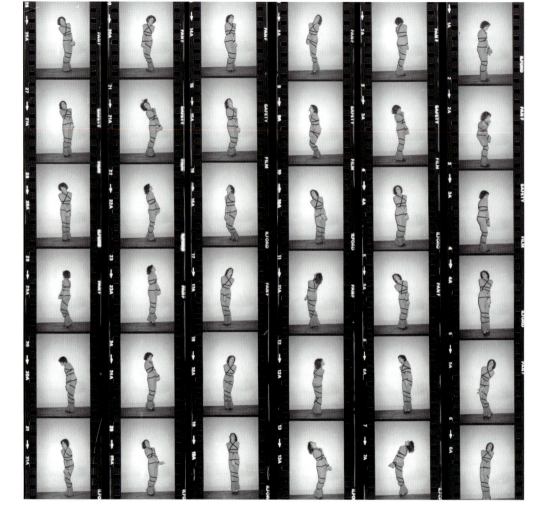

3.15 Suzy LAKE
Contact Sheet made in preparation
for the series *ImPositions*
1978
20.32 x 25.4 cm

Facing page

3.16 Vincent SHARP
Dog Behind Car Window, Toronto
1975
27.94 x 35.56 cm

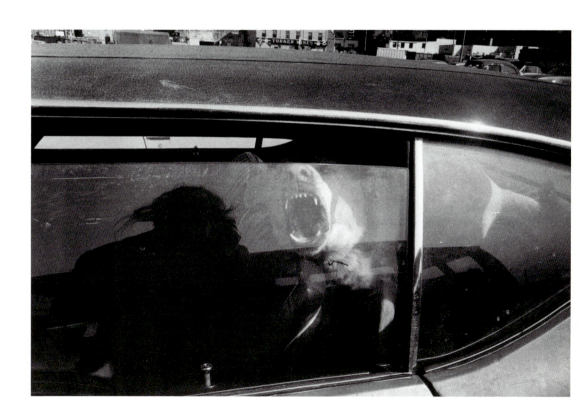

1977 sequence of photographs published as *Mona Nima*; the naked man trussed
with string and photographed in sections in AA Bronson's 1970 work *Body Binding*;
the dogs trapped in cars in Vincent Sharp's 1970s Toronto street shots; the many
stuffed animals in display cases at the Royal Ontario Museum photographed by
Michel Lambeth in 1957; the men in public spaces who are cut off by windows and
glass cases from the life around them in Montreal artist Tim Clark's 1997 exhibit,
entitled *The Melancholy of Masculinity*; the museum diorama depicting elk in their
natural habitat that makes up a triptych in Chuck Samuels' 1990 series, *Easy Targets*;
the porcelain animals behind glass in a Richard Holden panoramic colour photo-
graph of an Ottawa street corner made in 1979; the photomurals of caged pumas that
Ron Benner sealed with clay on to the surface of Lake Erie cliffs in 1984; the timber
wolf, hippopotamus, gorilla, and other animals Volker Seding photographed through
bars and grill work, or caught with faux-landscape painted on the walls of their cage,
for his 1991 *The Zoo Portfolio*; the stuffed, hand-made rabbits in a display case that
was part of the 1997 *slytod* installation of photographs and other objects by Diana
Thorneycroft. With Pierre Gaudard's 1975 photographs of life behind bars in medium
and maximum security prisons in Quebec and Ontario; Michael Semak's 1971 pic-
tures of animals in Italian slaughterhouses; Randy Burton's 1984 *Devonian Gardens*
and *West Edmonton Mall* series of images, showing carefully landscaped islands of
trees and other vegetation shut inside glass-enclosed business and shopping com-
plexes; the human figures trapped in boxes in Normand Grégoire's 1971 portfolio
Série 4, and in Judith Eglington's early 1970s sx-70 Polaroid images, and with Shari

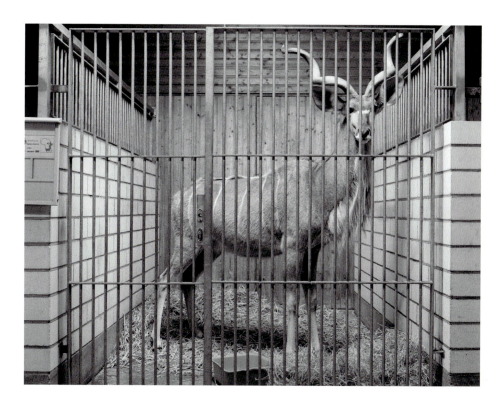

Hatt's work-in-progress in which she photographs the public observing confined wild animals. And with Lynne Cohen's 1998 "Warehouse," piled with boxes and mummified turtles covered with sheets of plastic; her many gruelling "Classroom" photographs from the 1990s where the torsos of human mannequins in suitcases, in one image, and casket-like stainless steel gurneys, in another, line up with military precision, and where animal cadavers hang from chains or lie mutilated on examining tables, or are seen penned inside a wooden stall meant to suggest the inside of a barn. Each image in a series of photographs Yukon photographer Eileen Leier made in a general store in northern Saskatchewan shows a mural painted on the store's wall, portraying a storybook rendition of European settlers interacting with First Nations Canadians, and leaning against the mural are antlers and stuffed animals. Montreal photographer Jean-Jacques Ringuette's "Pierre Mouchon," a well-worn stuffed animal that for Ringuette seems to be both sheep (*mouton*) and pig (*cochon*), appears in the 1995–98 photographic series *De la vraisemblance, autour du personnage de Pierre Mouchon* in various poses, some reminiscent of images from the history of photography, and also squashed behind glass in a crudely hewn wooden vitrine, just as dead birds, butterflies, ferns, and bugs are sealed under glass in Loren Williams' 1995 series of colour photographs, *Cabinet de curiosités*. Carol Marino's "Beaver at Home" frames an image of a beaver with head just above water, with actual twigs and rushes, so that the beaver appears to be seen through a window.

3.19 Jean-Jacques RINGUETTE
Pierre Mouchon se sait observé.
From the series *De la vraisem-*
blance, autour du personnage de
Pierre Mouchon (premier volet)
1995-1998
71 x 59 x 3.2 cm
Original in colour

3.20 Jin-me YOON
First card of *Souvenirs of*
the Self (Postcard Project)
1991
1 of 6 perforated postcards
10.16 x 15.24 cm each
Original in colour
(See also plate II)

Below left

3.21 Jin-me YOON
First card, reverse side,
of *Souvenirs of the Self*
(Postcard Project)
1991
1 of 6 perforated postcards
10.16 x 15.24 cm each
Original in colour
(See also plate III)

Below right

A 100%
Canadian
Product

Souvenirs of the Self

A project of six postcards by
Jin-me Yoon ©1991

Walter Phillips Gallery, The Banff Centre for the Arts, Banff, Alberta, Canada T0L 0C0
Photograph by Cheryl Bellows
A Between Views and Points of View project

우리가 이 오래된 박물관을

이 나라의 인상적인 박물관을

그녀는 호기심을 가지고 경이로움을

경직된 진열장 너머의 삶을 상상한다.

Banff Park Museum – Marvel over the impressive
collection of Western Canada's oldest natural history
museum. She looks with curiosity and imagines life
beyond the rigid casings.

Le musée du Parc national Banff – Étonnez-vous
devant l'impressionnante collection du plus vieux
musée d'histoire naturelle de l'Ouest canadien. Elle
regarde curieusement et imagine la vie derrière ces
vitrines rigides.

Jin-me Yoon's 1991 postcard project entitled *Souvenirs of the Self* was made in Banff and distributed in tourist shops as well as more traditional art world venues. The fold-out sequence begins with a picture of the artist, a Korean Canadian, photographed in a Banff museum in front of a glass-encased stuffed Canadian beaver; beside her is another case displaying a large fish. The series continues with images that, like so many other Canadian portraits, convey an overwhelming sense of dislocation on the part of the subject, a feeling of displacement of which the photographer, who is also the subject, is entirely conscious. Where we might expect to see a red-coated Mountie or smiling Caucasian tourist featured against the picture-perfect Banff mountain scenery and landmarks, Yoon has placed herself, an Asian Canadian woman. She has used her feeling of uneasiness within these surroundings to force her viewers to question their own, possibly racist, assumptions regarding the appropriate representation of Canadian culture. In this sequence of six images, Yoon brings together two of the most predominant preoccupations to be found within Canadian photography of the last forty years – the entrapment of animals and the inability of the individual to feel at home in either a social or natural context.

These same concerns are in evidence in the photo-installation pieces that make up Vid Ingelevics' 1990 *Places of Repose: Stories of Displacement*, a work that addresses his family's uneasy transition from Latvia to Canada. Ingelevics writes that in this series he is "dealing specifically with the first year of the exile of [his] mother and her two younger sisters from their rural home in Latvia. This included their 1944 flight from their home just ahead of the Red Army, their time as forced labourers on German farms, and ends on October 1945 with their arrival at the first of a series of post-war camps in the Bavarian region of Germany."[27]

To tell his "stories of displacement," Ingelevics has glued his and his family's photographs, along with the texts of interviews with his mother and aunts, into the drawers and interiors of second-hand dressers and wardrobes. The doors of these found objects literally open onto the ghosts of a past that the photographer's family continues to grapple with. In "Bureau #4," interviews with his mother and her sisters and an image of a Canadian aviators' memorial plaque located in Toronto are superimposed onto fields of wilted flowers photographed in one of the German towns where the women spent time after the war. In another piece, framed images of these women stand on a dresser top; a photo of a deer trapped behind a wire fence hangs over the old dresser where normally a mirror would be. Compare this Ingelevics installation to the many bedroom bureau mirrors photographed by America documentary photographers, where, as in Walker Evans's 1945 "Bedroom Dresser, Shrimp Fisherman's House, Biloxi, Mississippi," or Chauncey Hare's 1968 "Oakland, California," the constellation of family photographic portraits and snapshots and religious and political icons surrounding the mirror provide an indication of the economic and ideological cultures and personal histories of

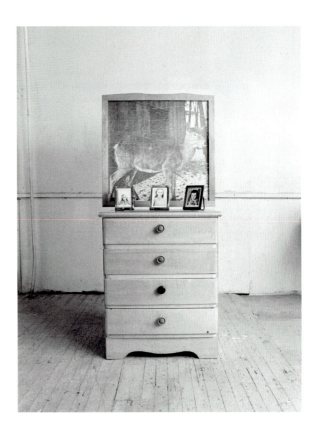

3.22 Vid INGELEVICS
Bureau #1 from the installation work
Places of Repose:
Stories of Displacement
1989/90

their owners. In contrast, Ingelevics' work reflects back, to the viewer who looks for himself or herself in his dresser's mirror, the image of a caged animal.

Canadians have not been entirely alone in photographing animals in cages; a notable American endeavour in this regard was Garry Winogrand's series of zoo photographs published in 1969 as *The Animals*. What is revealing, though, is that Winogrand's animals are almost without exception shown in ironic relation to human beings. Winogrand might capture a wolf behind bars and a human "wolf" caressing his lady friend in the same frame, but the Canadian photographer does not compare the human in this humorous way to caged animals. Rather, he or she identifies with the animals' constriction and pain.

Charles Gagnon made hundreds of Polaroid sx-70 images in the 1970s of the same country garden seen through the same window; nature is presented as cut off, inaccessible to both photographer and viewer. The entrapment of nature is everywhere in Gagnon's photographs. Trees and other vegetation are consistently cut off from the urban context that surrounds them: in "Building with Tree and Two Persons – Montreal, 1974," a solitary tree grows in shadowed isolation in a desolate corner of the city, and in "Plant, Mount Allison University, 1973" a rubber plant is surrounded by steel and glass. Trees are boxed in and smothered by steam

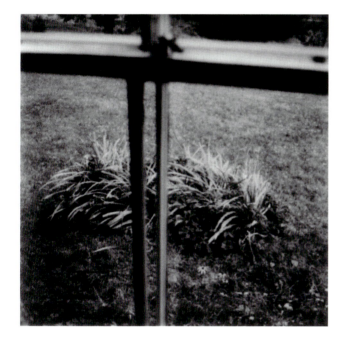

3.23 Charles GAGNON
SX 70
1976
7.9 x 7.8 cm
Original in colour
(See also plate VI)

on a street in "6th Avenue – N.Y.C." Jungle animals are frozen in caricature in "Painted Animals and Fence – Maine U.S.A., 1979," and in another untitled photograph made in 1973, a tiger has become a rug on the floor of a laundry room. In the 1966 "From a Hotel Room – N.Y., 1966," the hanging vegetation of a roof garden is the only hint of nature in a sea of skyscrapers and tenements, and ersatz nature has replaced the real thing in "Mies Building, Christmas – Westmount, Que.," where artificial stalactites decorate an empty, bunker-like office foyer.

Gagnon's "Motel – Lake George, N.Y.," is a photograph of the trunk of a tree that has been cut down and planted with flowers. The entire structure is surrounded by asphalt and is encircled by a white painted line reminiscent of highways and parking lots; the line provides an arbitrary but unassailable border between nature and culture, the same division provided by a windowpane in other Gagnon photographs. The seemingly unnecessary imposition of boundaries and

demarcations is referred to again in the lines drawn on the pavement of a parking lot in "Parking, 6 p.m. – Magog, Quebec." In "Pipes, Park, Church – Montreal," a stack of long pipes that look like portable white meridian lines sits beside a highway, on which are drawn actual traffic lines. Seen in the context of Gagnon's other work, the photograph underscores the ubiquity of a mind-set that marks off the "wild" and unmanageable from the domesticated and compliant, and is indicative of how Gagnon uses the stylistic stratagems of documentary photography to express the most abstract of philosophical notions.

What predominates in Lynne Cohen's early, symmetrically composed studies of public and private interiors is the evidence of a culture's overwhelming obsession with the appropriation and control of nature. Cohen's images from this period have been read primarily as examples of societal materialism, conformity, and "bad taste." But what has not been dealt with is that a great many of these outlandish and fascinating instances of kitsch have to do with dead or trapped animals, or with the attempted possession of the natural landscape. Typical Cohen images from the 1970s are of a "camping show" display featuring chairs made of antlers, a cut-out paper moon, a plywood backdrop and spruce trees; an office that for some unexplained reason has been decorated with dead leaves and tree

branches; dogs housed in cages stacked in a living room; a restaurant dominated by a stuffed moose head. Like the carcass of a dead animal, each image reminds us that something was once alive and vital, and no longer is. There is an aura of evisceration in all of these pictures, the smell of the slaughterhouse, and it is the culture itself that is seen as the great abattoir.

For a ten-year period beginning in 1971, Cohen compiled an exhaustive inventory of restaurants, meeting halls, hair salons, real estate offices, apartment lobbies, and numerous other public spaces. Together, they constitute a veritable encyclopedia of the visual evidence of our society's need to control nature, along with any culture that is "other" and thus threatening – witness the number of hairdressing salons, tanning studios, and restaurants whose interior decoration amounts to a cartoon travesty of the reality of other cultural groups – African, Polynesian, or Egyptian, for example. In Cohen's photographs it is imaging itself, representation, that seems to give the inhabitants of these spaces their sense of control over that which is *not* them and therefore not really susceptible to control at all, except by death – either actual or symbolic.

In Cohen's images we don't see the real landscape; nature appears in photographic wall murals, or silkscreened on to drapes that cover windows that might give access to the actual outdoors. Nor do we see real, living animals, only those that have been painted, photographed, or stuffed. In the frontal construction and the pristine rendering of detail of these images, and in their concentration on the visual "vernacular" as an index of social reality, Cohen is true to her American heritage. But in her preoccupation with death and entrapment she situates her photographs within a Canadian tradition of image-making.

A good deal of the action in Jean-Claude Lauzon's 1987 *Un Zoo la Nuit* takes place in an east-end Montreal restaurant that could be, with its ornamentation of stuffed animal heads, the setting of a Lynne Cohen photograph. As the film begins the central character, Marcel, is just being let out of prison, and he becomes determined to help his ailing father, Albert – who rarely appears without his pet bird "Florida" in a cage beside him – fulfil his dream of going on one last moose hunt before he dies. When Albert has a heart attack, Marcel at first is content to show him a film of moose in the wild on the wall of his hospital room, but then decides to help his father escape the hospital under cover of night to actually go hunting. The only prey available, however, are the animals caged in the nearby Granby Zoo, and after breaking through the zoo gates, Marcel encourages his father to shoot an elephant. He then takes a Polaroid photo of Albert with rifle in hand, sitting on the stricken animal, an image the father is able to show his estranged wife, with pride, just before he dies. By the film's end, Marcel is headed toward prison or death – he has orchestrated the killing of a corrupt cop and alienated the drug dealers whose money his father had been hiding for him. The mistress Marcel leaves behind ends up trapped as well. In one particularly harrowing scene we see her literally caged behind glass in a cubicle of the sex club where she

3.25 Vincent SHARP
Girl Yawning, Toronto
1975
27.94 x 35.56 cm

works; in order to speak to her Marcel has to insert a token so that the metal gate that closes her off will lift for a few moments, only to descend again.

Michael Schreier began in 1978 to take colour photographs of private gardens, and then of greenhouses like those at Ottawa's Experimental Farm and Rideau Hall, the official residence of the Governor General. After some initial studies of lush vegetation, it did not take Schreier long to start making pictures of potted plants trapped in airless glass houses surrounded by menacing-looking machinery. Ultimately, he was producing photographs with titles like "Isolation Chamber," in which the plants have disappeared and only the rows of metal beds on which they once lay remain. These scenes, many of them seen through panes of glass, remind one of nothing so much as pictures of the bunkhouses of concentration camps. In Eldon Garnet's 1992 *Vanitas*, a suite of three colour photographs, a dead bird hangs tethered to a stone that is wrapped in cord, and a dead fly hangs over a web of branches, bound in a red string. The seven prints of Garnet's 1990 *Trembling* include the close-up of a dead bird and a bucket bound by ropes to unspecified and blackened human body parts.

Canadian photographers don't only see animals and the natural landscape caught behind glass, or otherwise constrained, they see other people and themselves that way too. A woman in a car in one of Vincent Sharp's images seems as trapped as do the dogs in some of his other pictures; a woman photographed in 1984 by Raymonde April, as part of her series *Debout sur le rivage*, covers her face

3.26 Raymonde APRIL
Excerpt from
Debout sur le rivage
1984
100 x 100 cm

3.27 Michel LAMBETH
Royal Ontario Museum,
Toronto, Ontario
1957
25.5 x 17.2 cm

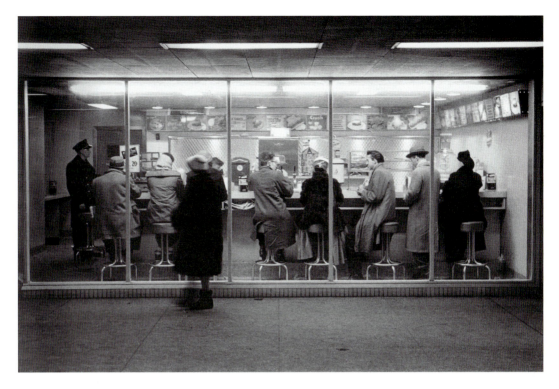

3.28 Michel LAMBETH
Eglinton Station, Yonge Street
Subway, Toronto, Ontario
1957
17.3 x 25.4 cm

and head with a opaque plastic page from a notebook, in effect placing herself behind "glass." The persons eating in a glassed-in diner in Eglinton Station were seen by Michel Lambeth as if they were caged in a zoo, as tourists sunning themselves in Tom Gibson's 1978 "Asilomar, California" are separated from the landscape around them by a windowed enclosure. In his series of photographs made at the Royal Ontario Museum, Lambeth shows us a young boy leaning against a museum case in which two stuffed lionesses are housed. The boy's reflection in the glass of the display case doubles his image; he resides both outside the world of the lionesses and inside that world as well. In Evergon's *Interlocking Polaroid* photographs, it is humans who are trapped behind glass, accompanied by various birds and animals. This identification of the human with the fate of the animal is made explicit in an image of the same series, in which the full-length skin of a polar bear is seen next to a knife and a split-open watermelon; Evergon calls this "Self-Portrait." Michel Lambeth's self-portrait in Union Station in 1959 is his reflection in the glass of a photo-booth that reads "Take Your Own Picture"; Lambeth appears to be trapped inside the machine looking out. Irene F. Whittome, who in 1994 produced an installation work entitled *Curio: Fantaisie-Fantasia-Fancy-Phantasterien* that was composed of a large stuffed turtle, and what appear

3.29 Irene F. WHITTOME
Self-Portrait
1976
120 x 120 cm

to be turtle eggs, enclosed in a glass display case, made in 1976 a series of nine photographs of a human hand tightly bound in wire, called *Self-Portrait*.

To anyone familiar with Margaret Atwood's classic study of Canadian literature, *Survival*, the idea that Canadians are preoccupied with "doomed and slaughtered animals,"[28] is not new. Atwood speculates that this probably hasn't so much to do with a sense of guilt at having founded a country on the fur trade as with the fact "that Canadians themselves feel threatened and nearly extinct as a nation, and suffer also from life-denying experience as individuals – the culture threatens the 'animal' within them." She feels that our "identification with animals is the expression of a deep-seated cultural fear." To Atwood, these animals "are us." "And," she continues, "for the Canadian animal, bare survival is the main aim in life, failure as an individual is inevitable, and extinction as a species is a distinct possibility."[29] Linda Hutcheon detects the symbolism of the threatened animal in Atwood's own novel *Life Before Man*, postulating that "[e]ven if there were not a scene in the novel in which [the central protagonist] Lesje catalogues the remains of giant tortoises [reminiscent of both Irene F. Whittome's *Curio* and so many photographs of stuffed animals behind glass made in the ROM by Michel Lambeth], the title ... would suggest this theme of historical extinction"; she says that for

Lesje, "the ROM is a kind of cemetery of the past, where even the model of the pale-ontologist in a display case seems to look like a corpse." Hutcheon remarks on the presence of the ROM and caged wildlife in Atwood's "Elegy for the Giant Tortoises," where tortoises are "historically heading for extinction and museums."[30]

Identification with beleaguered elephants is the central premise of Barbara Gowdy's 1998 novel, *The White Bone*; in the 1997 novel *Elephant Winter*, Kim Echlin writes that "[T]he story I am about to tell you is how I came to live with elephants in captivity."[31] Hutcheon feels that Atwood's *Life Before Man* is the source for "the most extended set of echoes" in Audrey Thomas's *Intertidal Life*, "with its similar symbolic time setting of Hallowe'en (and All Souls' Day)"[32]; "death ... frame[s] this novel"[33] just as death "loom[s] over" the fiction of Robert Kroetsch.[34] From her analysis of Canadian literature, Atwood concludes that "the central Canadian experience is death and the central mystery is 'what goes on in the coffin.'"[35] To her this recurring image is really one of "ultimate sterility and powerlessness, the final result of being a victim. Images of dead people in their coffins translate readily into images of oneself dead in one's own coffin"; for Atwood, Quebec poets in particular "have a disconcerting way of imagining themselves as dead."[36]

Canadian photography does align itself with what Atwood and others see as some of the central themes of Canadian literature. There is very real level on which all of Canadian photographic imagery appears morbid and depressing; if we were to diagnose the Canadian psyche on the basis of this evidence, we might decide that we are a nation of paranoid schizophrenics, who are unable to walk out into the street or visit a restaurant without seeing visions of dead animals and cruci-fixions. It would be possible, given this imagery, to conclude that we are, to use Atwood's term, "victims" who have been drained of life, who have lost all touch with what is instinctive, animal-like, natural, and life-enhancing in ourselves. Atwood's proclamations in this regard have had enormous cultural impact; no portrait of the Canadian psyche has had the currency of her vision of the Canadian as mere "survivor." But the work of many Canadian photographers, taken together, proposes something in addition to this despairing view. As I hope will become clear, Canadian photographs of the past half-century, while sharing aspects of form and content with Canadian writing, in the last analysis offer a refutation of, and alternative to, Atwood's pessimistic characterization of the Canadian imagination.

She dares mix; she dares cross the borders to introduce into language (verbal, visual, musical) everything monologism has repressed.

Trinh T. MINH-HA

Cotton and Iron

Now we know why all your equations
were equivocal — a pundit's brilliance,
yet disguising the grand with the puny —
of double voices speaking, gasping,
apostrophizing from the ground zero of the mouth

Seymour MAYNE

For A.M. Klein (1909-1972)

CHAPTER FOUR

Elsewhere

Here and There In the opening scene of Atom Egoyan's 1990 film, *Speaking Parts*, the heroine watches a videotape of her dead brother on the rectangular screen of the mausoleum wall behind which his ashes are kept. In this one shot, Egoyan perfectly encompasses, and gives narrative meaning to a configuration that appears again and again in Canadian photography: what Richard Rudisill and others contend the monolithic object is to the American artistic imagination, the rectangular opening into "another" reality is to ours. It would be impossible to overestimate the degree to which this window-like opening dominates Canadian photographic imagery.

The definitive and recurring Canadian photograph is one in which the image is separated into two planes or spheres – "inside" and "outside," "here" and "there" – by a rectangular, window or door-shaped opening. In a 1957 Michel Lambeth photograph this sketching out of "another" zone within that of ordinary reality is alluded to only very gently: in the Waddington Auction House the mirror of an old dresser seems to provide the opening into a reality that is totally other than that which we take to be the subject of the photograph – the room where a man sits amidst piles of furniture. In Tom Gibson's "Woman Inside and Outside," from 1972, the headless statue of a woman inside the room that Gibson is photographing from is completed by the head and arm of a woman seen outside, through a window. A not dissimilar interrelation of inner and outer worlds can be seen in Geneviève Cadieux's 1988 installation *Inconstance du désir*, where a pair of porcelain shoes

4.1 Tom GIBSON
Woman Inside and Outside
1972
27.94 x 35.56 cm

is placed on a strip of cement "sidewalk" in front of a photograph, hung at ground level, of a pair of bare feet stepping out of a pair of shoes.

Two zones of reality, mediated by a window, window-like opening, or door, one of which alludes to the entrapment of nature and, ultimately, to death, are delineated again and again in Charles Gagnon's photographs. Gagnon's articulation of this duality is insistent; the rectangular openings of his photographs, photographs that are often devoid of any event, "social" or otherwise, in fact help call attention to the same underlying paradigm in the more anecdotally loaded images of other Canadian photographers. The protagonist of the Canadian image, whether present or only implied, stands at the border between two realms, and we are able to recognize how this is expressed more obliquely in many other Canadian works because it can be seen so clearly in Gagnon's. Gagnon's 1969 "New England" photograph, of a window taken from inside a darkened porch, can be seen as *the* archetypal Canadian image; the series of literally hundreds of colour sx-70 Polaroid photographs that Gagnon took between 1975 and 1979 reiterate the configuration of the "New England" image. The Polaroids repeatedly show the window of a summer house leading to the garden beyond. In these images the seasons change, but what remains constant is not only the inaccessibility of nature, which is sealed away, but the fact that the viewer is situated in neither sphere, but rather at the point at which the two intersect – neither "here" nor "there," neither "inside" nor "out." This is the abiding leitmotif of Gagnon's work, and the potential for entry into another ontological space is the ultimate subtext of many, if not most, of his images. "Fireplace – New York, 1968," where the curved moulding of a fireplace functions as a window frame leading into blackness, and "Porch, Branch and Snow, 1977," a larger, black and white version of the colour Polaroids that look out into a backyard in winter, carve out two spheres – "here" and "elsewhere," what is here "and whatever else," the electronic message on the wall in a photograph Gagnon took in New York's Museum of Modern Art in 1989. An "elsewhere" is also evoked in "Funseekers Intl. – Ottawa, 1968," where a travel agency is photographed from outside its display window, the posters on the agency's wall touting some faraway destination. In "Candystore Window, Bloor St. – Toronto, 1973" the reflection of the photographer in the store window places him behind glass, in another dimension, where so many other Gagnon photographs situate nature. In "National Gallery: from Outside – Ottawa, 1978" a thin rectangle of light on the wall becomes a window. In the small, delicate street images Gagnon made around 1977 using a Minox pocket-size "detective" camera, doors and windows comprise the main subject matter; in a situation where sufficient openings weren't available, Gagnon created an extra one by photographing a patch of light in the shape of a window – in which is outlined the photographer's silhouette – between two actual store windows on a downtown street in Montreal. Here Gagnon draws on a long photographic tradition that began with the photographs taken by Eugène Atget in Paris in the first decades of the twentieth century, that of the

photographer capturing his or her own reflection in a store window, giving rise to a "surrealistic" confluence of the photographer, the scene on the street, and the items on display. Gagnon's use of this device is significant. Like other Canadian photographers, he enlists the syntax of the documentary tradition in the service of his own metaphysical ends. In this image the self, or some aspect of the self, is equated with a natural world that is beyond reach.

The digital removal of advertising logos and political slogans from signs in the urban landscape in Robin Collyer's 1995 retouched colour photographs – "Yonge Street #4," or "Election Signs," for example – creates eerie reminders of the degree to which the spaces we inhabit have become commodified, rife with text. But the blank rectangles of these now textless signs also appear like apertures cut into the fabric of the landscape, openings into some other dimension. A coffin-shaped sign photographed by Gabor Szilasi in Shawinigan, Quebec in 1988 is painted with a palm tree, setting sun, and water, reference to an "elsewhere" that is in stark contrast to the bleak suburban landscape that surrounds it.

¶ WINDOW images feature prominently in the work of Angela Grauerholz; these include the 1988 "Window," of a man and woman looking through a window to a hazy realm filled with white light; "Mozart Room" made in 1993, where bright light shines through shirred curtains and is reflected on the painted walls of a darkened, empty room; and "Interior," 1988, in which the only window in what seems to be a gallery

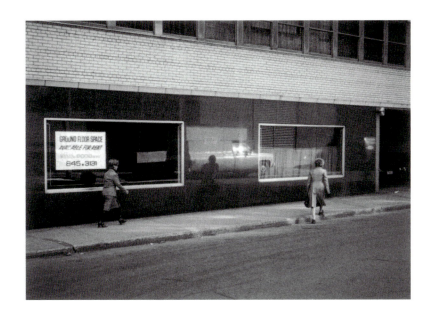

4.2 Charles GAGNON
New England, 1969
27.8 x 35.3 cm

Facing page

4.3 Charles GAGNON
MN: XVI-20-77
1977
6.9 x 9.3 cm

4.4 Angela GRAUERHOLZ
Mozart Room
1993
122 x 183 cm

of a historical museum gives off an intense, preternatural glow. In 1979 Michael Schreier produced a group of colour images entitled *Window Series*, in which the window itself takes up most of the photograph, its edge literally framing the scene outside – a snow-covered lawn and a wall of the neighbouring house. Marion Penner Bancroft's photographic installation work *View from inside cargo plane – dream 1984* features three photographs, mounted on poles, of the landscape seen through the windows of an airplane. David Hlynsky's *Windows Through the Curtain: An exhibition of photographs of Communist Europe prior to the fall of 1989* contained several photographs of the contents of store windows in Eastern Europe. But by prefacing the accompanying exhibition catalogue with a translucent frontispiece overlay with a window-shaped centre, he in effect placed the entire series of photographs taken behind the "Iron Curtain" on the other side of a window. Even within the fabricated "landscapes of the imagination" Holly King constructs in her studio and then photographs, the paradigm of the window is evident. A window frame is created by a transparent black veil that opens onto an otherworldly forest in King's 1997 colour image "The Veiled Forest," and there is an echo of Charles Gagnon's "New England Window" in King's 1989 black and white "Reverie on an Open Sea," where from the inside of a cave-like chamber one looks through an opening to a phantasmagorical seascape. A woman in a long white gown stands looking through a window in the 1996 "Sans Titre" by Montreal photographer Suzanne Grégoire.

Carole Condé and Karl Beveridge's photographic sequences, such as *Maybe Wendy's Right*, *Work in Progress*, and *Standing Up*, borrow the narrative form of the *photo-roman*, or photographic love-comic, to present fictionalized accounts of the effect of company lay-offs and union strikes on the lives of individual women and their families. In each of the constructed colour images of the 1980–81 *Work in Progress*, a woman sits in a kitchen whose accoutrements, along with her clothing, place the scenario within a particular time frame, like the early 1900s or the 1950s. As the kitchen decor changes from one image to the next in the sequence, so does what we see through the kitchen window, and in the photographs that sit on a shelf and grace a calendar hung on the wall. These pertain to the political reality outside the confines of the domestic setting, like the Spanish Civil War or the Hungarian revolution, the employment of women in munitions plants during World War II, or in domestic service at the turn of the last century. In several consecutive images, the women in *Standing Up* confront the repercussions of their troubling work situation – strained domestic relations, or violence on the picket line – in the form of images that appear in the bathroom mirror of their workplace.

Condé and Beveridge produce work that is more obviously politicized than that of most other artists in this country, as their writings and lectures make clear. What is germane here is that although their purpose for photographing is quite distinct from that of Gagnon, Grauerholz, and others, they have chosen to address the issues that concern them in the prototypically Canadian format of a window,

4.5 Carole CONDÉ
and Karl BEVERIDGE
Work in Progress, 1908
1980-81
40.64 x 50.8 cm
Original in colour
(See also plate VIII)

mirror, or other rectangular opening that delineates one zone of reality, the "here," from another, the "elsewhere." Like the Canadian "documentary" poem described by Livesay and others, Condé and Beveridge interweave historical fact from "outside" with the subjective experience of the series' protagonists. This same conflation of past and present informs Don Corman's window photograph from the 1979 series *Artifact/Artifice: History in the Making*; the image, taken from inside a room that seems completely contemporary, looks through a window to a barn and a wooden wagon from another era, loaded with hay. The legend printed directly under the photograph reads: "It was such a lovely day, time seemed to stand still." Sylvie Readman's mural-sized 1993 "Self-portrait at Window" superimposes the hazy image of the photographer's eyes and forehead on to a cityscape and sky seen through a window. Her "Rustling," made the same year, is a large colour diptych, in which the close-up of a section of an open window, through which rays of light, or "rustlings" of wind, are seen to move, is hung over a photograph of a woman's red, slightly opened mouth, on which is reflected the image of a windblown tree.

In the early 1980s Lynne Cohen's photographs began to change, as she moved away from the frontal and highly detailed images of vernacular spaces she had been producing for over fifteen years to a series of window images. In these the window is the one-way glass of university psychology labs and therapy rooms, where patients, subjects of experiments, or daycare children may be studied without their knowledge. What is seen on either side of these windows are the ingredients of an Orwellian nightmare of surveillance and control.

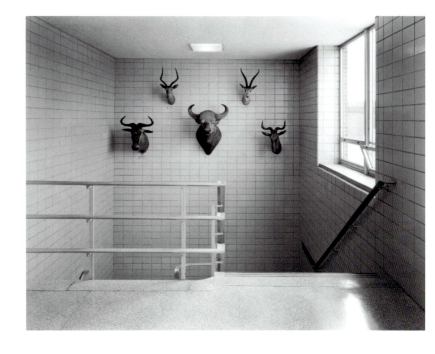

4.6 Lynne COHEN
Observation Room
1984
38.5 x 48.4 cm

Facing page

4.7 Lynne COHEN
Corridor
1981
40.3 x 50.6 cm

Without wishing to make too much of it, it is interesting to me that as Cohen began to construct her images in a more "Canadian" manner, she also stopped presenting her previous images in the fairly standard fashion she had been employing for many years. The titles that had situated her interior spaces within their social context – "Knights of Columbus, Hamilton, Ontario, 1977," for instance, or "Corridor, Biology Department, State University of New York, Potsdam" – were eliminated in favour of generic categories like "Laboratories," "Classrooms," and "Show Rooms," or shorthand titles like "Corridor." As she did away with the idea that it might be important to state that her images refer to the particular physical facts of specific places, she also stopped contact printing these 5 x 7 and 8 x 10 inch images, thus eliminating some of their precision of detail, and began to enlarge them to 20 x 24 or 28 x 36 inches and to show them framed in pastel Formica. She also stated that her images had never been documentary in the sense of being about "those places,"[1] but rather that their new mode of presentation indicated that they had really always been "pieces"[2] and not straight photographs at all. One way of reading this quite major shift would be as a move away from an American preoccupation with "significant facts" to a more Canadian mode of downplaying the referents to which, we had always assumed, her pictures were

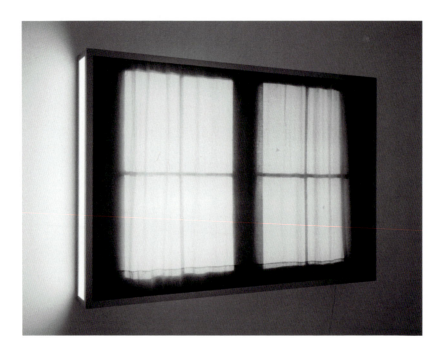

meant to allude. But Cohen's work has nonetheless maintained a strong vein of social criticism that is not seen in the work of most Canadian photographers.

The window has been a consistent choice of subject matter, over many decades, in the work, both photographic and non-photographic, of Michael Snow. His 1998 "Place des Peaux" is an installation of window-like structures made of coloured gel; "Speed of Light," a 1992 back-lit transparency, shows two bright, curtained windows, surrounded in darkness; "Snow Storm February 7, 1967," is composed of twenty images made out the window of Snow's New York studio. The window has been an important image in Canadian painting as well: notable examples include Winnipeg artist Lionel Lemoine FitzGerald's almost photo-realist 1950–51 "From An Upstairs Window, Winter," which looks through a window, on the sill of which are placed a pencil and a ceramic jug, onto trees and the neighbouring backyards, and Christopher Pratt's 1970 "Window with a Blind," in which the venetian blinds covering a window allow one to see through to a clear, almost white, sky.

Canadian photographers portray two distinct realms in other ways than the use of the rectangle, and it is sometimes in these pictures that the interpenetration or symbiosis of the two worlds becomes most evident. In Tom Gibson's street photographs this duality is often communicated in an amusing manner; for example, in "London, England, 1974," a man wearing earphones appears to be listening to the figures carved in relief on the monument wall in front of him. Many of Gibson's street images represent the unexplained appearance of some

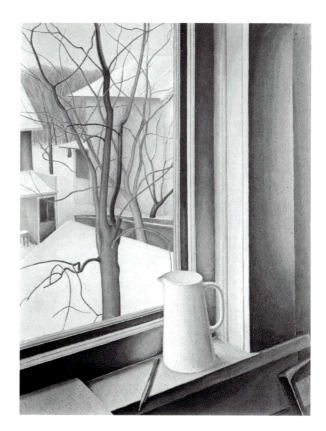

4.8 Michael SNOW
Speed of Light
1992
91.4 x 127 x 15.2 cm
Original in colour

Facing page

4.9 Lionel Lemoine FITZGERALD
From An Upstairs Window, Winter
1950-51
61 x 45.7 cm
Original in colour

kind of phantasmagorical, apparition-like reality that is completely antithetical to the banality of the context in which it is found, and yet which paradoxically seems to be an intrinsic part of that environment. Into the placidity of an unpeopled Ottawa intersection has erupted what looks like a fairytale castle; a parade of fantastically dressed individuals has sprung into existence amongst the steel and glass of a Toronto business street. During the decade Montrealer Robert Walker spent making colour photographs in the streets of New York City, he produced several images of persons in phone booths. Like the Gibson photograph of the man with his Walkman, what is intriguing is that Walker presents these preoccupied-looking individuals as if they were hooked up to some dimension of reality other than the gritty urban one around them.

Gabor Szilasi's images often incorporate the surreal intersection of two distinct historical periods, the "traditional" rural period and contemporary urban Quebec. This is apparent in his 1973 "Marie-Jeanne Lessard (St-Joseph de Beauce, Quebec)," where a giant bush, over which hangs a large Esso sign, both dwarfs the prim old woman who sits beneath it on a lattice-work bench and seems to divide the world of the picture into a disappearing past and a looming corporate future. In many of Szilasi's colour pictures of the interiors of small town Quebec homes,

the rectangle of the always-illuminated television provides access to a realm that is thoroughly foreign to the one its owners reside in. In several of these images of living rooms with plastic-covered sofas and elderly, sometimes sleeping inhabitants, only the television window provides any sense of life at all. Once again, life exists on one side of the visual equation and death and entrapment on the other.

One Szilasi work captures perfectly that sense of the ever-present co-existence of two different spheres of reality, one of which may have to do with death or imprisonment. Part of a series called *Portraits/Interiors*, produced from 1979 onwards, the image is made up of two photographs, mounted beside one another and meant to be seen together. The elderly Andor Pasztor is shown in black and white, slouched in a chair, gazing off into space; behind him on the wall is a large collection of what seem to be old family photographs. Next to this, in colour, is a close-up of the wall of photographs. The implication is that the world of memory and image is more real to Pasztor than the concrete one in which he resides.

4.11 Gabor SZILASI
Portraits/Interiors: Andor Pasztor, 1979
Diptych, 33 x 26 cm each; matt size 49 x 77 cm. Original in colour (left image)

Christos Dikeakos's colour panoramic photographs of the Vancouver skyline, landmarks like Stanley Park, and more mundane sites that include a city under-pass and an industrial canal use text that has been sandblasted into the glass cov-ering the images, (or, in other versions of the same works, words that have been applied directly to the photographic surface), to re-insert the "invisible" history of the indigenous Salish Nations back into the "visible" landscape. In addition to the Musqueam or Squamish names these locations originally bore, the words describe the significance of the sites in the community life of the Salish. In the 1992 "West End Panorama," for example, the place name "skwachays" and the words "waterfowl," "heron," "sturgeon," and "elk" may be read at various points on the image; below the image is the phrase "hole in bottom." Under the photo-graph of a park is the legend "good spring water," and in the landscape itself are the words "crabapple tree," "douglas fir," "cedar," "uyul'mux'," and "kwa' appulthp." These photographs attest to a web of complex and overlapping histories that are part of the land, and oppose the accepted Eurocentric record of the cultural her-itage of Vancouver and its environs. As well as inserting a history that has been suppressed back into the present, many of Dikeakos's pieces also draw attention to once vital, and now absent, animal and plant life. The text that winds around

ɕusnà um ▶

the great Marpole midden

4.12 Christos DIKEAKOS
ɕusnà um – Location of the Great Marpole Midden. From
the series *Sites and Place Names, Vancouver,* 1991-93
36 x 71 cm. Original in colour

4.13 Don CORMAN
Excerpt from the book
Comfort and Cleanliness
1980
40.64 x 50.8 cm
Original in colour

Below, left

4.14 Don CORMAN
Excerpt from the book
Comfort and Cleanliness
1980
40.64 x 50.8 cm
Original in colour

Below, right

Here your stay is attended by personal service and surrounded by quiet elegance.
Call from your bedside and somebody from the pantry personally responds to take your order.

The system of "every other week" should be used for turning mattresses.
One week the mattress can be turned from side to side, the other week from end to end.

4.15 Susan MCEACHERN
Detail of *On Living at Home, Part II – Domestic Immersion*, 1989. 40.64 x 50.8 cm each. Original in colour

Texts: (bamboo curtain) Consumption for the home is kept distinct from the economy as a whole; (basket of fabric and knitting) No matter what her obligations are outside of the home, a woman's self-esteem is affected by the cleanliness and orderliness of her home.

ordinary household objects in Halifax photographer Susan McEachern's *On Living at Home* images, part of a larger series entitled *The World Outside*, made in 1989, alludes to the depletion of resources in the developing countries that manufacture consumer goods for the North American market. Like Dikeakos's panoramas, these images establish a dialectic between seen and unseen realities; in a window photograph from *On Living at Home*, the outside is barely visible through a bamboo blind, and the small line of text along the wall inside the room reads "Consumption for the home is kept distinct from the economy as a whole."

The interpenetration of two registers of reality, sacred and profane, is apparent in Evergon's continuing series of photographs taken within the world of gay cruising grounds. Titled *Manscapes*, and begun in 1993, the images show rendezvous sites, such as parks and public toilets, covered with graffiti that is often testimony to the most virulent homophobia. While the documentary aspect of these photographs might have been depressing, Evergon's solarization of the black and white images brings another aura to them entirely. The luminous reversal of positive image into negative that is characteristic of the solarized print positions these images in a realm of transcendent beauty.

Don Corman's book of photographs entitled *Comfort and Cleanliness: A guide to the hospitality industry*, published in Halifax in 1980, juxtaposes hotel advertising copy ("Call from your bedside and somebody from the pantry personally responds to your order") and promotional photographs, most of which are in

4.16 Arthur RENWICK
Excerpt from the
series *Dislocation*
1988
Panel 6 of 6 panels
60.96 x 243.84 cm

4.17 Jin-me YOON
Touring Home From Away
1998-99
Photographic installation
Each lightbox 81.28 x 91.44 x 12.7 cm
Original in colour

Facing page

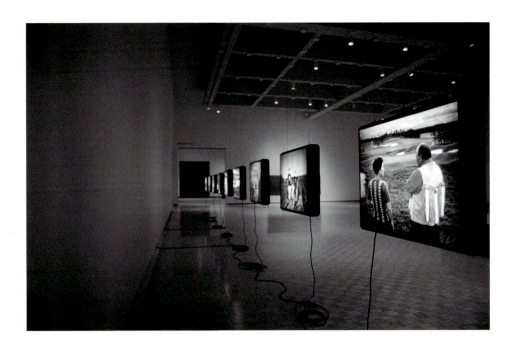

colour, of happy guests and comfortable surroundings, to text appropriated from hotel employee manuals ("The system of 'every other week' should be used for turning mattresses") and black and white photographs of chambermaids performing their duties behind the scenes. The photographs in Arthur Renwick's *Dislocation* series, taken on Vancouver's skid row, are also seen from the "other side" of middle-class life, from ground level and the point of view of what the viewer imagines to be a person living on the street. Michael Snow's 1974 film, *Two Sides [to Every Story]*, is simultaneously projected onto both sides of a screen, around which spectators are free to walk, and the action taking place in the film is seen from both front and back. Similarly, nine double-sided hanging light-boxes make up Jin-me Yoon's 1998–99 *Touring Home From Away*, whose photographs juxtapose members of an Asian Canadian family that could be Yoon's with vernacular icons of Canadian culture: a Tim Horton's coffee shop, a P.E.I. potato field, a statue of Anne of Green Gables. Double portraits make up Yoon's *A Group of Sixty-Seven* series, in which each of the sixty-seven Korean Canadian subjects is seen from the front, "looking out from"[3] Lawren Harris's 1924 painting "Maligne Lake, Jasper Park," and, photographed from behind, "looking into"[4] Emily Carr's "Old Time Coastal Village," painted in 1929–30.

An artistic trajectory not unlike that of Lynne Cohen can be traced in the work of the American-born photographer Mark Ruwedel, who has lived for many years in Montreal and British Columbia. From straightforward, frontal architectural

4.18 Geoffrey JAMES
*Looking towards Mexico,
Otay Mesa.* From the series
Running Fence
1997
76.2 x 101.6 cm

4.19 Claude-Philippe BENOIT
Untitled #3. From the series
*L'envers de l'écran, un
tourment photographique*
1984
40.6 x 50.8 cm

Facing page

and landscape photographs – including a re-visioning of sites photographed by Walker Evans in Ruwedel's hometown of Bethlehem, Pennsylvania, and a documentation of early North American movie theatres – over his years in Canada Ruwedel's images have begun to incorporate the dualistic viewpoint that characterizes so much of Canadian photography. His current landscapes, several of which are panoramas constructed over two or more images, retain the scrupulous attention to physical detail that has always distinguished the American landscape photograph. But over the past few years his pictures have begun to concern themselves, like Chris Dikeakos's panoramas, with an unseen dimension of the landscape. The authority of these exquisitely printed, "traditional" view-camera landscape images is undercut and then ultimately extended by the legends – "vintage bomb crater," "toxic waste dump," and "test and training range" – that have been lightly etched in lead pencil on their window mats. Many of Ruwedel's notations, the result of intense historical and geographical study of the region in which he photographs, refer to hidden pillage of the land by, among others, the military and nuclear industries, and to the multiple narratives, cultural and technological, that make up the history of a site. Ruwedel photographs are themselves of a piece with the work of contemporary "topographical" photographers like Frank Gohlke and Lewis Baltz, whose work Keith F. Davis describes as landscape that is "poignant, rather than sublime," holding "little promise of redemption."[5] What I find relevant here, with respect to a Canadian specificity of vision, is the way in

which Ruwedel has presented his concerns within a typically Canadian dualistic framework.

Running Fence, a 1997 project by Geoffrey James, commissioned by the Museum of Contemporary Art in San Diego, entailed photographing the San Diego/Tijuana border dividing Mexico from the United States. In almost every one of these images, "The end of the fence, looking east," for instance, in which the picture frame is divided in half by the vertical line of the fence, with human settlement on one side and empty desolation on the other, or "Looking towards Mexico, Otay Mesa," which shows densely packed housing on one side and bare scrubland on the other, James chose to present the landscape as bifurcated by the fourteen-mile fence. As Dot Tuer has written, "James does not offer up the expected shots of Mexicans anxiously waiting to cross the border, or sprinting across the desert toward a standing army of American police. Instead, there is a startling absence of people in his photographs and the relentless, almost overwhelming presence of the fence Through a singular fixation on the fence, he exposes the tensions between what can be seen, an imperial monument, and what cannot, the contin-uous movements of migrants who slip over and through and around it."[6] In noting the persistent dualism of James's images, his carving out of a relationship between visible and invisible registers of reality, Tuer picks up on the phenomenon that is present not only in *Running Fence* but which repeats itself over and over in Canadian photography.

Blank rectangular movie screens dominate the series of sixty black and white photographs Claude-Philippe Benoit produced between 1983 and 1985, titled *L'envers de l'écran, un tourment photographique*. For this series Benoit photographed the screening rooms of empty cinemas in Paris, Montreal, and Ottawa, from behind as well as in front of the movie screen; in many images the screen appears as a blank white rectangle that takes up most of the photograph and acts as a window-like opening into an abstract, oceanic elsewhere. In others the screen functions as a membrane, mediating between the spectators' seating area and a "behind the scenes" reality. In Benoit's 1991 installation *Apparition et absence*, projected black and white images — of the polished table and impressively tall bay windows of what could be a private men's club, the moss-covered trees and floor of an old-growth forest like that of the Queen Charlotte Islands, heavy machinery in an out-moded but still functioning factory, and against a black background, a band of light that came perhaps from the motion of cars at night — are titled, respectively, "Le Sociétal," "Le Lointain," "L'Economique," and "L'Abstrait," ["The Societal," "The Far Away," "The Economic," and "The Abstract"].[7] The meta-physical reality alluded to in the image Benoit calls "L'Abstrait," and which in dis-cussion he has referred to as "the elsewhere,"[8] recurs in a later group of his photographs called *CHAPITRE Ô-NU*, made in the United Nations building in New York during 1992 and 1993. In a pair of images from that series, titled "Ouverture, échappée," ["Missed Opening"],[9] for example, an interior shot of an empty UN

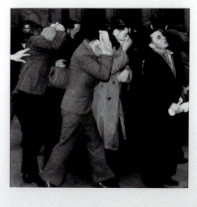

4.20 Claude-Philippe BENOIT
Ouverture, échappée
Diptych from *CHAPITRE Ô-NU*
of the series *LES LIEUX MAÎTRES*
1992
138 x 331 cm (overall)

Facing page

4.21 Roy ARDEN
Excerpt from *Rupture*
1985
Number 8 of 9 Diptychs
68.6 x 40.6 cm each panel
Original in colour (top section)
(See also plate IX)

audience hall is juxtaposed to an "abstract" image of the movement of light, reit-erating the existence of a realm that is "elsewhere," outside the social and mate-rial order of things.

Vancouver artist Roy Arden's series of diptychs from the 1980s, *Rupture* and *Abjection*, establish a dialectic between the political "realism" of photography and the ahistoricism of abstraction. Archival journalistic photographs of the 1938 Bloody Sunday riots in Vancouver are shown beneath colour photographs of a clear blue sky in *Rupture*; in *Abjection*, photo paper that has been blackened by light and then processed is placed above archival images of the confiscating of property from Japanese Canadians during World War II. A blood-red wall pro-vides the background on which are hung the photographs in Arden's 1985 *Mission*, which was made using archival images of a group of First Nations Canadians watching a re-enactment of the crucifixion. Similar juxtapositions of two fields of reality operate in Charles Gagnon's coupling of each of his *Painted Desert* pho-

4.22 Ian WALLACE
*Clayoquot Protest
(August 9, 1993), VI*
1993-95
200 x 152 cm
Original in colour
(See also plate X)

Above

4.23 Ian WALLACE
Hotel Alhambra, Paris II
2000-2001
61 x 61 cm
Original in colour

Below

STEREO

4.24 Jeff WALL
Stereo
1980
Diptych
213 x 213 cm each
Original in colour

tographs with a single-toned abstract painting of the same size, for example, "Ex Situ – Painted Desert, Arizona of Ground, 1999," and in any number of Ian Wallace's photographic series – *Poverty* (1982), *Studio/Museum/Street* (1986), *My Heroes in the Street* (1987), *Olympia I & II* (1987), *The Saint Etienne Series* (1989), 1993–95's *Clayoquot Protest (August 9, 1993)*, or *Masculin/Féminin* (1997) – in which "abstract," painted surfaces, which are almost always monochromatic or the plain surfaces of photographic paper, are mounted or laminated onto supporting surfaces next to photographs of environment protestors, poverty-stricken children, video clips of French New Wave cinema, or other social phenomena. What Wallace has written with respect to Roy Arden's *Rupture* holds for his own series as well: "The images of *Rupture*, then, point to two sides of politics: that of history, as an ideal of emancipation and defeat; and that of the abstract, transcendent, a historical plenum of the 'natural,'" which is embodied in actual photographs of the sky, but which also mimics an ideal, abstract, reductive, formalist tradition of modernist art. This latter tradition, in its negation of the literary, narrative and discursive image, has attempted to install a transcendent history, an amnesia of politics and an erasure of opposition, an emptiness that occupies space."[10] Wallace's 2000–01 single image "Hotel Alhambra, Paris II" brings together two central elements of the Canadian idiom: a photograph that looks through a window to a Paris rooftop is bordered on both sides by the "abstract" emptiness of monochromatic bands of paint.

4.25 Stan DENNISTON
Reminder #14, Left: Boulevard de
Maisonneuve E.& Rue Alexandre
de Sève, Montréal/ Right: Filbert and
Mason Streets, San Francisco
1978
Diptych
40.64 x 50.8 cm framed

In Jeff Wall's 1980 piece "Stereo," a wall-size colour photographic transparency of a nude man lying on a couch wearing headphones is coupled with a transparent panel that bears the word "stereo" written in large block letters, underlining the fact that the subject of the photograph, like the people attached to headphones and telephones in the photographs Robert Walker made on the streets of New York, exists both "here" (in this case, lying on a sofa), and "there," in the world into which he is transported by way of sound.

The duality of "here" and "elsewhere" also provides the base premise of Stan Denniston's 1979 *Reminders*. In this work pairs of landscapes or city scenes are mounted together; uniting each set of visually commonplace photographs is the fact that one locale has made the photographer think of the other. "Alexandre-de-Sève Street from Maisonneuve Boulevard East, Montreal, Quebec" brought to mind "Filbert Street from Mason Street, San Francisco, California" and so Denniston photographed the Montreal site, and before printing the resultant negative, travelled to the location he remembered in San Francisco and photographed it as well. The two – an actual place and an image that had existed for Denniston only in memory – are finally coupled in a photographic diptych. As in the work of Szilasi, Benoit, Gagnon, Wallace, and other Canadian photographers, what is abstract, "elsewhere," is given equal importance to and brought together with what is concrete, to form a typically Canadian duality.

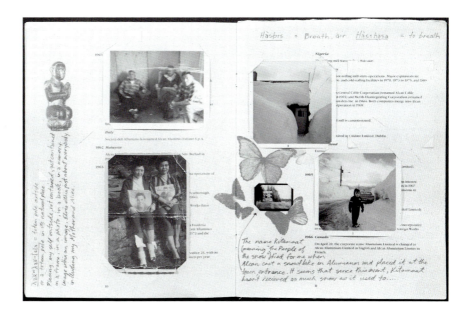

4.26 Arthur RENWICK
Landmarks
1992-95
Book with various
media inserted;
27.94 x 21.59 cm (closed)

Hybridities Several bodies of Canadian photographic work have emerged
since the beginning of the 1990s that demonstrate the Canadian preoccupation
with duality in a manner more directly linked to historical and political concerns
than most Canadian photographic work of the previous decades.

In the bookwork *Landmarks*, produced in 1992, Arthur Renwick has inserted
family snapshots, writings in the Haisla language of his mother's ancestors, his
own photographs and personal notations, and historical images of the Haisla
community of Kitimat, British Columbia into the pages of an Alcan of Canada
publicity booklet describing decades of that company's involvement in Kitimat.
Renwick's addenda, "ghosts" of his own, his family's, and Kitimat's past that
remain unacknowledged in the Alcan literature, interrupt and call into question
a corporate version of Canadian history. The interpenetration of two realities, so
often apparent in Canadian photography, manifests itself in Renwick's piece in
pulling together "past" and "present," "official" and "unofficial," and native and
non-native. But in contrast to earlier Canadian photography, in Renwick's work
this construct is brought to bear on explicitly social rather than metaphysical con-
cerns. Renwick's handwritten text makes evident his cultural ambivalence, his
identification with both Kitimat communities, that of his mother's family and of
the settlers from outside.

The passport and identification with the photographer's mother are central
to Jin-me Yoon's *Screens*, a 1992 installation dealing with the immigration of
Yoon's family to Canada at the time of the partition of Korea. Yoon has printed

4.27 **Jin-me YOON**
Detail from September/October
1993 *Ms* magazine photo-essay
version of the 1992 photographic
installation *Screens*

4.28 **Marisa PORTOLESE**
Annullato. From the series
Paysage Intranquille
1993
40.64 x 50.8 cm

Facing page

photographs and Korean text (translations are tacked on the exhibiting gallery's wall) on rice-paper-like surfaces and mounted these into movable screens whose sections can be folded to allow for varying juxtapositions of images. Each screen contains fragments of Yoon's mother's writing, including a letter sent to her parents in Korea when she and her daughters first arrived in Vancouver in 1968, and a childhood recollection of receiving candy from sailors on a docked American warship that seemed so wonderful that upon seeing it, she wanted to travel to America "in a dream."

Screens includes an enlargement of a page of the passport her mother used to enter Canada, in which is seen a picture of Yoon's mother, her sisters, and herself, and a contemporary restaging of the original passport photograph. In both, Yoon, the eldest daughter, takes the place usually reserved for the father in a traditional family photo: while the others sit, she is standing, her hands resting protectively on the shoulders of her mother and smallest sister. The two photographs suggest that the family dynamics established at the time of immigration, when Yoon's father had already been in Canada for some time, have endured.

In *Screens* the line that divides Yoon's homeland into two in the photograph of a map of Korea is echoed by the almost identically formed line of a scar in another image. In Yoon's work the uprooting of her family by war and the subsequent move to Canada is portrayed as the deepest of wounds. Yet it is one over which mother and daughter prevail, signalled by the fact that in their contem-

porary presentation of themselves they have adopted the authoritative crossed-armed stance of one of the group of American naval officers as he was photographed on the warship of her mother's remembrances, a detail Yoon plucks from the original snapshot and re-presents in a blow-up. Out of devastation, something has been retained. But the blank spaces that have been left on these screens bear witness to those parts of the family's history, and the connections to the past, that have been lost forever.

The rephotographed photo-collages that are found inside the doors and drawers of old wardrobes and dressers in Vid Ingelevics' 1990 *Places of Repose: Stories of Displacement*, discussed in the previous chapter, include pages from the passports of Ingelevics' mother and her sisters, who fled their rural home in Latvia just ahead of the Red Army during World War II, leaving their mother behind. The passport is also a pivotal image in *Paysage intranquille* and *Le Pays plat*, two series of black and white photographs by Marisa Portolese, produced in Montreal in 1993 and 1994. The passport in *Paysage intranquille* is her grandmother's "Passporto d'estero," that of an immigrant who is now considered "alien" in her mother country. In *Le Pays plat*, we are shown Portolese's mother's passport, which has also been annulled, indicating that because she has immigrated to Canada, she can no longer regain her Italian citizenship. Both represent, for the Canadian-born Portolese, the severing of ties to the parent's homeland felt by second-generation immigrants who exist between cultures. *Paysage intranquille* incorporates photographs of objects whose symbolism within Sardinian culture is all but lost in the North American context. In one are old wisdom teeth, signifying a cultural heritage that may have value for the immigrant's child, but which will decay and die. In another, patchouli leaves, used in Sardinia as a preserving agent, speak of the photographer's need to retain something of that past in order to come to terms with her own sense of displacement and of being culturally torn in two.

The feeling of loss and the mourning for an irretrievable cultural heritage also permeate Vancouver photographer Kiki Yee's 1992 *Excerpt from a Diary*. The series chronicles a trip she made to China to visit the villages where her mother and father were born, including a pilgrimage to the burial site of her father's ancestors. The red text printed on the plexiglass that overlays her full-faced self-portraits and the small "diary" accompanying the pictures discuss the deaths of her grandparents, and the linguistic and other barriers that separate Yee from the older members of her family.

The works of Ingelevics, Yoon, Portolese, Yee, and Renwick (who in *Landmarks* tells us his father's family was of Scottish origin) are of a piece with Canadian Mina Shum's 1994 film *Double Happiness*, in which a young Canadian Chinese woman tries to come to terms with the traditional and, to her, constraining beliefs of her immigrant parents. All grapple with the difficulty of existing in a cultural "in-between," living with one foot in each of two cultures, unable to identify completely with either. Their work addresses the fact that, as Japanese Canadian writer

Joy Kogawa has said, "a Canadian is a hyphen."[11] They are like the central char-
acter in Kogawa's novel *Obasan*, who "literally 'finds' herself located at the inter-
section of contradictory philosophical, political, historical, and biographical
narratives that designate her both 'Canadian' and 'Japanese,'"[12] and place her "in
the 'inside-outside position' of being Japanese Canadian."[13]

What Edward Said has written with regard to the situation of the exile might
also be said with respect to the work of these photographers: "most people are
principally aware of one culture, one setting, one home; exiles are aware of at least
two, and this plurality of vision gives rise to an awareness of simultaneous dimen-
sions, an awareness that – to borrow a phrase from music – is contrapuntal."[14]
It is just such an "awareness of simultaneous dimensions" that persistently informs
not only work having to do with the immigrant experience but all of Canadian
photography.

Dual Template Is the constant pointing to an "elsewhere" seen in the work
of Carole Condé and Karl Beveridge, Charles Gagnon, Claude-Philippe Benoit,
Stan Denniston, and many other Canadian photographers, simply another ver-
sion of the Canadian self-deprecation remarked upon by John Ralston Saul and
other commentators? In Saul's *Reflections of a Siamese Twin*, the author quotes the
Caribbean writer V.S. Naipaul, who "described élites of [the self-hating] sort with
great precision when writing about the establishment in Argentina, a country
which has similar contradictions [to those of Canada]. They were forever setting
the value of European culture against the real place in which they lived. For these
individuals …' the real world is felt to be outside, everyone at home is inadequate
and fraudulent.'"[15] Sociologist Ian Angus, writing about Canada, alleges that the
"deepest condition of dependency is to believe that the thought which constitutes
our humanness must belong somewhere else and that that which constitutes our
own condition is necessarily parochial."[16]

Literary critic Linda Hutcheon remarks that when the female protagonist in
Atwood's *Cat's Eye* grows up and decides to become an artist, she "runs into another
set of cultural conditions that provoke yet another ironic response in her. First
of all, she learns that 'art' is something that 'has been accomplished, elsewhere.'"[17]
This attitude is, of course, evident in the literature of other cultures whose mem-
bers feel themselves to be marginalized. In Simone Schwarz-Bart's 1981 novel,
Between Two Worlds, for example, the narrator says of her homeland, Guadeloupe,
that "it is a completely unimportant scrap of earth, and the experts have once and
for all dismissed its history as insignificant … as for the people, they believe
nothing happens on the island, never has and never will until the day it goes to
join its elder sisters at the bottom of the sea … They say that real life is some-

where else."[18] Self-denigration may be one aspect of a Canadian world view that consistently refers to a place that is "elsewhere," that repeatedly points from "here" to "whatever else," to borrow from the phrase seen on the wall in Charles Gagnon's photograph taken at the Museum of Modern Art. But the literary critics, political analysts, and cultural observers who have remarked upon the sense of duality present in various modes of Canadian cultural production have posited reasons other than colonial self-hatred that might account for the enduring presence of a Canadian dualistic vision.

Writing about Canadian film in his 1989 book, *Image and Identity*, R. Bruce Elder remarks that for early Canadian settlers, the "feeling that nature was unknowable developed into a dualistic view of reality, according to which reality is made up partly of mental stuff and partly of physical stuff, with the two entirely different from one another."[19] The photographic images of Michel Lambeth and Charles Gagnon that render nature inaccessible, always on the other side of a window or sealed in a glass case, indicate that this view of reality has persisted up to the present day. Elder sees the resolution of this problematic dichotomy as possible in the photograph. "Because the opposition of nature and consciousness is especially acutely felt in a harsh landscape and climate such as ours," he writes, "the realistic image which provides a model of the reconciliation of consciousness and nature has an especially important role in our culture."[20] Elder feels that "any sort of likeness can serve [this] role," but "a photograph can do so especially well, for nowhere other than in a photograph are consciousness and nature brought together in such an intimate cohabitation. Paradoxically, a photograph is at once both a product of consciousness that possesses some of the structures of nature and an emanation from nature that resembles the contents of consciousness." While this is a revealing insight, Elder argues that "the demand for accuracy" accounts for the "realistic, documentary impulse of much Canadian art," that "the expressive dimensions of artmaking here are often confined to discovering, and subsequently representing, a scene or landscape with which we feel a special degree of empathy,"[21] and that it is the representational nature of the photograph that Canadian filmmakers have adopted as their guiding principle. Elder draws these conclusions without examining Canadian photography or other visual arts such as painting (which are not primarily documentary), and instead bases his thesis on a questionable understanding of Cartier-Bresson's idea of the "decisive moment," attributing to that photographer a Purist approach his photographs do not possess. Nonetheless, when Elder points out that what he sees as the "metaleptical realism" of Canadian film is "a realism that escapes the problems of naïve realism" and possesses a "[s]elf-reflexivity" that "undoes the bounds between the image and its model" while remaining "profoundly sceptical about its relation to the world,"[22] he touches on a phenomenon related to the persistent attempt to sever the image from the facts in the world to which it refers that, as we have seen, is so characteristic of Canadian portrait photography in particular.

In *The Wacousta Syndrome*, an exhaustive survey of Canadian literature and visual art that does not include art photography, Gaile McGregor identifies a duality operating between the Canadian literary or visual subject and nature that is so extreme as to constitute "a denial of meaningful relation between man and nature-as-panorama, nature in the broadest sense."[23] McGregor's prototypical Canadian protagonist finds nature dangerous, repellent, and ultimately unknowable. A more positive version of the Canadian duality as it pertains to nature can be found in Ian Angus's *A Border Within: National Identity, Cultural Plurality, and Wilderness*. Angus writes that "English Canada may be defined through [the] metaphor of the New World encounter with wilderness combined with the invention of a border separating us from the United States – a border in the wilderness."[24] What I have identified as the prototypical Canadian photographic image, a window-like opening that separates two zones of reality and that often, as in the sx-70 Polaroids of Charles Gagnon, features nature on one side of that window, is a succinct visual expression of the border Angus describes. So, too, are the Gagnon photographs, described in the last chapter, in which white highway meridian lines feature so prominently, in one photograph separating an asphalt parking lot from a tree stump planted with flowers.

For Angus, Canada's "[c]entre-periphery relationship" with its founding empires created "a society in deep polarity between modern, historical, civilizing tendencies and a primal, archaic, and unhistorical encounter with wilderness."[25] This is, in fact, the very polarity evident in so many Canadian photographs. Angus writes that to the Canadian, this "[w]ilderness is not experienced as something to be transformed into civilization, but as a limit to the civilizing project, both an external limit – an outside – and a limit of depth … English Canadian thought has revolved around this polarity between civilization and the wilderness."[26] In a perfect description of so many Canadian photographic images, Angus states that the border that is the central organizing principle of the English Canadian collective imagination "does not separate two distinct spaces, but describes a tension between wilderness and civilization that cannot be erased."[27] For Angus, the definitive Canadian gesture is "the drawing of a line, a border that separates here from there,"[28] and he writes that "a border, after all, cannot be one without separating and yet relating two distinct sides."[29] It is precisely this inclination to carve out of reality a configuration that "separates here from there," and yet holds the tension between the two, that constitutes the specificity of Canadian photography.

In preparation for the book of photographs *Between Friends*, which would be presented to the United States as a bicentennial gift from Canada, the NFB Still Photography Division in 1975 commissioned thirty-two Canadian photographers to make photographs along the Canada–U.S. border. Photographers were asked "to interpret the border, to photograph the land and the people in the immediate vicinity of it, to document places in both countries where there is a sense of the

4.29 Michel LAMBETH
*New York – Quebec Border
through the Dundee Line Hotel,
Dundee Line, P.Q.*
1974
Original in colour
(See also plate XI)

border present in the daily lives of the people that live there."[30] Although most
of the over 250 photographs in the book are the predictable feel-good fare of
generic portraits, landscapes, and architectural photography, what is noteworthy
in this context is the paradigm that underpins the project itself. The photographs
in the book reside in the space "between" two distinct but interrelated zones, in
this case Canada and the U.S., and what is highlighted is literally a "border," which
Angus sees as so integral to the "English-Canadian" imagination. All of this is
brought together in one of the few distinctive photographs in the book, a colour
image by Michel Lambeth of a borderline painted on the floor of a pool hall that
straddles the two countries; "Québec" is painted on one side of the line, "N.Y."
on the other. Like the title of Robert Frank's 1992–99 diptych, "The View From
the Canadian Side," what is highlighted is the division between what is the "Cana-
dian side" and what is not.

4.30 Marlene CREATES
Excerpts from *Limites
municipales, Québec 1997*
1997
200 x 211 cm
Original in colour

A great many Canadian photographs visually depict what Angus sees as the
tension between "the anonymous murmur of convention and the disintegrated
babble of the wild," in which the border – in our photographs, most commonly a
window frame, or pane – "emerges as the place of a civilizing moment, of a switching
that cannot eradicate wilderness but is situated at the site where wilderness trans-
forms into civilization, where order and limitation emerge."[31] For Angus "[t]he
task of English Canadian philosophy is… to construct a civilizing moment through
the limitation invented by drawing a border."[32] It appears that not only English
Canadian philosophers but Canadian photographers (and not only "English"
Canadian photographers) have taken this philosophical task of drawing a border
between wilderness and civilization to heart. One obvious example, in addition
to the many Canadian photographs of windows or glass cases that separate the
human world from that of animals and the landscape, is Marlene Creates' 1997
project, *Limites municipales*. This was a photographic inventory of municipal signs,
whether found along the highway, on a bridge, or between two buildings, that
indicated the legal limits of the city of Quebec. Another is Geoffrey James's pre-
viously mentioned 1997 *Running Fence*, a series of photographs shot along the
Mexican-American border. David Duchow, who for the last ten years has pho-
tographed the natural world around his home on the border between Quebec and
the United States, writes that he "record[s] the ephemeral aspect of the natural
world as if such intelligence gathering pertained to some defensible borderline
between nature and us."[33]

The template of duality has been found by other writers to underlie Canadian artistic and political reality. David Howes argues that the arrangements of the songs written to raise money for famine relief in Ethiopia during the winter of 1984–85 – the American "We Are The World," Canada's "Tears Are Not Enough" (which includes Quebec's "Les yeux de la Faim"), and Britain's "Do They Know It's Christmas?" – unconsciously mirror the constitutional arrangements of the societies that produced them. Howes concludes that since the "legally sanctioned relations uniting persons to each other are not the same in Canada as in the U.S.," this "raises the question of what sort of influence these differences in constitutional organization have on the way Canadians and Americans think."[34] Although written for the same purpose, Howes points out that the songs appeal to three very different audiences: "the American song speaks of and to a 'we' while the British song is addressed to a 'you' that explicitly excludes 'them' (the Ethiopians), and the Canadian song, which falls between the other two, uses the expression 'you and I.'"[35] Canada's song even "involves a double dichotomization: not only does it divide the world in two, but by substituting 'you and I' for the British 'you' it divides those of and to whom it speaks in two as well."[36]

Howes contrasts what he calls the "bicentricity of the Canadian imagination and the concentricity of the American imagination," as manifested in these songs. He states that "[i]n America the accent is on 'oneness,'" whether at the level of the individual ('American individualism') or at the level of the country as a whole ('American nationalism') – America is the land of the 'I contain[ing] multitudes.' In Canada, the emphasis is on difference ('regionalism,' 'separatism') – Canada is the land of 'two solitudes.'"[37] Howes contrasts the "monism" of the U.S. constitution and the "multitudes," à la Walt Whitman, it contains with "the dualism that has pervaded virtually every construction ever placed on the Canadian constitution."[38] This "dualistic or bicentric scheme... arises out of the contrapuntal relation between the two so-called 'founding peoples': the English and the French."[39] As we have seen, these constitutional distinctions are also mirrored in the differences between typical American and Canadian photographs: the centrally placed "monolithic" American subject, be it person or object, versus the dualism of a picture plane and a world divided into two zones of reality in so many Canadian photographic images.

Howes argues that "the code (or mode of combination) of the American imagination is '1+1=2'; that of the Canadian imagination is '1+1=1+1.'"[40] Canadians speak of "bridging the distance," the Americans of "coming together as one." These, to Howes, are very different concepts, since "a bridge does not dissolve the distance between the points it joins – it keeps them separate in the very act of linking them to each other," exactly the function of the window pane in so many Canadian photographs. "Thus, the Canadian song posits a *diathesis* while the American song describes a *synthesis*, a fusion."[41] These mirror the "synthetic" mentality of the American constitution, which emphasizes equality or sameness,

and the Canadian constitutional "bilingualism, the emphasis on hierarchy, and the recognition of at least two distinct groups within society... [that] all contribute to the formation of a ... *diathetical* imagination. North of the 49th parallel, a 'unity of we' is not only unthinkable but legally unenforceable."[42] The "best" that Canadians can achieve is a "'unity of you and I,'" that is, of French *and* English, Roman Catholic *and* Protestant ... in the absence of fusion or 'perfect union,' there can be only juxtaposition."[43] What Howes means by "diathetical imagination" is "a mode of thinking that juxtaposes but does not synthesize." This is underlined for him in well-known Canadian titles such as Hugh MacLennan's *Two Solitudes* and Hugh Hood's *White Figure, White Ground*: "if both ... are white, there is no reason or way to distinguish between the two, (unless, of course, the minimal conceptual unit is a pair as opposed to a one)."[44] (We might add to the list the CBC radio program *Double Exposure*; Sheila Watson's classic Canadian novel *The Double Hook*; the film *Double Happiness*; *Double-Talking*, a book on Canadian art and literature, edited by Linda Hutcheon; Margaret Atwood's *Two-Headed Poems*; John Ralston Saul's *Reflections of a Siamese Twin*. And, reminding one of Michael Snow's double-sided film, Joni Mitchell's *Both Sides Now*, which CBC Radio music critic Robert Harris has called the most Canadian of all song lyrics for its reflection of what he says is the quintessentially Canadian state of being both insider and outsider at the same time.)[45]

This "diathetical imagination" that juxtaposes but does not synthesize, akin to Ian Angus's "tension between wilderness and civilization that cannot be erased," is apparent everywhere in Canadian photography. It is also apparent, to Howes, in Northrop Frye's *The Bush Garden: Essays on the Canadian Imagination*, "which forces one to think together two mutually exclusive categories (wilderness and garden),"[46] and in Frye's observation that "the 'Canadian point of view is at once more conservative and more radical than Wiggery [the liberal ideology of the American revolution], closer both to aristocracy and to democracy [equality].'"[47] This assertion is meaningful to Howes for "the way its author combines ideas from opposite ends of the political spectrum in his attempt to describe a single 'point of view.'" Frye's way of linking ideas to each other, which reproduces the relations uniting persons to each other under the Canadian constitution, is not perceived as anomalous or irrational, says Howes. Rather "the apparent irrationality ... of having two incommensurate accounts of every entity, both true, both exclusivist, dissolves when one perceives that the anomaly is not local, but rather the expression of a condition of being, and hence itself a principle of rationality."[48]

Echoing Frye, Ian Angus states that philosopher George Grant saw the specificity of Canada as based in both the British tradition of effecting "a compromise between the two extremes of liberty and order" and a Canadian one of "the blending of the best of the ancient civilization of western Europe with its maturity and integrity, with the best of North American life."[49] Angus also comments on the

entrenched dualism of the immigrant experience: "The phenomenon of immigration slices off a fragment of a culture and inserts it in another history as a subculture. If we can define a tradition hermeneutically as a historical continuity constructed as a synthesis of past and future through an active interpretation in the present, then immigration shatters this threefold temporal structure with a dualism of before and after."[50] He writes that immigrant society is even "a *layered periodization* of such dualisms," given, for example, the difference between the Jews and Ukrainians who came to Canada before the Russian Revolution and those who came after.[51] Because many Canadian ethnic communities had their genesis in traumatic political events that occurred elsewhere, "our society as a whole contains a multiplicity of these layered periodizations. Their temporal structures are dualistic but rooted in histories that go back to different events in different parts of the world – *plural dualisms*, we might say."[52] Such dualisms are apparent in the projects of Arthur Renwick and Jin-me Yoon, among other Canadian photographers.

Because Canada has neither the myth of birth out of revolution, like the U.S., nor the myths of origin held dear by centuries-old nations whose beginnings are now lost in prehistory, the country is denied the "rhetorics of nationhood." We must be content with the informing myth of English-Canada's historical continuity with the British tradition of order and sovereignty, exemplified by the Empire Loyalists' rejection of the American Revolution, or with a rhetoric that encompasses the many origins of Canada's multiple cultures. Angus points out the seeming incompatibility of these two Canadian animating myths, noting that they "both contain aspects of our history that cannot be ignored, since they are central to current reality, and cannot be mediated, since they would require a strong and encompassing sense of nationhood to do so. We thus tend to lurch back and forth between these two versions. We seem to have no rhetoric that we do not experience as partial at the very moment it was enunciated."[53] The problem for Angus is that "each of these captures only a half the current reality of our multicultural society... No mediation or synthesis seems possible."[54] Nor does synthesis seem possible within the structure of the perpetually dualistic Canadian photograph.

Dualities that are held in juxtaposition and yet not synthesized may be observed not only in Canadian photography, political organization, and songwriting but in Canadian literature as well. In a chapter of her book on the Canadian postmodern, with yet another title alluding to duality, "Seeing Double: Concluding with Kroetsch," Linda Hutcheon writes that "like Leonard Cohen, Kroetsch is the master of paradoxes, of opposites that do not merge dialectically, of doubles that stay double,"[55] and she characterizes Kroetsch's use of "mythic material" as ambivalent: "water, for instance, is symbolic of both death and rebirth in all of Kroetsch's work (as in Atwood's and Thomas's)." In contrast to a similar ambivalence about water in T.S. Eliot's "The Waste Land," "Kroetsch's is more an ambivalence-

as-mutual-undercutting, with no balancing of opposites, just underlining of duality."[56] Hutcheon refers to the way in which "dualities, binaries remain separated by the space on the page, held in tension,"[57] in Kroetsch's *The Ledger*, where the page of an actual accountant's ledger belonging to the author's father is reproduced, and poems "retain the form of columns ... but there is a subversion of the implied notion of 'balancing' the accounts."[58] The "entire doubling structure" of Kroetsch's *Alibi* is reflected in the "doubly named" protagonist, Billy Billy Dorfen, "a man with two lives and two lovers; things happen to him in twos, even attempts on his life."[59] Hutcheon says that the "doubled cry of the osprey ('*Gwan-Gwan*') that ends the novel reasserts duality, and in so doing reasserts life – though always in the face of death," an apt description as well of a great deal of Canadian photography. Hutcheon feels that "these final words of the novel may suggest some resolution, but it is paradoxically one that must come from acceptance of ambivalence."[60]

Hutcheon emphasizes that in Canadian "metafiction" the "postmodern contradiction [between the written and the oral] is often explored by polarizing, and then privileging, one of the poles in order to investigate the space in between."[61] Hutcheon also analyses "the obsessive dualities in the work of Margaret Atwood (body/mind; female/male; nature/culture; instinct/reason; time/space; lyric poetry/prose narrative)"[62] and concludes that "they create a permanent unresolved tension."[63] Jane Miller's recognition of the "double life" of the heroine in Atwood's *Cat's Eye*, which includes "the travelling part" of the wild, north country and the "Toronto part" of neat and tasteful houses,[64] resonates with Ian Angus's notion of a characteristically Canadian dichotomy of civilization and wilderness.

Gaile McGregor writes that "if we look closely at patterns of narrative preference it would seem that the Canadian confuses subject and object simply because he doesn't want to be identified too firmly with *either*,"[65] an ambivalence McGregor likens to the "'middle voice' [that] was actually codified as a category in early Greek speech."[66] As well, McGregor perceives the Canadian to be capable of a "dual awareness" that rejects both facile optimism and facile despair,[67] and Canadian fiction to be "an extremely complex aesthetic object which is simultaneously despairing and affirmative."[68] In a recent book on irony, Linda Hutcheon says that there is "a long history of argument that the key to the Canadian identity is irony, that a people used to dealing with national, regional, ethnic and linguistic multiplicities, tensions, and divisions have no alternative."[69] Hutcheon's definition of irony as that which "happens in the space *between* (and including) the said and the unsaid" and as "need[ing] both to happen"[70] is relevant to the dualistic aspect of Canadian photography we are discussing here. The Canadian use of irony in photography is more playful than that of, for example, American photographic imagery, where irony is most evident in documentary images of social problems. Examples of a Canadian irony in photography are Shelley Niro's 1991 triptych of herself and her sisters in 1950s hairdos, "Mohawks in Beehives

II," or under salon hairdryers in another 1991 triptych entitled "The Iroquois is a Highly Developed Matriarchal Society," and Henri Robideau's *Pancanadienne Gianthropological Survey*, which includes a panoramic image of the "Giant Shaft," erected near Grand Falls, Newfoundland: "When the Federal Government tried to find the appropriate gift for Newfoundlanders to commemorate the completion of the Trans Canada Highway, they decided to give them the shaft."

The Canadian dualistic "minimal conceptual unit" so apparent in Canadian photography, and identified by Howes in the songs discussed above, has been recognized by other commentators on Canadian visual imagery as well. In an article published in 1991, "French Kiss From a No Man's Land," Montreal art critic Johanne Lamoureux examines the work of five Quebec artists "who have thematized the question of the double and alterity."[71] Lamoureux includes in her discussion Geneviève Cadieux's *La Fêlure au choeur des corps* and finds significance in the fact that although "Cadieux's large light boxes have long depicted the body, often the female body, fragmented by cropping or repetitions,"[72] in this piece a new element appears. Here "Cadieux introduces for the first time, in a single image, coupled bodies in action but without the 'perfect fit' of usual representations of the kiss (such as Brancusi's, for instance). Here, each one hangs on the lips of the other without the possibility of suture." Lamoureux sees this kiss as "the site where representation is torn at the very moment when it seems to conclude," and writes that Cadieux "instates the kiss as the rupture into wholeness, literally as a crack, a fissure (*fêlure*)," which, to Lamoureux, is also "a failure, a checkmate of representation."[73]

Lamoureux interprets a lightbox transparency of a couple holding hands in Nell Tenhaaf's *Species Life*, which also incorporates images of a fabricated model of DNA, "as the ironic commentary on the confrontation of the two incompatible texts [a quote from feminist philosopher Luce Irigaray, and one from Nietzche], which are ... written in English across the whole picture."[74] What Lamoureux views as the "linguistic concern of artists from Quebec," which she says has been a "perennial fascination," consists of "an attempt to measure the possible interfaces *between* different languages as well as between different registers within a single language" [my emphasis].[75] She gives the example of André Martin's photographic series *Anagrammes II (Souvenir de Pina Bausch)*, "a work which also works between languages. In a series of twelve photographs, the silhouette of a man hails the viewer ... Quoting a fragment from Pina Bausch's choreography, each photograph spells out in the language of the deaf a segment of the song 'The Man I Love (I know we both won't say a word);' atop each of them is the English word that the gesture translates."[76] Lamoureux notes that Bausch "had already transposed the sung phrase into a gestural idiom: this transfer from a linguistic system to a speech of another order is inspired by a literal and perverse adherence to the words of the song: I know we both won't say a word." She feels that this series "should not be seen as a critique of representation; it is an exploration of lan-

b o t h

4.31 André MARTIN
Excerpt from the series
*Anagrammes II
(Souvenir de Pina Bausch)*
1987
1m x 1m
Original in colour

guage and of the alteration of meaning that occurs in the passage from a system to another, from a medium to another one."[77]

Linda Hutcheon's analysis of examples in Canadian literature of what she calls "historiographical metafiction" addresses together two of the characteristics that I consider central to Canadian photography: the frequent severing of the image from its referent in reality and its continuing dualism. Hutcheon says that because we are accustomed to the conventions of the novelistic genre, ordinarily when we read a novel we know that "what the text's language refers to (the referent) is a fictive universe rather than our 'real' one, however much it may be made to resemble the real."[78] She says, however, that this phenomenon is more complex in historiographical metafiction specifically "because the fictional nature of the referent is repeatedly stressed ... while its historical nature is also constantly being implied."[79] As examples she cites Chris Scott's Giordano Bruno in *Antichthon*, who "both is and is not the real historical Giordano Bruno," and Michael Ondaatje, who "[i]n writing of both Billy the Kid and Buddy Bolden in the self-consciously metafictonal way he does" also "chooses this middle ground

of reference, creating what we might call a 'historiographic' referent. Unlike the historical (or real) referent, this one is created in and by the text's *writing* (hence, historio*graphic*). The referent here is doubled; it partakes of two 'realities.'"[80] In the same way, the referent in a Canadian street photograph both is and is not meant to signify the thing to which it refers in reality, simultaneously partaking of the transparency of the medium and rejecting it. Sometimes a window is just a window in a photograph by Charles Gagnon, or other Canadian photographers, but more often it is also a portal to another ontological dimension.

Theorists have observed that postmodern literature and other arts question the "realist notion of transparent reference";[81] Frederic Jameson writes that in "the postmodern stage, signs are entirely relieved of their function of referring to the world."[82] Jean Baudrillard declares that in our era signs no longer have a referential function: "the signified and the referent are now abolished to the sole profit of the play of signifiers, of a generalized formalization in which the code no longer refers back to any subjective or objective 'reality,' but to its own logic."[83] In some respects it might be possible to view the Canadian photographer's refusal of photographic reference as primarily indicative of a postmodern use of the medium. But whereas postmodern practice at once uses and calls into question, or attempts to destabilize, the conventions of its chosen medium, the Canadian severing of the photographic image from its referent does not have as its only goal a postmodern undermining of photographic veracity. Those American photographers whose work has most often been associated with postmodernism, like Cindy Sherman or Barbara Kruger, work to deconstruct media representations of, for example, gender roles. Canadian photographer Donigan Cumming's portraits of disenfranchised Montrealers might be read as a postmodern critique of traditional documentary strategies. But Cumming's obvious directorial interventions – like those seen in the images from his 1991 book, *The Stage*, of, for instance, two men and a young boy and girl in a living room, who hold, with outstretched arms, a wok full of chicken pieces, or a man who displays, on a metal lawn chair, doll-sized chairs made of clothes pegs – serve most of all to catapault their subjects into a zone that is "elsewhere," outside the realm of the ordinary, far from the reality of the typical social documentary photograph.

The central conceit of John Ralston Saul's *Reflections of a Siamese Twin* is provided by Jacques Godbout's *Les Têtes à Papineau*, whose main protagonists are Siamese twins. "They have one body, two heads and two separate but interrelated personalities. Together they are very interesting."[84] But most people want them to become normal, banal, just as the Siamese twins in Atwood's allegorical "Two-Headed Poems" "dream of separation."[85] Saul, in a clear allusion to the threat of Quebec separation, quotes from the novel: "'It's for your own good!' said the doctor. 'One can't spend one's life half this and half that ... Gentlemen, you are nothing more than half-men.'" Saul likens this to the plea to "join the majority school of the monolithic nation-state," but "[t]he one question Godbout didn't

raise was the rate of mortality in operations to separate Siamese twins. It is very rare for both to live. Sometimes one survives. Usually neither."[86] Saul views dualism, so prevalent in Canadian photography, as deeply inherent to Canadian identity. In Canada, "there is the constant rebalancing between regional and wider visions, between two languages,"[87] and "the whole cultural history of Canada can be traced through the growing pleasure taken by the population from living on both levels at once without regarding the complexity as a matter of waste or desperately searching for simplicity."[88] To Saul, "Canadian culture could be defined as a celebration of overlap."[89] His analysis of the dualistic underpinnings of the Canadian collective mythology might equally apply to Canadian photography.

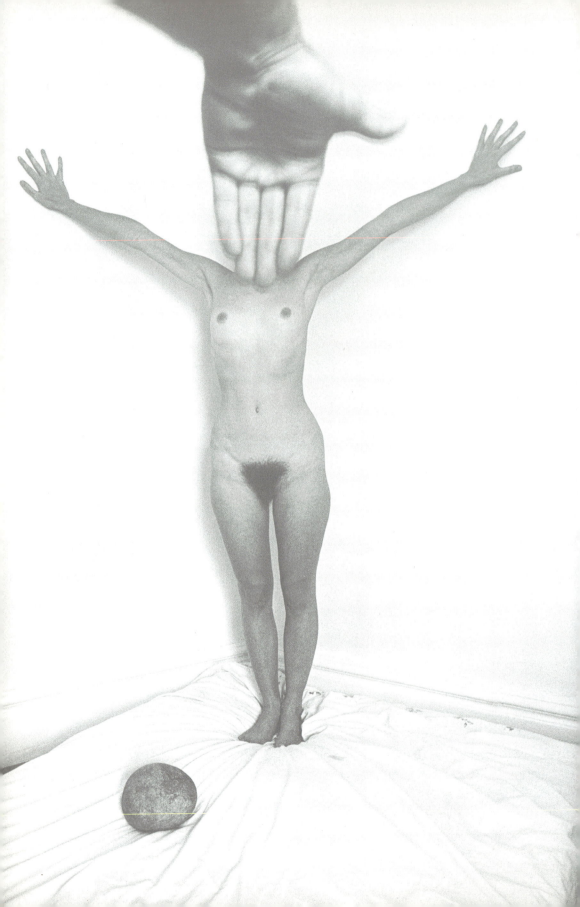

PART THREE – Rehearsal

"Anyway it was her fault Flora got away."

"What?" my father said.

"She could of shut the gate and she didn't. She just open'it up and Flora run out."

"Is that right?" my father said.

Everyone at the table was looking at me. I nodded, swallowing food with great difficulty. To my shame, tears flooded my eyes.

My father made a curt sound of disgust. "What did you do that for?"

I did not answer. I put down my fork and waited to be sent from the table, still not looking up.

But this did not happen. For some time nobody said anything, then Laird said matter-of-factly, "She's crying."

"Never mind," my father said. He spoke with resignation, even good humour, the words which absolved and dismissed me for good. "She's only a girl," he said.

Alice MUNRO

Boys and Girls

CHAPTER FIVE

Arrested Development

Motherless Child In a humorous photo taken by Michel Lambeth in Toronto's Allan Gardens in 1957, a very large man stands in the midst of rows of flower stands, holding a woman's tiny handbag. In another image, an anxious-looking man stands by a bench in Union Station, surrounded by luggage. He looks as if his train is about to depart and his travelling companion has failed to show up. Because this photograph is quite dark, we may not immediately notice the baby lying amidst the packages on the railway station bench.

At the Royal Ontario Museum, a man and his children are running up a flight of stairs; they seem upset. In an image of what looks like the interior courtyard of a museum, a young girl waits on a bench in front of a large gateway that leads to the outside; beside her is a baby carriage. The two, girl and baby, look extremely vulnerable, even abandoned, alone in the large stone room. A pram appears again in a picture in which an elderly and not particularly savory couple is seated beside a carriage that is shrouded in some kind of netting. All these images have in common the absence of a woman, or a mother, in situations where it would be appropriate that she be present. In several, it is suggested that the woman has left her partner or her family, and that he or they are not certain that she will return.

In an extremely striking Lambeth photograph taken at the St Lawrence Market, a man holds a girl of about a year old on his shoulders. Her body completely covers his head; in the photograph her face completes his body, and she looks at the camera in a surprisingly calm and mature manner – she appears to be in charge,

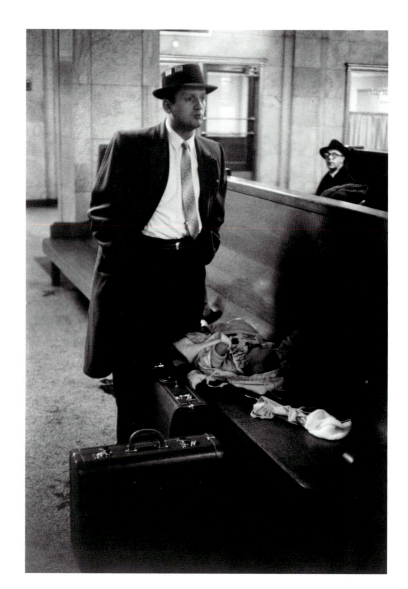

5.1 Michel LAMBETH
Union Station, Toronto, Ontario
1959
25.3 x 16.9 cm

5.2 Michel LAMBETH
St. Lawrence Market, Toronto, Ontario
1957
35.5 x 27.9 cm

to know what is going on, to be, in fact, the man's guiding energy. A close-up of a boy of about twelve or thirteen, also made at the market, is almost too painful to look at, because it reveals a face that is so preternaturally old and knowing, so full of disillusionment and fear. In the series of portraits of families, all of whom were living in conditions of extreme poverty, which Lambeth made in the St Nils region of the Gaspé, it is the children, and not the adults, whose faces register a full awareness of the implications of their circumstances. In one such photograph, bringing to mind the "international pool table" in his later *Between Friends* "New York/Quebec" border image, Lambeth uses a pool table to divide the image into two planes of action – at the far side of the table a man is taking a shot at a ball, unaware of the camera, while at the front of the table a little girl stands primly and looks almost pleadingly into the camera. In Lambeth's images, it is always children, and children only, who know what is really happening, and these children seem to sense that what is happening isn't wonderful, that it is something they will have to cope with alone because the adults in their world are either physically or emotionally absent.

The children in Nina Raginsky's photographs are presented in a very similar manner: it is only they, in contrast to the adults Raginsky portrays, who have not ossified into caricature, who seem truly alive to their situation. A picture Raginsky

5.3 John MAX
Untitled. From the book
Open Passport
1972
48 x 32.5 cm

took of a small brother and sister on the ferry boat from Vancouver to Victoria is simultaneously amusing and disturbing; the children, whose heads appear in the image to be too large for their bodies, are like gnomes with Mensa IQ's; they look cute and much too intelligent for their ages. The toddler in Jeff Wall's 1993 "In the Public Garden" stands alone in a small clearing. He holds onto the branch of a shrub as if taking his first steps, and as if he might topple over, with no one there to catch him. The photographer has bent down to photograph the child at his level, yet the child seems in jeopardy, and the photograph predatory.

The emotionally abandoned child who sees and understands too much, and for whom this knowledge is a burden that is carried alone, is the repetitive strain of John Max's *Open Passport*, published in 1974. Early on Max shows a picture of the little boy whom we follow throughout the book: the boy is rowing the oars of a boat in which a woman who could be his mother – and who is revealed later in the book to be so – sits behind him absorbed in a magazine. The boy is working hard to keep the boat afloat but she seems oblivious to, or uninterested in, his effort. On the opposite page, the image is repeated again as one of a block of four photographs. In another image in this group we see the little boy as an exasperated toddler; there is a large pot of food on the table in front of him, his hands are outstretched, and he appears to be either reaching for the food or pushing it away.

In the remaining two images are a couple, first in a quiet moment, with the woman seated in the lap of the man, who sits in a wheelchair; below that the same woman is laughing – it is another occasion and she has just thrown food into the man's face.

Open Passport is constructed so that what transpires throughout the book is seen through the eyes of the same young boy. What this boy sees is adults who make love but who in the same group of pictures appear to be violently arguing, men who hold women as if they are choking them, women and men who are estranged from one another. And what is consistent is that either the little boy who is the book's protagonist or another child is shown by the juxtaposition of images to be witness to the tension between adults, and to be aware of and affected by the emotional pain this tension engenders.

The women in this book are associated primarily with food, sensuality, and the body, and the men with religious or spiritual pursuit. A woman tends to the meal cooking on a stove; below her in another photograph is a Greek Orthodox priest whose face is obscured by his ceremonial hat and his beard. A young man prays and on the page facing him is a close-up of the lower back and buttocks of a woman; a man in a 1960s kaftan raises his arms in a gesture of supplication; the woman in the image next to him is photographed from behind wearing only a bra, as if she were undressing, and opposite them is a full-page portrait of a young boy.

Open Passport's ending is ambiguous. The final images echo those that begin the book. In contrast to the opening photographs of a small boy and his dog juxtaposed to the confines of a city back alley, we have a seawall that stretches to the infinity of the horizon and a mature, sun-weathered man who stands against a dark and almost stormy sky, his arms crossed firmly in front of his body. The photographs leading to this final page are a series of the little boy wearing a feathered "Indian" headdress. This image diminishes in size as we move toward the end of the book, and is successively coupled with photographs of a prairie highway as seen out the side window of a car, and a block of images comprised of pictures of the ocean, people meditating, a First Nations family in their tent, and some fishermen. The final photograph of the boy in his headdress faces a larger image of birds in the sky, the same dark sky the man at the end of the book stands against. All of this could be, and I think was meant to be, read as the boy's arrival at a place of wholeness, of grounding in a mature masculinity and a wholesome relationship to the family and the earth, after a childhood of pain.

But such an ending seems forced, wishful thinking on the part of the photographer, because there is really no point in the book's sequence where any transformation is seen to take place that would allow the child to move from a childhood of unmitigated anxiety into serene adulthood. The pictures of happy families and individuals at the book's end are almost all of persons from cultures other than that of the book's central figure; they are, for example, Native Canadians or Japanese. The fulfilment in which the photographer imagines he can share is an

idealization projected onto members of other ethnic groups, and this might indicate that he is not yet ready to confront the reality of his own painful heritage, emotional or cultural.

The sense of falseness that the book's resolution conveys is reinforced by the fact that as the protagonist moves toward what seems like wholeness, he moves away from images of women and the food, nurturing, and sexuality the photographer associates with his female figures. The book establishes a stereotypical dichotomy between abstract, male spirituality and concrete, female sensuality; at the end of the book the protagonist has opted for one half of the dyad only. This choice seems to have been presaged by the initial images of the child who pushes food away, and of the woman who uses food as a weapon with which to inflict, if not physical pain, at least humiliation. While this ending could be interpreted as having to do with the psychological separation from the mother many cultures have deemed necessary for the boy to progress to manhood, this doesn't ring true either. What can be said with certainty about *Open Passport*'s conclusion is that there is a movement away from the body of the world to the world of the spirit. And spirit here is perceived not as dwelling in matter, within the physicality of the world, as it is in American photography, but as being very distinct from it, above it, in the sky. The real movement at the end of the book is away from physical reality and toward image, and this is a re-statement, in narrative form, of what is happening all the time in Canadian photography.

Related to this is a subtext of homelessness that permeates many of Jeff Wall's images and every one of Jin-me Yoon's photographic installations. An older woman rummages for clothes in a large box that bears a piece of paper marked "Free" in Wall's 1985 "Abundance"; a man with dirty hair, no socks, and shoes without laces sits on a sidewalk to drink from a container wrapped in a paper bag in "Milk," 1984; a man stands in an industrial waste site looking at an upturned box of lettuce in "Bad Goods," 1984; a family is being driven from their home in 1988's "Eviction Struggle." Wall's 1986 "The Storyteller," in which First Nations individuals gather around a fire while others lie on a blanket in the shadow of a highway underpass, reverberates with a profound sense of cultural displacement. Nine double-sided lightboxes suspended from the ceiling make up Yoon's 1998–99 *Touring Home from Away*, in which members of the Yoon family and Prince Edward Island residents are photographed in relation to commercial and iconic signifiers of Canadian identity – a Green Gables convenience store, a Tim Horton's donut shop, a memorial that refers to the war Canadians fought in Korea, Yoon's ancestral home. In one photograph Yoon and what could be her son and husband pose in a potato field of the much-touted "red" earth of P.E.I.; in another Yoon and a Mi'kmaq leader are photographed against a landscape that may once have belonged to First Nations peoples but which in the photo on the reverse side of the hanging lightbox is revealed to be a golf course. The title of the piece speaks to Yoon's and many other Canadians' double-edged relationship to their country.

Yoon and her family are Canadians, yet because she is an immigrant, she can never be allowed to forget that she is also "from away," Island parlance for "outsider from the mainland." Canada is both home and not home.

The abandoned child that recurs in Canadian photography has also been perceived in iconic works of Canadian literature. Leon Surette finds significance in the fact that the two lovers in Margaret Laurence's *The Diviners*, Morag Gunn and Jules Tonnerre, "are profoundly isolated from their parent cultures."[1] Linda Hutcheon observes that "at least on the content level of [Leonard Cohen's] *Beautiful Losers*, all of the characters are orphans."[2] Hutcheon also points out that "the heroine of Aritha Van Herk's *No Fixed Address* has "ambiguous origins. In fact, she knows who her parents are, but for a long time refuses to believe it: 'She isn't convinced that she has a mother' and finds her links to that woman 'tenuous and unproven.' She was an unwanted child, who often ran away, and grew up without any hovering parental presence."[3]

In *Canadian Canons*, Surette mentions historian A.R.M. Lower's "motif of isolation from a parent culture" and "portrayal of Canada itself as an unwanted child abandoned by its British and American parents." Surette describes Lower, who was writing in 1952, as seeing Canada as "an accident: unwanted, certainly, and soon forgotten by one parent, the land from which the Loyalists came; unwanted, too, and often neglected by the other parent, the mother country. The parents had separated in anger; Canada was their unwanted, bastard child." Lower felt that Canadians "have continued to have a psychology appropriate to their parentage."[4]

John Ralston Saul, too, discerns "a desire among our élites – francophone and anglophone, federalist and separatist – to see themselves in the self-loathing manner of spurned colonial children."[5] To Saul, the Canadian élites' "first reaction in times of trouble remained and remains to seek the bosom of maternity, however indifferent the mother might be." Canada's "two theoretical mothers, England and France" were not "interested in this marginal, northern, poorish, peculiar country, because what really interested them was its neighbour to the south… From 1914 on, both Britain and France became obsessed by the United States. This is their child, because the real inheritance in international relations is not blood or language. It is power."[6] Saul considers Canada to be caught in a colonial "insistence on the maintenance of an illusory family relationship, where one limited only to political and financial interest existed and exists."[7] Is it this belief, that we have been forsaken by our "mother" cultures, that is given unconscious expression in our photographs?

Vancouver artist Ken Lum mounts staged colour photographs of seemingly pedestrian human moments next to coloured panels bearing very large-size text, in a variation of a syntax shared with other West Coast photographers Roy Arden and Ian Wallace. In one of these dual works, the photograph of a small, forlorn-looking girl hugging the knees of an equally dispirited man is paired with a dark

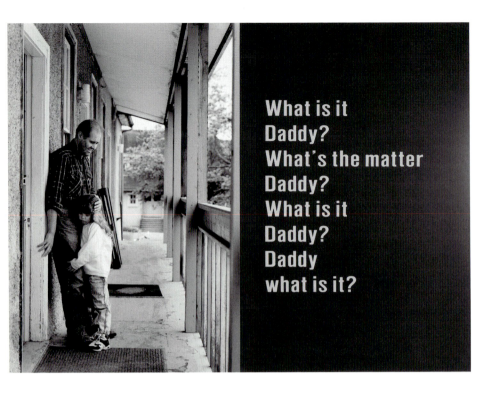

panel bearing the words "What is it Daddy? What's the matter Daddy? What is it Daddy? Daddy what is it?" Two 1989 Lum constructions bring together brightly coloured panels bearing the kind of garish lettering used in handpainted commercial signage, with photographs that show men alone with children who are in distress. A man sits on a rug in front of a fireplace holding three small children, of whom two, who may be twins, are crying. The legend accompanying this image is "Peter Ool Househusband." On a black panel to the left of a photo of a policeman holding a frightened female toddler is written "Little Krista & Mr. Policeman." These diptychs, in typically Canadian dualistic fashion, reiterate once again the leitmotif of the missing mother. In George Steeves' 1987–90 *Exile*, a suite of fifty-one photographs subtitled *A Journey with Astrid Brunner*, Brunner poses as her own mother, who, texts accompanying the images tell us, abandoned her during World War II. Perhaps the most poignant version of the orphan scenario in Canadian photography can be found in the work of the Montreal photographer Élène Tremblay. The children in Tremblay's large-scale series of reworked, anonymous family photographs, *Trous de Mémoire*, have been cut away from the family contexts in which they were found, and re-presented abandoned to the emptiness of totally white or totally black backgrounds. These distressing photographs chime with the portraits Cal Bailey made in his Winnipeg studio, the pictures of Orthodox

5.4 Ken LUM
"What is it Daddy?"
1994
182.9 x 243.8 x 5.1 cm
Original in colour

Facing page

5.5 Élène TREMBLAY
From the series
Trous de Mémoire
1994
20.32 x 25.4 cm

churches taken by Orest Semchishen on the Alberta prairie, and Jin-me Yoon's Banff self-portraits. Tremblay's children present in bold relief the sense of profound dislocation, the lack of grounding in a parental matrix, that is expressed in so many Canadian photographs.

Crucified Women In Clara Gutsche's pictures of store windows taken along Montreal's St Lawrence Boulevard and elsewhere in Montreal, Toronto, and Ottawa, published as the catalogue *Paysages vitrés/Inner Landscapes* in 1980, what is shown repeatedly are commercial displays that involve truncated and/or demeaning images of women. Like the mistress of the protagonist in Lauzon's *Un Zoo la Nuit*, it is the female that is caged in these images, just as it is always women and children who are crucified in Michel Lambeth's work. Gutsche's most recent project is a study of cloistered nuns, some of whom – like those in the 1991 "Le petit parloir/The Small Parlour, Le Monastère des Soeurs Carmélites, Trois-Rivières," the 1992 "Le grand parloir/The Large Parlour, Les Servantes de Jésus-Marie, Hull," or "Le grand parloir/The Large parlour, Les Soeurs de la Visitation,

5.6 Michel LAMBETH
*Canadian National Exhibition,
Toronto, Ontario*
1957
25.3 x 17.2 cm

Ottawa," made the same year – look into Gutsche's lens from behind a grill that severs them from the secular world.

Moira Egan has rephotographed and mounted on a free-standing wood panel the portrait of a female prison inmate taken in England during the nineteenth century. Titled "Détenue voilée," the piece shows a woman who, Egan's text reveals, has been forced to wear a heavy woollen veil so that she will not "contaminate" other prisoners by looking at or speaking to them. Egan's *Les internés d'un asile* is a row of six 5 x 7 inch mirrors that have had their silvering partly removed; as viewers look in the mirrors they see an image that is a conflation of themselves and a portrait of female asylum dwellers photographed in England in the 1870s by Dr Hugh Diamond, the so-called "father" of medical photography. Cheryl Simon's 1993 series *12 Criminal Women* displays women prisoners, many infamous, in reappropriated photographs that are barely visible through their coverings of frosted glass. Nicole Jolicoeur's 1992 installation *Stigmata Diaboli* includes blow-ups of nineteenth-century photographs of women whose backs are covered with welts. The fact that these marks appeared on the women's bodies after medical personnel had scratched names and dates on their skin was used as proof of their supposed "hysteria." Jolicoeur has draped these images in translucent white silk, which, like Simon's glass and Gutsche's store windows, functions to under-

5.7 Cheryl SIMON
Lizzie Borden. From the series
12 Criminal Women
1993
40.64 x 50.8 cm each

Left

5.8 Clara GUTSCHE
*The Large Parlour, Carmelite
Sisters, Trois Rivières.*
From *The Convent Series*
1991
72.5 x 92.5 cm

Below

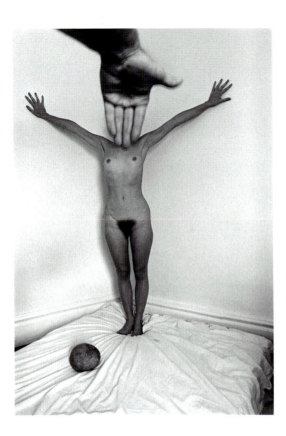

5.9 Michael SEMAK
Untitled
1976
20.32 x 25.4 cm

line the cultural entrapment and isolation of women. The oneiric self-portraits of Montreal photographer Susan Coolen, seen in series like *Exploring the Self* or *Dreaming*, both from the early 1990s, are replete with cages, mirrors, dead plants, and the photographer's bound hands and feet, which refer over and over to the imprisonment of the feminine spirit.

The slaughterhouse animals in the 1974 book of photographs by Michael Semak entitled *Monograph* were shown alongside images of women and residents of an insane asylum, with the implication that all have been victimized by society. In a 1976 Semak photograph a woman stands on a bed in the corner of a white room, her arms extended in the form of a crucifix. A stone sits incongruously on the bedsheet, and the hand of the photographer has reached out to completely cover the woman's face. Writing about this image, Martha Langford notes that this is "a woman in a man's pose," that the stone "threatens the nude like an unexploded grenade," and that the photographer's gesture "might be an act of chivalry or the theft of individuality."[8] These elements might also indicate Semak's identification with the female gender, and his understanding of women's precarious position within patriarchal culture. Diana Thorneycroft photographs both herself and other women bound with rope and wire, trussed like meat about to be cooked, attached to pseudo-medical devices that are redolent of both a gynecol-

ogist's examination room and laboratories used for experiments performed on animals. These images, which are shot in "forests" constructed of branches and leaves brought into the photographer's studio, reveal a profound identification between the victimization of women and that of animals. This is apparent in all of Thorneycroft's images, where bones, skins, and other remains almost always accompany her tortured women subjects; in "Untitled (Cross/Examination)," 1998, for example, a woman is tied with ropes to a wooden bench, and animal skulls are attached by chains to the same medical cabinet on wheels that she is hooked up to by tubes and wires. Canadian photography of the last four decades has demonstrated a preoccupation with the imprisonment not only of animals but of women as well, particularly women whom society has deemed criminal and/or insane. And these transgressive women are seen as symbolic of all women within patriarchy.

In Sylvain Cousineau's 1977 book of photographs entitled *Mona Nima*, the penultimate image is of a woman whose head and torso are bound; her hands are curled over her head and the nail on the wall above reinforces the photograph's crucifixion symbolism. Facing this, on the opposite page, is the final image, of a lopsided birthday cake with lit candles, shot against a plain white background. Just preceding this are pictures of the same woman crying, the close-up of a partly shaven female pubic area that bears a freshly sutured incision, a toilet in the corner of a black room, the back of a woman in a black slip who has next to her on a table a stainless steel receptacle that is either a cocktail shaker or something found in a hospital, and a still-life composed of a doll-size baby bottle, a container of cigars, and hanging on the wall, a dead bird. The woman, who is seen throughout the sequence, would not appear to be celebrating anyone's birth. Rather, the pictures seem to allude to a stillbirth, an ectopic pregnancy, or an abortion. She is portrayed as the one who will suffer as a result of the death the book hints has taken place. As in the images of Lambeth and Max, it is the feminine that is martyred and the relationship of mother to child that is mourned.

George Steeves portrayed the often harrowing lives of Ellen Pierce, Angela Holt, and Astrid Brunner in the 1981–84 series *Pictures of Ellen*, *Evidence*, made between 1981 and 1988, and *Exile: A Journey With Astrid Brunner*, from 1987–90. His 1994 photograph "Daisy," of a half-clothed woman with a crown of thorns and a crucifix at her crotch, is emblematic of the way in which all three women are seen by Steeves. In 1991 Montreal photographer Shari Hatt produced a photographic construction that, like the crucifixion images of Michel Lambeth, implies that the suffering of the feminine within society is analogous to that of Christ. The piece, titled *Fourteen Women*, is composed of fourteen pairs of head and shoulder portraits of women that have been sealed in plastic sacs containing water; like the woman who holds a plastic sheet over her face in a photograph by Raymonde April, the women trapped in cars photographed by Vincent Sharp, and the women in the works by Cheryl Simon, Nicole Jolicoeur, Moira Egan, Sylvain Cousineau,

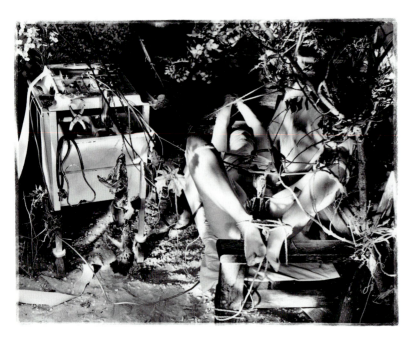

and Clara Gutsche described above, Hatt's women are shown in a position of entrapment. These pairs of black and white photographs are hung one above the other, forming two rows along a banner of red cloth. A woman is seen in the top photograph of the pair with her eyes open, the same woman in the bottom image with eyes closed. Each of the fourteen women's faces had beads of water on it when she was photographed; the water in the plastic sacs in which the images are encased reaches varying levels from woman to woman. The piece is dedicated to the fourteen women who died in the massacre at the University of Montreal in December 1989.

The notion of female crucifixion provides the underpinnings for such Canadian films as Denys Arcand's 1989 *Jésus de Montréal* and Paul Almond's 1970 *The Act of the Heart*; in the latter film it is a female protagonist who, in emulating Christ, performs a horrifying act of self-sacrifice. *Body Parts*, a 1990 series of five photographs by Ottawa photographer Peter Mosley, shows a nude couple who are holding up to one another the rubber parts – breast and vulva – of an inflatable sex toy. The couple, both woman and man, are in effect "trying on" the signifiers of the female gender. An image in which the woman presses the rubber face of the doll against that of the man, and in which he wears, like a belt, the female doll's cut-out sexual parts, is entitled "Crucifixion."

5.10 Diana THORNEYCROFT
Untitled (Cross/Examination)
1998
71.12 x 88.9 cm

Facing page

5.11 George STEEVES
Daisy. From the series
Excavations Project
1994
40.64 x 50.8 cm

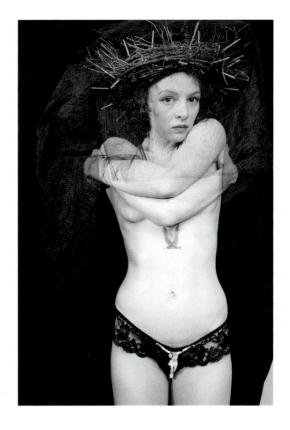

In her seminal study of the Quebec literary tradition, *Writing in the Father's House*, Patricia Smart advances the notion that the image that unifies French Canadian writing, from its very beginnings up to the present, is that of the (often murdered) female corpse. This dead female she finds lying on the doorstep of a house, blocking the exit, in a poem by Anne Hébert; under the foundation of the house, haunting her murderer, in Hubert Aquin's novel *Hamlet's Twin;* on a bloody pile of her massacred children in Victor-Levy Beaulieu's *Grandfathers*. This tragic female figure, which Smart equates with a "feminine-maternal" realm, "devastated by culture," surfaces everywhere in Québécois writing.[9] For Smart, the answer to the question Margaret Atwood believes is posed by all of Canadian literature and particularly Québécois poetry – "what goes on in the coffin?" – would have to do with the destruction of the feminine spirit.

This destruction is also evident in Canadian photography. In Canadian photography children are abandoned and the feminine is missing, trapped, or martyred. Yet, as seen in John Max's *Open Passport* and in our rejection of the literal dimension of photography, the feminine is also something to be escaped from, a force, like the physical world itself, from which it is necessary to flee.

The quiet fear, that came nearer to the surface now as she scanned the pages – she was in the "Salads" section – was that this thing, this refusal of her mouth to eat, was malignant; that it would spread; that slowly the circle now dividing the non-devourable from the devourable would become smaller and smaller, that the objects available to her would be excluded one by one.

Margaret ATWOOD

The Edible Woman

CHAPTER SIX

Rite of Passage

Several characteristics have emerged thus far in our investigation of Canadian photography: 1) a frequent rejection of the literal, denotative function of the medium and a concomitant attempt to separate the photographic image from its referent and the subject of an image from his or her surroundings; 2) the appropriation of conventional photographic vocabularies, such as that of documentary photography, in order to point to a metaphysical or symbolic, as opposed to natural or social, dimension; 3) a preoccupation with death, bondage, and entrapment, particularly of animals and women; 4) a tendency to see many situations as composed of two interrelated zones or spheres, which are often separated by a window or door-like opening; 5) the presentation of a world in which the feminine dimension is martyred or absent and children are abandoned, and where the feminine is also perceived as something from which it is necessary to take flight.

I had been looking at and thinking about Canadian photography for a long time before I began to see that, far from constituting a group of arbitrary and autonomous tendencies, together these characteristics form the symptoms of a known syndrome, a recognizable psychological malaise.

Glass Coffins There is a psychical realm other than that shared by Canadian photographers where visions of caged and dead animals are likely to occur, where the literal realm of earthly fact is shunned in favour of the imaginal. Toronto's Marion Woodman, a Jungian analyst and internationally known specialist in female eating disorders, has found that the inner lives of her anorexic analysands are characterized by images of concentration camps and of themselves as camp victims. The anorexic women with whom Woodman has worked in therapy also have recurrent dreams and fantasies of animals that are "dead, disabled … starving"[1] and of entrapment in "prisons,"[2] "a glass coffin,"[3] and plastic bags that are sealed off from life, like the women in the photographs of Raymonde April, Shari Hatt, Nicole Jolicoeur, and Cheryl Simon, and like the woman whose imprisonment is implied in Geneviéve Cadieux's installation *Broken Memory*, a large, glass, sarcophagus-shaped box from which was emitted the continuous and highly disturbing sound of a woman moaning, first shown in 1995 in London's Tate Gallery. These women speak of "a terrible sense of being 'caged' and longing to smash out";[4] one woman told Woodman that she had "a good relationship" to her body, and then added "but I don't like being tied to a dying animal."[5] The "stricken" animals they dream of are "almost dead from mistreatment,"[6] and these dreams, believes Woodman, reveal a "demonic force in the form of … animals, turned demonic because they are so outraged by gross insensibility to their needs."[7] Her anorexic analysands also dream frequently of skeletons and crucifixion. Other writers on anorexia, Kim Chernin among them, have commented on the predominance of prison and cage imagery in the dream lives of women with anorexia, a prevalence also very much in evidence in Canadian photography.

What is pertinent, though, is not just that the imagery that occurs so repetitively in Canadian photography mirrors that of the anorexic. The puzzling Canadian attempt to subvert the literal properties of the photographic medium, evident in the work of Angela Grauerholz, Michael Schreier, and Karen Smiley, also finds its echo in the anorexic's world. British therapist Marilyn Lawrence has written that the tragedy of the anorexic is that she ("she" because over 95 per cent of anorexics are women) takes literally the concept of the dualism of mind and body underlying our culture's long history of asceticism[8]. Woodman asserts that the anorexic, caught in a profound body-psyche split, is a soul that hasn't taken up residence in the body, that she is someone who suffers a "gap between head and body … spirit and matter."[9] So the anorexic's "spirit hovers somewhere above her head,"[10] just as the ghostly spirits of Smiley's, Zeppetelli's, and Cousineau's subjects appear to float in the atmosphere, no longer tied to their bodies. In the world of the anorexic, the constant attempt of the Canadian photographer to lift image from physical reality, spirit from body, the subject from his or her surroundings, would seem perfectly natural. In Chernin's words, for the anorexic, the ideal would be to be "without a body,"[11] to "remove the body from nature,"[12] to exist in a "disembodied … state like a ghost."[13] She wants, says

Woodman, to reduce herself to "pure spirit, pure essence";[14] she is "too pure to have a form."[15]

It isn't only that the terrain of the Canadian collective unconscious, as expressed by some Canadian photographers, proves to be remarkably like that of the anorexic. Both Canadian photographer and anorexic appear to have much invested in the sundering of body and spirit, matter and image. Along with Canadian photographers, anorexics, according to Angelyn Spignesi, "see the shades of the dead existing in all living things."[16] These skeletal women bear the spectre of death within life for all to see, in essence "carrying" death for a deeply death-denying culture. Their condition itself may be seen as the expression of a profound wish for death. Spignesi is the author of *Starving Women: A Psychology of Anorexia Nervosa*, a book whose subject she describes as "the woman's relation to the psychic underworld, to the imaginal figures and landscape underlying and permeating her bodily existence."[17] Spignesi believes that in order to come to an understanding of the anorexic it is important to differentiate between the realities of "underworld" and "upperworld." When we are in an "upperworld perspective," we view "ourselves and the world as it literally exists – as objects in time and space which we can observe or even measure, the world as immediately and objectively present to our consciousness."[18]

The underworld perspective "allows and necessitates a sense of the *interpenetration* of the sensible world with the imaginal realm";[19] [my emphasis] this interpenetration is the very hallmark of Canadian photography. Although in the upperworld the anorexic's condition is viewed only as pathological and the anorexic as the pathetic victim of an incomprehensible disease, for Spignesi she is, like all women in patriarchal culture, a female who "starves for the underworld"[20] from which she has been cut off for centuries. The anorexic is a woman of borderlines, caught at the crossroads between the upper, naturalistic zone and the lower, imaginal one. Like the Canadian photographer, she is acutely aware of the existence of death within life, of a world other than the literal, material one. The true affliction of the anorexic, for Spignesi, is our miscomprehension of her; she has been denied, by doctors and others, entry into the non-literal world of underworld shades and figures whose reality she would then be able to communicate back to us. Perhaps what Spignesi views as the medical world's pathologizing of the anorexic finds its parallel in a viewpoint like Atwood's, which deems the Canadian preoccupation with entrapment to be proof merely of our sense of victimization, and our fascination with death as leading only to a cultural dead-end.

For Marion Woodman, the anorexic's "flight from the feminine drives her off the ground."[21] She flees her own mother because she has been terrorized by what Jungians call her mother's negative masculine aspect, her negative "animus." A Jungian concept, the "animus" is the unconscious, "masculine" side of a woman's personality. The "'young growing part of the personality' was in most cases rigidly disciplined by the animus of the mother,"[22] and so the anorexic is "sick with the

poison of the negative mother complex."[23] Thus, healing for the anorexic "must come through the abyss of the absent feminine."[24] Woodman alleges that what is missing in the anorexic's family is the "feminine," precisely that which is absent in the world described by photographers John Max, Michel Lambeth, Élène Tremblay, and Ken Lum.

To the Jungian Woodman, positive "masculine" energy is "goal-oriented and has the strength of purpose to move toward that goal." Its power of penetration "inseminates and releases the creativity of the feminine." The feminine "contains the potential seeds for life; it knows the laws of nature and exacts those laws with ruthless justice; it lives in the eternal Now." The feminine has "its own rhythms, slower than those of the masculine, meandering, moving in a spiral motion." It may "work very hard, but its attitude is always one of play because it loves life."[25] And the "spiritual feminine is always grounded in the natural instincts so that no matter how spiritualized it becomes, it is always on the side of life."[26]

These Jungian definitions of "feminine" and "masculine" may seem unbearably essentialist to some readers. My own way of thinking about the question of female identity has as much, if not more, in common with that of critic Craig Owens. Owens has written, "Among those prohibited from Western representation, whose representations are denied all legitimacy, are women. Excluded from representation by its very structure, they return within it as a figure for – a presentation of – the unrepresentable."[27] Woodman's Jungian understanding of the feminine, is not, however, incompatible with Owens' reading of women's visibility, or lack of it, within Western culture. It is this lack of endorsement, within patriarchy, of all that her female body represents that the female anorexic rails against. In urging a return to "feminine" instincts, or imagery, Woodman is in effect recommending that women attempt to find within themselves the validation the culture refuses to offer them. In Owens' terms, the emaciated body of the anorexic might be seen as an attempt on her part to represent "the unrepresentable," the metaphoric starvation of the women within her world. Raised in a family and a culture whose predominantly patriarchal values are not mitigated by a validation of "the feminine," of women, the anorexic is consequently cut off from the reality of her own desires.

Therapists have commented that, like the "orphaned" Canada, the anorexic never feels she gets enough of her own mother, and yet neither are the two, mother and daughter, able to perceive of themselves as separate individuals. Akin to Canada's inability to separate from uncaring, colonizing "parents," remarked upon by Saul and others, this lack of psychic separation between mother and daughter emerges as the most commonly mentioned symptom in writings on anorexia nervosa. As with Spignesi, Woodman's prescription for the anorexic is that she be fed with images from the realm of the underworld. To Woodman, what is trapped in the cage of the anorexic along with her instinctual animal energy is what appears trapped in Canadian photographs as well – the "rejected," the "threat-

ened" feminine. Like the children in Michel Lambeth's photographs, the anorexic functions as an adult while her parents, most particularly her mother, are seen by her as in need of nurturing. Out of concern for a mother with whom she strongly identifies, the anorexic refrains from eating because her mother appears, on a very basic level, to be starving.

The anorexic – having been overlooked by parents who are in some way or other absent, who have failed to value the feminine in their own lives and as it is manifested in their daughter – feels she deserves no attention at all, that she is invisible, has not even the right to eat. The subtext of the anorexic's proclamations about herself, says Lawrence, is that she is empty, nothing. From the point of view of the naturalistic upperworld, says Spignesi, she appears as "emptiness," "nothingness,"[28] exactly as my students have tended to view Canadian photography.

Feminist therapists dealing with anorexics have come to view the condition as "a profoundly political act." Anorexia for them is a refusal to become a woman in a culture where women have no power, to enter into a body that throughout history has been identified with nature, sensuality, animals, the instinctual, and death, with all that is seen as uncontrollable and as such has been feared and reviled, and which Canadian photographers have shown themselves to identify with over and over again. Anorexics, submits Chernin, struggle against "emergence into femininity"[29] because femininity is presented as both severely limiting and utterly devalued within their culture. Some women "are sensitive enough," comments Woodman, "to recognize the parody of femininity that they are expected to emulate, and simply refuse to make that *rite de passage*."[30] Denying the prescribed feminine role, they prefer "to regress into childhood,"[31] hoping unconsciously that they might yet recuperate the nurturing and validation they have been deprived of by both their families and their culture. Similarly, A.R.M. Lower felt that we, as Canadians, have "continued to have a psychology appropriate to" that of a country abandoned by its parent nations.

With their boyish bodies rid of all womanly curves and their reproductive systems shut down, anorexics, to Spignesi, stand "outside ... gender,"[32] as they also stand between the borders of upper and lower worlds. To Woodman, there is a battle "between the feminine and the masculine ... raging in dramatic terms in [her] ... anorexic analysands."[33] It is, to me, significant, then, that fantasies of crucifixion, a configuration that is prevalent in Canadian photography to a degree not seen in the photography of other cultures, have also been linked to "male-female ambiguity."[34] For Freudian psychoanalyst Henry Edelheit, the image of crucifixion, like that seen in the photographs of Lambeth, Semak, and Steeves, masks the repressed memory of the "primal scene," the sight of the parents engaged in sexual intercourse, which may have engendered in the child a mental schema that is expressed in its "identification, simultaneous or alternating, with the copulating parents." In crucifixion fantasies "(which may be either conscious or

unconscious) the figure of Christ nailed to the cross represents the combined image of the parents and *at the same time*, by way of the *double identification* with the parents, it represents the helpless, observing child"[35] [my emphasis]. This brings to mind the child perpetually caught between a male and a female adult, who are in some cases making love, in John Max's *Open Passport*, and allows us to relate, hermeneutically, these and other images of "helpless, observing" children to the crucified women that recur in the works of many Canadian photographers.

The anorexic, like Canada, is in the throes of a profound identity crisis. "Life," declares Woodman, is "a desperate search" for identity in women with eating disorders.[36] The internal conflict of the child who has never been truly looked after by her parents, and longs to be, and yet who also needs to separate from those parents if she is to become herself, manifests itself in her relationship to food. Since she has not had the emotional nurturing that will enable her to take psychological leave of her parents and become autonomous, she regresses to a child-like state of emotional dependence, where her identity is still fused with that of her mother. Like Saul's "élites" or Lower's typical Canadian, she is unable to pretend to independence. Her regression – she may even grow down-like hair on her body like that of a fetus – and her rigidity in relationship to food cover the truth that she has no sense of herself as a person at all, that she has accepted others' definition of her, that separation from the parents seems to her premature, and autonomy impossible. Because of this lack of a firm sense of self, she is able to take many shapes, to "lose herself," writes Spignesi, "in the imaginal world of ... others,"[37] in "caricature."[38]

Both Marion Woodman and Kim Chernin read anorexia as a thwarted rite of passage, or initiation. They have commented on the similarity of the anorexic's self-imposed rituals with regard to food – only eating certain foods, in certain places, and at certain times, wearing perhaps a ritual dress – to ancient rites of passage, by which young adolescents were symbolically removed from childhood and then returned as adults into the cultural life of their community. Such rites involved separation from the mother and the descent, by fasting and other means, into a state of "nothingness," of symbolic death, from which the individual was reborn, having "died" to childhood. It is worth noting that anorexia often appears at adolescence or menopause, when a woman is being called upon to pass into a new stage of her development, to make an evolutionary leap forward that the culture at large and those around her may be highly unsupportive of, if not overtly hostile to. In this she resembles Canada, a country that for decades has wavered at the brink of its own evolutionary leap.

Anorexics bring themselves unwittingly to the point of ritual death, but are unable to make the next step into mature womanhood. Rather, a rite of potential transformation is tragically literalized and actual death by starvation becomes possible. The final stage of the initiation process, the death of childhood and

rebirth as an adult, never takes place. The anorexic refuses to die to her child-hood identity because she does not trust that rebirth into a desirable place within culture will follow; instead, she repeats over and over, with increasingly destructive results to herself, a disguised and frustrated rite of passage that goes unrecognized. Her self-starvation is a travesty of the ritual fasting that might provide initiation into her mature feminine self.

The parallels between the inner world and symptoms of the anorexic and the collective Canadian psychic reality as it is revealed in the work of Canadian photographers are striking and, I believe, fraught with implication. The interminable Canadian "identity crisis"; the country's, like the anorexic's, lack of a firm sense of self; the unrelenting preoccupation with death, entrapment, and flight from the physical manifest in our photographic practice; the Canadian inclination to adopt the "look" of images from somewhere else, to become "lost," like the anorexic, "in the imaginal world of others," and to see only "nothingness" in the products of our own creativity, are factors linking the Canadian imagination to that of the anorexic who refuses the fundamental passage to maturity.

Similar parallels have been found by another writer, in relation to contemporary Canadian installation art produced by women. Judith Mastai writes that in "Canada today, installation works are the predominant three-dimensional forms of women's work supported by the institutions of art. It has been disturbing to investigate this phenomenon and to conclude that it may stand for a form of anorexic self-regulation."[39] Mastai refers to works such as Jana Sterbak's 1987 *Vanitas: Flesh Dress for an Albino Anorectic*, a dress made of sixty pounds of rotting steak, and hung at the National Gallery in Ottawa to much public outcry. This work "almost too perfectly illustrate[s] the metaphor of the anorexic body – present through absence and therefore mourned."[40] Mastai's reading of installation works by Canadian women artists is that in them the "subject splits off from its corporeal presence," analogous to the Canadian photographer's severing of the photographic image from its referent. The Canadian women artists' imagery evokes "this split state" and "the absence, even the death, of the body of woman."[41] In an article that even the formidable research team of the Cinémathèque Québecoise has been unable to locate, but which both the filmmaker and I remember from many years ago, Micheline Lanctôt says that a psychiatrist told her that the vision of the world underlying her 1983 film, *Sonatine*, is an anorexic one. *Sonatine* tells the story of two alienated teenage girls who spend their days travelling back and forth on buses and subways in Montreal, and who, at the film's end, die in a suicide pact.

Canadian literature, as well, reveals a preoccupation with female eating disorders, and I have found that literary references to anorexia in psychoanalytic literature are very frequently Canadian. Female eating disorders are featured more than once in the characterization of the protagonists of Margaret Atwood, Canada's most iconic novelist. A young woman who looks like a "wraith" is hos-

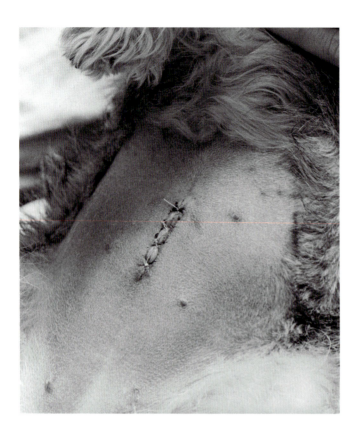

6.1 Raymonde APRIL
Excerpt from Part V of
L'Arrivée des figurants
1997
120 x 100 cm

pitalized because she won't eat, in the short story "Spring Song of the Frogs." The young heroine of *The Edible Woman* stops eating, and articulates throughout the book that the lives of the women around her, of her female role models, are repellent to her. Kim Chernin recognizes that Atwood's heroines, "taken together, the slender self-effacing Marian" of *The Edible Woman* and the plump, rebellious heroine of *Lady Oracle*, "form the poles that define our position as women in contemporary culture." Chernin also notices the same dichotomy in the dynamic between two next-door neighbours, one plump and one slim, in Margaret Laurence's novel *The Fire Dwellers*.[42]

Many writers on anorexia remark on the "collusion" of the female anorexic with the male-dominated value system that renders her "invisible." Both Canadian and American critics have detected a similar collusion on the part of the main female characters in Atwood's novels. In an examination of *Surfacing*, Marianne Hirsch offers the insight that "the ending of the novel is curiously suspended just before the moment of return to civilization and to language ... With the last sentence, the novel still resides within the dichotomies [culture and nature] it has been both building and challenging, dichotomies it finally lets stand and does not resolve." Hirsch finds that the novel remains at a "tenuous, liminal point"

between "the will to difference – a belief in an alternative – and the recognition of a deep complicity." She further argues "that this seeming liminality is in itself suspect, perhaps even dishonest," because "Atwood's narrator perceives her own complicity, which is equal to that of her parents, yet she continues to deny that perception, to suspend herself outside of history, to promise alternatives through myth."[43] Linda Hutcheon has written of Atwood's *The Handmaid's Tale* that "[h]ere men still rule; women still collude."[44] Unavowed collusion with a male perpetrator is what must be faced up to by the female prisoner in Atwood's *Alias Grace*, a collusion the female "prisoners" of anorexia, and perhaps those of Canadian photography, must also confront.

Betwixt and Between: Faking Death When we look again at the Canadian photographs that have been discussed so far, keeping in mind the similarities of our collective psychic outlook to that of the anorexic, and the notion of anorexia as a thwarted rite of passage, we may begin to understand these photographs as indications of something other than a national death-wish. Or more accurately, these pictures may indeed be seen to signal a collective desire for "death," but not for the physical annihilation that tombstones and crucifixes ordinarily signify. Contrary to what at first sight might appear to be the case, I believe that the death to which Canadian photographs refer is in fact the "death" that accompanies a profound passage from one state of being to another, and in that sense we may be only "Faking Death."

Very near the end of Raymonde April's photographic "polyphonic fresco"[45] *L'Arrivée des figurants*, a suite of thirty-three black and white photographs exhibited in 1997 and 1998, is the close-up of a newly shaven and sutured wound on the back of what might be a horse. This wound, in the context of a sequence whose opening features an image of April herself mysteriously dressed in period clothing, functions as both a punctuation mark and a kind of summing up of the personal drama alluded to by the previous photographs. Many of the people in the photographs of Donigan Cumming display scars, the freshly sewn sutures of surgery, or the wounds of amputation. A middle-aged woman raises her dress to show the gruesome traces of what might have been an operation on her ovaries, another woman opens the buttons of her dress to reveal the trace of an incision that runs from sternum to navel, a man poses with his prosthesis and the stump that is all that remains of his arm. In the photographic work of Geneviève Cadieux the spectator is forced to confront, in images that are mural-size, details of scars, bruises, and body parts that look wounded or diseased. In the 1990 *La Fêlure, au choeur des corps*, for example, a close-up of the mouths of a couple kissing is bracketed by two photographs of scars; despite the hair around these marks we are unable to

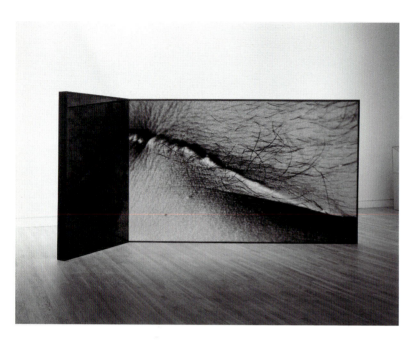

6.2 **Geneviève CADIEUX**
*Trou de mémoire,
la beauté inattendue*
1988
Photographic installation
208 x 472 x 14 cm
Original in colour

be certain what part of the body they are located on; in the sculptural *Trou de mémoire, la beauté inattendue*, made in 1988, a burnished mirror is joined at an oblique angle to a large colour photograph of a scar tufted with hair. At the centre of Sylvain Cousineau's *Mona Nima* is the image of an incision just above a woman's half-shaven pubic hair; the area above the cut is bruised. Shari Hatt's 1993 *Breast Wishes* features photographs of the ravages of breast reduction surgery; Nicole Jolicoeur's *Stigmata Diaboli* and *Petit prose* photographs show welts that are the result of names and dates scratched into the skin of "hysterical" female psychiatric patients. The lines drawn on the skin of the women who pose as goddesses in Holly King's 1982 photographic sequence *Hellenic Winds* mimic the marble surface of ancient Greek statuary, but also suggest that these female forms have been disfigured. The photograph of a scar is the signal image in Jin-me Yoon's *Screens*, which has to do with the passage of Yoon's family from one culture to another.

In *Rites and Symbols of Initiation*, Mircea Eliade describes the classic model of puberty initiation rites, by which the premodern adolescent undergoes "a basic change in existential condition" and completes passage into life as an adult member of his or her community. The young person emerges from the ordeals of this process, says Eliade, "endowed with a totally different being from that which he possessed before his initiation; he has become *another*."[46] Taken together, Canadian photographs produced in the last fifty years indicate that as a country we are

6.3 Donigan CUMMING
July 7, 1985. From the series
*Reality and Motive in
Documentary Photography,
Part 3*
1986
201 x 122 cm

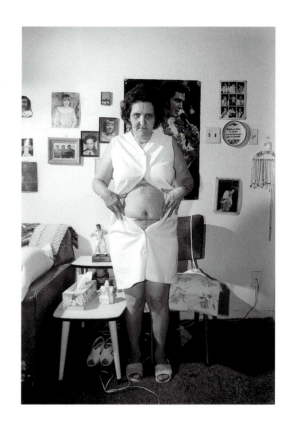

6.4 Sylvain P. COUSINEAU
Cicatrice. From the
series *Mona Nima*
1974
20.32 x 25.4 cm

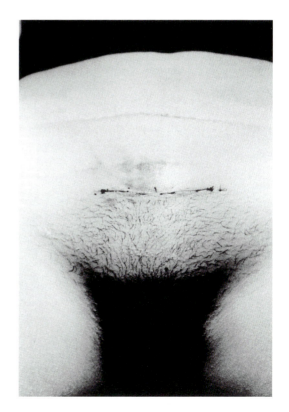

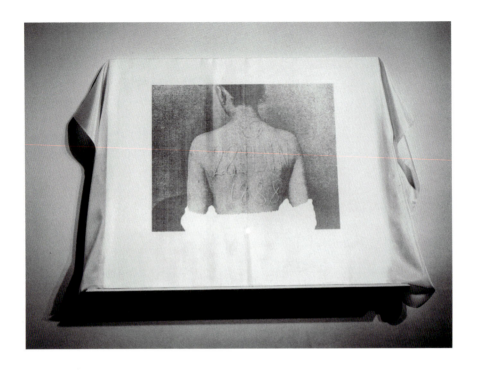

seeking, collectively, to "become another," to negotiate a change in our national "existential condition."

A central aspect of initiation ceremonies throughout history has been that of operations performed on the novices, "circumcision, the extraction of a tooth, or subincision … scarring or pulling out the hair."[47] Marion Woodman quotes Bruce Lincoln with regard to female initiation: he holds that the pattern of female rites of passage is one of "growth or magnification, an expansion of powers, capabilities, experiences" through which the young woman becomes "more creative, more alive, more ontologically real." This is accomplished by endowing her with "symbolic items that make of her a woman, and beyond this a cosmic being."[48] These items might include clothing, jewellery, songs chanted for the "woman-to-be," and paintings or scars placed on her body. Such scarification, Woodman remarks, "is meant to provide an experience of intense pain and an enduring record of that pain." The person is thereby "rendered unique." [49] The diagram of female ritual scarring used by Woodman to illustrate her discussion demonstrates markings that are amazingly similar in placement to the wounds of the female subjects in Cousineau's *Mona Nima*, Hatt's *Breast Wishes*, Jolicoeur's *Stigmata*

6.5 Nicole JOLICOEUR
28 juin 1888.
From the installation
Stigmata Diaboli
1992
Photographic installation
53.3 x 63.5 cm

Facing page

6.6 Janieta EYRE
Rehearsal #4
1993
76.2 x 101.6 cm
Original in colour
(See also plate XII)

Diaboli and other series, and in many Cumming images. Within many traditional cultures a young person has not earned the right to be treated as an adult, in fact is not deemed to be fully human at all until he or she has undergone a ritual death followed by resurrection or rebirth into adulthood. Has this not been the fate of Canada – to be a G8 nation that is nonetheless considered tentative, not quite real, somehow unproven?

The symbolic death to which adolescents undergoing initiation are subjected always includes a period of separation from the mother, during which the youths are considered, and consider themselves, actually dead, or to exist in a sacred, ghost-like space between life and death. It is just such a liminal, in-between zone that the characters in Thom Fitzgerald's 1997 film, *The Hanging Garden*, inhabit; the film is acutely disconcerting *because* it is unclear whether the main protagonist is living or dead, or if the film's action is taking place in "reality," memory, or some intertwining of the two. Like the mother in Fitzgerald's film, the mothers of initiates in some societies actually mourn the "deaths" of their children. In North American aboriginal societies in particular, says Eliade, "there is more than separation from the mother, which is characteristic of all puberty rituals; there is a break with the community of the living."[50]

Unlike photographers of other cultures, Canadian photographers have an unusual propensity for posing themselves as if they were dead, or in some way outside "the community of the living." Janieta Eyre's *Rehearsal* photographs, made

in 1993 and 1994, are various stagings of her own death: she is seen propped with her head on an open oven door, for example, or perched on a love seat, with legs splayed, strangled by a rope of pearls. In Susan Coolen's *Exploring the Self*, a narrative series of twenty-five images made in 1992, the photographer holds a rectangular frame through which is seen a mirror, and in a later photograph, she contemplates herself in the same mirror, which has been hung with metal chicken wire so that she appears in her reflection to be trapped in a cage. Then, over several photographs, she is seen stepping into a coffin-like box. A woman who is very likely the photographer, and who wears a truss while her hands are bound with rope and her head wrapped in plastic, lies on a metal stretcher in a studio "forest" in Diana Thorneycroft's 1998 "Untitled (Coma)." An androgynous young person, who is again almost certainly the photographer, lies with eyes closed on a bed that is swathed like the inside of a coffin in Thorneycroft's 1994 "Untitled (& if she wakes)." Two identical panels of Jeff Wall's triptych "Faking Death" show a young man laid out on a bed, his eyes cast toward the ceiling, a striped sheet covering him to the chest, while the first panel of the work reveals the man being tended to by lighting and make-up people as he prepares for the tableau. Stéphanie

Beaudoin's photographic project *Je suis morte*, began in 1993 when she announced her own death and displayed images of herself, photographed from above as if she were lying in state, in the display window of a downtown Montreal store. Beaudoin also erected a cenotaph bearing the date of her "death" and a photograph of her lying "dead" in her parents' backyard in Longueuil, Quebec. In her 1995 photograph "En repos," part of the *Je suis morte* project's 1997 installation *Corps réservé*, she is seen lying like a fairy-tale princess; the condensation that appears to have formed on the surface of the image makes it seem as if, like Sleeping Beauty, she is enveloped in a glass sarcophagus. (One of the "relics" Beaudoin exhibits as a part of this series has a head and shoulders photograph of her pretending to be dead, enclosed in a plastic snowdome paperweight.) The Beaudoin images are redolent of many others within Canadian photography, like the woman

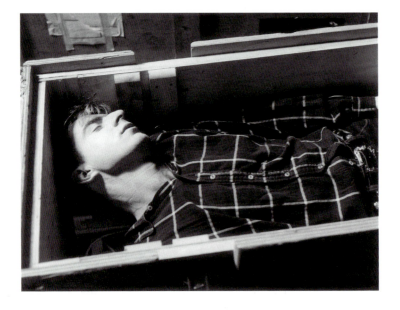

6.9 Stéphanie BEAUDOIN
Je suis morte, commémoration,
préservation, dissémination.
Detail from the "en repos"
section of the installation
préservation
1995
121.92 x 182.88 x 1.27 cm

Above

6.10 Paul LITHERLAND
Excerpt from the series *Souvenirs*
1993
20.4 x 25.4 cm
Original in colour

Left

caught behind the "glass" of a loose-leaf sheet of plastic in Raymonde April's 1984 photo from the series *Debout sur le rivage*, or Vincent Sharp's woman trapped behind a car window. The backdrop of Beaudoin's 1998 installation, *Le baiser capital; un choix capital*, which recreated a nineteenth-century photographic studio, was a nude photograph of her lying "dead" with a halo drawn over her head and the image of an "ice forest" behind her; the implication of her images is that after a period of suspension, the subject will awaken to (sexual) maturity. Paul Litherland shows an image of himself with eyes closed in a wooden coffin in his 1993 performance/installation *Souvenirs*, and in Michel Campeau's 2001 series *Humus*, Campeau poses over and over as if dead, lying prone in various landscape settings. It is of course impossible to be both dead and able to proclaim that one is dead, or to take one's own post-mortem image. But the paradoxical state of being these photographs describe is not at all inconsistent with that of the adolescent initiate who passes through a symbolic state of death as she or he moves from one ontological condition to another. Like so many other Canadian photographs, these very singular images of self-imposed death, or coma, or suspension of life, of rehearsing or faking death point to an unconscious desire on the part of the Canadian nation to experience some definitive rite of passage to maturity.

When we bear in mind the crucial separation period of the adolescent rite of passage, and the extent to which Canadian photographs mirror the inner world of the anorexic whose own initiation into maturity is considered to be incomplete, certain of our images begin to propose meanings other than those that seemed so obvious at first glance. Seen in this context, the spectral, disembodied presences in the photographs of Smiley, Zeppetelli, and Grauerholz, and the many other figures in Canadian photography who are in one way or another disconnected from their surroundings, take on new significance. The wraith-like forms of these photographs may appear disconnected from literal, physical reality because they inhabit instead a realm that is analogous to the ghostly, liminal world of the adolescent who is undergoing initiation into adulthood. That is to say that the sense of dislocation from one's environment expressed so clearly and so often in Canadian photography may in fact have more to do with a stalled rite of passage to national maturity than with the harshness of our climate or the failure of our political ideology to fully integrate immigrants into Canadian life. Could the body of the world and the "feminine," from which the subjects of so many Canadian photographs appear to want to flee, correspond to the mother these ghostly initiates are attempting to differentiate themselves from, in order that they may return to her, after a process of maturation, as fully autonomous adults? Is the photographic referent, that material fact to which the Canadian photographic image is so hesitant to attach itself, understood in the collective Canadian unconscious as the abandoning European "mother(s)" from whom we wish to separate? And with whom, anorexic-like, we remain enmeshed as we wait like orphans for a maternal recognition that, as Saul suggests, will never come?

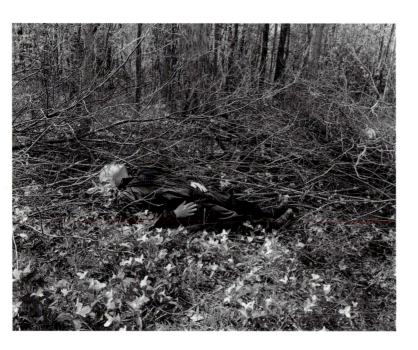

6.11 Michel CAMPEAU
Excerpt from the series *Humus*
2001
91.5 x 117 cm

6.12 Pierre D'ALPÉ
Albert. Diptych. From the series
Clothesminded
1990
25.4 x 25.4 cm each

Facing page

 The bound man in Evergon's *Interlocking Polaroid* series and the tied-up fig-
ures in the work of Lake, Thorneycroft, Whittome, and other Canadians also make
sense when examined with respect to adolescent rites of passage, that is, when
their binding is related to traditional forms of initiatory torture rather than to
some inherent Canadian masochism. The ritual tortures by which the adolescent
initiate is "killed" in order to be born again as a woman or man included in some
communities the binding up of the young person. And in many tribes the novice
undergoes a symbolic transformation into the opposite sex during the initiation
process, because it is believed that the young person is more likely to adapt to a
particular mode of being if he or she has first existed in a state of ontological
totality, which androgyny is considered to be. These neophytes are "sometimes
treated or symbolically represented as being neither male nor female," or "they
may be symbolically assigned characteristics of both sexes, irrespective of their
biological sex."[51] The neophyte might remain in this transitional or liminal period,
depending on the tribal tradition, for days or even years, but eventually he or she
will return to the community, having attained a mode of existence inaccessible
to those who have not undergone the initiatory ordeals, who have not tasted "death."
 Earlier I referred to Henry Edelheit's notion of crucifixion imagery as indica-
tive of "gender ambiguity," and directed the reader's attention to the recurring
images of crucifixion in Canadian photography. In addition to his many cruci-
fixion photographs, Michel Lambeth also makes reference to the "coalescence of

sexes" that is said to characterize the in-between, liminal period of initiation in his photograph of an out-sized man carrying a woman's small handbag, and in the image of the man with the head of a little girl. Pierre Dalpé's double portraits of Montreal transvestites, made from 1990 on, show, together, photographs of his subjects both before and after they have cross-dressed. Several American photographers, most notably Nan Goldin, have documented the phenomenon of transvestism, and the Americans Robert Mapplethorpe, Andy Warhol, Cindy Sherman, and Lucas Samaras, along with earlier French photographers Claude Cahun and Pierre Molinier, have photographed themselves in the masquerade of the other gender. Dalpé's images, however, are unique in their persistently double presentation, suggesting that his subjects reside simultaneously in two different gender spaces, or in the space between them.

Toronto's General Idea, which was made up of artists AA Bronson, Felix Partz, and Jorge Zontal, from the early 1970s produced photographic and other works around the theme of gender role-playing. These works were often shown in their publication *FILE*, whose logo was a visual and anagrammatical reversal of that of *Life* magazine, symbolically placing their sexually ambiguous subjects, like the young person who passes through initiation, "outside the community of the living," in the realm of the liminal. Diana Thorneycroft often appears androgynous in her allegorical self-portraits: in the diptych "Untitled (Twin)," 1992, she is seen, naked, as a female and then, bearing a penis, as a male; in "Untitled

6.13 Eldon GARNET
Position 11. From the series
Spiraling
1979
49.53 x 40 cm

(Animus/Anima)" from 1990, she presents herself caged, in a playpen, with both plastic breasts and penis, or as the subtitle of an image from 1990 in which she wears a male mask suggests, as a "She-boy." The double-sided photographic light-boxes of Jin-me Yoon's *Touring Home From Away* feature a small boy dressed in conventional male children's clothing and wearing an Anne of Green Gables wig.

In a triptych from Claude-Philippe Benoit's 1989–91 series, *Intérieur, Jour*, streaks of movement in the middle image function as a passage between the "civilized" setting of a richly appointed, wood-panelled living room and the "natural" one of a forest. Benoit refers to the abstract blurs of light in this and other related triple images as "the in-between."[52] A 1989 series of photographs by Montreal photographer Marie-Christine Simard, *Le Parcours*, is made up of thirty-six images taken at regular, timed intervals through the windows of buses travelling between Montreal and Ottawa. Eldon Garnet took a photograph every one hundred units of distance (as measured by the car's odometer) through one of the four windows of the car in which he was travelling from Toronto to Edmonton; the resulting images were each juxtaposed to a map showing the location where the photograph was taken; the series was published under the title *Spiraling* in 1979. Both these series, using prototypically Canadian window images, emphasize the position of a subject who, like the adolescent girls riding back and forth on buses and subway cars in Lanctôt's *Sonatine*, and the tribal adolescent initiate, inhabit the liminal realm of the "in-between."

The notions of an existential zone that is "in-between" and of bodily suffering linked to a rite of passage were brought together in *Flesh Made Stone*, a site-specific work by Kathryn Walter and Jin-me Yoon installed at the University of British Columbia in the summer of 1991. The piece was created in response to "The Goddess of Democracy," a statue on the UBC campus meant to commemorate the massacre of student demonstrators at Tiananmen Square. Across a courtyard from the stone goddess, the artists placed in the grass a 12 x 15 inch flat marble marker that read FLESH, in Chinese and English. Inside the nearby UBC Art Gallery hung a large colour photograph of the head of the statue, which was, before changes made by students in Beijing, modelled after the Statue of Liberty. At the other end of the gallery was another colour photograph of Vancouver's Manhattan West mega-development project, whose promoters employed the image of the Statue of Liberty as a marketing device. SCAR, WOUND, TEAR, BRUISE, and FRACTURE were inscribed in English and Chinese on marble plaques hung on girders throughout the gallery. On each side of the entrance into the exhibition space, in Chinese and English respectively, were placed plaques that read, lengthwise, CONSIDER SPACES IN BETWEEN. These legends may refer to the real struggle by vulnerable human beings that, in terms of public representation, is lost somewhere between the heroic representation of abstract principles and the commodification of political ideals. But the piece also addresses the liminal, in-between space of transition, fraught with danger, through which the Chinese nation must pass on the road to social change, and the "initiatory" suffering to which individual Chinese citizens are willing to submit themselves in order to bring such change about. Although the installation alludes to a political rite of passage that is not Canadian, its syntax is shared with many other contemporary Canadian works that use photography and have as their subtext the kind of cultural transformation to which *Flesh Made Stone* explicitly refers.

During the liminal phase, the subject of passage ritual is structurally, if not physically, "'invisible,'"[53] writes anthropologist Victor Turner. What Turner has postulated regarding the invisibility of the initiate seems to me to relate very directly to the Canadian inability to "see" and appreciate our own cultural and artistic production, including photography. Turner asserts that as members of society, most of us see only what we expect to see, that is, "what we are conditioned to see when we have learned the definitions and classifications of our culture." A society's "secular definitions do not allow for the existence of a not-boy-not-man," he writes, "which is what a novice in a male puberty rite is (if he can be said to be anything)."[54] Therefore to the members of his community this boy in the throes of initiation cannot be seen at all, but is "invisible." Turner defines rites of passage as "transitions between states," and understands "states" to include such "social constancies" as legal status or profession and "culturally recognized degree[s] of maturation," like the married state or the state of infancy. He declares that rites of passage are not confined only to culturally defined life-

crises of individuals but can "accompany any change from one state to another, as when a whole tribe goes to war."[55] In other words, entire cultures, like the Canadian one, can pass through the transitional state of initiation, can dwell in the zone of the liminal.

The "definitions and classifications" of culture that Canadians have absorbed from elsewhere appear to include ideas about the "appropriate" uses of photography, about what "states" of being photography ought to be used to address, which is to say, what subject matter will render any particular photographic image culturally "visible." And this may mean that we are unable to "see" our own photography, to recognize it as "ontologically real," because that photography so often deals with subjects who are in-between states, existing in a place between life and death analogous to the liminal position of the adolescent, "not-boy-not-man" initiate. Turner doubts that the boy in mid-passage may be "said to be anything at all" – when we look at our photographs we see "nothing," and when we look at ourselves as a nation we see nothing that we are able to recognize as "real." What Turner tells us is true for those members of a tribe who encounter an initiate, that it would be "a paradox" to see him, to see "what ought not to be there,"[56] is also true for us. The initiate who is considered to be neither living nor dead "ought not to be there" because, like the subjects of Stéphanie Beaudoin's *Je suis morte*, Jeff Wall's "Faking Death," or Diana Thorneycroft's "Coma," he or she exists outside a recognizably fixed "state," in a place of transition Turner calls "betwixt and between."[57] It is to just such a "betwixt-and-between" liminal zone that a great many of our photographs refer, and why, in part, they are "invisible" to us. What we are unable to see and acknowledge in our photographs and in our culture is that we are passing through our own adolescent rite of passage, our own struggle toward autonomy. (A fascinating reflection of this very phenomenon is the fact that Jeff Wall would not allow his "Faking Death" triptych, which has been reproduced elsewhere, to be shown in this book because he considers it to be "an inferior work," and that "any meanings it might pretend to disclose are spoiled by its lack of artistic quality."[58] There is no living artist, photographic or otherwise, whose work is more highly regarded within the artistic world than Wall. It is doubtful that any single work, even if unsuccessful, which "Faking Death" is not, could undermine Wall's singular reputation, and the artist must know this. To my mind Wall's refusal indicates a recognition that this piece, in which he enacts a death of the self, functioned for him as a passage between artistic adolescence and artistic maturity. It is this initiatory stage, and staging, of what he now deems was an artistic "not-boy-not-man", that he wishes to remain invisible.)

Jeff Wall at this writing is working on a photographic piece based on the novel *Invisible Man* by Ralph Ellison. "The book is one of the first important American novels written by a black writer," says Wall. "It deals with social invisibility."[59] I believe that it is no accident that Wall would take as the premise of a work the story of a man who retreats to an underground refuge to wait for his own culture

6.14 EVERGON
Denys in Scarf Bondages. From
the *Interlocking Polaroid Series*
1981
50.8 x 228.6 cm
Original in colour

to undergo a seismic transformation to one in which he will not, as an African American, be invisible. "Canadians feel invisible in a world which reflects no image of them,"[60] writes Marc Mayer in a catalogue essay that accompanied a group exhibition of Canadian art held in France. (Mayer sees this as the underlying meaning of a General Idea piece that is "a map of the world where Canada was missing, replaced by a marriage of the Atlantic and Pacific oceans." He writes that "this gag, which refers to the banal Canadian motto *A Mari usque ad Mare*, from sea to sea, goes beyond mocking Canada to mock the rest of the world, and especially the U.S., which takes precious little notice of their nearest neighbour."[61] But it may be that we are "invisible" to the rest of the world for the same reason the initiate cannot be seen by the members of his or her community, because we are locked in a state of transition to maturity.) The Wall installation promises to be a fitting trope for the rite of passage through "invisibility" to autonomy.

Angela Grauerholz has spoken of her photographs as a "moment of waiting, this in-between space,"[62] and the haziness of many of her ostensibly documentary images, like that of persons waiting on a train platform in the 1989 "Harrison," or circling aimlessly in "Crowd," made the same year, situates them in a zone that is somewhere between consciousness and unconsciousness, between memory, or the dregs of a dream, and the present moment.

Because adolescent initiates, who are "liminal personae," are "at once no longer classified and not yet classified,"[63] "neither living nor dead from one

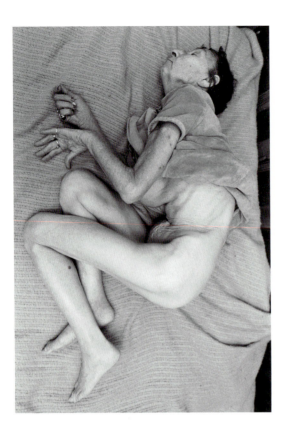

6.15 Donigan CUMMING
April 10, 1992. From the series
Pretty Ribbons
1993
127 x 86.4 cm
Original in colour
(See also plate XIV)

aspect, and both living and dead from another,"[64] and so "invisible,"[65] the symbols used to represent them in many societies refer to "the particular unity of the liminal: that which is neither this nor that, and yet is both."[66] Victor Turner has found that in the symbolism of initiation, "logically antithetical processes of death and growth may be represented by the same tokens, for example … by nakedness (which is at once the mark of the newborn infant and the corpse prepared for burial)."[67] This description of tribal representations of individuals in the liminal phase of initiation brings to mind again the naked and floating figures of Evergon's *Interlocking Polaroid* series, which I described earlier as appearing to be at once both "pre-natal" and "post-mortem," and the desiccated, aged body of Nettie Harris that is so often seen folded into fetal position in Donigan Cumming's 1993 *Pretty Ribbons* series. Like other aspects of Canadian photography, their ambiguous condition, like that of Turner's "liminal personae," becomes less mysterious when read as an indication that our country is undergoing a crucial stage of initiatory passage.

The same "economy (or parsimony) of symbolic reference"[68] that Turner finds in tribal representations of the initiate, and which Freud when speaking of dreams called "overdetermination," may be seen to operate within Canadian photography as well. Canadian photographs that indicate so unmistakeably our sense

of national malaise, our estrangement from and repression of the feminine, do describe a mode of being comparable to that of an anorexic adolescent stuck in the in-between stage of transition between child and fully fledged member of her community. But looked at again, the very same images point to a way through this frustrated rite of passage.

Turner speaks of symbolic overdetermination in reference to the ritual *sacra*, which include objects displayed to neophytes during initiation, as well as the sacred instructions given them regarding the origin and mythical history of their society. As Angelyn Spignesi remarks that the anorexic woman tends to lose herself in "caricature," Turner draws attention to the "exaggeration amounting sometimes to caricature"[69] in the masks, figurines, costumes, and other material exhibited in passage ceremonies. Canadian photographers, as well, frequently employ caricature in their portrayal of both people and situations; this can be seen, for example in the cartoonish images of Victoria eccentrics by Nina Raginsky, and of Montreal working-class citizens by Donigan Cumming. For many years Henri Robideau, assuming the persona of a "gianthropologist," produced panoramic landscapes that included oversized Canadian objects like the "Giant Spot in Canadian History, Craigellachie, B.C., October 1, 1982" ("It was here that two bands of steel were joined, binding Canada into one physical country from Ocean to Ocean"), and the Giant Nickel in Sudbury, Ontario. It is interesting to compare the text Robideau affixes to his Giant Nickel photograph, which emphasizes its extremely large size, with the text the American photographer and critic Allan Sekula appended to his 1986 photograph of the same monument, which notes that "the nickel is a modest coin, more modest than one of John D. Rockerfeller's dimes."

Montreal photographer Paul Litherland's 1993 installation *Souvenirs* was composed of colour images of the photographer posed in stereotyped, caricatural renditions of conventional male occupations, like pilot or businessman, as well as a picture of him half-naked and bound to a post. Standing on a table with these photographs were are also several images of Litherland dressed and made up as a woman, of himself vomiting, and also of him lying with his eyes closed in a wooden coffin-like box, playing dead. Spectators were invited to sit in a row of chairs in front of the table on which the images were displayed and to ask Litherland, who sat beside the table, to tell them a story about one of these photographs. Each time I have seen the performance, the stories the photographer has told have been of life-changing personal ordeal. The use of caricature, and the allusions to bondage, androgyny, an eating disorder, and a state of death-like suspension in Litherland's piece bring together elements of both traditional initiation rites and the "shape-shifting" world of the anorexic.

Caricature is a tendency that until recently was a particularly conspicuous aspect of Canadian narrative film, and the same may be said for Canadian television drama and situation comedy. The singular quality that enables one to almost instantly recognize Canadian television has to do with more than the production

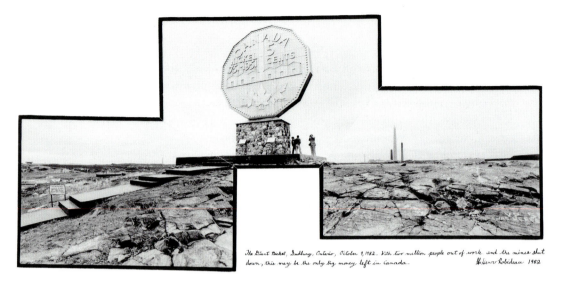

The Giant Nickel, Sudbury, Ontario, October 9, 1982. With two million people out of work and the mines shut down, this may be the only big money left in Canada. Henri Robideau 1982

6.16 Henri ROBIDEAU
Giant Nickel, Sudbury, Ontario, 1982. 132.08 x 73.66 cm

Text: The Giant Nickel, Sudbury, Ontario, October 9, 1982. With two million people out of work and the mines shut down, this may be the only big money left in Canada. Henri Robideau 1982.

values, which are noticeably low-budget next to those of comparable American efforts. Caricatured characters and action typify Canadian television, both its successes – comedy shows such as *Codco*, *SCTV*, *This Hour Has 22 Minutes*, and *Kids in the Hall* – and its embarrassingly unintentional parodies of American awards ceremonies, beauty pageants, and game shows. The exaggerated features of the traditional *sacra*, in Turner's opinion, are meant to force the neophyte into thinking about objects, persons, relationships, and features of their environment they have hitherto been taking for granted, to reflect upon, "with some degree of abstraction," the life of their community. The adolescent thus becomes "stamped"[70] with the basic assumptions of his or her culture during initiation. Perhaps Canadian photography, film, and radio and television comedy, where caricature plays a particularly strong role, are our own *sacra*, in which the elements of Canadian national identity of which we need to become cognizant, in order to mature as a culture, are being none too subtly pushed into awareness. [71]

The idea that Canada is not yet a mature nation is one we might like to consider *dépassé*, particularly since the vision of Canada as an adolescent has been around for some time now. Dermot McCarthy has observed that the Canadian literary histories written by Roy Palmer Baker in 1920 and by J.D. Logan a few years later were "controlled by the metaphor-system of growth from a colonial, derivative culture to a mature national identity."[72] McCarthy goes on to say that Canadian literary history, "from the first anthologies, has been obsessed with the 'single central subject or theme' of national identity and has presented that iden-

tity as 'unfolding' in the 'plot' of the national history; indeed, the growth of that identity *is* the plot of the national history."[73] Denis Salter describes the Canadian theatre community as "stuck inside a kind of time capsule from which it has only recently begun to emerge."[74] Previously, "it was naively assumed that *the* classic Canadian play, which would allay all our fears about our neo-colonial insufficiency, would be written and staged one day ... once we had grown up to be just as important as other cultures." "Put this way," says Salter, "the problematic issues inherent in the very notion of *the* classic play could be endlessly deferred. So, too, could the very idea of 'Canada' itself, no matter which theatrical (dis)guises it decided to adopt."[75] Sherry Simon, writing about the Quebec literary tradition, mentions "the heritage of negativity which the novel brought with it to the 1960s." This heritage included the complaint by critics that "the relative failure of the novel in Quebec up until the 1960s is in reality a political failure; the Quebec novel does not 'measure up' to the standards which would make the literary form (and the society it expresses) fully realized."[76] Yet, "the 1960s are generally accepted as the years that saw the flowering of Canadian fiction," declares Linda Hutcheon. In her view, the sixties were a decade of "government support for publishers and artists, and the general feeling that in cultural terms Canada had finally ceased to be what Earle Birney once called a 'highschool land/deadset in adolescence.'"[77] Much as we might wish for this to be true, on the evidence of our photographs and indeed much other Canadian artistic production, it is clear to me that, at least at an unconscious level, we still understand ourselves to be locked in adolescence. Some readers may feel that this is a colonialist observation. I do not mean to intimate that Canada is in fact an immature nation, but rather that our photographs indicate that unconsciously, on a collective level, we continue to regard ourselves as immature. Our photography tells us that we have a colonial attitude toward ourselves. This may not be a comfortable observation in this time of post-colonial studies, but it is what I observe to be the case.

Yet if we adopt the metaphor of the anorexic trapped in the realm of the liminal, the spectre of death that haunts Canadian photographs ceases to signal only a national hopelessness and points instead to an unconscious demand we make of ourselves. Our photographs indicate that we are undergoing a death of our culture as we know it, a rite of passage that is meant to lead from an adolescent identity fused with that of its motherland to autonomy as a nation. There are indications everywhere in Canadian photography not only that this is a necessary step but that the possibility exists of a post-adolescent collective identity that, rather than having been imposed from the outside, springs from our own inner authority, and is thus authentically ours.

As for the inevitable question: If our photographs suggest that we consider ourselves to be caught in a stalled rite of passage to maturity, and have done so since at least 1955, has there been any discernable movement in this almost half-century interval? I would answer that shifts can be observed within what never-

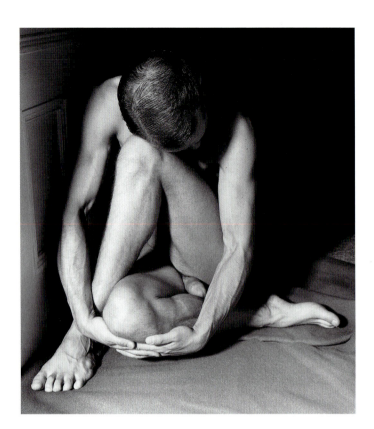

6.17 Chuck SAMUELS with Sylvia
POIRIER
After Weston. From the
series *Before the Camera*
1991
24 x 19 cm

theless remains a landscape of liminality. Certain preoccupations, like bondage
and entrapment, very prevalent up to the end of the 1980s, have receded into the
background, just as the caged beaver is literally in the background in the first
image of Jin-me Yoon's 1991 postcard series. Other strains of our common theme
song seem to me to be emerging with increasing insistence, as is evidenced by
the recent spate of Canadian images of subjects who are faking death. In this sense
Wall's image was prescient. Another such tendency, mentioned earlier, is the
recent use of the Canadian dualistic framework to pointedly address questions
of cultural hybridity; in earlier works this paradigm was not employed as con-
sciously. The significance of these changes can be taken to indicate that, like a
2000 work made by AA Bronson discussed in the conclusion, in which Bronson
too is seen to rehearse his own death, Canadians are becoming more conscious
of their characteristic state of liminality and embracing it as well.

Once we recognize the nature of the liminal, "other" world to which our images
refer, recurring characteristics of Canadian photography that appear to have been
without signification fall into place, and reveal themselves as indications both of
a way through a stalled rite of initiation and of the mature role that awaits us as
a nation.

Female Canada "I think of Canada as female,"[78] artist Joyce Weiland famously proclaimed, and it has become a commonplace of Canadian cultural criticism to assert that Canada is feminine, often because of the marginal position shared within Western culture by both women and Canadians. Linda Hutcheon cites Lorna Irvine, who "believes that the female voice 'politically and culturally personifies Canada.'" Hutcheon also refers to Susan Swan's 1983 novel, *The Biggest Modern Woman of the World*, in which "the reader is told: 'to be from the Canadas is to feel as women feel — cut off from the base of power.'"[79] She mentions as well critic Monika Gagnon, who "argues the same Canada/woman connection,"[80] and she says that Atwood "has frequently compared the powerless status of Canada to that of women."[81] The common denominator in these assertions is the parallel between Canada's colonial position *vis à vis* more powerful nations and the powerlessness of women within patriarchal culture.

The ultimate Canadian photograph may be that made by Kelly Wood and shown in 1993 during *Le Mois de la Photo*, a city-wide group of exhibitions held biannually in Montreal. This was a black and white photo-construction called "Flag," in which the maple leaf in the Canadian flag has been replaced by the hunched-over body of a nude woman. (In the same series of exhibits, across the street from the Université de Montréal, where fourteen female engineering students were murdered in 1989, Kati Campbell's installation *Symptom* was shown. On facing walls of the exhibition space, which had been painted blood-red, were two rows of seven mirrors each, bordered on each side by parentheses-shaped, blinker-like frames. On entering this room one had to pass by a table that functioned like a giant type-setting tray, carrying phrases from the media coverage of the massacre: "feminist" or "there you are, he said.") Identification with the feminine position within culture is made explicit in Chuck Samuels' early 1990s series entitled *Before the Camera*, in which Samuels, in images such as "After Weston" and "After Man Ray," photographed himself in the poses, and with ersatz versions of the props, of well-known female nude studies from the history of photography. In 1989, Brian Piitz photographed his own male body in typically "feminine" art historical poses, and in poses that are redolent of those in the albums of photographs of women patients in various stages of "hysterical" seizure, made in a Paris asylum by clinician Jean-Martin Charcot and his assistants in the 1870s.

Just as both John Ralston Saul and Margaret Atwood take Siamese twins as a central metaphor for their reflections on Canada, the French-born, British writer Nicole Ward Jouve, who lived for several years in Winnipeg, refers to a French fairy-tale creature called "moitié-de-poulet" to express the situation of the bilingual who lives between linguistic and cultural realities; she feels this cultural position is analogous to that of women. Jouve writes that "doing the splits geographically, linguistically, poses problems of identity. It's a more graphic form of what women who strive to speak with their own voice experience anyway."[82] She says that in illustrations of this "half-chicken," it is cut down the middle length-

wise, from head to tail. "Moitié-de-poulet is about right. Half is half. My presence in one country, one language always means my absence from the other."[83] "Bilinguals" like herself, Jouve maintains, "are always here and somewhere else at the same time."[84] It is this sense of being "here and somewhere else at the same time" that is the distinguishing feature of Canadian photography, evident in the dualistic works of Carole Condé and Karl Beveridge, Charles Gagnon, Lynne Cohen, and Stan Denniston, among many others. For Jouve, the translator "is a being in-between" who "endlessly drifts between meanings. S/he tries to be the go-between … [and is] led to reflect on how particular translations become constructed. What gets lost, what is gained, what and how altered, in the passage from one language to the next."[85] This brings to mind Johanne Lamoureux's analysis of André Martin's *Anagrammes II (Souvenir de Pina Bausch)* as "an exploration of language and the alteration of meaning that occurs in the passage from a system to another."[86] The process of translation, to Jouve, is "eminently 'feminine,'" for "[w]hen you translate, the absolute status of nouns, the 'Name-of-the-Father,' is shaken. Exchanges between words are no longer 'full,' that is, guaranteed by the law of the Father, the law of significance. Identities cease to be stable. You escape from definition, from the law which rules and partitions women, which prevents femininity from coming into being. Translation = no man's land = woman's land?"[87] This chimes with the title of Lamoureux's article, "French Kiss from a No Man's Land." Jouve writes of the "strain[ing]" that goes on under "a *dual*, a *bilingual*, situation."[88] By "dual," she "mean[s] that instead of being 'in control,' having 'one being' which is French *or* English, working-class *or* middle-class, 'male' *or* 'female' (*and* enjoys a 'proficiency' of some sort in the 'other' mode) you are –'moitié-de-poulet,' quoi."[89] This, the quintessentially Canadian state of duality, is most succinctly expressed in the image from the Martin *Anagrammes II* series that has the word "both" inscribed above the silhouetted figure signing the word in the language of the hearing impaired.

Eva Hoffman, who immigrated to Canada from Poland as an adolescent, also writes of the duality engendered by the new language that it is often incumbent upon the immigrant to acquire: "This language is beginning to invent another me. However, I discover something odd. It seems that when I write (or for that matter, think) in English, I am unable to use the word 'I.' I do not go as far as the schizophrenic 'she' – but I am driven, as by compulsion, to the double, the Siamese-twin 'you.'"[90] Nancy Huston, the Alberta-born novelist who has lived and written in Paris since the mid-seventies, writes that "Souvent, je trouve difficile – déroutant, déstructurant – de ne coïncider vraiment avec aucune identité; et en même temps je me dis que c'est cette coexistence inconfortable, en moi, de deux langues et de deux façons d'être qui me rend le plus profondément *canadienne*. Elles ne veulent surtout pas se réunir; elles ne veulent même pas forcément se serrer la main, se parler entre elles; elles tiennent à se critiquer, à ironiser, à faire des blagues l'une aux dépens de l'autre; en somme, elles revendiquent toute l'ams-

biguïté de leur situation." [91] ("I often find it difficult – confusing, destabilizing – to not really coincide with any identity; at the same time I tell myself that it is this uncomfortable co-existence, within me, of two languages and two ways of being, that makes me most profoundly *Canadian*. [These two languages and ways of being] above all don't want to come together; they don't even necessarily want to shake hands, speak to one another; they are inclined to criticize one another, to speak ironically, to make jokes at the expense of one another; in sum, to claim all the ambiguity of their situation."[92]) As we have seen, it is this doubleness that does not want to "come together" as a monolithic unity that, more than any other trait, characterizes the Canadian photographic image.

Jouve says that the situation of the bilingual "exemplifies what Catherine Clément describes as the anomalous position of *woman* in culture."[93] Women, Clément argues, "along with … chamanns and witches … belong to two opposite orders at once: as human beings, they are on the side of the Rule, the Symbolic, what orders the natural. As biological beings, having periods, pregnancies, they are seen to be on the side of natural rules."[94] Marianne Hirsch observes that "this sort of double consciousness has, in fact, become a paradigm for the discussion of women's writing within feminist criticism." She cites Sandra Gilbert and Susan Gubar, who have "spoken of 'duplicity' and a palimpsestic structure," and Elaine Showalter's "strategies of submerged plots within dominant plots which create a 'double-voiced discourse.'"[95]

Reading Jouve's description of the bilingual as "doing the splits" reminds me of a 1998 sculpture by Italian Canadian Montreal artist Francois Morelli entitled "Hip Hop," in which a pair of roller skates is joined together by an expandable metal spring reminiscent of a child's Slinky toy. The sculpture seems made to order for someone who "does the splits," either linguistically or culturally, as Arthur Renwick, Jin-me Yoon, Marisa Portolese, and other Canadian photographers who deal with issues of culture hybridity are obliged to do. Hutcheon uses a similar metaphor to refer to the double condition of women. She finds that many feminist critics "argue that the condition of marginality (with its attendant qualities of muteness and invisibility) has created in women a 'divided self, rooted in the authorized dualities' of culture."[96] Elizabeth Grosz has written that "[w]omen, their bodies, and pleasures thus exist in a double dynamic: as products of patriarchy, they are indeed socially castrated, subordinated, made passive; yet women are also excessive, plural, within one world, men's, and also another, their own, different from and resistant to men's."[97] Referring to the title of Luce Irigaray's well-known treatise, she writes that "[t]he sex which is 'not one' is thus not a zero or lack but always at least two, fundamentally plural, ambiguous, open-ended, always capable of bringing new meanings to the world."[98] In its essential duality, as well as in its anorexic symptoms, the Canadian imagination reveals its identification with the female in culture, and may have developed a particularly "feminine" vocabulary with which to express itself.

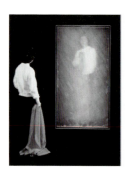
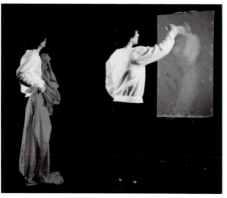
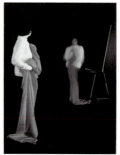

6.18 Sorel COHEN
An Extended and Continuous Metaphor #6
1983
Photographic installation
1.83 x 4.57 m
Original in colour

Luce Irigaray and French feminist writer Hélène Cixous speak of the multiplicity of the feminine, which resists integration into a monolithic, "phallologocentric" whole. The notion of a femininity that is "fundamentally plural" resonates with John Ralston Saul's assertion that "[t]he essential characteristic of the Canadian public mythology" is "its complexity." In his opinion, if we were to "accept our reality – the myth of complexity," this would amount to "a revolutionary reversal of the standard nation-state myth," and we would thereby accept "to live out of step with most other nations."[99] To Saul, though, we are instead "overcome by a desperate desire to present ourselves as a natural and completed experiment, monolithic, normal, just another one of the standard nation-states."[100] "Our élites" with their "colonial mind," ask, "glancing straight ahead over the border, why can't we be just like them – bluff and clear and monolithic,"[101] as we have wished for our photography to look like the monolithic American image. These élites "weep before the ever-retreating mirage of the unhyphenated Canadian,"[102] and we entertain the thought that Canada "is not a real country."[103] Both Canadian photography and Canadian art in general manifest a "feminine" multiplicity in the uncommon number of multiple personalities and adopted personae they enlist: the several alter-egos of Evergon (which include Cellulose Evergonni, who produces the works we know as Evergon's; Eve R. Gonzales, an old woman who makes colour photographs of the details of tombstones and mortuary sculpture in Mexico and Europe that are printed by A.P., her Anonymous Printer; and Egon Brut, self-described "photographer and eroticist/pornographer"), and the assumed identities of Mr Peanut, General Idea, and the N.E. Thing Company. Female mul-

tiplicity appears in British Columbia photographer Hannah Maynard's late nine-teenth-century self-portraits in which, by the use of superimposition, several images of the photographer occur together in one frame – in one photograph Maynard pours tea for her double, while a third self in a window-like frame on the wall pours tea on the double's head. This multiplicity is evident as well in the ghost-like selves that appear in Anne-Marie Zeppetelli's work; in Montreal pho-tographer Sorel Cohen's large colour photographs from the 1983 series *An Exten-ded and Continuous Metaphor*, where she appears not only as a painter but as the painter's posing subject and within the painter's portrait-in-progress as well; and in the *Incarnation* series of more than sixty images by Toronto's Janieta Eyre, where doubles of the photographer appear in vaguely vintage or historical apparel, as "Twin Manicurists," for example, or in the 1995 "Confession" as pseudo-Flemish kitchenmaids who are echoed in a double portrait hung on the wall, of themselves in Victorian dress.

An exhibition of Raymonde April photographs held at the Galerie Rochefort in Montreal in the winter of 1994 included, amongst other images, an elegant, toned, almost mural-sized black and white "interior" portrait of a woman sitting in a book-lined room, printed on canvas and hung unframed; a smaller black and white landscape image reminiscent of nineteenth-century French photogra-phy; several portraits that, given the clothing of the people photographed, looked as if they might have been shot fifteen or twenty years earlier; a sequence of five small images of a Paris street seen through a window; "atmospheric," "impres-sionistic" images of the Quebec landscape; and anecdotal, snapshot photos, including one of a person rolling in the grass with a dog. This installation of images was startling for the degree to which it departed from the conventional struc-tures of photographic sequencing, including the more or less linear narrative that characterized April's own work until the end of the 1980s. And the exhibit was the first of April's in a twenty-year career in which no self-portraits were included that would help position the viewer in relation to the other images in the sequence. Although observers of April's work over the year or two leading up to this exhibit might have noticed her work moving away from traditional photographic nar-rative, the Rochefort exhibition seemed to implode narrative from the inside out, in effect to step outside the bounds of conventional sequencing and propose instead a vision that resists narrative closure altogether. Unity of genre, subject matter, format, time frame, and "style" were all absent. Yet in its gathering together of disparate fragments of experience, the work approximated the texture of the real, even as it abandoned any attempt at integration into a unity that would be recognized as such given the usual terms of reference. The exhibit was anything but a random grouping of images; on the contrary the distinctive voice of the pho-tographer was very much present in the work. In its refusal of arbitrarily imposed homogeneity and totalizing narrative, its embracing of multiplicity, the instal-lation demonstrated the "unity" that is made up of "non-unity," the "one that is

several" that Irigaray, in *This Sex Which Is Not One*, says characterizes the polymorphous feminine sensibility.[104]

Writing about the novels of Robert Kroetsch, Linda Hutcheon states: "There is a paradoxical desire to show the temptation of the 'single' vision as seen in mythic 'universality,' sameness, and system and yet to contest it by 'the allure of multiplicity' – parody, fragmentation, decentring."[105] She concludes that "[f]or Kroetsch Babel is a positive story because it recounts the breaking up of that originary single collectivity that allowed the multiple to flourish: 'making everything into *one*' at the expense of historical, cultural, and linguistic diversity"[106] is a negative value. The visionary protagonist of Atwood's *Lady Oracle* possesses "multiple" personalities that defy her efforts to integrate them into a unified whole. Referring to *Lady Oracle*, Hutcheon considers that unlike men, "who are said to have a firm sense of a single, coherent, rational identity (or to think that such a sense of self is possible and desirable), Atwood's women seem to possess subjectivities that are much less easily defined in traditional terms, that are more fragmented and even multiple."[107] Hutcheon feels that Atwood works "to question the very nature of selfhood as it is defined in our culture," and that "perhaps irony becomes the only mode available for a female protagonist who realizes that the unified self her culture has taught her to desire may be inappropriate for her as woman."[108]

The monolithic sense of identity, which Saul and David Howes equate with an American or European concept of the nation-state, is, in these terms, a "masculine" understanding of the self. A "feminine," polymorphous identity that resists the notion of a subject that is stable, unitary, centred, and "whole" is thus more amenable to the "complexity" that Saul identifies as so fundamentally Canadian. The questioning of the unified subject that was evident in Raymonde April's Rochefort exhibit reflects a feminine sensibility that we, as Canadians, may not yet have been able to own in any way that goes beyond an identification with the powerlessness of the colonized.

Whenever I have noticed the use by a non-Canadian of the visual configurations I identify as Canadian, it has been in the work of women photographers. The close-up of a pubic scar in the American Nan Goldin's 1986 book, *The Ballad of Sexual Dependency*, entitled "Ectopic Pregnancy," is remarkably like the newly sutured wound in Sylvain Cousineau's 1977 *Mona Nima*. Photographs the young American photographer Francesca Woodman made before her suicide in 1981, of stuffed animals and her own naked body trapped in glass display cases, partake of a vocabulary that has been developed and elaborated on by Canadian photographers both male and female. The intersection of two worlds – middle-class, North American designer kitchen, and the battlefields of the Viet Nam war – in Martha Rosler's 1969–72 collaged images that make up the series entitled *Bringing the War Home: House Beautiful* are reminiscent of Canadian works from those of Susan McEachern to the narrative series of Carol Condé and Karl Beveridge, which

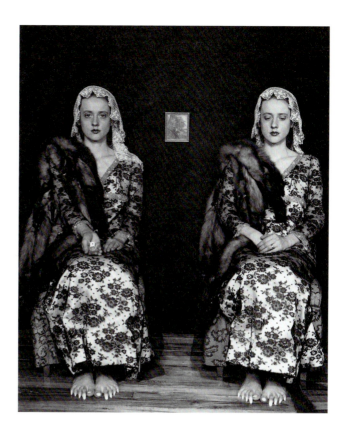

6.19 Janieta EYRE
Twin Manicurists
1995
76.2 x 101.6 cm

allude to the interpenetration of two registers of social reality, one "here," another "elsewhere." As well, Rosler, a highly regarded theorist and artist, has produced a series of photographs and text entitled *the bowery in two inadequate descriptive systems*, in which, like the work of the Quebec artists examined by Johanne Lamoureux, meaning takes place in the space between modes of representation. These shared vocabularies underline the fact that, at least at the imaginative level, Canadians identify with the struggles of women within culture. The syntactical elements Canadians share with a handful of images made by American women photographers are those that convey a sense of powerlessness or a "double consciousness," which several commentators characterize as particularly feminine. Just as Americans may consistently photograph "the object" but don't have a monopoly on that way of portraying the world, Canadians are not the only ones who photograph entrapment or duality. However, Canadians do so to a much greater degree than other photographers; what are marginal tendencies in American photography, found in the work of a very few American photographers, are the norm in Canadian photography.

If Canada is stuck like the anorexic in an adolescent process of initiation and cannot break through to the maturity that rests on the other side, why would this

6.20 EVERGON
The Chowder Maker
1986
50 x 60 cm
Original in colour

be so? Is it not for the same reason the starving young woman is unable to push through her own death-like state and be born again as a "new," more "ontologically real," adult woman? Perhaps, just as she believes that emergence into full womanhood in her culture can be an unwelcoming and even dangerous proposition, at some level Canadians sense the feminine consciousness they participate in collectively (even if they would not name it as such), and are as reluctant to assume that identity and bear it into Western culture. The courage required by individual women who wish to function in the world as they really are, and not as women "dressed in men's clothing," is the same courage that Canada as a culture requires in order to assert itself, on its own terms, within a larger cultural arena. The knowledge that a feminine, imaginal consciousness is desperately needed to balance the over-inflated and distorted masculine principle that currently rules our culture and our world may provide us with the resolve necessary to make the contribution our images tell us we are destined to make.

At the end of Irene Claremont de Castillejo's *Knowing Woman*, the author, a Jungian analyst, recounts a dream she herself had, which brings to mind the many female corpses "under the foundations" discovered by Patricia Smart in the novels and poetry of Quebec. The dreamer descends into the bowels of the earth to a hospital ward, and beyond that through a trap door and down a flight of stairs to a sea of water in which a woman is drowning. In the dream, de Castillejo manages to rescue the woman and to get her to the hospital, but there she is told that the only thing that will do any good is to bring this exhausted and confused woman up into

the sunlight. To de Castillejo the dream says that "the feminine soul image of a woman is still in great distress because it has remained in the unconscious and it desperately needs to be brought into consciousness."[109] Taken together, Canadian photography informs us of what we may not yet consciously know, that as a collectivity we have a particular affinity to the feminine spirit and thus a responsibility to help usher this sensibility into the world.

In *The Chowder Maker*, a large-size, three-panelled Polaroid work made by Evergon in 1986, the beaming face of an ample woman, whose head is draped in white like that of a medieval cook is surrounded by bowls, cabbages, and lemons. *The Baker*, another Evergon Polaroid triptych made the same year, shows a plump and smiling elderly woman, wearing a baker's turban, standing behind an arrangement of articles that includes an earthenware bowl, eggs, dough and flour; these articles, like the food in *The Chowder Maker*, are exquisitely bathed in light. In both these pictures, the relationship of the women to the food that surrounds them is sensual and full of pleasure; that these women might be starving or even hungry is the last thought that would enter a viewer's mind. Rather, the women seem to rejoice in the lusciousness of the food and in the process of transformation that is cooking. No social imperative to be slender, no fear of womanly curves thwarts their appetite. These photographs are a validation of the feminine experience, because in them women are allowed to embrace the food that nourishes them and to appear to be beautiful while doing so. Unlike the woman in de Castillejo's dream, Evergon's full-bodied women are anything but sickly and in need of care.

As we attempt to live out the reality we have seen in our "dreams," in our photographs, and to allow this message of who we really are to inform our lives, we could do worse than to keep before us these radiant images of feminine fulfilment and desire.

I Nina RAGINSKY
The Kirkpatrick Sisters in front
of the Empress Hotel, Victoria,
British Columbia
1974
17.1 x 11.4 cm

Souvenirs of the Self

A project of six postcards by
Jin-me Yoon ©1991

Walter Phillips Gallery, The Banff Centre for the Arts, Banff, Alberta, Canada T0L 0C0
A Between Views and Points of View project
Photograph by Cheryl Bellows

Banff Park Museum – Marvel over the impressive collection of Western Canada's oldest natural history museum. She looks with curiosity and imagines life beyond the rigid casings.

Le musée du Parc national Banff – Étonnez-vous devant l'impressionnante collection du plus vieux musée d'histoire naturelle de l'Ouest canadien. Elle regarde curieusement et imagine la vie derrière ces vitrines rigides.

II Jin-me YOON
First card of *Souvenirs of the Self (Postcard Project)*
1991
1 of 6 perforated postcards
10.16 x 15.24 cm each

III Jin-me YOON
First card, reverse side, of *Souvenirs of the Self (Postcard Project)*
1991
1 of 6 perforated postcards
10.16 x 15.24 cm each

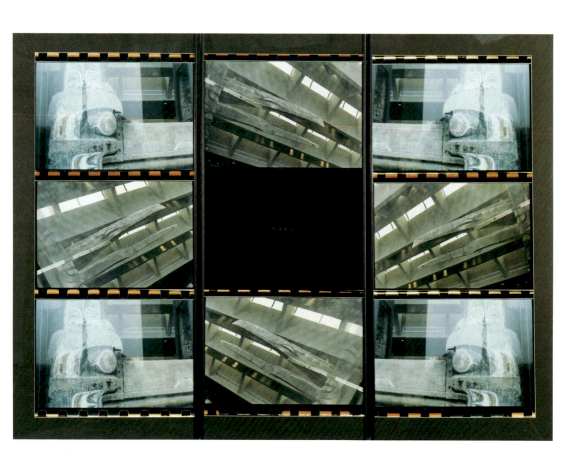

IV Arthur RENWICK
Cage
1989
152.4 x 182.88 cm

V EVERGON
Horrific Portrait
1983
50.8 x 60.96 cm

VI Charles GAGNON
SX 70
1976
7.9 x 7.8 cm

VII Sylvie READMAN
Autoportrait à la fenêtre/Self-portrait at Window
1993
169.5 x 247.5 cm

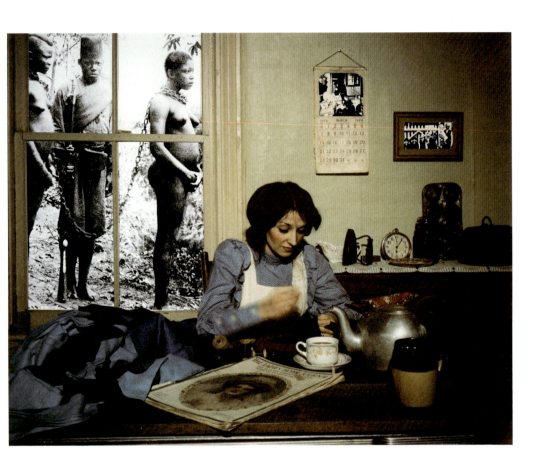

VIII Carole CONDÉ and Karl BEVERIDGE
Work in Progress 1908
1980-81
40.64 x 50.8 cm

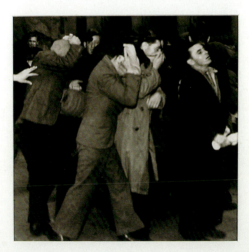

IX Roy ARDEN
Excerpt from *Rupture*
1985
#8 of 9 Diptychs
68.6 x 40.6 cm each panel

X Ian WALLACE
Clayoquot Protest
(August 9, 1993), VI
1993-95
200 x 152 cm

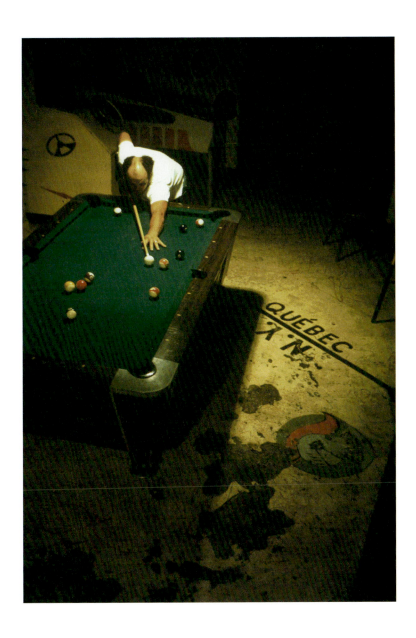

XI Michel LAMBETH
New York – Quebec Border through the
Dundee Line Hotel, Dundee Line, P.Q.
1974

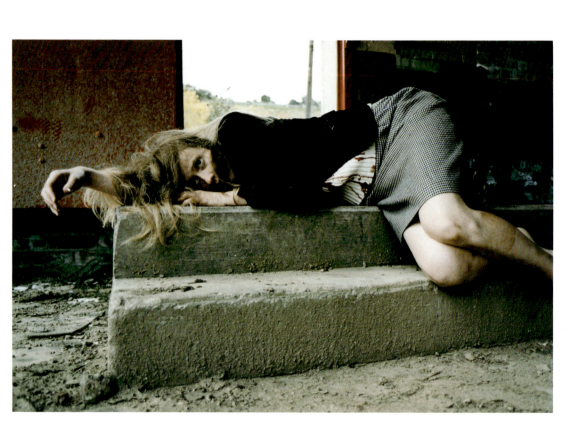

XII Janieta EYRE
Rehearsal #4
1993
76.2 x 101.6

XIII Geneviève CADIEUX
Parfum
1991
152.5 x 579 cm

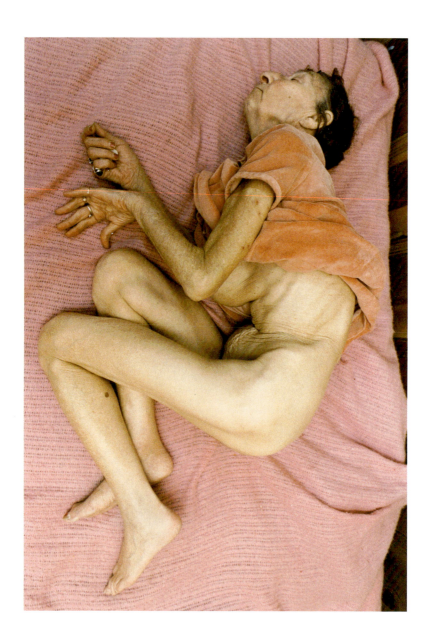

XIV Donigan CUMMING
April 10, 1992. From the series *Pretty Ribbons*
1993
127 x 86.4 cm

XV Shelley NIRO
Detail from *Are You My Sister?*
1994
Photographic installation
101.6 x 640 cm overall

XVI Jeff WALL
The Flooded Grave
1998-2000
228.6 x 282 cm

XVII Barbara SPOHR
Untitled
n.d.
60.8 x 50.7 cm

PART FOUR – Entering and Leaving

I am neither living nor dead and cry
From the narrow between.

SAPPHO

CHAPTER SEVEN

Home Is Here

Descent Writing about the analysis of dreams, Freud said that it was some-times possible, with the help of the unconscious process of condensation, to "combine two quite latent trains of thought into one manifest dream, so that one can arrive at what appears to be a sufficient interpretation of a dream and yet in doing so can fail to notice" a possible "second" meaning.[1] Something akin to this may be observed with respect to the collective dream that is Canadian photog-raphy. The characteristics that appear, at first, to be symptomatic only of Canada's state of suspension in a rite of passage can be seen to express, as well, another latent message altogether. The same distinguishing features – the dual vision of the world, the preoccupation with dying, bondage, and entrapment, the flight from the body of the world – that spell out in metaphor our pathology disclose to us as well the landscape of a powerful feminine identity, a privileged relationship to both the imaginal underworld from which the anorexic is so estranged and the wilderness that is distinctly Canadian. Canadian photographs tell us about our malaise, but also about our cure. They suggest how we might rid ourselves of mor-bidity and live out our destiny in a conscious way.

Even before the viewer encounters the photographs and text of Mark Leslie's 1992 *Dying with AIDS/Living with AIDS*, the title of the book alone is sufficient to position the photographer, who is the narrative's protagonist, in that in-between space alluded to over and over again in Canadian photography – the point of inter-section between "here" and "elsewhere," life and death. Leslie speaks from this

7.1 Sandra SEMCHUK
*Self-portrait, the day I said
good-bye to Baba, Meadow Lake,
Saskatchewan, April 1976*
18.8 x 23.8 cm

7.2 Sandra SEMCHUK
*Baba's grave, Meadow Lake,
Saskatchewan, July, 1977*
18.8 x 23.8 cm

Facing page

psychic space throughout his book, from the stance of someone who, having been diagnosed with AIDS before the current era of drug "cocktails," cannot help but be acutely aware of the presence of death in life. As we have seen, from the work of Michel Lambeth and many others, this awareness permeates Canadian photography. Both this photographic sequence and another by Sandra Semchuk tell of voyages that take their protagonists out of ordinary, "daylight" existence into subterranean realms of image and memory. Like so many individual Canadian photographs, these sequences present in narrative form a dual world that is composed of separate but interpenetrating realms, one of which has to do with death.

Angelyn Spignesi regards anorexia as indicative of the afflicted woman's "relation to the psychic underworld, to the imaginal figures and landscape underlying and permeating her bodily existence."[2] She believes that in order to come to an understanding of the anorexic, it is important to understand that all women in patriarchal culture, but particularly anorexics, are starving for that "lower, imaginal" world. The anorexic woman particularly is caught at the crossroads between this lower world and the naturalistic one. It is interesting, then, given Canada's affinity with the anorexic's inner landscape and the duality informing so much of Canadian cultural expression, that the vision of bilingualism described by Nicole Ward Jouve in *White Woman Speaks With Forked Tongue* uses as well the metaphor of upper and lower worlds: "Whilst one language is being spoken or written, it is daylight for it. The unspoken other language has gone

under, is in the dark. But as earth keeps revolving and everything on it exists, the dark language, even when unheard and invisible, continues its antipodean existence."[3] Is it the constant awareness of an "other" language — French or English or Ojibway or Mandarin — that is *not* ours, or not the language we are speaking at any given moment of utterance, that has helped to carve out in our collective unconscious a pathway to some "other," "under" world?

Like Mark Leslie's book, Sandra Semchuk's 1982 sequence of eighty-seven photographs, entitled *Excerpts from a Diary*, begins with death. The narrative opens with a portrait of the photographer's elderly grandmother, or Baba, posed on a sofa with her two grown sons, one of whom is Semchuk's father. With this is a self-portrait of Sandra sitting on her grandmother's bed, and an image made the same day, titled "Self-portrait, the day I said good-bye to Baba, Meadow Lake, Saskatchewan, April, 1976," of Semchuk and her camera and tripod taken in the mirror of Baba's dressing table. On the dresser and around the mirror have been placed snapshots and portraits of Baba's family, including what look like high school yearbook pictures of Semchuk herself.

The remainder of the Semchuk sequence is framed by two pictures of Baba's burial place: the newly dug grave, covered in a mound of earth, photographed in July 1977 on a prairie field that is barren save for one small tree, and, over eighty photographs later, the same gravesite photographed in July 1979. In this picture, which ends the series, it is evident that time has passed, grass and flowers have

7.3 Sandra SEMCHUK
Self-portrait (from the kitchen series),
RR6, Saskatoon, Saskatchewan,
October, 1977
18.8 x 23.8 cm

grown, and, in contrast to the aridity of the earlier scene, we see Semchuk's
daughter Rowenna and her Aunt Elsie hugging one another next to the grave.

Between these two quite different graveyard pictures, Semchuk presents a
tale of self-examination and transformation constructed almost entirely from
self-portraits, head and shoulder shots of Semchuk dressed and undressed, against
a blank wall or out in nature and often identified only with the date the image was
taken, and many images of Semchuk in her kitchen, cable release in hand, posed
against windows that look out on to the prairie landscape. In these interior por-
traits, several of which include Semchuk's daughter, the changing of the sea-
sons is revealed by the shifting articles on the kitchen table – a Christmas tree, a
Hallowe'en pumpkin. The frontal head and shoulder portraits of Semchuk run
an emotional gamut, from images of ecstasy to those of great distress, accompa-
nied by titles such as "Co-operative Self-portrait, Dad and I, Regina, April, 1980,"
"Self-portrait with Baba's apron on, Rowenna's 3rd birthday, October, 1977," or
"Self-portrait, mother unexpectedly died, August, 1981." We see as well Sandra
in affectionate exchange with other women, and blocks or pairs of images where
the tenor of the relationship between the photographer and her mother, or father,
or the husband that the titles tell us she is separating from, is made painfully clear.
The journey into herself that Semchuk begins with the deaths of her grandmother
and, on another level, of outworn aspects of her own identity is as alive and dynamic
as the burial pit that teems with sea creatures in Jeff Wall's "The Flooded Grave."

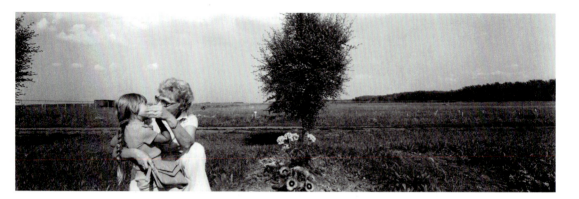

7.5 Sandra SEMCHUK
*Rowenna and Aunt Elsie at Baba's
grave, Meadow Lake, Saskatchewan,
July, 1979*
15.8 x 47.6 cm

Of the writers on anorexia who consider it essential that the starving woman make a "descent" to her feminine ground of being, several find the Greek mother/daughter myth of Demeter and Persephone to be a useful paradigm of the search for a feminine principle "lost" to both women and men in a patriarchal culture. Parallels to the Demeter/Persephone legend, as well as to an earlier Sumerian tale of female descent to the Land of the Dead, can be found in Semchuk's *Excerpts from a Diary* and Leslie's *Dying with AIDS/Living with AIDS*, and in the work of Diana Thorneycroft and other Canadian photographers. When examined alongside these ancient myths, both sequences suggest that the "death" so often alluded to in Canadian photography and other forms of expression may not be the final annihilation of physical death, and by extrapolation, of Canada, but another kind of "death" altogether.

The mirror and the grave opening Semchuk's narrative are classic *omphalos* or navel symbols, two of many sites that have been considered since ancient times to be variations of the *axis mundi*, or "cosmic centre," where the worlds of humans, the gods, and the dead intersect and where passage between these realms is possible. The archetypal *omphalos* is the mound of earth (like those seen repeatedly in the photographs of Charles Gagnon) that the Greek oracle at Delphi sat on, and which was considered to be the "world's navel" with its umbilical cord stretching to the wisdom of the underworld below. Mountains, caves, female genitals (sometimes called "the holy door"), clefts in the ground, trap doors, ladders, wells, trees, and bridges as well as the actions of jumping through water, turning the eyes inward, or entering a hole in the ground have historically all been considered to represent entrances from the world of the living to that of the dead, gate-

ways to the underworld and its unconscious depths. All of these configurations and actions reoccur in Canadian photography.

Mark Leslie's chronicle of life with AIDS opens with a preface and a glossary of medical terminology relating to the symptomatology and treatment of the virus. The book continues with an image of Leslie seen from the neck up, his head thrown back against a sofa over which hangs a drawing of a well-built, heavily tattooed young man. Leslie's expression is one of pain and exhaustion, and the vitality of the nearly nude man in the drawing seems to refer to a life Leslie once had and on the other side of which he is now forced to live. One is reminded of an earlier Canadian work by Marion Penner Bancroft, in which the principal subject, Dennis, is a young man dying of cancer. In this 1978 series of over twenty images titled *For Dennis and Susan: Running arms to a civil war*, the photographer makes frequent use of the windows of a summer cottage, a large window looking from a hallway into Dennis's hospital room, and the plastic draping around his bed in order to underline his isolation – Dennis, like Leslie, occupies a psychic space that is somewhere between living and dying – from his wife Susan, other members of his family, and his friends. Both works bring to mind another, mentioned in the previous chapter, whose subject exists in a similar state of "betwixt and between." In *Pretty Ribbons*, Donigan Cumming's 1993 installation composed of black and white and colour photographs, journal extracts and sound, Nettie Harris, a woman in her early eighties, is shown over and over again. Dressed or without clothing, alone or with another, awake or asleep, Nettie Harris is most often seen in a fetal position. This pre-natal pose is at odds with the visual evidence of a body that is old, creating the kind of ambiguity that is also evoked by an image that appears near the end of *Dying with AIDS/Living with AIDS*. Titled "My Calvin Klein Ad," the photograph is of Leslie reclining on a beach. His pose mimics that of a fashion spread, but the thinness of his body and the disposable diaper he wears in place of swim trunks serve to place him in an in-between zone not unlike that occupied by Cumming's Nettie, Bancroft's Dennis, and the subjects of Evergon's pre-natal/post-mortem *Interlocking Polaroid* series.

The text to the left of the image of Leslie on his sofa, the first entry of this journal, dated 19/9/91, reads, "Yesterday I shit my pants while walking home. Last night I woke up with my legs and sheets covered in watery excrement for the second night in a row."[4] On one level Leslie's book is a straightforward account of his life with AIDS, where chronic diarrhea denotes serious infection and excruciating physical pain. But while informing us of the medical details of his illness, Leslie at the same time presents these facts symbolically as a way of describing his subjective experience of the disease. In *The Dream and the Underworld*, psychoanalyst James Hillman writes that dreams of diarrhea can be understood as "radical compelling movements into the underworld or as an underworld that has come to sudden and irrepressible life within us, independent of who and where we are."[5] In these dreams, says Hillman, "we are crossing a border," and "diarrhea

signals the daylight order at its 'end.'" Dreams in which there is an "immediate need to defecate ... or the discovery that one has soiled oneself ... can be read as underworld initiations," as "death experiences for the dayworld ego."[6]

Like Semchuk's opening images of Baba's grave and of herself in a mirror, Leslie's written allusion to diarrhea and the photos of himself writhing on his bed in pain at the opening of his book announce that he has embarked on a journey into a territory that has little to do with his previous, "ordinary" life. As he struggles to come to terms with the punishing effects of his disease and his own mortality, Leslie, like Semchuk, encounters the demons of his past. Semchuk enters the world of her inner life through a mirror that is surrounded by snapshots of her family's past history. Leslie begins the section of his book that portrays a visit to his family in Alberta, from whom he has long been estranged, with the photograph of a gas station late at night. Part of the garage's sign is burnt out, leaving the word HELL emblazoned across the sky – the confrontation with his past proclaims itself explicitly as a journey to the depths. Like Semchuk, Leslie makes use primarily of self-portraits and images of friends and family in recounting his exploration of this psychological netherworld.

The journeys of the protagonists in *Dying with AIDS/Living with AIDS* and *Excerpts from a Diary* follow the structure of classic initiatory voyages of descent and return, death and rebirth, the prototype of which is the Greek legend, retold in Gluck's opera, of Orpheus, who, grief-stricken at the death of his wife, descends to the underworld to convince the god Pluto to allow her to return to earth. More relevant to the stories of Semchuk and Leslie and to the situation of the anorexic who has lost touch with both the feminine and the imaginal within herself are the ancient legends of female voyage to the depths referred to above. These sequences take the shape of heroic descent into darkness and peril, into an experience of death and nothingness followed by rebirth, a transformed relation to the self, and a renewed connection to life. They also offer an understanding of death that is particularly relevant to Canadian photography.

Gates Semchuk's "dark night of the soul," which she seems to enter by way of a grave, echoes very clearly ancient cycles of female descent into the earth, dismemberment, epiphany, and regeneration. Initiates of the Eleusian Mysteries, women and men who came to ancient Athens from around the world to celebrate the holy Eleusian rites, reenacted the suffering of Demeter, Goddess of the Grain, at the loss of her daughter, Persephone, to the underworld. The Demeter/Persephone myth recounts how Persephone was picking flowers in a field when the ground before her suddenly split open and out of the earth, riding a chariot, appeared the underworld god Hades. Hades raped Persephone and then returned

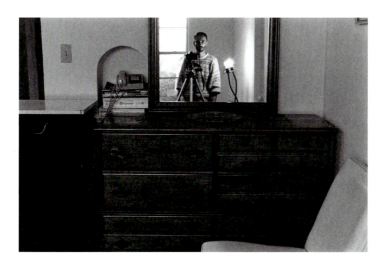

7.6 Mark LESLIE
Untitled. From the
series *Dying with
AIDS/Living with AIDS*
1992
20.32 x 25.4 cm

7.7 Mark LESLIE
*Sign on the outskirts of
Red Deer, Alberta, next
to the hotel I stayed at.*
From the series *Dying with
AIDS/Living with AIDS*
1991
20.32 x 25.4 cm

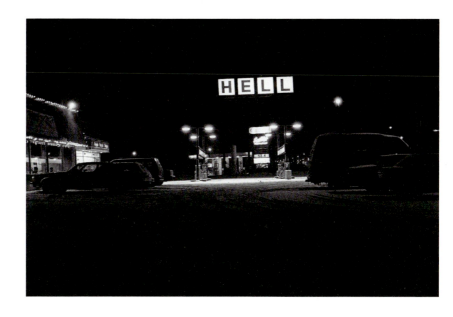

with her as his captive to the Land of the Dead, the subterranean realm where he reigned as king.

When Demeter discovered her daughter's absence, she was grief-stricken and searched for Persephone far and wide. She refused to eat, sleep, or bathe, forbade anything to grow on the earth, and declared that no further sacrifices would be made to the gods and that no species should mate until Persephone returned. Even though she had been warned to eat nothing in the underworld, before leaving Hades Persephone ate the pomegranate seeds Hades had given her, thus ensuring that she would return to live in the earth as Queen of the Underworld for a third of each year. When reunited with her daughter, Demeter was ecstatic, and she made the earth fertile again. In ancient Greece Demeter was considered to be the first Eleusian initiate, the first to comprehend what had happened to her daughter in the Land of the Dead. This understanding constituted the epiphany experienced by initiates at Eleusis, a vision that conferred a fearlessness in the face of death.

After days of fasting, the Eleusian initiates made their way to a grotto indicating the entrance to the underworld. Spiritual rejoicing occurred when a priest proclaimed that Persephone had given birth to a holy child in the underworld – the goddess of death had given birth, and so birth in death was seen to be possible. A vision of the underworld goddess appeared, rising above the ground, and then an ear of corn was silently displayed. The Eleusian initiates thus acquired a faith that when they themselves arrived in the underworld, following the passage first opened by Persephone, they would find not death but life. It was understood that Persephone existed simultaneously in two realms, the Land of the Living and the Land of the Dead, where she continued to reign over dead souls and act as a guide to the living who might visit the underworld. She functioned as a psychopomp who could communicate between ordinary and non-ordinary reality, upper and lower worlds.

Like Persephone, the narrator of Mark Leslie's *Dying with AIDS/Living with AIDS* can communicate to others from a realm that is "out of life," and with which he has become intimately acquainted. Although Leslie's narrative details moments of great pain, both physical and psychological, the work culminates in a photograph, in colour, of his feet and the ocean horizon, an image that seems to signal his arrival at a place of serenity. Like the Eleusian initiates, those who encounter his book may be bolstered by the hope he offers in the face of death; like Persephone he has forged a path for others in an underworld he has been forced to inhabit. It is into this underworld that the deaths of her grandmother, mother, and of her marriage have propelled Semchuk; out of the death of her life as she knew it she is able to find rebirth, and thus to hold out for others the promise of the same.

The Demeter/Persephone myth might provide a useful template for understanding the "unresolved" duality that undergirds many individual Canadian photographs and series of photographs, as well as the two sequences we are discussing

here. In *The Mother/Daughter Plot*, literary theorist Marianne Hirsch writes that as "we follow Persephone's return to her mother for one part of the year and her repeated descent to marriage and the underworld for the rest ... we have to revise our notion of resolution. At the end of the story, Persephone's allegiance is split between mother and husband, her posture is dual. The repeated cycle relies not on reconciliation, but on continued opposition to sustain and perpetuate it. Persephone literally enacts the 'bi-sexual oscillation' of the Freudian female plot."[7] This "bi-sexual oscillation" characterizes both the anorexic mode of being and the in-between, liminal state of adolescent initiation, both of which I have compared to the Canadian imagination as it is reflected in Canadian photography like that of Michel Lambeth and Evergon.

Leon Surette has remarked that the "inversion of the Demeter-Persephone-Pluto myth is a recurrent motif for Atwood. Her heroines – like Susanna Moodie and Catherine Parr Traill - are commonly threatened by all that is sacred to the earth goddess, and feel safe in the chthonic depths." Surette feels this is made explicit in Atwood's short story "Death by Landscape," in which a thirteen-year-old, Lucy, "simply disappears while she and the narrator, Lois, are having a pee in the woods at summer camp." The narrator "cannot – like Wordsworth for *his* Lucy – take comfort in the thought that *her* Lucy is rolling round in earth's diurnal course with rocks and stones and trees." Instead the narrator "imagines that Lucy is in the Group of Seven paintings hanging on her apartment wall, which 'open inwards on the wall, not like windows but like doors. She is here. She is entirely alive.'"[8] This image is remarkably like the final shot in Patricia Rozema's *I've Heard the Mermaids Singing*, in which the film's main characters, all of whom are female, walk through a door into a photographic darkroom that has transformed into a shimmering landscape. The underworld appears in other Canadian novels and films and it is noteworthy that these feature women or adolescents as their protagonists: the heroine of Atwood's *Cat's Eye* is a middle-aged woman who at the book's climax remembers how the childhood trauma of burial in a graveyard became a transformative and healing underworld encounter with a dark goddess figure. The pivotal character of Atwood's *The Robber Bride* returns from the dead to prey on the female friends who had believed they were finally rid of her evil machinations. The main characters of Margaret Laurence's *A Jest of God* and *The Fire Dwellers*, who are sisters, spend their childhoods living above, and in adulthood continue to be psychologically haunted by, the basement funeral parlour run by their father. The elderly woman who runs away from her comfortable Montreal home and marriage in Constance Beresford-Howe's *The Book of Eve* escapes to live in a basement apartment and undergoes a period of radical transformation, as, like the woman in Semchuk's narrative, she explores long-repressed aspects of her feminine identity. Robert Morin and Lorraine DuFour's 1984 video production, *The Thief Lives in Hell*, shot out the window of a second-floor apartment, is punctuated by phone calls to a suicide hotline and the explosive

7.8 Henri ROBIDEAU
Acts of God, Panel I
1998
76.2 x 50.8 cm

ramblings of a schizophrenic living on the floor below. Two recent commercially successful Hollywood movies written, directed, produced, or some combination thereof, by Canadians – Allan Moyle's *Pump Up the Volume* and Lorne Michaels and Mike Myers' *Wayne's World* – both feature adolescent lead characters who broadcast messages from the subterranean depths of their basements. In this they resemble the previously mentioned work-in-progress by Jeff Wall, based on Ralph Ellison's *Invisible Man*, a novel in which the main character, an Afro-American, forsakes his racist culture by retreating to an underground existence in a forgotten section of a basement in Harlem. In Michael Rubbo's 1990 film, *Vincent and Me*, an adolescent Canadian girl who aspires to become an artist and who is obsessed with the work of Van Gogh falls asleep on a houseboat in Holland. While asleep, she visits Van Gogh in a field in Arles, and returns to the present and the waking world with a Van Gogh painting in hand.

Henri Robideau's 1998 text and image work, *Acts of God*, begins with a panel of two photographs, mounted one above the other. The upper image shows the wall of a kind of cave into which skulls and bones appear to have been embedded, and which would be pitch dark but for Robideau's flash. The handwritten text below it reads: "My French Grampa insists, 'Remember your un, deux, trois and don't forget the ancestors in the Land of the Ancestors.'" Robideau's grandfather also tells him that "heaven and hell are right here on earth! You'll see. In no time at all, it's phsshtt!, rich and poor, out the same door." The bottom image of the panel is of a gravestone marked "Robideau," with the legs of a man standing behind the stone while a woman in the foreground walks away from it. In a reiteration of the Canadian theme of death within life the panel tells us that "Mom became quite the authority on time after many years of working in a clock factory. Thanks to her, the question, 'When will the world come to an end?' has an answer. She says, 'The world comes to an end every day for someone.'" *Acts of God* tells the story of Robideau's disenchantment with his native American culture, the decision to become a "Canadian Artist," and a move with his partner to Quebec, his own particular Land of the Ancestors, where things do not go well. This tale of woe is laden with images of suffering: a mouse caught in a trap, a plaster head of John the Baptist on a plate, and finally, a photograph of a newborn pig corpse in a glass jar, and a man passed out, or dead, on a sidewalk. A sign next to the remains of the pig says "Please Turn Pig Slowly." The text below the pig photograph reads: "Still, there must be a way to salvage something from all my years of Canadian Art struggle. It's too late to begin carving a likeness of myself into the Rocky Mountains, so in a desperate attempt to leave an enduring mark on Canadian Art I bequeath my body to the National Gallery with the stipulation that my pickled remains become a permanent back-lit installation piece." Despite the humour of Robideau's piece, the familar Canadian template of descent into the Land of the Dead and identification with trapped and dead animals, is evident.

George Steeves' *Edges*, made in 1979–89, is a series of diptychs that pairs black and white images of Steeves and his family and friends – including one titled "'Joe' the Macaw," in which a woman talks to a bird as she sits beside its cage – with non-silver images of mostly inanimate objects that are often hand-coloured in a highly expressionistic manner. *Edges* visually recounts a hellish voyage of death and a rebirth; at the heart of the series are several versions of "The Suicide Attempt of 1985," in which Steeves is seen in a hospital bed, hooked up to an IV unit, his face and hands bearing evidence of chemical burns. Coming from an entirely different photographic tradition, in the early 1980s Mark Ruwedel used a large-format camera to document spaces that constitute the borders between cemetery and non-cemetery land in New Jersey, Philadelphia, Montreal, and elsewhere, literally photographing a zone between the living and the dead. A series of landscape images made in the western United States while he was living and teaching in Montreal all have titles alluding to Hell: "Hell's Half Acre," "Devil's

The Road to Hell

Lookout," "The Road to Hell," "Devil's Speedway," "Devil Gate," and so on. Cheryl Sourkes' 1987 series of fifteen re-photographed hand-coloured and collaged transparencies of images taken from mythology, science, and the detritus of her everyday life is entitled *From the Book of Gates*, in reference to the gateways leading to the regions of the underworld. In an introduction to the series Sourkes explains that the images "are a possible version of the slow hours of the descent to the unconscious. Each photograph in the series *From the Book of Gates* is the nexus of a wisdom, or an ordeal in the journey through winter or darkness or life."[9] One of the most arresting images of the series, titled "The Dream in the Mirror," brings together, against a black background, red- and fawn-tinted re-appropriated images: drawings of Inuit masks, a schematic diagram of astro-nomical and meterological cycles, a two-headed snake whose shape duplicates that of fallopian tubes and womb, and an image that appears to be taken from an ancient Greek vase, of one woman caressing the genitals of another. That the series has at least in part to do with the meeting of an inner source of feminine strength in the unconscious seems to be confirmed by the preponderance of fem-inine symbolism in the images and the accompanying text, in which Sourkes

7.9 Mark RUWEDEL
The Road to Hell. From the
series *Pictures of Hell*
1996
60.96 x 71.12 cm overall

Facing page

7.10 Cheryl SOURKES
*The Dream in the Mirror,
From the Book of Gates*
1987
51.1 x 61.2 cm
Original in colour

refers to several mythological goddess figures, including Ishtar of Mesopotamia. "When I speak of the goddess I understand her to be woman, in some pure concentration of her attention,"[10] writes Sourkes. As in Semchuk's *Excerpts from a Diary*, in Sourkes' work what is found as the inner gates are opened is greater knowledge and appreciation of the feminine self.

In one of the oldest myths known to humanity, written on clay tablets in the third millennium B.C. but considered to be much older, Ishtar, also known as Inanna, Sumerian Queen of Heaven and Earth, descends to encounter Ereshkigal, the dark Queen of the Netherworld. In a mythical pattern that prefigures the Christian one, Inanna faces suffering, humiliation, flagellation, crucifixion, and death in the underworld, and then is restored to life from the Land of No Return. Inanna goes to the underworld to attend the funeral of the goddess Ereshkigal's husband, and is divested of a piece of clothing at each of the seven gates leading to the goddess's realm. She is judged by the seven judges of the underworld, killed by Ereshkigal, and her corpse hung on a peg, where it turns to rotting green meat. (One cannot help but consider, in this regard, Jana Sterbak's dress of rotting meat, *Vanitas: Flesh Dress for an Albino Anorectic*, Andrea Szilasi's 1996 "Hanging Figure.) Inanna is restored to life, and in the end it is agreed that she will spend half of each year in the underworld.

As in the myth of Persephone, the earth was barren while Inanna was absent below, as barren as the ground surrounding the grave site of Semchuk's grand-mother as Semchuk first photographed it. The Sumerians believed that one passed into the darkness and returned from it through Inanna's "door."[11] To Sylvia Brinton Perera, Inanna's voyage may be viewed as "a descent for the purpose of retrieving values long repressed, and of uniting above and below in a new pat-tern."[12] In our "perilous age,"[13] she contends, Inanna's retrieval of the powers symbolized in Ereshkigal offers our own culture a guide for recuperating a femi-nine spirit that has for too long been banished to the underworld. Again putting one in mind of Jeff Wall's photograph of an open burial pit full of sea life, Guy Maddin describes the pit into which will fall, at one point or another, all the char-acters of his 1997 film *Twilight of the Ice Nymphs*, as "the bog of the great under-world. It's going to contain blood, milk, wine, sperm, crystal objects pushed up from beneath, and then it's only appropriate that each character must bathe in this stuff so that they are a part of Mother Nature and [the] timeless power of the gods that are now forced underground by Judeo-Christian order."[14]

Next to the photographs Mark Leslie presents of his mother, dressed in black leather with whip in hand, is a text telling us that she works as an S & M domina-trix. "I don't believe I ever received a compliment from her that wasn't meant to diminish me in some way," writes Leslie. "The curious thing is that she now makes a living playing this game of putting people down or hurting them."[15] The colour photographs Leslie's mother has taken of herself in her working gear are framed in the book by two images of Leslie himself dressed in drag. He tells his reader, "I've only cross-dressed once before in my life. I don't know why but after seeing my mother in Alberta I felt compelled to dress this way. A man in one of the bars told me 'Tu es la plus belle.' When I went home and took off my makeup and became a man again, I was ecstatic."[16] The flagellation Inanna suffers in Ereshkigal's realm before she is impaled on her peg finds its parallel in Leslie's encounter with the dark and powerful "goddess" who is his mother; although she is poten-tially so destructive, when he identifies with her, he is empowered.

In Evergon's large-scale Polaroid polytych from the late 1980s called *The Three Fates*, three women play with strands of wool. They are the mythical old women who decide the fate of humankind, says the photographer. One gathers the yarn, one spins the life, and the one who cuts decides where the life will end.[17] The skulls that emerge from blackness in each of the end panels of this piece sit-uate these female Fates in the netherworld that is the realm of Persephone, Ereshkigal, and the Eye Goddess featured in Cheryl Sourkes' *From the Book of Gates*, whose eyes, observes Sourkes, are "spirals simultaneously moving towards birth and death."[18]

The film *It Starts With a Whisper* by Brantford, Ontario photographer Shelley Niro and filmmaker Anna Groneau concerns the search of a young First Nations woman named Shauna for a sense of positive cultural identity. Throughout the

film, Shauna negotiates her way between the upperworld reality of her everyday life, rendered in a manner that caricatures CBC docudrama, and a psychic underworld where she meets and is taught by the spirits of three wildly funny and eccentric "matriarchal aunts." These sections of the film are phantasmagorical, presenting a world that is separate from Shauna's "daylight" life but to which she, like Semchuk's protagonist, travels to find feminine wisdom that brings about personal transformation and empowerment.

A 1997 mixed media installation by Winnipeg photographer Diana Thorneycroft was entitled *slytod*, an allusion to the tag game she and her siblings played as children while living on a military base in the Black Forest of Germany. Thorneycroft has said that "tod" means "death" in German, and that "it is the notion of playing tag with death that permeates the installation."[19] The visitor to this exhibit entered a pitch black "underworld" that could be illuminated with the help of a flashlight obtained at the entrance, just as the photographs in the installation were created by Thorneycroft moving a flashlight in the dark over her constructed, studio environments while the lens of her camera remained open. The floor of the gallery was covered in leaves, and the space was rife with a sickly-sweet odour. Within Thorneycroft's shadowy reconstructions of forests and lakes, bound or masked figures, sometimes of indeterminate gender but most often women, hung tied in positions of crucifixion, or, as in "Untitled (Iron Lung)," 1997, lay totally constrained with only a bandaged, screaming face exposed. These women were orally probed with gynecological and other medical devices; another was tethered to a tree next to a hanging row of dead, skinned animals. Several of the photographs, like that of a bandaged and bound figure lying on a gurney, under which were piled stacks of plastic baby dolls, alluded to the death of a child; in "Untitled (Deceased Infant Mask)," a figure wearing what looks like an oxygen mask with a large photographic lens attached to its nose-piece lies in a baby carriage along with several fish. An image that was included in the *slytod* catalogue but not the original exhibit shows a woman, who has a mask attached to her face with gauze bandages, lying on a sheet with her legs spread, and her feet tied to a wooden structure on which a row of armless, plastic baby dolls with shaved heads and bleeding vaginas are lined up. The plastic tubes attached to the woman's genitals lead to the tiny masks attached to the faces of the female dolls. On the sheet next to the woman are an ice pick and other quasi-medical instruments.

Outside the darkened exhibition room, a glass case held painted, cloth rabbits hanging on hooks from a wire, and beneath them, on a bed of leaves, four mounds of white powder. Also displayed outside the room were wolf skulls, the "Deceased Infant Mask," which had clearly been made in part from a Canadian flag, and costume pieces like codpieces and chastity belts. Inside the gallery, Thorneycroft's photographs shared their subterranean space with masks fashioned from animal parts – hooves, bones, feathers and snouts – and medical and military equipment; the masks bore titles like "Snake Mask" and "Spider-Mouth

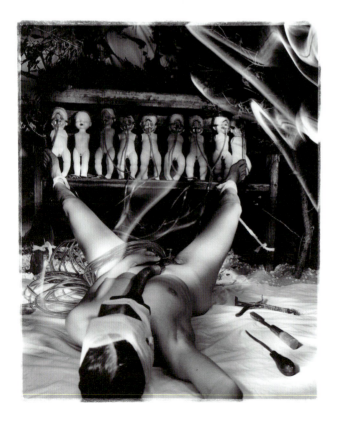

7.11 Diana THORNEYCROFT
Untitled (Iron Lung)
1997
76.3 x 93.98 cm

Above

7.12 Diana THORNEYCROFT
Untitled (Witness)
1998
81.28 x 71.12 cm

Left

Mask with Stethoscope." These photographs, like all of Thorneycroft's images, communicate great anguish, a particularly feminine suffering, like that of Inanna in the underworld; they are Canadian in their identification with the torment of women, and with tortured and dead animals. As in Sylvain Cousineau's *Mona Nima*, the most obvious allusion in these photographs is to the female experience of abortion or stillbirth, painful events that can bring in their wake profound psychological transformation.

(In a recent review of a book of Thorneycroft's photographs,[20] Kim Echlin also links them to the Inanna myth and "the tradition of female descent to the underworld." She writes that the myth "shows the essence of female transformation, how it demands her choice, compulsion, courage and finally adherence to the 'law' of the underworld." Echlin feels that Thorneycroft's images "capture the act of deliberate descent to the unknown.")

The 1996 Canadian film *Kissed*, directed by Lynne Stopkewich, tells the story of a woman who is erotically involved with the bodies of dead men, and obsessed with "crossing over" into the world of the dead. Near the end of the film the woman declares that "all transformation happens because life turns into death." Perera tells us that Ereshkigal, before being abandoned to the *kur*, the "alien place outside patriarchal consciousness," was, like the Greek Demeter, a grain goddess who lived on the earth. To matriarchal consciousness she represented "the continuum in which different states are simply experienced as transformations of one energy."[21] But to the patriarchy, the death she embodies becomes "a rape of life, a violence to be feared and controlled as much as possible with distance and moral order."[22]

Home When dealing with Canadian photography, one would do well to keep in mind the distinction that Perera draws between death as it is perceived from the respective viewpoints of patriarchal and matriarchal consciousness. As I have mentioned, it is easy to assume, as writers referring to the preponderance of death imagery in Canadian literature have done, that this fixation reveals a chronic sense of defeat and impotency latent within the Canadian spirit. When viewed in the context of the myths we are discussing here, however, the pervasive phantom-like presences and images of graves, tombstones, and entrapment of Canadian photography suggest a cultural imagination drawn to death, but not necessarily death as it is understood "from the perspective of the patriarchy," that is, death as total and final destruction. Rather, the death that is everywhere in our images and so easily misread is, I believe, death as perceived from what Perera calls a "feminine" standpoint, death as a process of inevitable and life-engendering transformation. I have argued that the subjects of many Canadian photo-

graphs, like those of Bancroft and Semchuk, exist in a metaphysical zone analogous to the transformative, death-like "betwixt and between" of traditional adolescent initiatory passage; the evidence presented by Canadian photography suggests that it is "feminine" transformation and maturation to which the death imagery seen over and over again in our photographs, novels, poems, films, and other modes of expression, ultimately refers.

Nor is it obligatory to read the recurring images of crucifixion in Canadian photography as emblematic of a country's sense of martyrdom and despair. When considered together with Henry Edelheit's understanding of crucifixion imagery in dreams as a signal of dual gender identification, and Victor Turner's description of the tribal adolescent initiate who is neither one sex nor the other and yet somehow both, these configurations of crucifixion take on a more hopeful meaning, one that has to do with the initiatory process that Canada as a culture is attempting to pass through. And if related to the Inanna/Ereshkigal myth, which pre-dates the Christian one and concerns itself with a feminine rather than masculine quest, the crucified women in Canadian photography speak not only of a loss of feminine values but also of the way back to them, through Inanna's "door." Understood from the standpoint of feminine consciousness, the "world below" is not necessarily the home of corporeal annihilation and the final loss of self, but is instead, like the Land of the Dead experienced by Inanna and Persephone, a site of fruitful transmutation. The crucifixion photographs of women made by Lambeth, Cousineau, Thorneycroft, Semak, Steeves, and others may have much more to do with Inanna rotting on a peg in the netherworld in order that profound metamorphosis can occur than with the image of Christ on the cross. From this standpoint we can begin to see that many Canadian photographs are akin to the images of Leslie's and Semchuk's narratives, because in one way or another they, too, point to the terrain of an underworld journey and a descent to the "feminine."

In response to a dream that began with her entry into a passageway under the earth, a woman wrote to analyst Linda Leonard that she felt she had "descended to the depths of pain, depression, and chaos where the powerful goddess Ereshkigal resides, where the possibility of feminine transformation still lives to empower women to face the masculine as an equal." In this woman's dreams, writes Leonard, "this sacred place was not above, but deep in the heart of the earth; not apart from finite physical existence, but in the very reality of her mortal human life."[23]

Despite the psychological suffering conveyed in many of the head and shoulder self-portraits that make up the bulk of Semchuk's series of photographs, what is striking is that in contrast to many similar portraits within Canadian photography, in Semchuk's images there is no feeling of dislocation from one's surroundings at all, but rather a sense that the subject of the images, in descending into herself, has found a certain grounding or her true "home," as Perera says of Inanna in the netherworld. It is also instructive to compare Semchuk's photographic narrative, concerning itself as it does with a return to the past of child-

hood and with marital breakup, to the ways in which similar concerns are dealt with in John Max's *Open Passport*. Where Max's sequence describes a fleeing from flesh, the instinctual, and the feminine, and no real transformation at all on the part of the book's protagonist, Semchuk's work involves an embracing of the body, the earth, and the feminine within herself. It leads, after relentless self-examination and the daring to confront painful regions of her inner reality, to spiritual change and renewal. Mythologically, this echoes Inanna's acknowledgment of Ereshkigal's suffering and the recognition of her underworld sister's feminine power. And the excruciating awareness of bodily processes and deterioration imposed on him by his disease forces the narrator of Leslie's book into the "reality of [his] mortal human life," as his coming to terms with the unfinished business of his past and his own impending death brings spiritual rebirth.

This same sense of being grounded in the "home" that is the feminine self is evident in Shari Hatt's 1993 photographic deck of cards, *51 1/2 Men in My Bedroom*. As in the Cal Bailey portraits discussed in chapter 2, Hatt's subjects are shown against a backdrop – in this case red and gold hangings that resemble theatre curtains, hung in what the title tells us is Hatt's bedroom – that has nothing to do with their own lives. These subjects, the fifty-one men and a boy, range from punk rocker and posy-bearing, gawky young man on a date to an Elvis impersonator and the "sensitive" man of 1990s advertising who is dressed in jeans with nude torso, holding a baby. The poses and costumes that make up their various personae indicate that they, like Bailey's subjects, have been removed from their own environments, but no sense of dislocation is evident, as it was in Bailey's series. This is because the men Hatt photographed reside in that psychic realm of images that Spignesi and Woodman consider to be the true "home" of the feminine spirit. Hatt's images of men are precisely that, inner images that together make up her archetype of the masculine.

Jin-me Yoon's self-portrait with the words "Home is Here" inscribed in the space normally reserved for the signature on a passport photograph was created as an anti-racist statement to be hung in the Vancouver transit system. But the subtext of the work tells the viewer that the sense of Canadian cultural dislocation addressed in Yoon's earlier *Souvenirs of the Self* – and heard in Northrop Frye's famous question with respect to Canada, "Where is here?" – is to be answered within her own, and the country's, feminine self. Of those images by Anne-Marie Zeppetelli in which spectral images of the photographer emerge from the shadows, many take as their subject matter what Zeppetelli calls *Home*, and portray the metaphorical "rooms" of a woman's life – "The Room of Childhood," "The Room of Love," or "The Study Room," for example. Aspects of Zeppetelli's imaginal life, these echo the various selves discovered by Semchuk in her own "descent to the feminine."

The journey Semchuk makes in order to meet the feminine power within, expressed as it is in a series of self-portraits that number out the days and record

subtle shifts in emotion and in one's relationship to the world over time, is suggestive of the female menstrual cycle. This most archetypal of feminine internal voyages, during which one is driven into the reality of the body and taken to ordinarily repressed regions of the psyche where profound metamorphosis can occur, when one "dies" to the old definition of self and then rises anew, is dealt with more overtly in Shari Hatt's 1992 series, *the jubilation of Eve*. In this work six women have been photographed from above in sections; each vertical, full-length, larger-than-life portrait of a nude woman surrounded by green vines is made up of six smaller photographs. These are hung facing six head and shoulder portraits of the same women with their eyes closed.

As in Hatt's earlier homage to the fourteen slain Montreal women, the women's faces in these smaller, 16 x 20 inch golden-coloured portraits are dotted with beads of water. Several of the women in the full-length images have blood between their legs; some have roses in their hands, one holds a skeleton, and another has a snake entwined in her feet. The references to death and menstruation together speak to the patriarchal disdain of the life of the body and the fear of physical death this ultimately masks, and to the fact that this contempt for nature has been projected on to women and the "curse" they bear. But the juxtaposition of the head and shoulder portraits to the skeleton and the blood also affirms that what seems like death, from the point of view of a culture in which the masculine principle has become over-inflated, may in reality have nothing to do with a threatening loss of the self. Rather, death is presented as a regenerative process to which one submits, without fear and in "jubilation," as part of a natural order, and from which one is born again, renewed. Hatt has said[24] that the water on the women's faces in the smaller portraits signifies that they have been purified, cleansed. As in other Canadian images, death here appears as a desirable transformation that is directly tied to the rhythms of nature, just as Semchuk's rejuvenation in *Excerpts from a Diary* is linked to these cycles by the seasonal changes evident both inside and outside her kitchen window. In a similar manner, Judith Eglington's 1973 sequence, *Earth Visions*, details the constant transmutation within nature of her human subjects; the dénouement of the book occurs with images of entry into cleansing, transformative waters. Cheryl Sourkes' images of feminine underworld power make recurrent visual allusions to natural processes of regeneration, and include, in the print titled "Gate Theory," a Persephonean ear of corn.

With a gallows humour that is typical of his work, Michel Lambeth presents the familiar Canadian conflation of life and death, and the ever-recurrent entranceways to the realm of the dead, in his photograph of the parking lot of the old Art Gallery of Ontario. Here parking spaces for the museum visitors, marked in large rectangular outlines on a brick wall, are labelled as if designated for long-dead artists Raphael and Michelangelo. In a Lambeth picture taken in 1960, a suburban family garage features both a real car and, coming out of the darkness

of the garage's interior, a smaller car only large enough to be driven by a toddler. The picture suggests the existence of a zone of darkness into which one travels and returns again, renewed. The same place of darkness appears in a Lambeth photograph made in Toronto's Union Station: in long shot people are seen drifting in and out of the dark rectangular entrances of an underground tunnel. The last photographic work Lambeth produced was a portfolio of ten prints of female genitals seen in extreme close-up, lit in a manner more evocative of medical photography than of Edward Weston. These do not seem incongruous in relation to his other work when one remembers that many cultures have worshipped women's sexual organs as gateways to the "other world," from which all life is born.

Silhouette For many years, when looking at Canadian photographs, I noticed over and over again a figure whose significance I was unable to understand at all, although now it seems obvious. This presence runs through photography from across Canada, in both street photography and highly subjective, narrative work, but I first observed it in Michel Lambeth's images. In 1965 Lambeth produced for publication in a weekend newspaper supplement a series of photographs called *Hospital with a Heart*; among them was, for its context, a curiously uniformative if emotionally resonant picture titled "Sunnybrooke Emergency, Toronto." In the centre of the frame, a man who is almost entirely in shadow sits on a bed or gurney, head in hand, while a nun who must also be a nurse, appears to comfort him. This picture always puzzled me, because it was one of the few Lambeth images in which human beings, who are ordinarily so estranged from one another in his photographs, appear to be connecting at all. Moreover, the man is presented as dazed, as if coming to not from any physical trauma but from an existential one. For some time this photograph held a kind of numinosity and mystery for me that an understanding of its documentary content did nothing to dispel.

The man in silhouette recurs again in another Lambeth image that at first appears self-explanatory – at the Canadian National Exhibition in Toronto two plump, middle-aged women sit in lawn chairs, and behind them one can see under the awning of a concession stand through to the fairground midway. On second glance, however, the picture is more disconcerting: the women's chairs seem to float, not touching the ground, and where the picture plane in which the women reside and the plane of the fairground beyond meet, that is, mediating between the "here" of the foreground and the "beyond" delineated by the rectangular opening of the kiosk, is the black silhouette of a man. In another Lambeth variation on this configuration from 1962, a man at the "Victory Burlesque" is clearly seen, but the almost naked stripper whose breasts he is so studiously examining is totally in shadow; she appears as a statuesque outline cut from the picture.

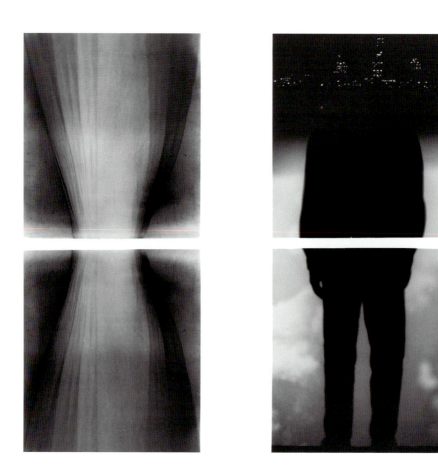

7.13 Louis LUSSIER
Vases communiquants/Communicating Vessels
Diptych
1995
169 x 81 cm each

Embedded as this dark figure always is in the social ground of Lambeth's photographs, it was difficult at first to speculate about the significance of its vaguely foreboding presence. Then I began to notice this shadowy silhouette everywhere in Canadian photography. Again and again in the various narrative sequences produced by Raymonde April in the 1980s, in *Personnages au Lac Bleu* or *Jour de verre* for instance, or in many of the twenty-five images of *Cabanes dans le ciel*, the mysterious black form, or a group of such forms, appears at the point of intersection of two picture planes, exactly where, for example, the outline of a window frame divides the image into two. Or the silhouetted figure exists alone, as the only subject matter of the April image. The shooting ranges and police academy instruction rooms Lynne Cohen photographed in the mid-1980s feature individual silhouette targets, or rows of them, and silhouette figures appear as well in several earlier Cohen pictures — in a model home, and on the walls of a health club and a roller skating rink.

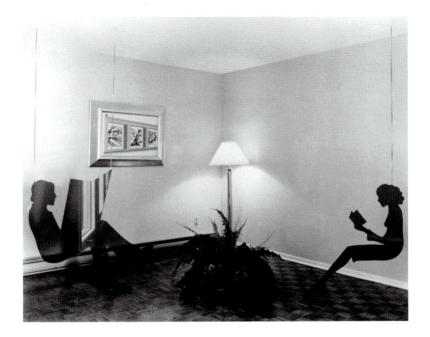

7.14 Lynne COHEN
Model Living Room
1976
111 x 129 cm

¶ André Martin's previously discussed series of colour photographs, *Anagrammes II (Souvenirs de Pina Bausch)*, are centrally placed portraits of a dark human silhouette, as Vancouver photographer Chick Rice's portraits, like "Tommy 1978–88," "Kate Positive, Winter 1982," and "Philip Negative, Spring 1982," are often totally in black or white SILHOUETTE. Denis Farley's 1989–94 *Études pour Caleb sèche* images show silhouette hands and feet, and a human profile whose silhouette doubles are reflected in a pool of water. A couple in silhouette, with their backs to the camera, look through a window at another couple, their doppelgängers existing in some other, parallel world, in Gaétan Charbonneau's 1988 "Sans titre, Montréal." Silhouettes dominate Louis Lussier's *Matière grise* series of photographs, like the silhouette that walks in profile next to an image of a winding staircase that leads to an open door in a 1995 diptych called "Le promeneur," or the male figure in silhouette that sits on a high bench, facing the camera, as if looking at the night-time city skyline that is seen through a window in the adjoining photograph in another, untitled diptych, or the silhouette butterfly trapped in a glass belljar, unable to reach the forest represented in an image hanging on the wall next to it, in the single photograph "Nature morte #3," 1991. Lussier's 1995 diptych, *Vase communiquants/Communicating Vessels*, juxtaposes two vertically split images. In one the head of a full-length male silhouette merges with the skyline of a city at night, and next to him is a vortex of movement

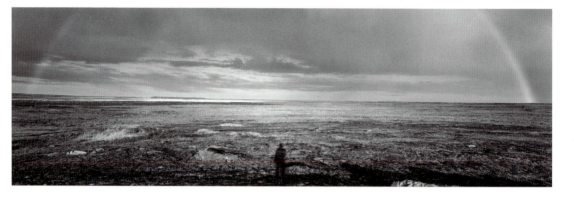

7.15 Richard HOLDEN
Arctic Panoramics,
May 21–June 29–N.W.
of Rankin Inlet, N.W.T.
1980
15.24 x 45.72 cm
Original in colour

7.16 Paul LITHERLAND
Fragile Fronts
1989
210 x 150 cm
Original in colour

7.17 Sylvain P. COUSINEAU
Silhouette. From the series
Mona Nima
1974
20.32 x 25.4 cm

reminiscent of many Claude-Philippe Benoit pairings of a concrete "here" and a blurred, abstract "elsewhere." In Sylvain Cousineau's *Mona Nima* the cut-out of a woman's profile on the painted glass of a door is entitled "Silhouette de Papier Noir," and in "Silhouette avec un Trou" the shadow of a woman's body falls against a crumpled white sheet that hangs from a ceiling and bears a cut-out hole at the level of her womb. A photograph from the same book shows a woman standing in profile; she holds a black cloth over her head and shoulders, so that she, too, becomes a silhouette. When Charles Gagnon, in a photograph from his Minox series, created, out of light, an additional window-like opening on a downtown Montreal street already full of such openings, he situated his dark shadow directly in the centre of this rectangle, as Richard Holden placed his silhouette under a rainbow that stretches across the sky of a panoramic colour photograph made in the Northwest Territories in 1980. In 1989 and 1990, Paul Litherland made a series of blue-toned prints constructed with photograms of a naked male silhouette who gazes down at his erect penis; the man stands at the centre of the irregularly shaped opening, which appears to have been ripped into the image. A white silhouette in the shape of a woman has been cut out of a photograph of trees and a lake in Shelley Niro's installation *Are You My Sister?*, leaving a white, woman-shaped opening in the landscape. In the next print in this suite of eleven photographs, the others of which are all portraits of women, the woman-shaped

landscape silhouette, toned orange, appears surrounded by blank white photographic paper, reminiscent of the isolated, cut-out children in Élène Tremblay's *Trous de mémoire*. Issac Applebaum's 1990 photographic installation, *Cruelty of Stone*, includes photoetchings on animal skin of walking silhouette figures; a dark silhouette stands inside a giant blossom that is surrounded by black in Hull photographer Marc Audette's colour image from the 1994–95 series *L'Intutition D'Ovide*. A silhouette descends an escalator in the top panel of a work from a series of paired photographs with text titled *Il y a des royaumes qui nous sont à jamais interdits*, made in 1988 by Jean-Jacques Ringuette. The bottom panel of this double work shows the floor of a desolate-looking kitchen, and the text, written by poet Gérald Gaudet, asks: "La cérémonie des … Est-ce bien la façon? Est-ce bien la manière de danser après le meurtre?" ("The ceremony of … Is that really the way? Is that really the way to dance after the murder?")[25]

Mireille Laguë's *Le Paysage Falsifié* – black and white images that are almost seven feet high – show full-length, shadowy silhouettes of a woman superimposed onto empty landscapes. The frontal form of a black silhouette is the central image in Cyndra MacDowall's 1987 sequence of eight photographs, *Some Notes on Ending*, in which a woman is seen acting out her feelings of grief at the termination of a love affair. MacDowall's 1992 "Eclipse" uses three images of the head and shoulders of a female couple, one of whom is in silhouette, to refer to the merging of personalities

that occurs within a relationship. In Saskatoon photographer Frances Robson's 1992/93 photo, "In the Darkly Purple Night Air," a yellow human silhouette in the centre of the frame is surrounded by a haze of purple. Michel Campeau's 1988 auto-biographical book of photographs and text, *Les tremblements du coeur*, is composed of well-known images from the history of photography, snapshots from Campeau's childhood, and his personal photographs, many of which are of his wife and child. Campeau more than once represents himself as a silhouette that is juxtaposed to the rectangle of a movie screen or a large photographic blow-up. Geneviève Cadieux's 1986 *The Shoe at Right Seems Much Too Large* is an installation piece in which two large, colour, backlit images are hung side by side in a darkened room. One is of the shadow of a woman floating over a pair of high-heeled shoes. Next to this is a skeleton-like tomogram, or medical image, in colour, of the inside of the body, of a person standing in the same posture as the shadow silhouette. Opposite these is the photo-graph of a pair of eyes, framed in a wooden box that suggests the stage of a theatre; a kinetic mechanism inside the box causes shadows to continuously move across the image of the eyes. In Bertrand Carrière's 1982 "Sur le Train entre Paris et Rouen, France," both the photographer's shadow and his reflection waver in the glass of a railway compartment window that looks out on the French countryside. Two people, seen from the back, their forms reduced almost to silhouette, look through a window

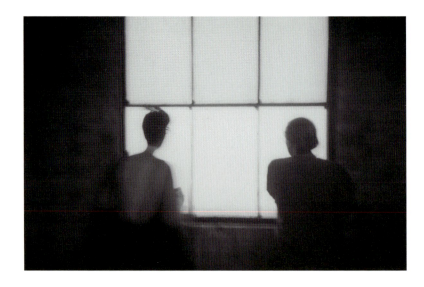

in Angela Grauerholz's large-scale 1988 Cibachrome photograph "Window," and in another Grauerholz image from 1992, "La Conductrice," a bus driver in silhouette looks out the front window of an almost empty bus; what is seen through the window is the mere suggestion of trees in a haze of white. A woman in a long nightgown, her head in silhouette, gazes out a window at the far end of an empty room on the upper floor of a building in a 1995–97 image by Suzanne Grégoire. Her hand rests on the window pane, and her posture suggests that she has purposefully walked across the room, drawn to the white light that is on the other side of the window.

The sequence of black and white photographs in Serge Clément's 1998 book, *Vertige Vestige*, is replete with both windows and silhouettes. Streets are seen through windows at night or through gauzy window curtains. A windowsill and the movement of a curtain are mirrored in the enamel paint of a door. A street full of walking shadow silhouettes, a lace-covered window, another smaller window, and a 1940s fan are collaged together by either superimposition or the reflection of light. A person of indeterminate gender is seen in silhouette in profile, sitting inside a car, against frost-encrusted car windows. A woman in silhouette holding an umbrella walks past another car window. A silhouette is reflected against a mesh door or window. A silhouetted man walks away through a door, a shadow couple embrace, and in the book's penultimate image, a male silhouette walks through a leafy opening that has been created by reflections on a pane of glass.

All of the portraits in Stephen Andrews' photographic installation *Facsimile*, which commemorates persons who have died of AIDS, are seen in silhouette; these images are reworkings, in graphite and wax, of obituary photographs that were sent to Andrews by fax machine. The large diptychs of Nicole Doucet's 1990 series *Témoin Rouge* couple photographs of small silhouette figures or figures whose faces are obscured in black, some of whom have been photographed out of doors at night, with texts which describe the passage of the human spirit from life to death.

7.20 Angela GRAUERHOLZ
Window
1988
121.92 x 162.56 cm

Facing page

7.21 Suzanne GRÉGOIRE
Untitled
1995-97
76.2 x 60.96 cm

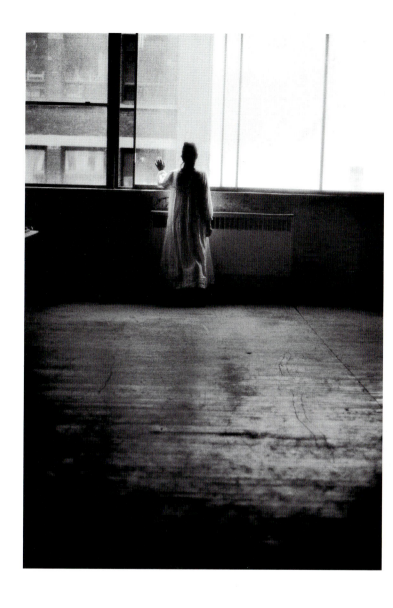

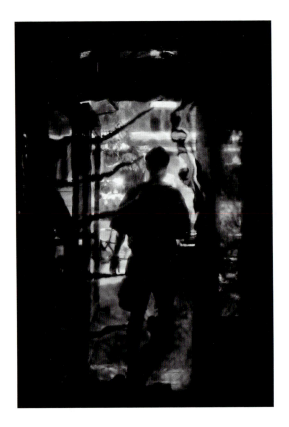

7.22 Serge CLÉMENT
Coulée, Québec, Québec
1996
83.82 x 114.3 cm

Photographers like the American Lee Friedlander and André Kertesz make use of their shadows when presenting socially charged or, in the case of Kertesz, what might be called "lyric" photographic moments. But I know of no other photography but Canadian where the shadow or silhouette appears in the way that it does, standing at the intersection of two zones of reality that have been articulated within one image, or, as in the work of April, Martin, Clément, Litherland, Laguë, Robson, and Lussier, where such a figure so often becomes the principal subject of a photograph.

The meaning of this figure remained obscure to me until *The Spirit Sings* arrived in the city where I was living. This was the much-criticized exhibit of First Nations artifacts organized by the Glenbow Museum in 1988 and circulated across Canada, and suddenly the exhibition's logo, a stylized rendering of an ancient two-sided Ojibwa shaman's drum, appeared everywhere, on posters and banners, throughout Ottawa. The form of the logo echoed the simple black silhouette figure that appeared on one side of the original drum. It then became evident to me that the placement of the silhouette found in Canadian photography – always alone or at the juncture of two zones of the picture, where one of those regions is in some way or other equated with death – would be consistent with the position of the

shaman, the psychopomp who like Persephone and Inanna can travel to the Land of the Shades and then return again.

Toward the end of his life, the aging uncle in Joy Kogawa's novel *Obasan* "got dizzier and dizzier ... By the time they got him to the hospital, his eyes were rolling." His daughter thinks "he was beginning to see everything upside down again ... the way we see when we are born." The narrator feels that for her uncle, "everything had started reversing and he was growing top to bottom, his mind rooted in an upstairs attic of humus and memory, groping backwards through cracks and walls to a moist cellar. Down to water. Down to the underground sea."[26] This passage brings to mind the disoriented man seen in silhouette in the photograph by Michel Lambeth, and suggests that he, too, might have been seeing "everything upside down." James Hillman remarks that in dreams the "hospital and doctor's office are not only ... places of getting better. They are also places where the collapse of the corporeal is given refuge,"[27] where "something material is losing its substance and thrust, where a physical impulse or animal drive is descending toward the underworld."[28] Instead of regarding such a dream image as "a neglected soul needing saving" or "medical attention," we may understand it as "a soul going through ... a movement like Persephone's fall into the chasm."[29]

Given Hillman's symbolic analysis, the man in Lambeth's hospital emergency room photograph, the only one in the image whose features are obscured in black, might be seen to be returning from that otherworldly realm that Lambeth obliquely refers to in almost every photograph he produced. The elements we are discussing exist almost below the threshold of conscious awareness in Lambeth's work, barely able to emerge from the hold of his ostensibly humanistic subject matter and his *Family of Man* documentary style. But what is nascent in his photographs becomes manifest not so many years later in the images of the Canadian photographers of the generation that followed Michel Lambeth.

In Evergon's *The Anatomy Lesson*, constructed in the late 1980s from six large Polaroid images, the head and torso of a pale and extremely thin young man are enveloped in darkness. Like the nun who comforts the patient in Lambeth's hospital image, a doctor tends to this deathly-looking youth, probing his side. The blackness that surrounds this "patient" is enclosed by a rectangular picture frame, and on the table next to him sits a skull. The visual nod Evergon makes to art history does nothing to obscure the basic Canadian schema of a rectangular opening into "another world" from which emerges a figure who appears to reside at once both outside life and in it, a psychopomp who can negotiate a "breakthrough in plane" between the "Great Above" and that dark realm of transformation, the "Great Below."

But then driving home, driving out of the hot red-brick streets and out of the city and leaving Miss Marsalles and her no longer possible parties behind, quite certainly forever, why is it that we are unable to say – as we must have expected to say – Poor Miss Marsalles? It is the Dance of the Happy Shades that prevents us, it is that one communiqué from the other country where she lives.

Alice MUNRO

Dance of the Happy Shades

Standing outside Club Elvis we did a strange thing. We shook hands. It was a long time since I'd felt Harold's hand. The last time I'd held it, he was lying dead in the hospital bed he had thought was a drawer or a coffin.

Matt COHEN

Last Seen

CHAPTER EIGHT

Underworld Geography

Fence The space in-between and the border, both so integral to Canadian photography, also have a presence within the imagination of other cultures. Margaret R. Higonnet writes that Gloria Anzaldúa's "meditations on what it means to be a Chicana lesbian poet" start from "the negative connotation of the border."[1] She quotes from Anzaldúa's *Borderlands/La Frontera: The New Mestiza*: "A borderland ... is in a constant state of transition. The prohibited and forbidden are its inhabitants. Los *atravesados* live here: the squint-eyed, the perverse, the queer, the troublesome, the mongrel, the mulatto, the half-breed, the half dead; in short, those who cross over, pass over, or go through the confines of the 'normal.'"[2] However, writes Higonnet, even though "the borderland originates as a negative site of exclusion, it can also become a site of self-performance where the intersection of allegiances or exclusions enables a creative distance from oppressive ideologies." Anzaldúa writes that "*I made the choice to be queer*," so "being 'both male and female,' she feels she has 'an entry into both worlds.'"[3]

Critic Emily Hicks has pointed out that in Mexican writer Federico Campbell's novella *Todo lo de las focas* (Everything About Seals), which takes place in the border region of the U.S. and Mexico, "two or more referential codes operate simultaneously."[4] Debra Castillo writes that "Campbell reminds us that illegal border-crossers ... are not '*mojados*' (wetbacks) but '*alambrados*' (fence climbers) or perhaps '*alambristas*' (high-wire walkers), who do not wade the river but instead confront the entanglements of the fence," a fence that "rises up to divide the nar-

rator's world, and to divide himself – a steel fence in the soul dividing self from body, spirit from mind."[5] The narrator is "caught on the fence,"[6] deprived of speech and turned into a 'bilingual cripple.'"[7] Seals, whose border-crossing abilities Campbell's narrator admires, are "evoke[d] … in a context of mutilation, or death." These seals "become associated with those other deformed 'halfway beings,' the human border dwellers, who also seem pathetic and mutilated when they cross the line from one space into another."[8] They "belong to two worlds and to neither."[9]

Several of the preoccupations that emerge from these tales of borderland dwellers are shared by Canadian photography: death, a dual sexual and gender identification, and an ability to "cross over" into other realms and to participate in two worlds at once. But it is noteworthy that in these works the bilingual who dwells at the intersection of two worlds is cast in a negative or equivocal light. In contrast to this is Linda Hutcheon's positive assertion that Robert Kroetsch and many other Canadian writers show us that the margins on which Canadians live "offer a paradoxical site of both influence and freedom from influence."[10] This Canadian periphery is "the place of possibility: Kroetsch's border town of Big Indian in *What the Crow Said* is deliberately on the border of Alberta and Saskatchewan; [Jack] Hodgins' Vancouver Island is self-consciously on the edge of the continent."[11] Ian Angus ascribes positive moral value to "[t]he wager of Canadian philosophy," which is "thinking civilization from its periphery."[12] Canadian photographs, as we have seen, often situate their subject and/or their viewers at a border site that is between "here" and "there," life and death, self and other, humankind and nature. This border-dweller can take the form of a protagonist in a narrative sequence, such as those of Marion Penner Bancroft, Mark Leslie, and Sandra Semchuk, or of a silhouette figure standing at the edge of two worlds, like those seen in individual images or series of images by Raymonde April, André Martin, Nicole Doucet, Angela Grauerholz, and many others.

Critics who are uncomfortable with the portrayal of the persons in Donigan Cumming's photographs insist that the photographer must somehow have manipulated his unsuspecting subjects into posing in a manner that, to these viewers at least, is undignified and patronizing, particularly toward the working class.[13] Many of Cumming's subjects *have* been caught in decidedly unconventional behaviour. In the 1990 series entitled *The Mirror, the Hammer and the Stage*, for example, people sleep on bare mattresses in bedrooms and living rooms with their clothing taped to the walls. Typical images from *Reality and Motive in Documentary Photography* include one of two women in hats and overcoats standing in a living room holding up a framed photograph and two statues of Elvis Presley; an older man, against a kitchen wall, dressed in underwear and a suit jacket decorated with military medals; and a man in striped boxer shorts facing the wall of a bedroom, as if he had been put there by a school teacher for misbehaving, while on his bed sits an assortment of real and stuffed animals.

Is the only possible interpretation of Cumming's work that economically disadvantaged members of society are being set up to be gawked at like the performers of some pathetic sideshow? Or, as his admirers would have it, that all of Cumming's strategies are meant to hugely exaggerate, and in so doing underline, the kind of intervention that is an inevitable part of the transaction between photographer and subject? While compelling arguments have been offered by both sides in the ongoing Cumming debate, ultimately the way in which the documentary content of his photographs is understood depends on who is doing the viewing and the context in which the images are seen. Cumming's work is often compared to that of American photographers like Diane Arbus, whose works raise similar questions, but when viewed alongside the work of other Canadian photographers, questions about the "social" message of these images become, in one sense, moot.

In *Dreamtime: Concerning the Boundary Between Wilderness and Civilization*, Hans Peter Duerr writes that "a reversal of the ordinary"[14] has been used since ancient times to indicate that one is dealing not with a being "inside" culture but someone who has at least one foot "outside" or "beyond" culture.[15] Duerr says that this inversion represented that which was not amenable to description in everyday language, to conceptualization within what he calls "the fence"[16] of civilization. He gives examples of such "contrarian" beings as the warriors of the Cheyenne nation who would say "no" when they meant "yes" and vice versa, and if asked to walk, mounted a horse; and the members of a medieval French order who in summer wore heavy fur coats and lit fires in their fireplaces while foregoing warm clothing in the winter. Cumming's subjects – who wear fur coats posing next to the beds in their hospital rooms, or military decorations while standing on their beds vacuuming – exhibit precisely this reversal of ordinary patterns of behaviour,[17] which Duerr sees as the mark of one who "smuggle[s] [him]self in between the worlds" of "ordinary" reality and the "beyond,"[18] and thereby attains a privileged vision of reality. In this respect, Cumming's photographs are but one more example of Canadian photography's persistent positioning of the subject in that place that is "betwixt and between" the worlds of "inside" and "outside," "here" and "there," life and death.

Duerr's book concerns itself with historical periods such as the Middle Ages, when "separations dissolved" and "the fence or hedge"[19] separating the domain of wilderness from that of culture was not considered to be an insurmountable boundary, as it is today, but a structure that could be crossed over. In archaic times it was understood that the "cultural" nature of humans was only one side of their being, "inextricably bound" to their other, "animal self," which became visible to those who "stepped across the dividing line."[20] Unlike our own, he writes, archaic mentality was characterized by the belief that "we can only know who we are if we experience our boundaries and, as Hegel would put it, if we thus cross over them."[21] To earlier cultures this meant "expunging the boundary"[22] sepa-

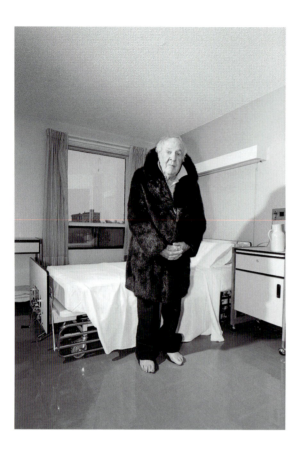

8.1 Donigan CUMMING
July 19, 1985. From the
series *Reality and
Motive in Documentary
Photography, Part 2*
1986
48 x 32.5 cm

rating human nature from animal nature. The shamans, who could transform themselves into animal form, were those who could "look their 'animal nature' in the eye, something usually kept under lock and key in their culture."[23] Canadian photographs like those made by Michel Lambeth, Diana Thorneycroft, and Evergon provide ample evidence of the degree to which we believe this "animal nature" to be sealed away from access in our own culture, and of our predilection for a shamanistic "crossing over" the frontiers of ordinary reality.

Duerr mentions that "Whites" used to call the members of small, non-Western societies "savages," a word derived from the Latin *silvaticus*, "of the forest" or "wild." This is ironic, he says, because these "savages" still had knowledge of their "wilderness." To them, "the Whites" are people who believe that the more they advance their fence into the wilderness the better they will understand the world, and who maintain that it is possible to understand civilization while staying inside its enclosure. This vision of Western culture corresponds to Ian Angus's notion of Canadian "border," which establishes a demarcation between civilization and wilderness without an attendant need to conquer the wild; Angus's border may be read as analogous to Duerr's "fence." As we have seen, Angus distinguishes the Canadian metaphor of the border "from the dominant metaphor of the United

States, the frontier," which leads to an "outward rush ... without limit" that "claims all of America for itself." For Angus, this attitude, so apparent in American landscape photography, has meant not an embracing of the wilderness but a domination of it, "a taming, a turning it back into 'Europe,' that is, civilization."[24] Angus says that Canadian social history was never articulated around a frontier in this manner because the government was always there first; "human order was almost always present, though not reducing the threats of nature or the encounter with wildness."[25] These differences can be observed in comparing the photographs of Canadian landscape photographers Thaddeus Holownia and Geoffrey James with the work of American photographers like Ansel Adams and others, which celebrate the monumental uniqueness of the American landscape as that nation's destiny made manifest. Holownia's 1989 book *Dykelands* was the culmination of ten years of photographing the Tantramar salt marshes at the head of the Bay of Fundy, where for centuries land has been claimed for human use by dyke walls holding back the sea, literally drawing a border between human life and nature, or "wilderness." Using, like Holownia, the wide sweep of the panoramic format, James, whose early work at least can be said to spring from the pastoral tradition of his English education, was engaged for many years in an ongoing photographic study of classical gardens, including those of France and Italy – topiarian specimens that were the epitome of the European "taming" of nature, of the rendering of nature "civilized."

Angus asserts that there is "a deep ambivalence in the English Canadian psyche. Fear of the wilderness, scarcity, leads us to despoil and take without thought of yesterday or tomorrow, but at the same time produces a staggering awe that looks back to the native people and ahead to a civilization that does not imagine itself omnipotent."[26] He says that these conflicting points of view are based in the same experience, the realization that the wild "does not need us ... Awe of unlimited and purposeless wilderness leads us to use it like a paper cup; and also to pause, take in the snow-blind, and create limits and goals without denying the wild – to draw a border, a limit."[27] The "English Canadian identity has been predicated upon a need to maintain the border between one's own and the Other."[28]

Duerr says that those members of earlier cultures who wanted to live consciously within the fence, to be consciously domesticated and dwell in the world of order, "had to leave the enclosure at least once in their lives"[29] and live in the wilderness. They would roam the forests as "savages" in order to experience, in the wilderness, the animal nature within themselves; they could know what "inside" meant only because they had once been "outside." So, for example, a West African witch would leave the everyday world and travel to "another world" that was a "companion" to the ordinary one. Her face would assume the traits of an animal, that is to say, her "animal" nature became visible. This, writes Duerr, signified a fundamental switch in the witch's mode of perception, and shows that she was able to "dissolve within [herself] the boundary between civilization and wilder-

ness,"[30] to cross the fence separating her "civilization side" from her "wilderness side," and so develop a consciousness of her "cultural nature."[31] The Canadian photographer, ever mindful of the "wilderness" on the other side of a window-pane "border" and of the "animal nature" enclosed in a glass case, demonstrates the ability to maintain a simultaneous awareness of both "inside" and "outside," "civilized" and "savage" reality.

Also relevant to Canadian photographic imagery are the cults that survived in marginal areas of Europe right up to the Renaissance, whose members fell into a catatonic state while their "souls" rode about on animals such as rabbits, cats, butterflies, and mice; they travelled "invisibly with their spirit, while their bodies rested." Whether they turned into animals or hybrid creatures or reversed their social roles, these groups were all seen to exist "outside of time," to have lost their normal, everyday aspect and become beings of the "other" reality, the beyond. Those who crossed this "border of knowledge" were considered to be neither of this nor of the other world; they were like the witch or *hagazussa* of the Middle Ages, so called because she sat on the *hag* or fence that passed behind the village gardens and, like Angus's Canadian "border," separated the community from wilderness. This *hag* was a being who lived "between" the worlds, participating in both "outside" and "inside" at the same time. She is like the goblin who "squats on the border and sees to it that … life does not congeal into a 'solid fortification.'"[32] Archaic societies accorded special privileges to wild and ghostly bands of youths who were treated as "dead" and who had the right to sit in judgment and to accord punishment because they had been "outside" the social order. It was *because* they were once "outside" that "they were able to recognize that order and thus maintain it.[33]

Several of the photographs in Anne-Marie Zeppetelli's black and white 1993–94 sequence entitled *Ritual* show the photographer both inside her house – placing a lit candle on a table, or writing in a large open notebook by the light of a lantern – and standing outside in a forest at night. In a large-scale, untitled Zeppetelli colour diptych, a fire blazes in a wood-burning stove, and around the room float several transparent, ghostly faces that are all the photographer's; in the adjoining image a huge full moon hangs over a trail of candles burning in a field of snow. Zeppetelli's shadowy, multiple faces appear again in the third panel of a colour triptych, this time at night in a forest that glows with red light. Like Zeppetelli's earlier *Home* series, these photographs were shot over several minutes while the photographer moved herself and various objects in and out of the frame, leaving phantom trace images of both these objects and herself. In another colour triptych, a woman's red-stained hands hold a small bowl of red liquid, and amongst the panoply of objects on the table in front of her are branches of spruce from the forest outside. In the adjoining image, we see blurred hands painting the pages of an open notebook that is filled with colour, and around the table she is painting on are several ghostly Zeppetelli faces.

The implication of all these works is that while the subject of the photographs is "here," "inside," aspects of herself are also actively engaged in a realm that is "elsewhere," "outside." Each series also suggests that it is the woman's creativity, music, painting, or writing that transports her to these "other" worlds, and that also enables her to give voice to the visions she encounters on her travels. Similarly, in Myriam Laplante's 1997 *Transit* series, a transparent woman sits in a chair, her eyes rolled upward as if she were in a trance, while three transparent versions of the same man hover over her. In another image, this transparent woman looks into the camera while what could be male, "spirit," aspects of herself walk in different directions around her chair.

While Duerr prescribes a return to an archaic understanding of the "other side," crossing over the boundary that separates the worlds doesn't mean, he says, "that we should endlessly move our fenceposts further and further into the wilderness and ceaselessly clear, work, categorize what is 'out there,'"[34] just what Ian Angus accuses the United States, with its "frontier" mentality, of having done. Rather, he advises, we ourselves should "turn wild," not so that we will "surrender" to our own wildness but in order to acquire consciousness of ourselves as tamed, cultural beings. Duerr writes that a society that is as unconscious of itself as ours is bent on subjugating the wilderness by either rejecting or "cultivating" it. In what could be a description of Arthur Renwick's photographs of First Nations artifacts "caged" in a museum of anthropology, or the premise of any number of Lynne Cohen images, he writes that what "was formerly a totem pole now supports the ceiling of a country home or adorns the garden of a museum as melancholy booty."[35]

As civilization has become increasingly complex, we have lost this archaic knowledge of the "outside" and dealt with the "other world" by repressing or "spiritualizing" it, says Duerr. An attempt has been made "to shoo the *hagazussa* off the fence, to chase her from the boundary of culture into the wilderness, from dusk into night."[36] Beings like the witch have thus lost their "double features" and come to represent more and more what has been disowned by culture. And so the "demons" who exist "between night and day,"[37] who have been chased into the wilderness, return now in a distorted and more threatening form. Once sent away, says Duerr, they "were not content to squat on the fence any more, they sneaked up the cellar steps at night and knocked on the doors."[38] As the central character in Margaret Atwood's *Cat's Eye* remarks, comparing our Hallowe'en to Mexico's All Soul's Eve: "We've rejected that easy flow between dimensions: we want the dead unmentionable, we refuse to name them, we refuse to feed them. Our dead as a result are thinner, grayer, harder to hear, and hungrier."[39] The many phantom beings of Canadian photographs may be signalling to us that because we have for so long repressed our own place "on the fence," denied our own "other face" (the face the young boy in the Michel Lambeth photograph sees reflected in the museum case that holds stuffed lionesses), what is disavowed returns to

haunt us, like the "ghosts" who torment the characters in Winnipeg filmmaker Guy Maddin's movies.

Duerr says that women have always been "on the boundary," open to the other world. All women are outside, he writes, but mermaids are "more outside" than all the others.[40] In non-Western societies like that of the Bakweri of Mount Cameroon, the "outside" world of the mermaids is also the realm in which women feel at home. A Bakweri woman who becomes possessed by a spirit being leaves the world of culture, dresses in a skirt made of bark, receives a mermaid name and learns the language of the mermaids, which is unintelligible to males. "She avoids contact with all cultural objects, especially those things made by Europeans or by men, and lives in a strange world inaccessible to men". But while she has become "ritually, that is *consciously*" wild, she has not, says Duerr,"*surrendered*" to the wilderness. And once she has been "outside," she is ready for the "inside," which in her community means prepared for marriage with a man. She is capable of culture in a "much more elementary sense" than the men, and her "ritually defused"[41] wildness will protect her community against an invasion of the mermaids into the realm "within the fence."

The narrative structure of Atwood's *Surfacing*, which created a novelistic paradigm of female quest, echoes that of the Bakweri mermaid's journey. The novel climaxes with a life-changing epiphany: after destroying the symbols of culture she finds in the cabin in the woods she has retreated to ("I rip one page from each of the books, Boswell and *The Mystery of Sturbridge*, the Bible and the common mushrooms and *Log Cabin Construction*, to burn through all the words would take too long. Everything I can't break, frying pan, enamel bowl, spoons and forks, I throw on the floor"),[42] the protagonist "dies" to her old self, and enters a state of ecstasy in which she feels herself metamorphosing into a wild animal, sleeping in a "lair," leaving her "droppings" on the ground. Like the Bakweri mermaid, who eschews contact with cultural objects, she is now "out." Her eyes fall on a frog and she knows that it "includes" her, she has broken through the barrier that separates her from the animals – animals that from the beginning of the novel she has seen slaughtered and victimized by male hunters – and through what she herself calls the "fence" that keeps the ghosts away. Once on the "other side," she meets the spirit of her dead mother.

A not dissimilar rejection of the products of culture and positioning of women "outside" the bounds of civilization have been observed by Linda Hutcheon in Robert Kroetsch's *What the Crow Said*. In this novel oral modes such as "animal (and animal-like) noises, folk legends, and, in general, the traditions of storytelling" are opposed to "what one character ... himself a printer – calls the 'Gutenberg conspiracy.'"[43] Hutcheon says that in that novel "Kroetsch creates a wonderfully absurd allegory of McLuhan's prophecies for the fate of 'typographical man.' He begins by taking literally the gender form of McLuhan's general label: it is his *men* who are print-oriented, who are therefore maimed and

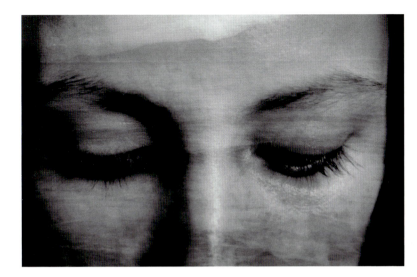

8.2 Anne-Marie ZEPPETELLI
Le Mauvais Oeil. From a series
of five prints
1998-99
0.61 x 0.91 m each

destroyed by their need to imprint themselves in a visual manner on their place
and time. His women, earthy and fecund, exist in another world, one closer to
the natural yet ritualized continuity of folk traditions."[44] Hutcheon says that
Kroetsch's writing has been seen by a variety of critics as "caught in fundamental
tensions characteristic of a border or boundary (or fence-sitting?) Canadian sit-
uation."[45] Similarly, the heroine of Marion Engel's *Bear* goes "outside" and under-
goes a confrontation with her "wild," animal nature and a transformation into a
regenerated, what she calls "younger," self, when she spends the summer alone
on an island with a bear as her lover.

The Bakweri mermaid is like the Inuit shaman described by Mircea Eliade
who is willing to see himself as a skeleton, to look death in the face. Both become
conscious of "life's limits" because they have flown beyond its everyday bound-
aries. This surrendering of ordinary boundaries Duerr links to the flight of the
shaman. With the relinquishing of personal boundaries, the "limits of our person[s]
now include matters we formerly saw as belonging to the outside world."[46] The
ordinary ego boundaries "evaporate and so it is entirely possible that *we* suddenly
encounter ourselves at places where our 'everyday body,' whose boundaries are
no longer identical with our person, is *not* to be found." Such an "expansion of
our person," says Duerr, could "easily be described as 'flying.'"[47] The female pho-
tographer in Patricia Rozema's film flies and has "heard the mermaids singing";
at the end of the film she enters with other women into the forest "wilderness"
of "another" world. In light of Duerr's research, the metaphor of the mermaid is
a particularly appropriate one for a Canadian photographer. Like the subjects of
so many Canadian images, the mermaid is "between the worlds" and so, like the
shaman, can present to civilized humanity a vision of its "other nature," and reveal
to culture its "double face."

Looking Inward The dark silhouette appearing in so many Canadian photographs directs the viewer's attention to the metaphysical realm of the shaman or psychopomp, the one Duerr says is able to look his or her animal nature in the eye. The shaman dwells at the borders, like so many inhabitants of Canadian photographs, and is able to "demolish the barriers between dream and present reality, [and] open windows upon worlds inhabited by the gods, the dead, and the spirits."[48] It is this shamanic capacity that the Canadian photographer tells us is the rightful heritage of our border-dwelling existence. Canadian photography is filled with indications that the topography our imagery reflects is not, despite appearances, a natural or societal one, but subterranean, that our photographs may be likened to a shamanistic travelogue from the Land of the Dead.

Years ago a student of mine, François Desjardins[49], working on a research project on the self-portrait in Canadian photography, pointed out that there seemed to be a great many Canadian photographers who presented themselves with their eyes closed. I have found Desjardins to be correct – Canadian photographers frequently portray themselves and others, particularly women, with their eyes closed, turned inward, or obscured in some way, or with their faces and heads covered. In many traditions of shamanism, during the shamanic seance a kerchief covers the medicine man or woman's eyes or even the entire face; this was believed to aid the shaman's powers of concentration. The women in the head and shoulder portraits of Shari Hatt's homage to the fourteen slain Montreal students and in *the jubilation of Eve* are shown with their eyes closed. These recall a series produced by Frances Robson in the early 1980s, of strips of photographs of three women of varying ages, all with their eyes closed. They resemble as well the many installation pieces by Geneviève Cadieux where the subjects of her photographs have their eyes closed or obscured in some manner. These Cadieux works include the 1989 triptych *Hear Me with Your Eyes*, in which two larger-than-life images, one in black and white and one in colour, of a woman with her eyes closed who appears, trance-like, to be crying out in pain or in ecstasy, are juxtaposed to an equally large black and white close-up of her mouth; and a 1991 diptych entitled *Parfum*, where a large black and white image of a woman's closed eyes is coupled with a very similar coloured image; both sets of eyes appear to be covered with mucus or to have tears in them. In Sylvie Readman's 1991 "Cinématographe" the rectangle of a drive-in movie theatre screen, photographed at night, has been printed so that overlaying it is the enlarged drawing of a closed eyelid. An upside-down pair of closed eyes, over which have been printed the trees and barns of a country farm, is hung below the image of a wheatfield, vignetted in black, in Readman's "On a Distant Horizon," made in 1993. Readman superimposes her own closed eyes onto a cityscape that is reflected in a windowpane in the 1993 "Autoportrait à la fenêtre." These large-scale Readman photographs bring together the Canadian dualistic paradigm, through the use of the screen and the window, and the inward-looking Canadian subject.

8.3 Sylvie READMAN
*Autoportrait à la fenêtre/Self-
portrait at Window*
1993
169.5 x 247.5 cm
Original in colour
(See also plate VII)

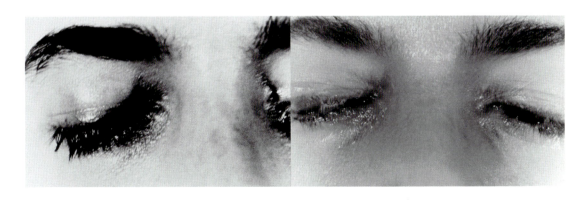

8.4 Geneviève CADIEUX
Parfum
1991
152.5 x 579 cm
Original in colour
(See also plate XIII)

8.5 Charles GAGNON
Drugstore – Greenwich Village, N.Y.
1968
35.3 x 27.8 cm

8.6 Geneviève CADIEUX
Portrait de famille
1991
Photographic Installation
230 x 230 x 30.5 cm each lightbox
Original in colour

Facing page

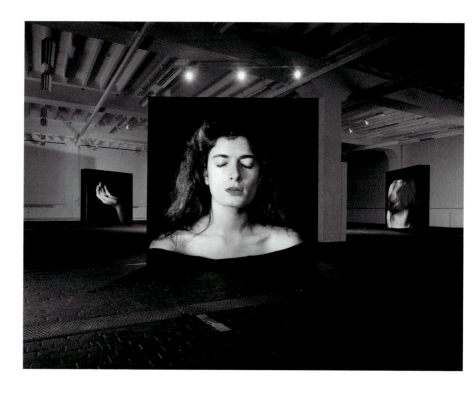

¶ Geneviève Cadieux's 1991 *Portrait de famille* consists of lightbox portraits of the photographer's father, mother, and sister, all of whom have their **EYES CLOSED**; the 1992 *Roppongi Project*, an *in situ* work installed as a billboard in downtown Tokyo, was made up of dozens of photographic close-ups of closed eyes, seen singly and in pairs. Charles Gagnon included at the end of a 1998 retrospective of his photographic works an image that, for him, was highly uncharacteristic because of the lack of "openings," windows or doors, ordinarily found in his work. "Drugstore – Greenwich Village, N.Y., 1968" was the photograph of a male mannequin's head in a pharmacy window; the model wears a black sleep mask over his eyes.

The subjects of David Rasmus's series of portraits of friends who have died of AIDS have their eyes closed, and their faces are partially obscured behind the flowers he has placed on their black and white portraits before rephotographing them in colour. Diana Thorneycroft's subjects, like the woman who wears a black eye mask, and whose open screaming mouth is seen from behind a transparent veil that covers her head and chest in "Untitled (Fish Bride)," 1992, have their faces swathed in transparent cloth or gauze bandages, or hidden behind masks. Even the stuffed animal in Jean-Jacques Ringuette's 1995–98 *De la vraisemblance, autour du personnage de Pierre Mouchon* appears with a piece of crumbled, opaque paper over his head in a photograph entitled "La naissance du visage."

In a sequence of five black and white photographs completed by Anne-Marie Zeppetelli in 1994, the central image is a self-portrait. The photographer appears to

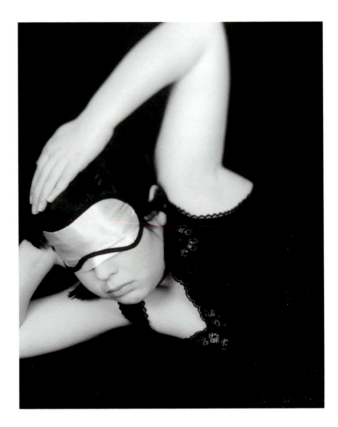

8.7 Marisa PORTOLESE
Untitled. From the
series *Amuletta*
2001
50.8 x 60.96 cm
Original in colour

be asleep on a pillow, her eyes are closed and her long hair flows around her head, and flames seem to rise from her chest and cover her mouth. It is only at second glance that these flames reveal themselves to be the reflection of light on the surface of the water under which, the viewer suddenly realizes, Zeppetelli is submerged. The other images in this short sequence, entitled *Birthday*, are of blocks of written text that have been dispensed by an antique fortune-telling machine; of the remains of a meal and a birthday cake lit with candles, and in a solarized photograph, of a piano on which sit candelabra, books, wineglasses, and sheet music. The final image is entirely black save for three spectre-like, almost transparent faces, all of which are the photographer's. In another Zeppetelli sequence of five images, created at the same time and called *Making Fire*, the photographer's head is shown in the corner of an image where she is also seen lying on the floor, with her eyes closed, in front of a pot-bellied stove filled with kindling wood. On top of the stove sits an old science text-book, opened to a page bearing the diagram of a butterfly. The image in the centre of the sequence is a close-up of a fire, raging in the stove. The closed or lowered eyes of the photographer signal in both these sequences, as they do in other Zeppetelli images, like the 1998–99 "Le Mauvais Oeil," that the events taking place are interior ones, part of a descent to a psychic underworld. Each sequence also indicates that what has taken place on these journeys inward is a kind of alchemical metamor-

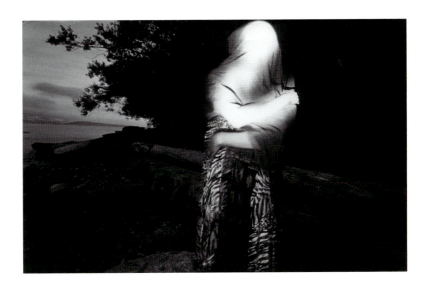

8.8 Judith EGLINGTON
Earth Visions
1972
Gelatin silver print
40.64 x 50.8 cm

phosis and rebirth, symbolically brought into being by the transformative agency of fire. In *Birthday* it is an image of the photographer's ghostly "spirit" selves that ends the series; this seems to indicate that it is these multiple, feminine aspects of herself that have been born. The last image of *Making Fire* is of the photographer peering through a framed glass, under which are pinned many butterflies, classic signifiers of regeneration from a death-like, "larval" state. The fact that these butterflies are dead and sealed under glass is but one more instance of the Canadian sense of the entrapment of the feminine spirit and the natural world, and of a constant identification of one with the other.

Nicole Doucet's 1991 video and photographic piece, *Alibi*, which in Latin means "elsewhere," explicitly links an inward-looking subject to a shamanistic journey to the Land of the Dead. The work begins with an image, printed on aluminum, of a person who is blindfolded; following this are black and white photographs of monuments taken in Père-Lachaise cemetery and a monitor built into the wall that is showing a video representing the voyage of the spirit from life to death. In the work of Judith Eglington, both the narrative sequence *Earth Visions* and her later sx-70 Polaroid work, people are seen over and over again with their entire heads wrapped in cloth; at a pivotal moment in the inner voyage of the protagonist in Normand Grégoire's narrative sequence of forty-eight images, *Polyptyque Deux*, published in 1970, a figure totally shrouded in a white cloth suddenly appears. Hamish Buchanan's *Veiled Men* series shows men, some posed as if laid out for burial, with bands of cloth covering their eyes, or fabric wrapping their faces and heads or draped over both their heads and bodies. Marisa Portolese's 2001 *Amuletta*, a sequence of twenty-four photographs that is explicit in its attention to the female rite of passage into sexual maturity, includes an image of a pre-pubescent girl whose eyes are covered in a pink satin mask. The Sylvain Cousineau book *Mona Nima* has several pictures of women with their heads and faces covered in cloth, including the photograph in which a

woman appears crucified and another where a black head covering turns a woman, seen in profile, into a silhouette. The image unites the familiar Canadian motifs of both shamanic silhouette and inward-looking subject. Many of Raymonde April's photographs, including several in the 1984 series *Debout sur le rivage*, show individuals covering their faces and heads with scarfs and other objects; in April's work these often appear in sequences which also feature black silhouetted figures.

The many Canadian photographs of individuals with covered faces and closed or obscured eyes underline the fact that it is an internal geography that our photographs make reference to. Seen in this context, the shrouded female prisoner of Moira Egan's *Détenue Voilée*, discussed earlier, takes on a significance altogether different from the obvious one – now it is the visionary capacity of the woman, her shamanistic abilities, that can be seen to be so threatening to the culture as to be "kept under lock and key." The subjects of the photographs of Cadieux, Hatt, and Readman, amongst others, are recognizably shamanic figures, in one way or another indicating that they are able to execute the difficult transition from the Land of the Living to the Realm of the Dead and the Spirits, and to return again.

In communities all over the world, throughout history, it has been the shaman, sorcerer, witch doctor, or medicine woman or man who in states of trance "dies," descends to the World Below or ascends to the heavens, and then returns to communicate to the living the secrets of the supernatural world. Within the cultures in which she operates, the shaman contributes to the knowledge of death, of "funerary geography,"[50] because the worlds she visits and the beings she meets during her ecstatic journeys in the beyond are described by her in detail during or after her trance. Members of her tribe then become familiar with the "infernal topography" that, writes Mircea Eliade, "all over the world the shaman was the first to communicate to the living."[51] Canadian photographers like Diana Thorneycroft, Cheryl Soukes, Susan Coolen, and Evergon may be seen to bring to *their* viewers visions of an underworld geography.

The Land of the Shades the shaman is able to travel to and describe is, according to James Hillman, a "psychic or pneumatic"[52] realm, one full of "ghosts, spirits, ancestors, souls, daimones."[53] Quoting Ovid, Hillman says the dead in this underworld are shades who wander "bodiless, bloodless and boneless."[54] To Hillman, entering this underworld means leaving "the perspective of nature, flesh and matter" for that of the "immaterial, mirrorlike images" the Greeks called *eidola*. The *eidola* of the underworld are essences, "ideational forms and shapes that form and shape life, but are so buried in it that we only 'see' them when pulled out in abstractions,"[55] as we can only see the images and constructions in Diana Thorneycroft's dark, "underworld" installation, *slytod*, with the aid of a flashlight. *Eidola* are "this world in metaphor."[56]

How like these shadowy, underworld *eidola* are the ghostly, homeless figures of Canadian photography. Hillman says that we are misguided when we attempt

to relate the *eidola* of our dreams to the material facts of our existence, even when these dream presences come disguised as people we know in our waking lives. These essences have their own reality, without reference to our daylight world. Canadian photographs, which so steadfastly refuse to point to any material fact in the world – in Barthesian terms, to "adhere" to their material referents – resemble in this respect, as well their phantom-like appearance, these spectral essences, the *eidola* of the underworld. It is this peculiar property, the *eidola*-ness, of Canadian photography, that is never addressed directly but is nonetheless so apparent in *Les images des autres*, Nicole Gingras's hauntingly beautiful film on the photographic works of Raymonde April, Johnide, Brian Piitz, and Sandra Semchuk, mentioned in chapter 2. This same metaphoric quality, this sense of image as pure image and never referent, is personified in the central characters who flicker in and out of black, like the ghosts of early film history, in Guy Maddin's macabre, death-obsessed movie dramas *Archangel* and *Tales from the Gimli Hospital*. The haziness of all of Angela Grauerholz's photographs, not only her portrait series, likewise situate them, like those of Karen Smiley, Anne-Marie Zeppetelli, and other Canadian photographers, in an otherworldly space. Northrop Frye may have felt that Canadian literature is "haunted by lack of ghosts,"[57] but in Canadian photography, they are everywhere.

Hillman distinguishes between the "body" or "ego" soul and the "shadow," "ghost," "death," or "image" soul.[58] The "body" soul and "death" soul are independent of one another. The "death" soul appears only outside the body and is dormant during the conscious, waking life of the individual, but becomes active during dreams, visions, and shamanic trances. While photographers in most countries, when photographing people, address themselves to the earthly "body" or "ego" self of their subjects, it may be said that Canadian photographers like Grauerholz, Zeppetelli, Cousineau, Smiley, and Laplante see and capture something analogous to the "death," "ghost," or "image" soul of the persons in front of their cameras.

Hillman stresses that the realm of the dead was "full of persons" and "everything in the dead's world [was] animated."[59] To the ancient Egyptian, for instance, there existed "no objective death in the sense of corpses as things without souls."[60] The metaphysical "elsewhere" and ghostly presences seen or referred to in so many Canadian photographs and films may have a great deal more to do with this "animated" underworld full of "death" souls than with the concrete, flesh and blood reality that is the stuff of American or European photography. The world of Canadian photography is one where, as in Jeff Wall's most well-known images, it is possible to picnic with the "Undead," for dead soldiers to talk, and for graves to be full of life.

Entrances or openings that mediate between life and death are constantly alluded to in photography produced in this country and in fact constitute Canadian photography's most predominant configuration. In all cultures where shamanism

is practised, it is felt that the shaman is able to conduct the dead person's soul to the underworld because she knows the entrances in the earth through which she can descend to Hell, or because she knows "the hole in the sky" through which she can fly up to Heaven. The shaman, like the Greek Persephone or the Sumerian Inanna, accompanies the "death" soul to the realm of the shades and "opens" the road of the extraterrestrial regions for the soul of the departed. Writing about Inuit art in *The Coming and Going of the Shaman*, Jean Blodgett states that within shamanic belief systems, illness is thought to be caused by the flight of the patient's soul. A fugitive soul may have been frightened away by evil spirits or stolen by a dead person reluctant to make the voyage to the Land of the Dead alone. In these cases it is the shaman who, in trance, undertakes a journey to the sky or the depths of the underworld to find the patient's missing soul, or who sends one of her helping spirits to find the runaway soul for her.

The passage into the place that is "somewhere else" is often posited in Charles Gagnon's street photographs as entry into the ground, a journey that since classical antiquity has represented descent into the underworld, the realm of the dead. Entrance into a subterranean world is proffered by a tunnel in Gagnon's "Underpass, Trees, Chemin de la Côte-des-Neiges – Montreal"; by a trap door in "Transformer Access – Westmount, Que."; by a manhole in "Near the Wadsworth Atheneum – Hartford"; a garage door in "9:45 p.m. – Banff, Alberta"; and by underground garages in "Parking Ramp and Flower – Montreal" and "Addington St., Garage Door – Montreal." What appears at first to be a wooden trapdoor on the floor of a forest in winter, in the black and white photograph Marie-Christine Simard used as the central image in her 1996 installation *Specimens*, upon closer inspection reveals itself to be instead discarded window frames, piled one on top of the other, with the top window slightly askew as if it were a lid to be opened. In *Specimens* photographs of a female nude that seems to have been left hanging from the ceiling in a darkened room, barely discernable shapes in shadow-filled interiors, and domestic details like a bowl of half-eaten cherries are shown encased in plexiglass boxes. The photograph of stacked windows, entitled "Ambre gris," which Simard features as the key to this grouping, presents, in the most unambiguous manner possible, the ubiquitous Canadian window as the portal to another world.

Ouverture Échappée Like the "missed opening" of Claude-Philippe Benoit's diptych "Ouverture, échappée," discussed in chapter 4, many of Charles Gagnon's photographs describe the thwarting of the possibility of a gateway into another world. In Gagnon's "Exit – Montreal," the door-like entranceway is closed, as are the faux-window indentations that might once have allowed for entry into another space but no longer do. The same impenetrability is apparent in "Building with

8.9 Marie-Christine SIMARD
Ambre Gris
1996
40.64 x 50.8 cm

8.10 Charles GAGNON
Exit – Montreal
1973
27.8 x 35.3 cm

8.11 Charles GAGNON
Corner of Girouard St.
– Montreal
1973
27.8 x 35.3 cm

Right

8.12 Charles GAGNON
Window with X – Montreal
1979
27.8 x 35.3 cm

Below

8.13 Charles GAGNON
Moving Truck, Hydrant,
Blocked up Door – Montreal
1977
27.8 x 35.3 cm

Flag – Ottawa," as it is in the darkened window of "Justice of the Peace: Near Poughkeepsie, N.Y.," which includes a smashed-up car as the embodiment of the disaster that can occur when no escape is available, and in the taped-up window in "Broken Plate Glass Window – Soho." In "Window with X – Montreal," the chances of admission through either an underground cavity or a window are both negated, by the "X" etched in the glass of the window and by the cover that closes up the grave-like structure next to it. In "Untitled – Montreal," entry is prohibited into the "Blue Room" of the business whose closed-off window Gagnon has photographed, and so, as in other photographs, Gagnon uses the reflection of the street behind him to produce the illusion of a window entrance. The escape that is only illusory occurs again in "Plants, Montreal Museum of Fine Arts – Montreal," where a real exit sign is posted above the doors at the top of the stairs and a spectral one is reflected in the glass of the museum guard rail. People in Gagnon's 1977 Minox series, if they are seen in close-up at all, are shown from behind a car windshield, as if the photographer were situated on the "other side" of one of the openings his photographs, in one way or another, so consistently present. In Gagnon's "Bank Vault with Truck and Man – Montreal," a truck is parked on an empty street, its back doors seeming to offer rescue from the imposing, box-like appendage that threatens to fall off a building and onto the sidewalk; in "Moving Truck, Hydrant, Blocked up Door – Montreal," a ramp leading into the rear of a truck might provide an exit were it not for an obstacle in the way. In "Corner of Girouard St. – Montreal," steps lead up to the door of a suburban home, while other doors appear at the rear of a truck parked in the street. The exit from the

8.14 Charles GAGNON
Cleaner, Mailbox, Sign, Plant – Montreal
1976
27.8 x 35.3 cm

world these trucks might offer may be forbidden or may not always be possible. This is suggested in "Cleaner, Mailbox, Sign, Plant – Montreal," in which a sign indicates that trucks are prohibited. This Gagnon photograph lends itself to comparison with similar photographs of innocuous urban or suburban streets taken in the 1970s and 1980s by photographers such as Stephen Shore and Lee Friedlander. The overriding feature of the American photographs is the banality of the environments they were taken in, with the visual puns the housing developments and small towns offer affording the photographers a kind of tawdry consolation prize. While a photograph by Gagnon may look like these ironic American street images, his use of the vernacular material of the streets is radically different. In his photographs, windows, piles of dirt, trucks, and, in this particular case, a sign that reads "no trucks allowed," have been transposed to metaphor. Here the truck is not a truck, but a transit out of everyday life; perhaps it is even death.

Gagnon's entrances and exits are ambiguous: given his many images of nature entrapped, they might be read as doorways out of a forlorn world eviscerated of life, leading away from a self in which instinct has been eradicated, or they may instead be interpreted as portals to mystical ecstasy, analogous to the magical gates of the shamans, for whom the road linking the Land of the Living and the Land of the Dead remains open. Whatever the case may be, it would seem that when the exits and entrances in Gagnon's photographs are blocked, we are presented with the despair of a consciousness unable, at least for the moment, to achieve transcendence, to descend to the "feminine," shamanic zone of the imaginal.

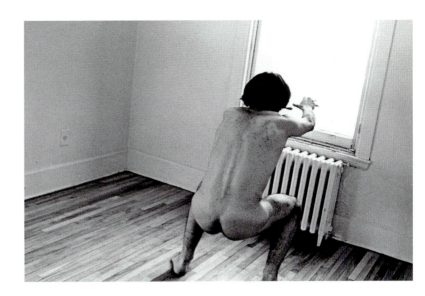

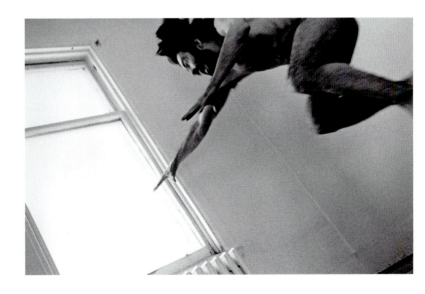

8.15 Normand GRÉGOIRE
Polyptyque Deux
1970
16.3 x 24.4 cm

Above

8.16 Normand GRÉGOIRE
Polyptyque Deux
1970
33.5 x 49.3 cm

Below

Using a metaphoric, theatrical photographic syntax that was shared by several Quebec photographers of the 1960s and 1970s, including John Max and Judith Eglington (and the legacy of which may be seen in the works of Michel Campeau and, to some extent, Raymonde April), Normand Grégoire gave expression to a similar desire for transcendence and the thwarting of that desire, using iconic elements that are very close to those of Gagnon, even given the more restrained idiom of Gagnon's street photography. Where Gagnon finds anonymous window openings in city streets, Grégoire employs the solitary window of a bare apartment, but both photographers use these openings to point to a particular order of metaphysical pursuit. The second image of Grégoire's 1970 National Film Board *Image 7* publication, *Polyptyque Deux*, shows a naked man in an empty corner of a white room, poised as if to jump through a closed window, through which is seen only an expanse of white light. A shrouded figure appears, and then the naked man seems as if he is flying toward the window, his face contorted in a scream. These images are juxtaposed to others of shapes embedded in the visual static of television "snow," including a split-screen image of a helicopter; the head and shoulders of a man whose face is covered in goggles, what could be a gas mask, and a scarf; and the close-up of a fly on the screen of a door or a window. The male figure embraces a woman by the window, and a few images later we see snow falling in front of an apartment building, and then the closed window from the outside. Superimposed onto this is a transparent male figure in a dark coat, who, spirit-like, enters the window carrying a long, coffin-like box. A few photographs later the man and a female companion are seen wading through a blizzard of the television "snow," both holding long boxes, and then he is seen alone, again poised as if to fly out the window. The tableau that follows is like an image of a medieval Dance of Death – the couple, in silhouette against the sky, hold their long boxes above their shoulders, covering their heads; in the very next image the man grasps at the image of a window projected onto a wall. The sequence ricochets between frantic attempts at escape through the window into some other register of being, and the encounters with a feminine presence and with death that take place in the zone Grégoire represents by the use of television interference. In the last photographs of the work, the darkened figure of a woman walks through the kind of horizontal lines that appear on the screen of a malfunctioning television. This is followed by an image filled only with these lines, then a blank white page, and in the final photograph, the naked man is in front of his window, readying himself for flight again.

Although Grégoire's use of television imagery is at times awkward and heavy-handed (one incongruent photograph is of television graphics that read "things go better with Coke"), even the most sophisticated of Canadian photographic work carries this underlying paradigm of flight into, and return from, a zone that can only be alluded to through signifiers of death. The white light that is seen through Grégoire's window is not so dissimilar from that which glows on the other

side of the windows in several photographs by Angela Grauerholz, for example. The Gagnon and Grégoire photographs of openings, exits, and moments of transcendence could serve as an emblem for all of Canadian photography. In Canadian photography a choice is presented: on the one hand, to remain stuck in the desire to separate oneself from the life of the body and the body of the physical world — to fly into the head in the manner of an anorexic, to rip image from referent, to flee from the mother and the feminine, like the protagonist of John Max's *Open Passport* — or, on the other hand, with our dual awareness of "under" and "upper" worlds, death as well as life, to "cross over" and explore realms that are outside "civilization" and the "daylight" world.

It seems that the Canadian collective imagination is able to express its privileged relationship to the unconscious and to the realm of images that is the underworld through symbolism that corresponds to the cosmology of shamanism. For example, the motifs that occur in shamanic initiations performed all over the world appear to a remarkable degree in Canadian photography. Just as the adolescent undergoing tribal initiation is considered to be "dead," and in some cultures is actually buried, the candidate for initiation to the vocation of shaman, too, enters a "larval existence, like that of the dead." She is, like the subjects of initiation rites, "assimilated to the dead,"[61] just as Janieta Eyre, Jeff Wall, and Stéphanie Beaudoin have posed as if dead in their photographs. She might wear a funerary mask or have her face or body rubbed with ashes or other substances, to give "the pallid hues of ghosts,"[62] like the persons in Judith Eglington's *Earth Visions*.

The future shaman in dream or trance "sees" her body being tortured or violently dismembered by demons or ancestral spirits, who, playing the role of masters of initiation, "kill" the novice. She watches them, for example, cutting off her head or tearing out her tongue. Her eyes may be torn from their sockets, she may be cut into pieces, reduced to a skeleton, or her hands chopped off; she is then returned to life with a "new" body full of magical powers. Initiatory dismemberment or chopping up of the body appears in a series of portraits of women produced by Shari Hatt in 1991 entitled *Consumption*. Each of the women in the series is costumed to correspond to patriarchal stereotypes of the female; portrait titles include "Virgin," "Bride," "Whore," "Castrating Bitch," and "Feminist Dyke." In each, there are pieces of food on the women's lips — the Virgin has a small fish slipping from her mouth, cake and icing have been smeared across the face of the disgruntled-looking Bride — and the props in their hands — a bouquet for the Bride, a pair of scissors for the Castrating Bitch — are signifiers of the caricatural roles assigned to women within male-dominated culture. The arms of the women have been cut off: the portraits are composed of three sections, a central panel for the torso and a side panel for each of the women's outstretched arms. Like many other Canadian photographs, those of Cheryl Simon and Nicole Jolicoeur, for example, this series alludes to the suppression of feminine power; like the heroine of the Grimm Brothers' tale "The Handless Maiden," each of the women

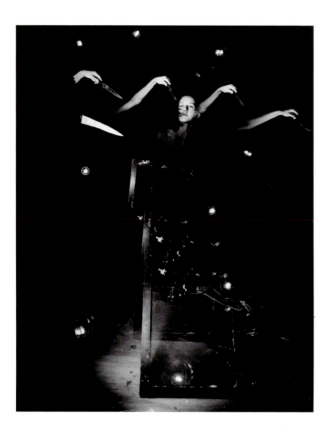

in these images has had her feminine potential severed by the symbolic Fathers who value her only in relation to their own desires. As with the candidate to shamanism, each "witnesses" this desecration of her body, a "death" of herself.

Evergon's colour photographic construction entitled "Self-Portrait" includes a polar bear skin, a large knife, and a split-open watermelon that, because of the red backlighting in the image, seems to "bleed" onto the bear's skin. This brings to mind Eliade's tales of the traditional devouring of Inuit candidate shamans by polar bears who reduce the initiates to bones. At the centre of a short sequence of photographs made by western Canadian photographer Barbara Spohr around 1980 is the image of a large kitchen knife, photographed at menacingly close range, stuck into a table top; next to this is the picture of a large, glowing heart. Following these is a photograph of a ceramic "leaping fish," the Buddhist symbol of the mind that can, like the shaman's, execute the passage in consciousness from the human realm to that of the spirits. In Susan Coolen's 1993 *Dreaming* series of self-portraits, the photographer appears, as is the case in many of her photographs, as a transparent, spectral presence; in one image her face is bloodied and she is surrounded by floating hands, all bearing large knives.

Eliade's Inuit shaman could see his own skeleton, and Blodgett recounts that under certain circumstances the shaman could become transparent, like Coolen's

and Anne-Marie Zeppetelli's self-portraits, like the transparent figure entering a window in Normand Grégoire's *Polyptyque Deux*, or like the silhouettes that inhabit the landscape in Mireille Laguë's *Le Paysage Falsifié* or float in Geneviève Cadieux's *The Shoe at Right Seems Much Too Large*. Then others could look through the shaman and see her skeleton as, courtesy of medical technology, one sees inside the body in the Cadieux work.

Helping Spirits The animal companion is a predominant feature of Canadian photographic imagery, seen in photographs from the straightforward street photography of Tom Gibson to the "directorial" productions of Evergon. The people in Gibson's images appear to be closely connected to animals; they often wear the skins of animals on their backs, or their clothing bears animal designs. In one Gibson image, a woman approaching the camera has elephants knitted into her sweater and the man walking toward her has a pheasant on his. The subjects of Gibson's images are also frequently tied to their animals by leashes, and more often than not it is the animal who appears to be leading its human "owner." In a Lynne Cohen photograph, the wall next to a bed covered with a fur spread and pillow is hung with a black bear skin; this fur silhouette seems animated, poised to leap off the wall. That the room is otherwise totally empty and the fur on the wall is lit by a spotlight enhances the comic sense that the human occupant of this lair/room has transformed into animal form.

Evergon has consistently paired his human subjects with animal and/or bird "familiars." In a print called "Gyrfalconmen Mating," from the 1979 *Paper and Porcelain Men* colour xerox series, a man whose head and shoulders are covered by a bird reaches out to kiss another, similar bird; in the 1979 Xerox *Bum Print Edition*, men's bodies are entwined with that of a salamander, and a man in the sky has a bird on his back. The subjects of the 1982 colour series *Torsos with Light* have their chests covered with fish, birds, or horses, and those of the 1983 *Caucasians in Birdland* are coupled with magpies, cockatoos, toucans, and flamingoes. A young girl lies entwined with a peacock in the 1989 polytych of five large-scale Polaroids called *Peacock and Night Rider*. Animals and birds also accompany humans in Evergon's *Bondage Scapes*, and the men in his ongoing *Ramboys —A Bookless Novel* transform into human-ram hybrids with the aid of masks and headdresses.

Blodgett writes that the shaman, "unlike his fellow Inuit, was capable of dealing with evil spirits, malevolent forces and the deities."[63] An essential dimension of the shaman's initiation was the acquisition of helping spirits, who were frequently animals and who assisted him in his transactions with the supernatural. It was "through them that the shaman communicated with the forces that ruled the earth."[64] The identification with animals evident in the photographic images of

8.18 Élène TREMBLAY
Excerpt from the series
Ne Tueras
1992
40.64 x 50.8 cm
Original in colour

Right

8.19 Sandra SEMCHUK
*Self-portrait (from the
land location series), RR6,
Saskatoon, Saskatchewan,
May, 1977*
18.8 x 23.8 cm

Facing page

Michel Lambeth, Tom Gibson, Evergon, and many others indicates that when they are no longer "kept under lock and key" or trapped behind glass but related to in a conscious way, animals in the Canadian psychic landscape may function as psychopompic companions in a symbolic descent to the imaginal underworld.

Not only can the shaman take possession of his animal spirits, he can turn himself into an animal as well. To assume this new identity, he dons the skin of an animal or clothing decorated with the fur of his familiar, like the people in the photographs of Tom Gibson and Donigan Cumming; he might put on an animal mask, like Evergon's Ramboys or the persons in Diana Thorneycroft's images. Several distinctively Canadian motifs come together in Élène Tremblay's 1991–92 colour series, *Ne tueras*, where animal shapes, a bear or a deer, for example, have been cut out of the landscape. These white silhouettes, reminding one highway "animal crossing" signs, may be read as entranceways into a realm beyond the natural, or, like the many other silhouette figures in Canadian photography, they may be taken as well as signifiers of (in this case, animal) psychopomps who, like

the shaman and her familiars, can traverse the boundary between life and death. At the same time, the loss of animals in the landscape, which these cut-out forms suggest, reiterates the concern with threatened animals that is evident in many Canadian photographs. In a more recent series by Tremblay, oblong-shaped openings seem to have been cut into a colour landscape image; these forms reappear in an accompanying grid of toxic-coloured cut-out "lakes." One of the Paul Litherland silhouettes discussed earlier is placed in an opening that is surrounded by animal fur, signalling the presence of an animal spirit that accompanies the psychopomp in the descent through the door to the underworld. There are indications in Semchuk's *Excerpts from a Diary* that during her symbolic descent to the underworld she transposes into animal or bird form. The fur around the hood of her parka in one self-portrait seems to be growing from her head, and in another, the full sleeves of her blouse flap in the wind like the wings of a bird ready for flight.

Of all the shaman's powers, the most awe-inspiring is her ability to "fly," linked by Duerr to the ability to cross the "fence" of civilization into the wild. As illustrated by Evergon's many series of humans accompanied by, or riding on the backs of, bird "familiars" and the self-portraits in which Semchuk appears to be transforming into a bird, the capacity for flight is alluded to again and again in the work of Canadian photographers. In fact, there are few Canadian photographers who have *not* created images that make reference to the passage into another zone of reality, either by flying, descent, or, as we have seen, by simply mapping

8.20 George STEEVES
Christmas, "Fallen Bird," Ellen's Wedding Dress. From the series *The Pictures of Ellen*
1981
20.32 x 25.4 cm

Left

8.21 Hamish BUCHANAN
Detail from *Some Partial Continua, Sequence 6*
1991-96
126 x 20.4 cm
Original in colour

Facing page, above

out an opening into another world. Wings appear throughout Anne-Marie Zeppetelli's *Home* series, floating in the air by themselves or attached to women's clothing. Floating wings appear in Susan Coolen's ghostly self-portraits, alongside images, like the one described above, where she seems to be passing through a shamanic-like dismemberment. Coolen's 2001 installation *Be the First Woman on the Moon* includes a sculptural board game: each station of the game features a photograph of an object specific to female life, as well as an instruction; with the image of a sanitary pad is the legend: "You Didn't Get Your Wings. GO HOME," and with a pack of birth control pills, "Operating Costs Too High. LOSE 28 DAYS." Her equally humorous 1997–98 *Astral Projections* incorporates black and white prints of saucers that were literally flying, a cleverly lit burnt potato posing as a view of Mars, and other transformed domestic objects; her 1998 "Celestial Bodies" projected images of stones "floating" in dark space onto semi-translucent scrims, arranged in a labyrinthine configuration through which the viewer was invited to walk. Christos Dikeakos's rephotographed and hand-painted collages, made over a ten-year period beginning in 1976, centre around the thwarted flight of Icarus and his failure to transcend the bounds of human physical and spiritual limitation. In addition to mythological drawings, news photographs, and found objects, the collages include appropriated Eadweard Muybridge photographs of human locomotion, many of which have wings sketched or painted on, and many other visual allusions to flight, as well as shamanic images of skeletons, human beings with wings made only of bones, and women who are half-flesh, half-skeleton.

8.22 Lynne COHEN
Flying School
1980
111 x 129 cm

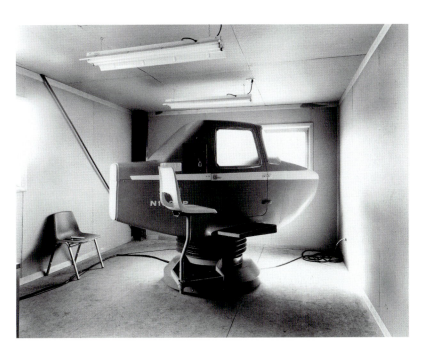

8.23 Raymonde APRIL
Excerpt from *Une Mouche*
au Paradis
1988
170 x 120 cm

Thwarted flight is alluded to in images as dissimilar as George Steeves' 1981 photo, titled "Christmas,'Fallen Bird,' Ellen's Wedding Dress," of a woman splayed face down on a rug, wearing a a white satin gown and a stole that seems to erupt from her shoulders like wings; in the claustrophobic rooms that house tiny, permanently grounded training airplanes in Lynne Cohen's various "Flying School" pictures; in Diane Poirier's 1988 series of painted-on photographs, entitled *L'Avion frappé par la foudre* (Airplane Hit by Lightning), in which a cardboard plane is made to crash and descend into water by the intervention of a human hand. Like Charles Gagnon's taped-up and broken windows, in all these images flight from the material world is shown to be an unattainable desire.

¶ Grown men play with toy airplanes in a field in a photograph by Tom Gibson. Like the heroine of *I've Heard the Mermaids Singing*, the young woman in a series of colour self-portraits by Laurie MacMillan flies through the air. In the 1990 "Self-Portrait (Dog Face Father Mask)," Diana Thorneycroft lies on a quilt wearing a plastic dog snout, fake breasts, and, over the eyes and forehead, a photographic mask of her father's features; her eyes, or those of her father in the photo-mask, stare at the toy airplanes that glide in front of her. A slender, sexually ambiguous figure, who is holding a life-sized baby doll and whose face can be partially seen from behind a mask made from the photograph of a middle-aged man's face, stands in front of a wallpaper backdrop that is covered in clouds and airplanes in Thorneycroft's 1990 "Self Portrait (Father and Child with Clouds)"; a model plane dangles over, and grazes, the body of this figure. Planes seem to fly over the masked body holding a plastic baby in Thorneycroft's "Self-portrait (Father Mask Water Dream)," made the same year.

Hamish Buchanan creates constructions of coloured and toned photographs mounted together in horizontal rows of varying lengths. Along with 1950s family snapshots, photographs of pre-World War II German nudists cavorting in the countryside, and museum installations of Greek statuary are images of caged animals and birds, crucifixion, and **FLIGHT**. In one piece a man has his arms outstretched in the form of a crucifixion and in the next two frames another man stands against a blackboard on which has been drawn, extending from his shoulders, a pair of wings. Embedded in the homoerotic and autobiographical fabric of Buchanan's work is a quintessentially Canadian structure of symbolism, including an allusion to flight. In 1988, Raymonde April photographed herself in silhouette holding rhubarb cuttings from a garden in such a way that the giant leaves appear to sprout from her back like wings; the photo makes up part of a series entitled *Une Mouche au Paradis* (A Fly in Paradise). Michel Campeau's autobiographical *Les tremblements du coeur*, features wings throughout – on a bedroom wall; seeming to grow from the neck of Montreal policeman; in a projected image of a man wearing wings that looks as if it has been appropriated from Wim Wenders' *Wings of Desire*.

Douglas Curran's book of photographs and text, *In Advance of the Landing: Folk Concepts of Outer Space*, published in 1985, deals with the activities of persons who quite literally wish to communicate with beings in the sky. Over a ten-year period

8.24 Douglas CURRAN
*Concrete flying saucer
found in the San Bernardino
Hills. Perris, California*
1979
40.64 x 50.8 cm

8.25 Jin-me YOON
between departure and arrival
1996/1997
photographic/video installation

Facing page

Curran travelled across North America recording home-made flying machines – spaceships and flying saucers – and "indigenous," unofficial launching pads, re-entry sites, and UFO-detecting stations. He also photographed a plethora of rocket-shaped gift shops, restaurants, and gas bars, as well as groups like the Unarius Concave of Light, whose members dress as they believe they did during previous lives on other planets.

Angela Grauerholz's 1988 "Clouds" was taken from high above the earth, and Marion Penner Bancroft's *View from inside cargo plane – dream 1984* is three large photographs of airplane windows and the view outside the windows.

Jin-me Yoon's 1996/97 installation work *between departure and arrival* placed the viewer directly inside the liminal space of an airplane travelling not only between two geographical points but between cultures as well. When this installation was shown at Vancouver's Western Front, two clocks, one marked "Seoul" and the other "Vancouver," with their sixteen-hour time difference, were hung at the gallery's entrance. Clouds that had been videotaped from an airplane were projected onto the gallery's far wall; at times during the projection the edge of the airplane's window was visible. A long mylar scroll hung a few feet in front of this wall; on the scroll was a photo-transfer of the top of a woman's head in which the hair has been parted into a Y-shape. (This is an image that features prominently in Yoon's installation *Screens*, discussed earlier, and which the artist has said[65]

represents, in that context, the common ground shared by mother and daughter as well as the separate paths their lives must inevitably take.) In the wall behind the scroll a monitor played a nine-minute video loop of a montage of historical footage found in British Columbia's provincial archives, including a 1950s Canadian newsreel. The footage referred mostly to Asian immigrants to Canada: Chinese workers and Japanese-Canadians being interned during World War II and Canadian troops readying themselves to enter the Korean War. Curator Judy Radul characterizes the video monitor in this installation as a "window" and writes that the installation "images both an aerial specificity (a consciousness above the clouds, beyond specificity) and a subject historically determined in relation to media images of Asian history,"[66] the familiar Canadian dichotomy of "here" and an abstract "elsewhere" seen in the works of Roy Arden, Ian Wallace and others.

In an analysis that helps to illuminate not only what is happening in Yoon's work but perhaps also an aspect of what goes on in a great deal of Canadian photography, Radul writes that "[h]aving 'flown over' a present written by the past (a territory of flickering images), the one who is 'between departure and arrival' has trouble imagining landing in an unwritten future. The desire to never come down, to escape from inhabiting a racialized body or nation, springs from here."[67] As we have seen, not only do many Canadian photographs indicate that Canadians, as a collectivity, wish to remain in an "in-between" place of liminality, they

indicate as well that we are reluctant to "come down" to a culture that restricts expression of the "feminine" multiplicity we so closely identify with, a multiplicity that when transposed to the political realm would allow for a multi-"racial," as opposed to racially monolithic, culture. (The painterly patches of colour that Roy Arden and Ian Wallace juxtapose to images of problematic social reality, or the bands of white space that run across the top of Arthur Renwick's series of photographs *Dislocation*, taken from the vantage point of someone lying on the street, carve out as well a zone uninscribed by history from which the viewer and the subjects of the images might be reluctant to "land.") Radul's "aerial specificity" that is "beyond specificity" closely parallels the "aerial sublime" that "posits a realm of freedom within the everyday,"[68] referred to by Mary Russo in relation to female aviators and acrobats in her book *The Female Grotesque*. Russo writes that freedom as expressed in flight is still an almost irresistible image for women, who are "latecomers to the scene of political identity," and that this image appears "again and again" in women's writing. What Russo has to say with respect to acrobats might equally apply to the conflicted attitude Canadians, in their art photography, express toward physical reality in general and their own surroundings in particular. For the acrobat, "the earth has a double aspect corresponding to the ambivalent situation; she is dangerous because of her irresistible attraction which, if unconditionally surrendered to, may cause mortal damage; but at the same time she is loving and forgiving, offering her embracing safety to the [acrobat on her] skillful return."[69] Within the metaphor of shamanic flight out of and back into ordinary reality, the Canadian photographer has been able to express ambivalence toward a collective existence that is neglected or ignored by its "parent" nations, insignificant or invisible to the rest of the world, and unwelcoming to many of its inhabitants.

Over a period of several years during the 1970s and early 1980s, when he lived and worked in Mabou, Nova Scotia, Robert Frank created a group of collaged and hand-coloured images that in both form and content represented a definitive departure from the well-known documentary photography he had produced while living in Europe and the United States. Frank's Canadian work dealt with the death of his daughter, and in almost every image, including the one entitled "Another World," there appeared constructions similar to the "soul ladders" and ropes used by the shamans who escort the souls of the departed to the Land of the Dead.

In most of Frank's Mabou collage works, a pole standing outside his home was the central element; the repetition of the pole within each collaged image, together with the words that have been scratched into the negatives, as for example: "For my daughter Andrea/Who died in an airplane crash/at TICAL in Guatemala on Dec. 23," heightens the sense of this pillar as intrinsically linked to the photographer's inner experience of his daughter's death. In many of the images, like "Electric Dog in Mabou," a dog stands beside the pole like the myth-

ical Cerberus, canine guardian of the underworld. In others, photographs are strung along a rope tied to poles outside the photographer's house. In one the mask of a human face, complete with hair, hangs from the top of the pole, as, in preparation for a ritual whereby the Siberian Yakut shaman escorts the soul of a sacrificed animal to the sky, trees outside his tent are stripped of their leaves and on the tops of the branches are hung dead birds and skulls. The trees are connected by rope, and the shaman makes a motion in imitation of a bird flying and rises to the sky, along the Axis of the World. Like the painted, ghostly-looking cloth rabbits that hung from a wire in a glass case outside Diana Thorneycroft's *slytod* installation, with their *omphalos*-like piles of white powder beneath them, offering entrance to the underworld, the Frank Mabou photographs employ a distinctly shamanic vocabulary.

The visual vocabulary that Frank used for this series of images borrows from his earlier work; here motor vehicles, for example, continue to be emblematic of individual existential quest. However, in the Mabou images these signs are removed from the social context of Frank's *The Americans* photographs and inserted into a more personal, symbolic world. The landscape Frank constructs with his Mabou collages and diptychs is neither social nor natural but metaphysical. What is significant for the purposes of this discussion is not only that these constructed images, like many Canadian photographs, deal with the subject of death but that they do so in a manner that is both radically unlike Frank's previous imagery and very much like the way Canadian photographers see the world.

Western Canadian photographer Barbara Spohr created a great many images that conform to the prototypically Canadian structure of two zones – "here" and "there," "inside" and "outside" – joined by a window-shaped opening. At times she photographed through actual windows, and in other instances window forms were created in her photographs by shadow. More frequently, Spohr fashioned windows or openings by painting around the edges of her photographs. In some cases these painted frames take up so much of the print that the world seen in the photograph, what is "there," "outside," as opposed to the photographer's "here," begins to recede, threatens even to disappear. This is particularly the case with images she made toward the end of her life. Spohr, who spent many of her years as a photographer in Banff and in Nelson, British Columbia, and who died at the age of thirty-two in 1987, knew from early adolescence that her life might be cut short by cancer. More than most of the many Canadian photographers who represent the world as divided into two interconnecting realms, Spohr directs the viewer's attention to this configuration itself and to what it might mean as a way of envisioning reality. In Spohr's work there is no overlay of a more recognizable photographic genre – documentary, portrait, landscape – to obscure this basic Canadian schema. To a certain extent her photographs, like Charles Gagnon's "New England" window image, are that Canadian template, and nothing else.

The 35mm and square format images around which Barbara Spohr created coloured window-like openings frequently refer to the descent into water; in many cultures, the shaman's descent to the lower regions during a seance is signalled by his sinking into the ground like a man drowning, or he might be transported to the bottom of a lake to begin his journey into the Other World. Spohr's hand-coloured "window" frames often have painted into them animal forms, which are evocative of the helping spirits that accompany the shaman to the world of the dead. A photograph of a man whose body is submerged underwater is outlined by a blue rectangular frame on which are painted crocodiles. In another image, which Spohr seems to have photographed from below the surface of water, the head and shoulder of a swimmer are barely emerging from the surface; this photograph is surrounded by a black "window" spotted with blue polka dots. Varying shades of blue paint provide the "window" frame through which is seen the sky, a rushing waterfall the size of Niagara, and a foreground of mist that Spohr seems to have been part of as she photographed and which her painted frame extends beyond the photograph. Stencil-like forms of squirrels, bears, camels, wolves, and goats on a pink frame surround a photograph of a tiny figure that is absolutely dwarfed by what one is tempted to liken to a "World Tree," used by the shaman to climb to the opening in the sky that led to the heavens.

In the late 1970s in Banff Spohr took a group of photographs of her body clothed in a purple dress and juxtaposed to a mountain, a traditional shamanic site of passage to the home of the spirits at the Centre of the World. She photographed this series in black and white and printed the resulting negatives on colour photographic paper, lending the colours an intensity equalling that of the spiritual experience the images record, one which is portrayed as having been both transcendent and deeply grounded in the feminine body.

What Spohr sees "outside" the "windows" she creates in her images often isn't the life of what Angelyn Spignesi calls the "upperworld" but rather the components of a shamanistic netherworld. Both the mountain and the rainbow are considered to be shamanic bridges connecting earth and sky, or the world's mystical Centre. A rainbow appears in Spohr's photograph of the giant oak "World Tree" and also in a picture in which Spohr photographed her feet as she walked along a wooden pathway, every slat of which is painted another hue of the rainbow. Through a blue-painted opening appears an unearthly-looking blue dog surrounded by black; like the "Electric Dog" that often stands near the pillar of Robert Frank's Mabou photographs, it brings to mind Cerberus guarding the entrance to the Greek underworld. Inside a pale pink frame, a golden retriever standing on a wharf looks directly into the camera. Both dogs function, like the animals depicted in the frames Spohr painted around her images, as "familiars" who will guide the photographer and the viewer into the "other world" seen through the window-like openings in her photographs.

8.26 Barbara SPOHR
Untitled
n.d.
25.3 x 20.2 cm
Original in colour

8.27 Barbara SPOHR
Untitled
n.d.
60.8 x 50.7 cm
Original in colour
(See also plate XVII)

When Spohr's images do not look through openings to an underworldly "other side," they give the sense, as when she seems to be photographing from under water, that it is she who inhabits a subterranean "elsewhere," that she is already in the Land of the Dead, looking out onto the world of the living. In these images what is photographed is seen from a distance – tiny, faraway figures run a race or dive into water, or frolic in the ocean, as in an image where the rectangular frame has been created by shadow and a trio of persons look as if they have walked out of a 1950s magazine ad. In other images in which the painted frame takes up most of the print, through that frame are seen, often in deep shadow, everyday objects like coffee cups and sunglasses, artifacts that are personal but nonetheless seem removed from the photographer, in a realm other than the one in which she resides and from which she photographs. Like the shaman and like the protagonist in Mark Leslie's *Dying with AIDS/Living with AIDS*, Spohr communicates to the viewer from the position of one who has made the descent out of ordinary life and who resides in a zone that is in-between life and death.

Linked to the notion of the shaman who drowns, or plunges into water to reach the "other world", is the crossing of rivers and streams by the soul before it may enter the infernal regions. Jolicure Pond in New Brunswick, as it was photographed

8.28 Thaddeus HOLOWNIA
Jolicure Pond
1997
17.78 x 43.18 cm
Original in colour

by Thaddeus Holownia in colour from the same vantage point under varying atmospheric, seasonal, and light conditions between 1996 and 2000, offers an oval-shaped opening into the earth. Andrea Szilasi's 1998 "Figure in Lake" literally weaves the photograph of the body of a woman into another photograph of a lake, so that the body seems to be either drowning or emerging from the water. Many of the bodies of water in Barbara Spohr's images are suggestive of otherworldly streams, and the landscapes Lucie Lefebvre fabricated out of paper, fabric, and slide projection in her Quebec City studio and then photographed in colour in the late 1980s are equally subterranean. These phantasmal valleys, cascades, and grottos often contain bridges joining rocks or mountains, spanning a river or the sky. Holly King also photographs eerily lit, miniature theatre sets, landscapes constructed out of crumpled paper, cellophane, tiny artificial trees and shrubs, painted surfaces, and bits of photographs. Her groups of black and white and coloured images of imaginary landscapes, with series titles like *The Forest of Enchantment*, *The Waters*, and *The Gardens*, evoke nothing so much as an underworld reality. This is made explicit in her 1992 colour photograph, "Chamber of Passage," where a ladder leads from an underground space of shadows, clay, and shining crystals to the light of a circular opening that gives on to the ground above. The symbolism of the "funerary bridge" is tied to the myth of the bridge that once

8.29 Andrea SZILASI
Figure in Lake
1998
181 x 148 cm

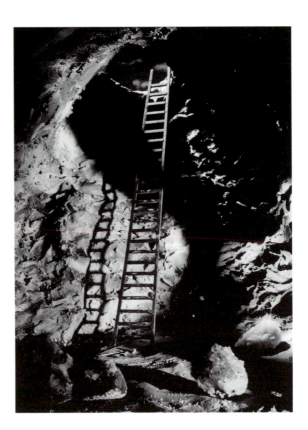

8.30 Holly KING
Chamber of Passage
1992
158 x 122 cm
Original in colour

connected earth and sky, by means of which, in mythical times, people passed to heaven without obstacle. Within shamanic cosmology, it is believed that once these mythical, effortless communications between earth and heaven were broken off, humans could no longer cross the bridge except "in spirit," that is, either after death or in ecstasy, and one who succeeds in moving through this passage must do so instantly.

The binding of the body that occurs so often in the photography of Irene F. Whittome, Suzy Lake, Evergon, and others, and which at first sight might appear only masochistic, is also found in the shamanic world. The shaman has herself tied down when she undertakes journeys to the Land of the Dead and the heavens. She takes this precaution so that she will journey in "spirit" only; otherwise she might be carried into the sky and disappear forever.

When discussing Patricia Rozema's film *When Night is Falling* in the introduction, I stated that the uncanny "awakening" and running free of a dog that had been dead and buried could be seen to represent a radical shift in the Canadian imaginative paradigm. Seen in the context of the many animals who are portrayed as either caged or dead in both Canadian photography and film, the release of Rozema's dog and of the female instincts with which it is associated in the film is analogous to a similar image that comes at the end of Raymonde April's sequence

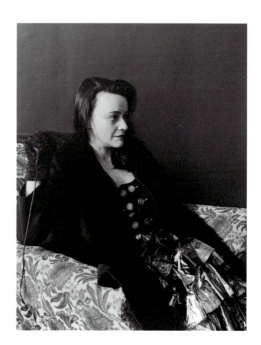

8.31 Raymonde APRIL
Excerpt from Part I of
L'Arrivée des figurants
1997
120 x 88 cm

L'Arrivée des figurants. The introductory section of April's suite of thirty-three large-scale photographs includes an image of the photographer looking forward, toward the images that follow, and another of a woman diving into water. It appears that, like the protagonists in the narrative sequences of Sandra Semchuk and Mark Leslie and the subjects of the photographs of Barbara Sphor and many other Canadian photographers, April has embarked on an inner, subterranean journey. The photographs that ensue – including those of a spider that appears to be trapped behind a window screen, an "upside-down," underworld landscape, a field with stone stairs that lead to a cleft-like entrance into the earth, the photographer seen through a chain-link fence that divides the image into two, a close-up of a rope that dangles in the air like a noose, a person of indeterminate gender who lies with his eyes closed, and a freshly sutured wound on the shaven coat of what could be a horse – bring together several elements of the recurring metaphoric vocabulary of Canadian photography. The sequence speaks of a "death" of some aspect of the photographer's fictional alter-ego, and of a transformation that culminates in the photograph of a man who is bending over to pat one of the two dogs at his feet. I believe that this image, like the "rebirth" of Rozema's dog and the photograph of a person rolling on the grass with a dog in April's 1994 Galerie Rochefort ensemble of photographs, signals a release from bondage, and the beginnings of

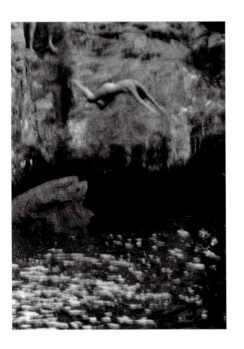

8.32 Raymonde APRIL
Excerpt from Part I of
L'Arrivée des figurants
1997
120 x 85.5 cm

Left

8.33 Raymonde APRIL
Excerpt from Part III of
L'Arrivée des figurants
1997
120 x 92,5 cm

Right

8.34 Raymonde APRIL
Excerpt from Part III of
L'Arrivée des figurants
1997
120 x 88 cm

Left

8.35 Raymonde APRIL
Excerpt from Part V of
L'Arrivée des figurants
1997
120 x 100 cm

Right

8.36 Raymonde APRIL
Excerpt from Part II of
L'Arrivée des figurants
1997
120 x 175.5 cm

Facing page

8.37 Marlene CREATES
Excerpts from *Entering and Leaving*
St. John's, Newfoundland 1995
11.4 x 16.5 cm each
Original in colour

a conscious relationship to the psychopompic "animal" self sealed away for so long in the collective Canadian psyche.

Our photographs tell us that Canada, like the ancient *hagazussa* "on the fence," is able to offer a viewpoint that provides *our* own civilization with an enhanced consciousness of itself, ensuring that life inside the modern encampment will not "congeal into a 'solid fortification,'"[70] into life lived as if death and the "other world" did not exist. If we are willing to embrace this vision of ourselves, then the Hollywood stereotypes of Canada as the wilderness one runs to when the law or the draft board come calling – from which we are constantly and unsuccessfully attempting to free ourselves – may be understood to persist because they are somehow close to the mark but just out of register. Our photographs show that it is not that Canada *is* the wild to the rest of the Western world's civilization, the "out" to everywhere else's "in," as the country is so often portrayed. Rather the Canadian imagination revealed in our photographic imagery is one tempered by the knowledge of culture that comes from having, in Duerr's language, "stepped over the fence" into the "beyond" and returned again, with an enhanced awareness of what it means to be human and "civilized." Angela Grauerholz's 1994 *Églogue ou Filling the Landscape* is a sculptural archive in which are housed twenty-seven portfolio boxes containing 216 photographs. Like Marlene Creates' twin photographs, "Entering and Leaving St. John's, Newfoundland 1995," which look in both directions from a point along the highway, Grauerholz's work is divided into sections called "Entering the Landscape" and "Leaving the Landscape." The negotiation between "here" and "there", wilderness and civilization, is a journey that the subject and the viewer of Canadian photography regularly undertake – a conscious voyage across the "border," over the "fence," into the alchemical, underworld depths of the self, and back again.

8.38 Angela GRAUERHOLZ
Disparition
1995
122 x 183 cm

CONCLUSION

At the end of this search for a Canadian specificity of image, I see that Canadian art photographs made over the last five decades all point to the same unexpected conclusion.

The photographs of Diana Thorneycroft, Vincent Sharp, Lynne Cohen, Evergon, Arthur Renwick, and other Canadian photographers indicate the extent to which Canadians identify with bound and caged animals and picture themselves as trapped (in individual isolation, in time and space, in mortal existence, within cultural constraints). In their photographs, like those of Michel Lambeth, Tom Gibson, and Michel Campeau, Canadians can be seen to be inordinately preoccupied with death and with crucifixion. All this appeared to me at the beginning of this study to be only pathological, the cries of hopelessness.

Yet every Canadian photograph that does not show entrapment delineates a move toward freedom from metaphysical confinement. The flight into the sky proposed by the narrative of John Max's *Open Passport* chimes with the refusal of worldly physicality so evident in the Canadian use of photographic portraiture like that by Karen Smiley, Angela Grauerholz, or Nina Raginsky, and with our atypical wish to sever image from referent. This longing to "slip the surly bonds of earth," in the words of one of Canada's most often quoted poems, is reiterated in the panels of blue sky that hang over Roy Arden's images of documentary fact, in the escape from mortality proferred in almost every photographic image Charles Gagnon has made, in Jin-me Yoon's attraction to the "aerial sublime," and in the

myriad images like those of Hamish Buchanan, Christos Dikeakos, and George Steeves that refer to an Icarusian failure of flight.

I have found that the essential Canadian photographic paradigm, seen in the photographs of Gagnon, Geoffrey James, Condé and Beveridge, Angela Grauerholz, Raymonde April, and so many others, is one of duality – life and death, "here" and "elsewhere" – and that other writers, too, have discovered a similar duality informing our literature, song, and political life. The Canadian tradition, so often understood, particularly in photography, as a documentary one, has instead to do, like the diptychs and polytychs of Claude-Phillipe Benoit and Ian Wallace's photographic juxtapositions, with a particularly Canadian dialectic between documentary fact and a symbolic or abstract "elsewhere". This dialectic, often expressed in Canadian photography by the use of a window, is not so simple a matter as the fact that the United States – that is to say "the action," "real life" – is out "there" while we are left "here."

We can note that the persistent duality of our photographs is unlike the monolithic object (Edward Weston's peppers, the frontally placed buildings of Walker Evans) seen repeatedly in the Transcendentalist American photographic image, and read as well in our photographs the deeply felt lack of a fixed, monolithic identity. We can also see in our photographs that this lack gives rise to the lament for a "mature" identity, the wish for what John Ralston Saul calls the "majority school of the monolithic nation-state." Look at Michel Lambeth and Ken Lum's motherless children, Élène Tremblay's baby from which all grounding has been cut away, the women trapped under glass in photographs by Raymonde April, Cheryl Simon, and Nicole Jolicoeur, and the subjects of images by Jeff Wall, Stéphanie Beaudoin, Paul Litherland, Janita Eyre, and Michel Campeau, all of whom are "faking death." Like an adolescent anorexic girl, we see ourselves as if we have never been definitively tested, have not managed to negotiate some requisite rite of passage (a revolution? a civil war?), and so we pine for it. As if to prove that this collective initiation has really taken place, we trot out our scars, like those in the photographs of Donigan Cumming, Genevieve Cadieux, or Sylvain Cousineau's *Mona Nima*, where a birth that was planned for has not taken place.

What we have not yet become conscious of, on a collective level, is that Canadian dualism indicates a laudatory capacity to view a given situation from more than one place, to hold two realities in tension without seeking an arbitrary resolution (David Howes' "mode of thinking that juxtaposes but does not synthesize," Robert Kroetsch's "doubles that stay double"), and an acute awareness of borders (Ian Angus's "border within"). Our photographs indisputably point to a shamanistic predilection to cross that border – from upper to lower world, daylight to darkness, civilization to wilderness – and return back again, to "die" and return transformed or to remain, like Cumming's Nettie Harris or Evergon's Denys, in the liminal in-between.

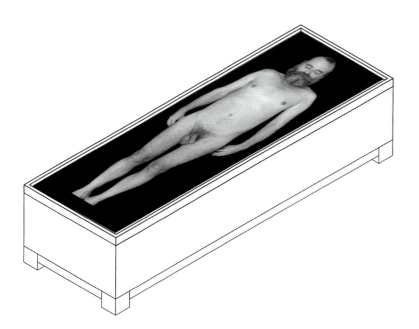

C.1 AA BRONSON
Sketch for *AA Bronson
August 22, 2000*
2020 x 720 x 500 mm

Many of the qualities that I have identified as Canadian may be observed in a recent work by AA Bronson. Under the clear plexiglass cover of the wooden coffin-like construction Bronson built in 2000 is a black and white photographic transparency, a full-length image of the artist lying naked with his eyes closed. Bronson appears to be sealed under glass, floating in a place where time has been suspended, and, because of the structure's casket shape, mimicking his own death.

Made after the deaths from AIDS of his General Idea partners, Felix Partz and Jorge Zontal, the piece, "AA Bronson, August 22, 2000," marks the painful passing of Bronson's identity as a member of the group that had lived and worked together for twenty-seven years. The work speaks of Bronson's submission to the changes that loss and grief have wrought, of the transition from his role as part of General Idea to that of solo artist, of the process of initiation into a new life.

Enter a grave, "The Flooded Grave" of Jeff Wall, and know that it will be full of life. Or the prairie grave of Sandra Semchuk's grandmother, and find that it offers the promise of an all-encompassing transformation of the self. Fly through windows, Charles Gagnon's, Normand Grégoire's, or Barbara Spohr's windows, or into the sky, Jin-me Yoon's sky. Disappear into the landscape, or the earth, or the underworld, Diana Thorneycroft's underworld, and return and then descend again. In dozens of guises Canadian photography presents one over-riding imperative, and it is this directive that constitutes its specificity: reach for some definitive monolithic self, for the finality of "maturity," for a "real" identity, but then refuse it, and hold out instead for that state of always becoming that Bronson's coffin and so many Canadian photographs describe so compellingly and so well.

NOTES

Introduction

1 Saul, *Siamese Twin*, 470
2 Jayamanne et al., "Conversation Piece," 94
3 Christ, *Diving Deep*, 18
4 Moi, *Sexual/Textual Politics*, 132
5 Angus, *Border Within*, 49
6 McCarthy, "Canadian Literary Histories," 33–4

Chapter One

1 Coleman, "Photography Book as Autobiography," 25
2 Cousineau[-Levine], "Sensual Estrangement," 10

3 Bennett, "Conflicted Vision," 137–8
4 Lyons, *Social Landscape*, n.p.
5 Ibid.
6 Angus, *Border Within*, 210–11
7 Ibid., 107
8 Ibid., 108
9 Said is quoted in Ferguson, "Introduction," 11

Chapter Two

1 V. Fouque, quoted in Newhall, *History of Photography*, 17
2 Bazin, "Ontology of the Photographic Image," 144
3 Ibid., 144–5
4 Ibid., 145

5 Arnheim, "Nature of Photography," 155
6 Ibid.
7 Benjamin, "Short History of Photography," 163
8 Ibid.
9 Sontag, *On Photography*, 92
10 Ibid.
11 Ibid., 93
12 Ibid., 154
13 Ibid.
14 Ibid., 95
15 Barthes, *Camera Lucida*, 3
16 Ibid., 4
17 Ibid., 5
18 Ibid.
19 Ibid., 5–6
20 Ibid., 6
21 Ibid.
22 Ibid., 28
23 Ibid., 45

24 Ibid., 78
25 Ibid., 80
26 Ibid.
27 Ibid., 76
28 Ibid., 76–7
29 Ibid., 6
30 Barthes, "Photographic Message," 190
31 Bullock and Stallybrass, eds., *Dictionary of Modern Thought*, 386
32 Morin, *Idea of North*, n.p.
33 Nadar, "My Life as a Photographer," 9
34 Raginsky conversation with author.
35 Sander, *Men Without Masks*, n.p.
36 For a summary of this debate, see Langford, "Donigan Cumming," 14–33
37 Rudisill, *Mirror Image*, 232
38 Ibid., 170
39 Holmes is quoted in Newhall, *History of Photography*, 22
40 Rudisill, *Mirror Image*, 16
41 Ibid.
42 Ibid., 20
43 Ibid., 31
44 Ibid., 13
45 Ibid., 236
46 Ibid., 234
47 Dijkstra, *Cubism, Stieglitz and William Carlos Williams*, 106
48 Weston, "Photographic Beauty, 163
49 Newhall, ed., *Daybooks of Edward Weston: Vol. II.*, 147
50 Ibid., 155

51 Weston, "Photographic Beauty," 154
52 Livingston, "Robert Bourdeau," n.p.
53 Stott, *Documentary Expression*, 5–6
54 Ibid., 6
55 Ibid., 7
56 Ibid., 20
57 Ibid., 19–20
58 Ibid., 21
59 Orwell, "England Your England," 39–40
60 Cartier-Bresson, "Decisive Moment," 47
61 Trachtenberg, "*Message from the Interior*," 15
62 Trachtenberg, "Artist of the Real," 13
63 Ibid.

Chapter Three

1 Thomas, "Canadian Nationalism," 77
2 Langford, ed., *Contemporary Canadian Photography*.
3 Thomas, "Canadian Nationalism," 77
4 Linda Hutcheon, *The Canadian Postmodern*, 195
5 Ibid., 198
6 Jones, *That Art of Difference*, 3
7 Ibid., 4
8 Ibid.
9 Ibid., 13–14
10 Ibid., 14; 13
11 Ibid., 7
12 Surette, "Canadian Canon," 24

13 Sontag, *On Photography*, 15
14 Ibid., 70
15 Ibid.
16 Barthes, *Camera Lucida*, 32
17 Ibid., 79
18 Bazin, "Ontology of the Photographic Image," 145
19 Becker quotes Zilboorg in *Denial of Death*, 16
20 Ibid., 17
21 Williams, "Secret Places," 17
22 Ibid., 11
23 Ibid., 14
24 Bronson, public lecture, Concordia University, Montreal, December 2001
25 Bronson, *AA Bronson*, 22
26 Howard, B6–7
27 Ingelevics, "From Places of Repose," n.p.
28 Atwood, *Survival*, 76
29 Ibid., 79
30 Hutcheon, *Canadian Postmodern*, 150–1
31 Echlin, *Elephant Winter*, 4
32 Hutcheon, *Canadian Postmodern*, 118
33 Ibid., 117
34 Ibid., 178
35 Atwood, *Survival*, 222
36 Ibid., 224

Chapter Four

1 Conversation with author
2 Ibid.
3 Gagnon, "Conversation with

Jin-me Yoon," 58
4 Ibid.
5 Davis, *American Century of Photography*, 439
6 Tuer, "Photographing Against the Grain," 68–9
7 My translation.
8 Benoit, conversation with author.
9 My translation.
10 Wallace, "Roy Arden," 25
11 Kogawa is quoted in Hutcheon, *Other Solitudes*, 5
12 Jones, *That Art of Difference*, 19
13 Ibid., 139
14 Said, "Reflections on Exile," 366
15 Saul, *Siamese Twin*, 373
16 Angus, *Border Within*, 207
17 Hutcheon, "Splitting Images," 260
18 Schwarz-Bart, *Beween Two Worlds*, 13
19 Elder, *Image and Identity*, 29
20 Ibid., 2
21 Ibid.
22 Ibid., 186.
23 McGregor, *Wacousta Syndrome*, 17
24 Angus, *Border Within*, 132
25 Ibid., 129
26 Ibid.
27 Ibid., 133
28 Ibid., 126
29 Ibid., 111
30 Monk, ed., *Between Friends*, n.p.
31 Angus, *Border Within*, 133
32 Ibid., 126

33 Duchow, Artist's Statement, 19 January 2002 (unpublished)
34 Howes, "We are the World," 322
35 Ibid., 315
36 Ibid., 334
37 Ibid., 325
38 Ibid., 324
39 Ibid.
40 Ibid., 325. Howes indicates that this is borrowed from David Turner.
41 Ibid., 327–8
42 Ibid., 322
43 Ibid., 323
44 Ibid.
45 Harris, host of "I Hear Music," said this on CBC Radio on 1 July 2001 during a program dedicated to Canadian music.
46 Howes, "We are the World," 323
47 Ibid.
48 Ibid.
49 Angus, *Border Within*, 31
50 Ibid., 142
51 Ibid.
52 Ibid.
53 Ibid., 143
54 Ibid., 142–3
55 Hutcheon, *Canadian Postmodern*, 161
56 Ibid., 165
57 Ibid., 168
58 Ibid.
59 Ibid., 177
60 Ibid., 182
61 Ibid., 53
62 Ibid., 4
63 Ibid., 158n6
64 Miller, *Seductions*, 160
65 McGregor, *Wacousta Syndrome*, 315
66 Ibid., 316

67 Ibid., 423
68 Ibid., 440
69 Hutcheon, *Irony's Edge*, 7
70 Ibid., 12
71 Lamoureux, "French Kiss," 49
72 Ibid.
73 Ibid., 50
74 Ibid.
75 Ibid., 52–3
76 Ibid., 53–4
77 Ibid., 54
78 Hutcheon, *Canadian Postmodern*, 85
79 Ibid., 85–6
80 Ibid., 86
81 Ibid., 2
82 Connor quotes Jameson in *Postmodernist Culture*, 47
83 Connor quotes Baudrillard, ibid., 52
84 Saul, *Siamese Twin*, 14
85 Atwood, *Two-Headed Poems*, 59
86 Saul, *Siamese Twin*, 116
87 Ibid., 426
88 Ibid., 411
89 Ibid.

Chapter Five

1 Surette, "Canadian Canon," 27
2 Hutcheon, *Canadian Postmodern*, 33
3 Ibid., 126
4 Surette, "Canadian Canon," 25
5 Saul, *Siamese Twin*, 366
6 Ibid., 369–70
7 Ibid., 22
8 Langford, *"Semak, Michael,"* 924

9 Smart, *Writing in the Father's House*, 151

Chapter Six

1 Woodman, *Pregnant Virgin*, 60
2 Woodman, *The Owl Was*, 79
3 Woodman, *Addiction to Perfection*, 35
4 Woodman, *The Owl Was*, 79
5 Ibid., 25
6 Woodman, *Addiction to Perfection*, 125
7 Woodman, *The Owl Was*, 54
8 Lawrence, *Anorexic Experience*, 34
9 Woodman, *Addiction to Perfection*, 88
10 Woodman, *Pregnant Virgin*, 39
11 Chernin, *The Obsession*, 20
12 Ibid., 23
13 Woodman, *Pregnant Virgin*, 88
14 Woodman, *Addiction to Perfection*, 55
15 Ibid., 78
16 Spignesi, *Starving Women*, 98
17 Ibid., x
18 Ibid., xi
19 Ibid.
20 Ibid., 61
21 Woodman, *The Owl Was*, 79
22 Ibid., 22–3
23 Woodman, *Pregnant Virgin*, 119
24 Woodman, *The Owl Was*, 96
25 Woodman, *Addiction to Perfection*, 15
26 Ibid., 16

27 Owens, "Feminists and Postmodernism," 59
28 Spignesi, *Starving Women*, 14
29 Chernin, *The Obsession*, 21
30 Woodman, *The Owl Was*, 23
31 Ibid., 89
32 Angelyn Spignesi, *Starving Women*, 15
33 Marion Woodman, *Addiction to Perfection*, 20
34 Edelheit, "Crucifixion Fantasies," 198
35 Ibid., 198–9
36 Woodman, *The Owl Was*, 40
37 Spignesi, *Starving Women*, 24
38 Ibid., 32
39 Mastai, "Anorexic Body," 144
40 Ibid., 142
41 Ibid., 143
42 Chernin, *The Obsession*, 72, 73
43 Hirsch, *Mother/Daughter Plot*, 145
44 Hutcheon, *Canadian Postmodern*, 156
45 Gingras, "Sister-Images," 136
46 Eliade, *Rites and Symbols*, x
47 Ibid., 4
48 Woodman, *Pregnant Virgin*, 18
49 Ibid.
50 Eliade, *Rites and Symbols*, 67
51 Turner, "Betwixt and Between," 8
52 Benoît, conversation with author
53 Turner, "Betwixt and Between," 6
54 Turner, Ibid.
55 Ibid., 4, 5
56 Ibid., 8
57 Ibid., 18
58 Wall, e-mail to author
59 Howard, "School's Out," B6–7
60 Mayer, "Canadian Irony," 58
61 Ibid.
62 Grauerholz, public lecture
63 Turner, "Betwixt and Between," 6
64 Ibid., 7
65 Ibid., 6
66 Ibid., 9
67 Ibid.
68 Ibid.
69 Ibid., 13
70 Ibid., 17
71 In his 2002 "*Montreal Main*: Uncertain Identities" *Take One* 11, no. 38 [July/August 2002]: 38–40, film critic Peter Harcourt points out that Allan Moyle and Frank Vitale's seminal 1974 film *Montreal Main*, ends on the note of gender ambivalence that has been sounded throughout the movie: "As the credits roll, Beverly Glenn-Copeland sings out again her final refrain: Brother, Sister – Who do you think you are?" (40). Harcourt also refers to the film's questioning of notions of maturity. He contrasts

the film's two com-
petitive philosophical
attitudes," that of
central characters
Johnny and Frank,
who don't "assume
they know the emo-
tional priorities of
existence," and the
"essentialist position
represented by [a
straight bourgeois
couple]" who take it
for granted "that the
emotional priorities
of human nature are a
given. One simply has
to *mature* into them.
Caught between these
life assumptions are
both Johnny and
[Frank] – Johnny
because, at 12 years of
age, he is not yet an
independent agent,
and Frank, because he
is so afraid of who he
is and of what he
might become" (39).

72 McCarthy, "Canadian
Literary Histories,"
38
73 Ibid., 44
74 Salter, "National
Theatre," 90
75 Ibid.
76 Simon, "Culture and
Its Values," 169
77 Hutcheon, *Canadian
Postmodern*, 1
78 *Vernissage*, 18
79 Hutcheon, *Canadian
Postmodern*, 6, 204
80 Hutcheon, "Splitting
Images," 268
81 Hutcheon, *Canadian
Postmodern*, 138
82 Jouve, *White Woman
Speaks*, 17

83 Ibid., 19
84 Ibid., 44
85 Ibid., 47
86 Lamoureux, "French
Kiss," 54
87 Jouve, *White Woman
Speaks*, 28
88 Ibid., 34
89 Ibid.
90 Hoffman, "Lost in
Translation," 399
91 Huston, *Pour un
patriotisme de
l'ambiguïté*, 38
92 My translation
93 Jouve, *White Woman
Speaks*, 41
94 Ibid. Jouve is quoting
Clément.
95 Hirsch,
*Mother/Daughter
Plot*, 95
96 Hutcheon, "Splitting
Images," 257
97 Grosz, "Irigaray's
Notion," 191
98 Ibid.
99 Saul, *Siamese Twin*, 9
100 Ibid., 14
101 Ibid., 325
102 Ibid., 8
103 Ibid., 140
104 Irigaray, *Sex Which is
Not One*
105 Hutcheon, *Canadian
Postmodern*, 165
106 Ibid.
107 Ibid., 145
108 Ibid., 144
109 de Castillejo, *Knowing
Woman*, 182

Chapter Seven

1 Freud, *Introductory
Lectures*, 173
2 Spignesi, *Starving
Women*, x

3 Jouve, *White Woman
Speaks*, 40
4 Leslie, *Dying with
AIDS*, n.p.
5 Hillman,
The Dream, 184
6 Ibid.
7 Hirsch,
*Mother/Daughter
Plot*, 103
8 Surette, "Canadian
Canon," 201n19
9 Sourkes, "Book of
Gates," 153
10 Ibid., 154
11 Perera, *Descent to the
Goddess*, 13
12 Ibid., 14–15
13 Ibid., 15
14 Gonick, dir. *Guy
Maddin*
15 Leslie, *Dying with
AIDS*, n.p.
16 Ibid.
17 Evergon, conversa-
tions with author.
18 Sourkes, "Book of
Gates," 159
19 Langford, "Origins
of Diana," 12. I rely
here on Langford's
description of the
slytod exhibit.
20 Echlin,
"Metamorphosis,"
c14–15
21 Perera, *Descent to the
Goddess*, 21
22 Ibid.
23 Leonard, *Way to the
Wedding*, 54
24 Hatt, conversation
with author
25 My translation
26 Kogawa, "Obasan," 88
27 Hillman, *The Dream*,
53–4
28 Ibid., p. 54
29 Ibid., p. 147

Chapter Eight

1 Higonnet, "Mapping the Text," 203–4
2 Ibid., 204
3 Ibid.
4 Quoted in Castillo, "Borderlines," 151
5 Ibid., 152
6 Ibid., 158
7 Ibid., 161
8 Ibid., 156
9 Ibid., 157
10 Hutcheon, *Canadian Postmodern*, 174
11 Ibid., 3
12 Angus, *Border Within*, 96
13 Gutsche, "Open Parody," 25; Langford, "Donigan Cumming," 14; Adams, "Passing By," 9
14 Duerr, *Dreamtime*, 46
15 Ibid.
16 Ibid., 47
17 Ibid., 72
18 Ibid., 109
19 Ibid., 64
20 Ibid., 64
21 Ibid., 125
22 Ibid., 74
23 Ibid., 87
24 Angus, *Border Within*, 128
25 Ibid., 129
26 Ibid., 125
27 Ibid., 125–6
28 Ibid., 111
29 Duerr, *Dreamtime*, 64
30 Ibid., 87
31 Ibid.
32 Ibid., 95
33 Ibid., 37
34 Ibid., 125
35 Ibid., 126
36 Ibid., 47
37 Ibid., 46
38 Ibid., 49
39 Atwood, *Cat's Eye*, 409
40 Duerr, *Dreamtime*, 45
41 Ibid., 46
42 Atwood, *Surfacing*, 177
43 Hutcheon, *Canadian Postmodern*, 54
44 Ibid.
45 Ibid., 162
46 Duerr, *Dreamtime*, 87
47 Ibid.
48 Eliade, *Shamanism*, 511
49 François Desjardins is now an assistant professor in the Faculty of Education at the University of Ottawa.
50 Eliade, *Shamanism*, 509
51 Ibid., 214
52 Hillman, *The Dream*, 40
53 Ibid.
54 Ibid., 46
55 Ibid., 51
56 Ibid., 55
57 Frye, "Lack of Ghosts," 122
58 Hillman, *The Dream*, 104–5
59 Ibid., 214n49
60 Ibid.
61 Eliade, *Shamanism*, 64
62 Ibid.
63 Blodgett, *The Coming and Going*, 48
64 Ibid.
65 Yoon, conversation with author
66 Radul, *Jin-me Yoon*, 14–15
67 Ibid., 19
68 Russo, *Female Grotesque*, 11
69 Ibid., 39
70 Ibid., 95

BIBLIOGRAPHY

Abbott, Bernice. *The World of Atget: 176 Photographs by Atget*. New York: Horizon Press 1964

Adams, Hugh. "Passing By On the Other Side: Theatre of the Forgotten and Art of the Scars of the People. The Work of Donigan Cumming," In *Donigan Cumming: Gimlet Eye*. Cardiff: Ffotogallery and Chapter 2001

Adams, Robert, Lewis Baltz, Bernd Becher, Hilla Becher, Joe Deal, Frank Gohlke, Nicholas Nixon, John Schott, Stephen Shore, and Henry Wessel Jr. *New Topographics: Photographs of a Man-altered Landscape*. Rochester, N.Y.: International Museum of Photography at George Eastman House 1975

Agee, James and Walker Evans. *Let Us Now Praise Famous Men*. 1941. Reprint. New York: Ballantine 1974

Allaire, Serge, Martin Brault, Lise Gagnon, and Jean Lauzon under the direction of Michel Lessard. *Montréal au XXe siècle. Regards de photographes*. Montreal: Les Éditions de l'Homme 1995

Alland, Alexander, Sr. *Jacob A. Riis: Photographer and Citizen*. Millerton, N.Y.: Aperture 1974

Allen, Jan, cur. *The Female Imaginary*. Kingston: Agnes Etherington Art Centre 1994

Allen, Karyn, cur. *The Winnipeg Perspective 1979 - Photo/Extended Dimensions. Barbara Astman. Sorel Cohen. Suzy Lake. Arnaud Maggs. Ian Wallace*. Winnipeg: Winnipeg Art Gallery 1979

Allison, Denis, Danielle April, Patrick Altman, Michel Bélanger, Karole Biron, Reno Salvail, and Joanne Tremblay. *Souvenir Écran*. Quebec: VU 1994

Angus, Ian. *A Border Within: National Identity, Cultural Plurality, and Wilderness*. Montreal: McGill-Queen's University Press 1997

Applebaum, Issac, Andrea Kunard, and Richard Rhodes. *Issac Applebaum*. Montreal: Centre Saidye Bronfman 1991

April, Raymonde. *Raymonde April*. Torino: Galleria The Box 1994

− *Réservoirs Soupirs. Photographies 1986-1992*. Quebec: VU 1993

April, Raymonde, Keith Bell, Georges Bogardi, Gail Fisher-Taylor, Monika Gagnon, Robert Graham, Serge Jongué, Denis Lessard, Michael Mitchell, Carol Corey Phillips, Dot Tuer, Ian Wallace, and Peter Wollheim. *13 Essays on Photography*. Ottawa: Canadian Museum of Contemporary Photography 1990

Arbus, Diane. *Diane Arbus*. Millerton, N.Y.: Aperture 1972

Arden, Roy. *West*. Vancouver: Artspeak Gallery 1988

Arnheim, Rudolf. "On the Nature of Photography." 1974. In *The Camera Viewed: Writings on Twentieth-Century Photography. Volume II - Photography After World War II*. Ed. Peninah R. Petruck. New York: E.P. Dutton 1979

Arts Council of Great Britain. *'From today painting is dead': The Beginnings of Photography*. Reprint. n.p.: Victoria and Albert Museum 1975

Asselin, Olivier and Vincent Lavoie, curs. *De la Curiosité. Petite anatomie d'un regard*. Montreal: Dazibao 1992

Atwood, Margaret. *Alias Grace*. McClelland & Stewart 1996

− *Cat's Eye*. 1988. Reprint. Toronto: McClelland-Bantam, Seal Books 1989

− *The Handmaid's Tale*. 1985. Reprint. Toronto: McClelland-Bantam, Seal Books 1986

− *Lady Oracle*. Toronto: McClelland & Stewart 1976

− *The Robber Bride*. New York: Doubleday 1993

− "Spring Song of the Frogs." In *Bluebeard's Egg*. 1983. Reprint. Toronto: McClelland & Stewart-Bantam, Seal Books 1984

− *Surfacing*. 1972. Reprint. Don Mills, Ont.: General Publishing Co., PaperJacks 1973

− *Survival. A Thematic Guide to Canadian Literature*. Toronto: House of Anansi Press 1972

− *Two-Headed Poems*. New York: Simon and Shuster 1978

Augaitis, Daina, ed. *Frame of Mind: Viewpoints on Photography in Contemporary Canadian Art*. Banff: Walter Phillips Gallery 1993

Augaitis, Daina and Sylvie Gilbert, curs. *Between Views*. Banff: Walter Phillips Gallery 1991

Avedon, Richard. *Portraits*. New York: Farrar, Straus and Giroux 1976

Baier, Lesley K. *Walker Evans at FORTUNE 1945-1965*. Wellesley, Mass.: Wellesley College Museum 1978

Bailey, Clayton. *Waiting: Photographs by Clayton Bailey*. Winnipeg: Winnipeg Art Gallery 1978

Baillargeon, Richard, André Dion, Cristiane Jobin, and Lucie Lefebvre. *Fragments. Photographie actuelle au Québec*. Quebec: VU 1985

Baldus, Eduard, Robin Collyer, Penny Cousineau-Levine, Pierre Dorion, and Guy Pellerin. *Ailleurs*. Montreal: Dazibao 2000

Barnouw, Erik. *Documentary: A History of the Non-Fiction Film*. New York: Oxford University Press 1974

Barret, André. *Nadar. 50 Photographies de ses illustres contemporains*. Paris: André Barret 1975

Barss, Peter, cur. *Canadians: A National Photography Show About People*. Halifax: The Art Gallery, Mount Saint Vincent University 1978

Barthes, Roland. *Camera Lucida: Reflections on Photography*. Trans. Richard Howard. New York: Hill and Wang; Farrar, Straus and Giroux 1981

− "The Photographic Message." 1961. In *The Camera Viewed: Writings on Twentieth-Century Photography. Volume II -Photography After World War II*. Ed. Peninah R. Petruck. New York: E.P. Dutton 1979

Bazin, André. "The Ontology of the Photographic Image." 1945. In *The Camera Viewed: Writings on Twentieth-Century Photography. Volume II - Photography After World War II*. Ed. Peninah R.Petruck. New York: E.P. Dutton 1979

Beaton, Cecil and Gail Buckland. *The Magic Image: The Genius of Photography from 1839 to the Present Day*. Boston: Little Brown and Co. 1975

Becker, Ernest. *The Denial of Death*. New York: Macmillan Publishing, The Free Press 1973

Belenky, Mary Field, Blythe McVicker Clinchy, Nancy Rule Goldenberger, and Jill Mattuck Tarule. *Women's Ways of Knowing*. New York: Basic Books 1986

Bénichou, Anne. *Anne-Marie Zeppetelli*. Montreal: Dazibao 1994

– *Nicole Doucet. De "Témoin Rouge" à "Membre Fantôme."* Montreal: Occurrence 1994

Benjamin, Jessica. *The Bonds of Love: Psychoanalysis, Feminism and the Problem of Domination*. New York: Pantheon Books 1998

– "The Oedipal Riddle." In *The Problem of Authority in America*. Eds. John P. Diggins and Mark E. Kann. Philadelphia: Temple University Press 1981

Benjamin, Walter. "A Short History of Photography." In *Creative Camera International Yearbook 1977*. London: Creative Camera 1976

Benner, Ron. *Ron Benner: Other Lives*. Saskatoon: Mendel Art Gallery 1988

Bennett, Donna. "Conflicted Vision: A Consideration of Canon and Genre in English-Canadian Literature." In *Canadian Canons: Essays in Literary Value*. Ed. Robert Lecker. Toronto: University of Toronto Press 1991

Benoit, Claude-Philippe. *CHAPITRE Ô-NU*. Ottawa: Ottawa Art Gallery 1994

– Conversation with author. Montreal, 1993.

– *Intérieur, jour*. Vancouver: Presentation House Gallery 1991

Beresford-Howe, Constance. *The Book of Eve*. Toronto: Macmillan 1973

Bhabha, Homi K. "The Other Question: Difference, Discrimination and the Discourse of Colonialism." In *Out There: Marginalization and Contemporary Cultures*. Eds. Russell Ferguson, Martha Gever, Trinh T. Minh-ha, and Cornel West. 1990. Reprint. New York: New Museum of Contemporary Art and Cambridge: MIT Press 1994

Birrell, A.J. *Into the Silent Land: Survey Photography in the Canadian West, 1858-1900*. Ottawa: Information Canada 1975

Blache, Pierre, Marcel Blouin, and Marie-Josée Jean, eds. *L'éternel et l'éphemère. Le Mois de la photo à Montréal. Septembre 1995*. 9 vols. Montreal: Mois de la Photo 1995

Blache, Pierre, Marcel Blouin, and Frank Michel, eds. *Le Mois de la photo à Montréal. Septembre 1993*. Montreal: Vox Populi 1993

Blessing, Jennifer, cur. *Rrose is a Rrose is a Rrose: Gender Performance in Photography*. New York: Guggenheim Museum 1997

Blodgett, Jean. *The Coming and Going of the Shaman: Eskimo Shamanism and Art*. Winnipeg: Winnipeg Art Gallery 1978

Bolen, Jean Shinoda. *Goddesses in Everywoman: A New Psychology of Women*. New York: Harper and Row, Harper Colophon Books 1985

Borcoman, James. *The Photograph as Object: 1843-1969. Photographs from the Collection of the National Gallery of Canada*. Ottawa: National Gallery of Canada 1969

Borcoman, James and Geoffrey James. *Eugene Atget: Six Photographs*. Edmonton: Edmonton Art Gallery n.d.

Bordo, Susan. *Unbearable Weight: Feminism, Western Culture, and the Body*. Berkeley: University of California Press 1993

Borsa, Joan, cur. *Making Space: Suzanne Lacy, Susan McEachern, Frances Robson, Honor Kever Rogers*. Vancouver: Presentation House and Toronto: Mercer Union 1988

Boulanger, Chantal. *Nicole Doucet*. Quebec: VU 1995

Brandt, Bill. *Bill Brandt*. London: Marlborough Gallery 1976

– *Shadow of Light. Photographs by Bill Brandt*. New York: Da Capo Press 1977

Brassai. *Brassai*. New York: Museum of Modern Art 1968

– *The Secret Paris of the 3o's*. Translated by Richard Miller. New York: Pantheon Books 1976

Brennan, Teresa. *The Interpretation of the Flesh: Freud and Femininity*. London: Routledge 1992

Bronson, AA. *AA Bronson: 1969 - 2000*. Vienna: Secession 2000

Brookman, Philip, cur. *Robert Frank: An Exhibition of Photography and Films, 1945-1977*. Santa Cruz: Mary Porter Sesnon Art Gallery, College Five, University of California 1978

Bruch, Hilda. *Eating Disorders: Obesity, Anorexia Nervosa, and the Person Within*. New York: Harper Collins, Basic Books 1973

– *The Golden Cage: The Enigma of Anorexia Nervosa*. Cambridge: Harvard University Press 1978

Bry, Doris. *Alfred Sieglitz: Photographer*. Boston: Museum of Fine Arts 1965

Buckland, Gail. *Reality Recorded: Early Documentary Photography*. Greenwich, Conn.: New York Graphic Society 1974

Buell, Lawrence. *Literary Transcendentalism: Style and Vision in the American Renaissance*. Ithaca: Cornell University Press, Cornell Paperbacks 1973

Bullock, Alan and Oliver Stallybrass, eds. *The Fontana Dictionary of Modern Thought*. 1977. Reprint. London: Fontana Books 1983

Burnett, David and Marilyn Schiff. *Contemporary Canadian Art*. Edmonton: Hurtig Publishers in co-operation with Toronto: Art Gallery of Ontario 1983

Campeau, Michel. *Jeune Photographie: Susan Coolen, Manon Fafard, Guy Fréchette, Rosaura Guzman Clunes, Élène Tremblay, Julie Tremblay, Loren Williams*. Montreal: Dazibao 1994

– *Les tremblements du coeur*. Quebec: VU and Montreal: Editions Saint-Martin 1988

Campeau, Michel, Penny Cousineau, Marie Carani, Pierre Dessureault, Evergon, Michel Gaboury, Gaétan Gosselin, Lucie Lefebvre, Henri Robideau, Reno Salvail, Cheryl Sourkes, Gabor Szilasi, Ann Thomas, and Katie Tweedie. *Marques et Contrastes. La photographie actuelle*. Quebec: Sagamie 1987

Capa, Cornell, ed. *The Concerned Photographer*. New York: Grossman 1968

Cartier-Bresson, Henri. "Introduction to the Decisive Moment." 1952. In *Photographers on Photography: A Critical Anthology Edited by Nathan Lyons*. Ed. Nathan Lyons. Englewood Cliffs, N.J.: Prentice Hall in collaboration with Rochester: George Eastman House 1966

Castillo, Debra A. "Borderlines: Federico Campbell and Ana Castillo." In *Reconfigured Spheres: Feminist Explorations of Literary Space*. Eds. Margaret R. Higonnet and Joan Templeton. Amherst: University of Massachusetts Press 1994

Chakravorty Spivak, Gayatri. "Explanation and Culture: Marginalia." In *Out There: Marginalization and Contemporary Cultures*. Eds. Russell Ferguson, Martha Gever, Trinh T. Minh-ha, and Cornel West. 1990. Reprint. New York: New Museum of Contemporary Art and Cambridge: MIT Press 1994

Chartrand, Denis, Sandra Marchand, Yolande Racine, and François Desaulnier. *Tendances actuelles au Québec*. Montreal: Musée d'art contemporain de Montréal 1978

Cheetham, Mark A. with Linda Hutcheon. *Remembering Postmodernism: Trends in Recent Canadian Art*. Toronto: Oxford University Press 1991

Chernin, Kim. *The Hungry Self: Women, Eating and Identity*. 1985. Reprint. New York: Harper and Row, Perennial Library 1986

– *The Obsession: Reflections on the Tyranny of Slenderness*. 1981. Reprint. New York: Harper and Row, Perennial Library 1982

Christ, Carol P. *Diving Deep and Surfacing: Women Writers on Spiritual Quest*. 1980. Second edition Boston: Beacon Press 1986

Christmas, Lawrence. *Canadian Coal Miners: Photographs by Lawrence Christmas*. Edmonton: Edmonton Art Gallery 1983

Cixous, Hélène. "Castration or Decapitation?" In *Out There: Marginalization and Contemporary Cultures*. Eds. Russell Ferguson, Martha Gever, Trinh T. Minh-ha, and Cornel West. 1990. Reprint. New York: New Museum of Contemporary Art and Cambridge: MIT Press 1994

— "Sorties: Out and Out: Attacks/Ways Out/Forays." In *The Feminist Reader, Second Edition*. Eds. Catherine Belsey and Jane Moore. Malden, MA: Blackwell 1997

Clark, Douglas, cur. *Sweet Immortality: A Selection of Photographic Portraits*. Edmonton: Edmonton Art Gallery 1978

Clarke, Graham. *The Photograph*. Oxford: Oxford University Press 1997

Clément, Serge. *Vertige Vestige. Photographie de Serge Clément*. Laval: Les 400 Coups 1998

Cohen, Lynne. Conversation with author. Ottawa, 1989

— *Occupied Territory: Lynne Cohen*. Ed. William A. Ewing. New York: Aperture 1987

Cohen, Lynne, Jean-Pierre Criqui, Johanne Lamoureux, Frédéric Paul, and Ramon Tio Bellido. *Lynne Cohen*. Limoges: F.R.A.C. Limousin and Paris: Hôtel des Arts - Fondation Nationale de Arts 1992

Cohen, Matt. *Last Seen*. 1996. Reprint. Vintage Canada 1997

Cohen, Sorel. *An Extended and Continuous Metaphor*. Lethbridge: Southern Alberta Art Gallery 1984

Coleman, A.D. "The Photography Book as Autobiography." *The New York Times*. 11 August 1974

Condé, Carole and Karl Beveridge. *Political Landscapes*. Toronto: Gallery TPW 1998

Connor, Steven. *Postmodernist Culture: An Introduction to Theories of the Contemporary*. 1989. Reprint. Oxford: Blackwell 1995

Corkin, Jane, ed. *Twelve Canadians: Contemporary Canadian Photography*. Toronto: Jane Corkin Gallery 1981

Corman, Don. *Comfort and Cleanliness: A Guide to the Hospitality Industry*. Halifax: n.p. 1980

Cousineau[-Levine], Penny. "Barbara Spohr's Border Crossings." In *Barbara Spohr: Apparent Reasons*. Curated by Katherine Lipsett. Banff: Whyte Museum of the Canadian Rockies and Calgary: The Glenbow Museum 1995

— "An Elemental Landscape: Sable Island." In *An Elemental Landscape: Sable Island. Photographs by Thaddeus Holownia*. Sackville, N.B.: Owens Art Gallery 1995

— "Introduction" to *The Banff Purchase: An Exhibiton of Photography in Canada*. Toronto: John Wiley and Sons 1979

— "Post-post." In *L'éternal et l'éphemère*. Montreal: Mois de la Photo 1995

— "Robert Frank's Postcards From Everywhere." *Afterimage* 5, no. 8 (February 1978): 6-8

— "Sensual Estrangement: Earth Visions/Visions Terrestres by Judith Eglington." *Afterimage* 1, no. 10 (February 1974):10

Cousineau, Sylvain P. *Mona Nima*. Almonte, Ont.: Powys Press 1977

Cousineau, Sylvain P. and Francis Coutellier. *exzéo*. Moncton: Éditions d'Acadie 1975

Creates, Marlene, cur. *The Diary Exhibition/Journaux intimes: Michel Campeau, Janine Carreau, May Chan, Patrick Close, Stephen Cruise, Martha Davis, Sara Diamond, Marcel Gosselin, Jamelie Hassan, Michael Mitchell, Carla Murray, Wilma Needham, Mary Paisley, Sandra Semchuk, Sandra Tivy, Geoffrey Wonnacott*. St John's: Art Gallery of Memorial University 1987

Cumming, Donigan. *Gimlet Eye*. Cardiff: Ffotogallery and Chapter 2001

— *Reality and Motive in Documentary Photography*. Ottawa: Canadian Museum of Contemporary Photography 1986

— *The Stage*. Montreal: Maquam Press 1991

Curran, Douglas. *In Advance of the Landing: Folk Concepts of Outer Space*. New York: Abbeville Press, 1985

Dale, Jack, Michael deCourcy, Christos Dikeakos, Judith Eglington, Gerry Gilbert, Roy Kiyooka, Glen Lewis, Taras Masciuch, Michael Morris, N.E. Thing Co. Ltd., Jone Pane, Timothy Porter, Peter Thomas, Vincent Trasov, and Robertson Wood. *B.C. ALMANA(H) C-B.*. Ottawa: National Film Board of Canada 1970

Dary, Anne and Jean-François Taddei, curs. *Canada. Une nouvelle génération*. Gétigné-Clisson: FRAC des Pays de la Loire, La Roche-sur-Yon: Musée Municipal, and Les Sables-d'Olonne: Musée de l'Abbaye Sainte-Croix 1993

Davis, Keith F. *An American Century of Photography from Dry-Plate to Digital: The Hallmark Photographic Collection*. Second edition. Kansas: Hallmark Cards and New York: Harry N. Abrams 1999

de Beauvoir, Simone. *The Second Sex*. Trans. and ed. H.M. Parshley. 1952. Reprint. New York: Bantam Books 1953

de Castillo, Irene Claremont. *Knowing Woman. A Feminine Psychology*. 1973. Boston: Shambhala Publications 1990

de Duve, Thierry, Boris Groys, Blaise Pascal, and Arielle Pelenc. *Jeff Wall*. 1996. Reprint. London: Phaidon Press 1998

Déry, Louise. *Espaces intérieurs. Le corps, la langue, les mots, la peau*. Quebec: Musée du Québec 1999

Dessureault, Pierre, cur. *Sandra Semchuk: How Far Back is Home...*. Ottawa: Canadian Museum of Contemporary Photography 1995

Dijkstra, Bram. *Cubism, Stieglitz and the Early Poetry of William Carlos Williams: The Hieroglyphics of a New Speech*. Princeton: Princeton University Press 1969

Dikeakos, Christos, cur. *Ian Wallace: Selected Works 1970-1987*. Vancouver: Vancouver Art Gallery 1988

Douglas, Claire. *The Woman in the Mirror: Analytical Psychology and the Feminine*. Boston: Sigo Press 1990

Downing, Christine. *The Goddess: Mythological Images of the Feminine*. New York: Crossroad Publishing 1981

Duerr, Hans Peter. *Dreamtime: Concerning the Boundary Between Wilderness and Civilization*. Trans. Felicitas Goodman. 1985. Reprint. Oxford: Basil Blackwell 1987

Echlin, Kim. *Elephant Winter*. 1997. Reprint. Toronto: Penguin 1998

— "Metamorphosis. The Dark Vision of Diana Thorneycroft." *The Globe and Mail*. 11 June, 2000

Edelheit, Henry. "Crucifixion Fantasies and Their Relation to the Primal Scene." *International Journal of Psycho-Analysis* 55 (1974): 193-9

Edey, Maitland. *Great Photographic Essays from LIFE*. Boston: New York Graphic Society 1978

Elder, R. Bruce. *Image and Identity: Reflections on Canadian Film and Culture*. Waterloo, Ont.: Wilfrid Laurier Press in collaboration with The Academy of Canadian Cinema and Television 1989

Eliade, Mircea. *Rites and Symbols of Initiation: The Mysteries of Birth and Rebirth*. Trans. Willard R. Trask. New York: Harper and Row, Harper Torchbooks 1958

— *Shamanism: Archaic Techniques of Ecstasy*. Trans. Willard R. Trask. 1964. Reprint. [Princeton]: Princeton University Press, Princeton/Bollingen Paperback 1974

Ellison, Ralph. *Invisible Man*. New York: Random House 1952

Engel, Marian. *Bear*. 1976. Reprint. Toronto: McClelland & Stewart, New Canadian Library 1985

— *The Tattooed Woman*. Markham, Ont.: Penguin Books 1985.

Esonwanne, Uzoma. "Feminist Theory and the Discourse of Colonialism." In *ReImagining Women: Representations of Women in Culture*. Eds. Shirley Neuman and Glennis Stephenson. Toronto: University of Toronto Press 1993

Evans, Walker. *American Photographs*. 1938. Reprint. New York: East River Press 1975

— *Walker Evans*. New York: Museum of Modern Art 1971

Evergon. Conversations with author. Montreal and Ottawa, 1989.

Featherstone, David, ed. *Observations: Essays on Documentary Photography*. Carmel: Untitled 35. The Friends of Photography 1984

Ferguson, Russel. "Introduction: Invisible Center." In *Out There: Marginalization and Contemporary Cultures*. Eds. Russell Ferguson, Martha Gever, Trinh T. Minh-ha, and Cornel West. 1990. Reprint. New York: New Museum of Contemporary Art and Cambridge: MIT Press 1994

Fiedler, Leslie. *Freaks: Myths and Images of the Secret Self*. New York: Simon and Schuster 1978

Firestone, Shulamith. *The Dialectic of Sex: The Case for Feminist Revolution*. 1970. Reprint. New York: Bantam Books 1971

Flomen, Michael. *Details/M. Flomen*. Montreal: Yajima/ Galerie 1980

Foster, Alasdair, ed. *Loitering With Intent: Evergon*. Paddington: Australian Centre for Photography 1999

Frank, Robert. *The Americans*. 1959. Reprint. New York: Aperture 1969

— *The Lines of My Hand*. n.p.: Lustrum Press 1972

— *Robert Frank*. Paris: Centre National de la Photographie 1983

Freud, Sigmund. *Introductory Lectures on Psycho-Analysis: The Standard Edition of the Complete Psychological Works*. Trans. James Strachey. London: Hogarth Press 1961

Freund, Gisèle. *Photographie et société*. n.p.: Éditions du Seuil 1974

Friedlander, Lee. *Lee Friedlander Photographs*. New City, N.Y.: Haywire Press 1978

— *Self Portrait*. New City, N.Y.: Haywire Press 1970

Fry, Philip. *Charles Gagnon*. Montreal: Montreal Museum of Fine Arts 1978

— *Sylvain P. Cousineau. Photographies et peintures*. Regina: The Dunlop Art Gallery in collaboration with Banff: The Walter Phillips Gallery n.d.

Frye, Northrop. *The Bush Garden: Essays on the Canadian Imagination*. Toronto: House of Anansi Press 1971

— *Divisions on a Ground: Essays on Canadian Culture*. Toronto: House of Anansi Press 1982

Fry, Northrop. "Haunted by Lack of Ghosts." In *Mythologizing Canada: Essays on the Canadian Literary Imagination*. Ed. Branko Gorjup. Toronto: Legas 1997

— *Northrop Frye on Culture and Literature: A Collection of Review Essays*. Ed. Robert D. Denham. Chicago: University of Chicago Press 1978

— *The Stubborn Structure: Essays on Criticism and Society*. Ithaca: Cornell University Press 1970

Fullerton, Kim, cur. *Fabrications: Hamish Buchanan, Catherine Opie, David Rasmus*. Toronto: Toronto Photographers Gallery 1995

Fuss, Diana. *Essentially Speaking: Feminism, Nature and Difference*. New York: Routledge 1989

Gaboury, Michel. *Regard sur la photographie actuelle au Québec. Lucie Lefebvre. André Martin. Daniel Dutil. Roberto Pellegrinuzzi. Diane Poirier*. Chicoutimi: Galerie Séquence 1988

Gagnon, Charles. *Charles Gagnon. Observations*. Quebec: Musée du Québec 2000

Gagnon, Monika Kin. "Other Conundrums: Monika Kin Gagnon in Conversation with Jin-me Yoon." In *Jin-me Yoon: Between Departure and Arrival*. Cur. Judy Radul. Vancouver: Western Front 1998

Gagnon, Paulette. *Angela Grauerholz*. Montreal: Musée d'art contemporain de Montréal and Les Publications du Québec 1995

Gallop, Jane. *The Daughter's Seduction: Feminism and Psychoanalysis*. Ithaca: Cornell University Press 1982

Garnet, Eldon. *Caves*. n.p.: Artculture Resource Centre 1984

– *The Fallen Body*. Ottawa: Canadian Museum of Contemporary Photography 1998

– *Spiraling. JFM 232*. Toronto: Impulse 1979

Garvey, Susan Gibson, cur. *Rephotographing the Land: Marlene Creates, Patricia Deadman, Lorraine Gilbert, Ernie Kroeger, Sylvie Readman, Sandra Semchuk*. Halifax: Dalhousie Art Gallery 1992

Gascon, France, cur. *Clara Gutsche. La Série des couvents. The Convent Series*. Joliette: Musée de Joliette 1998

Gee, Helen. *Photography of the Fifties: An American Perspective*. Tucson: Center for Creative Photography, University of Arizona, 1980

Gernsheim, Helmut in collaboration with Alison Gernsheim. *A Concise History of Photography*. Second printing, revised. London: Thames and Hudson 1971

– *The History of Photography From the Camera Obscura to the Beginning of the Modern Era*. New York: McGraw Hill 1969

Gibson, Tom. *Signature 1*. Ottawa: National Film Board of Canada Still Photography Division 1975

– *Tom Gibson: False Evidence Appearing Real*. Ottawa: Canadian Museum of Contemporary Photography 1993

Gingras, Nicole, ed. *Le Mois de la Photo à Montréal*. Montreal: Mois de la Photo 1989

– ed. *Le Mois de la Photo à Montréal. Septembre 1991*. Montreal: Mois de la Photo 1991

– cur. *Raymonde April. Les Fleuves Invisibles*. Joliette, Que.: Musée D'Art de Joliette 1998

– "Sister-Images." In *Raymonde April. Les Fleuves Invisibles*. Joliette, Que.: Musée D'Art De Joliette 1998

Goddard, Harold Clarke. *Studies in New England Transcendentalism*. 1908. Reprint. New York: Humanities Press 1969

Godmer, Gilles. *Geneviève Cadieux*. Montreal: Musée d'art contemporain 1993

Goldenberg, Naomi R. *Changing of the Gods: Feminism and the End of Traditional Religions*. Boston: Beacon Press 1979

Gonick, Noam, dir. *Guy Maddin: Waiting for Twilight*. n.p.: Marble Island Pictures 1997

Gowdy, Barbara. *The White Bone*. 1998. Reprint. Toronto: Harper Collins 1998

Gowin, Emmet. *Emmet Gowin Photographs*. New York: Knopf 1976

Grauerholz, Angela. *Angela Grauerholz Photographien*. Münster: Westfälischer Kunstverein 1991

– "Grauerholz. Photographs." In *An/other Canada, Another Canada? Other Canadas*. Amherst: The Massachusetts Review 1990

– Public lecture. Faculty of Fine Arts, Concordia University, Montreal. 1998

Grégoire, Normand. *Série 4. Normand Grégoire*. n.p.: National Film Board of Canada 1971

Green, Jonathan, ed. *Camera Work: A Critical Anthology*. Millerton, N.Y.: Aperture 1973

– ed. *The Snapshot*. Millerton, N.Y.: Aperture 1974

Greenhill, Ralph and Andrew Birrell. *Canadian Photography: 1839–1920*. Toronto: Coach House Press 1979

Grierson, John. *Grierson on Documentary*. Ed. Hardy Forsyth. London: Collins 1946

Griffin, Susan. *Woman and Nature: The Roaring inside Her*. New York: Harper and Row, Harper Colophon Books 1978

Grosz, Elizabeth. "Irigaray's Notion of Sexual Morphology." In *ReImagining Women: Representations of Women in Culture*. Eds. Shirley Neuman and Glennis Stephenson. Toronto: University of Toronto Press 1993

Grover, Jan Zita. "Landscapes Ordinary and Extraordinary." *Afterimage* 11, no. 5 (December 1983): 4–5

Gutman, Judith Mara. *Lewis W. Hine: 1874–1940*. New York: Grossman 1974

Gutsche, Clara. *Clara Gutsche: Paysages vitrés/Inner Landscapes*. Montreal: n.p. 1980

— "Open Parody, Hidden Agenda: Donigan Cumming." *Vanguard* (May 1984): 25

Hancock, Emily. *The Girl Within*. New York: Ballantine, Fawcett Columbine 1989

Hanna, Martha, cur. *Orest Semchishen: In Plain View / Voir Clair*. Ottawa: Canadian Museum of Contemporary Photography 1994

— cur. *Suzy Lake: Point of Reference*. Ottawa: Canadian Museum of Contemporary Photography 1993

— cur. *Words and Images*. Ottawa: National Film Board of Canada Stills Division 1980

Harcourt, Peter. "*Montreal Main*: Uncertain Identities." *Take One* 11, no. 38 (July/August 2002): 38–40

Harlow, Barbara. "Sites of Struggle: Immigration, Deportation, Prison, and Exile." In *Reconfigured Spheres: Feminist Explorations of Literary Space*. Eds. Margaret R. Higonnet and Joan Templeton. Amherst: University of Massachusetts Press 1994

Harper, J. Russell. *Painting in Canada: A History*. Second edition. 1977. Reprint. Toronto: University of Toronto Press 1981

Hatt, Shari. *Breast Wishes*. Quebec: VU 1997

— Conversation with author. Montreal, 1992

Haworth-Booth, Mark. *Photography Now*. London: Dirk Nishen Publishing and The Victoria and Albert Museum 1989

Heilbrun, Carolyn G. *Writing a Woman's Life*. New York: Random House, Ballantine Books 1988

Held, Michael, Colin Naylor, and George Walsh. *Contemporary Photographers*. New York: St Martin's Press 1982

Herzog, Hans-Michel, ed. *The Body: Contemporary Canadian Art*. Zurich: Edition Stemmle AG 1994

Hickox, April. *New Borders, New Boundaries. Nouvelles frontières, nouvelles démarcations*. Toronto: Gallery 44 Centre for Contemporary Art 1991

Higonnet, Margaret R. "Mapping the Text: Critical Metaphors." In *Reconfigured Spheres: Feminist Explorations of Literary Space*. Eds. Margaret R. Higonnet and Joan Templeton. Amherst: University of Massachusetts Press 1994

Hillman, James. *The Dream and the Underworld*. New York: Harper and Row, Perennial Library 1979

Hirsch, Mariannne. *The Mother/Daughter Plot: Narrative, Psychoanalysis, Feminism*. Bloomington: Indiana University Press 1989

Hlynsky, David, ed. *New Canadian Photography. La Nouvelle Photographie canadienne*. Toronto: Image Nation 26, Fall 1982

Hobson, Greg. "A Horrible Exhibition." In *The Dead*. Curs. Greg Hobson and Val Williams. Bradford: National Museum of Photography, Film and Television 1995

Hobson, Greg and Val. Williams, curs. *The Dead*. Bradford: National Museum of Photography, Film and Television 1995

Hoffman, Eva. "Lost in Translation." 1989. In *The Norton Book of Women's Lives*. Ed. Phyllis Rose. New York: W.W. Norton 1993

Hohn, Hu and Lorne Falk, curs. *The Banff Purchase: An Exhibition of Photography in Canada*. Toronto: John Wiley and Sons 1979

Holownia, Thaddeus. *Extended Vision, Vision élargie: The Photography of Thaddeus Holownia 1975–1997*. Ottawa: Canadian Museum of Contemporary Photography 1998

Holownia, Thaddeus and Penny Cousineau. *An Elemental Landscape: Sable Island. Photographs by Thaddeus Holownia*. Sackville: Owens Art Gallery 1995

Holownia, Thaddeus and Douglas Lochhead. *Dykelands: Photographs by Thaddeus Holownia. Poems by Douglas Lochhead*. Montreal: McGill-Queen's University Press 1989

Holubizky, Ihor, cur. *Geneviève Cadieux*. Toronto: The Power Plant 1988

Howard, Cori. "School's Out." *The National Post*. 8 March 2000, B6–7

Howes, David. "'We Are The World' and Its Counterparts: Popular Song as Consitutional Discourse." *Politics, Culture, and Society* 3, no.3 (Spring 1990): 315–39

Hughes, Mary Jo. *Hamish Buchanan: Veiled Men*. Kingston: Agnes Etherington Art Centre 1995

Hujar, Peter. *Portraits in Life and Death*. New York: DaCapo Press 1976

Hume, Sandy, Ellen Manchester and Gary Metz, eds. *The Great West: Real/Ideal*. Boulder: Department of Fine Arts, University of Colorado at Boulder 1977

Huston, Nancy. *Pour un patriotisme de l'ambiguïté*. Montreal: Éditions Fides and cétuq 1995

Hutcheon, Linda. *The Canadian Postmodern: A Study of Contemporary English-Canadian Fiction*. Toronto: Oxford University Press 1988

– ed. *Double-Talking: Essays on Verbal and Visual Ironies in Contemporary Canadian Art and Literature*. Toronto: ECW Press 1992

– "Introduction" to *Other Solitudes: Canadian Multicultural Fictions*. Eds. Linda Hutcheon and Marion Richmond. Toronto: Oxford University Press 1990

– *Irony's Edge: The Theory and Politics of Irony*. 1994. London: Routledge 1995

– *The Politics of Postmodernism*. London: Routledge 1989

– *Splitting Images: Contemporary Canadian Ironies*. Toronto: Oxford University Press 1991

– "Splitting Images: The Postmodern Ironies of Women's Art." In *ReImagining Women: Representations of Women in Culture*. Eds. Shirley Neuman and Glennis Stephenson. Toronto: University of Toronto Press 1993

Huyda, Richard, Andrew Birrell, and Peter Robertson. *Reflections on a Capital: 12 Ottawa Photographers. Selected from the National Photographic Collection in the Public Archives of Canada. Reflets d'une capitale: 12 photographes d'Ottawa. Choix tiré de la Collection Nationale de Photographies aux Archives Publiques du Canada*. Ottawa: Public Archives of Canada 1970

Ingelevics, Vid. "From Places of Repose: Stories of Displacement 1989." In *Messages Sent/Received*, Cur. Justin Wonnacott. Ottawa: SAW Gallery 1991

Irigaray, Luce. *This Sex Which is Not One*. Ithaca: Cornell University Press 1985

James, Geoffrey. *Asbestos*. Toronto: The Power Plant 1994

– *Giardini Italiani. Un pellegrinaggio fotografico*. Rome: Comune di Roma, Assessorato alla Cultura and Ambasciata del Canada, Centro Culturale Canadese 1985

– guest ed. *An Inquiry into the Aesthetics of Photography*. Toronto: Artscanada No. 192/193/194/195, December 1974

– *Running Fence*. Vancouver: Presentation House 1999

– cur. *Transparent Things, Transparences: The Artist's Use of the Photograph. L'utilisation de la photographie par l'artiste*. Ottawa: The Canada Council 1977

Jayamanne, Laleen, Leslie Thorton, and Trinh T. Minh-ha. "If Upon Leaving What We Have To Say We Speak: A Conversation Piece." In *Discourses: Conversations in Postmodern Art and Culture*. Eds. Russell Ferguson, William Olander, Marcia Tucker, and Karen Fiss. New York: New Museum of Contemporary Art and Cambridge: MIT Press 1990

Jeffrey, Ian. *Photography: A Concise History*. London: Thames and Hudson 1981

Jones, Manina. *That Art of Difference: 'Documentary-Collage' and English-Canadian Writing*. Toronto: University of Toronto Press 1993

Jouve, Nicole Ward. *White Woman Speaks with Forked Tongue: Criticism as Autobiography*. London: Routledge 1991

Jung, C.G. and C. Kerenyi. *Essays on a Science of Mythology: The Myths of the Divine Child and the Divine Maiden*. New York: Harper and Row 1949

Kahmen, Volker. *Art History of Photography*. Trans. Brian Tubb. New York: Viking Press, A Studio Book 1974

Karamcheti, Indira. "The Geographics of Marginality: Place and Textuality in Simone Schwarz-Bart and Anita Desai." In *Reconfigured Spheres: Feminist Explorations of Literary Space*. Eds. Margaret R. Higonnet and Joan Templeton. Amherst: University of Massachusetts Press 1994

Karsh, Yousuf. *Karsh Portfolio*. Toronto: University of Toronto Press 1967

Kerenyi, C. *Eleusis: Archetypal Image of Mother and Daughter*. New York: Pantheon Books, Bolligen Series 1967

Kertész, André. *André Kertész: Sixty Years of Photography 1912–1972*. New York: Grossman 1972

Keshavjee, Serena, ed. *Slytod: Diana Thorneycroft*. Winnipeg: Gallery 1.1.1. and The University of Manitoba Press 1998

King, Holly. *Territoires de l'imaginaire/Landscapes of the Imagination*. Ottawa: Canadian Museum of Contemporary Photography 1998

Kirby, William, cur. *The Manitoba 1976 Juried Photography Exhibition*. Winnipeg: Winnipeg Art Gallery 1976

Klein, William. *William Klein: Photographs*. Millerton, N.Y.: Aperture 1981

Kogawa, Joy. "Obasan," In *Other Solitudes: Canadian Multicultural Fictions*. Eds. Linda Hutcheon and Marion Richmond. Toronto: Oxford University Press 1990

Krauss, Rosalind and Annette Michelson, eds. *October 5. Photography: A Special Issue*. Cambridge: MIT Press 1978

Krauz, Peter, cur. *Quebec Photography Invitational. Photographie actuelle au Québec*. Montreal: Centre Saidye Bronfman 1982

Lamoureux, Johanne. "French Kiss From a No Man's Land. Translating the Art of Quebec." *Arts Magazine* 65, no. 6 (February 1991): 48–54

– *Irene F. Whittome. Bio-Fictions*. Quebec: Musée du Québec 2000

Langford, Martha, cur. *Atlantic Parallels. Parallèles Atlantiques. Works by Ten Photographers. Oeuvres de Dix Photographes*. Ottawa: National Film Board of Canada 1980

– ed. *Contemporary Canadian Photography From the Collection of the National Film Board*. Edmonton: Hurtig 1984

– "Donigan Cumming: Crossing Photography's Chalk Lines." In *Reality and Motive in Documentary Photography*. By Donigan Cumming. Ottawa: Canadian Museum of Contemporary Photography 1986

– cur. *George Steeves: 1979–1993*. Ottawa: Canadian Museum of Contemporary Photography 1993

– cur. *La Méthode et l'extase. Richard Baillargeon. Michel Campeau. Betrand Carrière*. Montreal: Occurrence 2001

– "The Origins of Diana." In *Slytod: Diana Thorneycroft*. Ed. by Serena Keshavjee. Winnipeg: Gallery 1.1.1. and The University of Manitoba Press 1998

– "Semak, Michael." In *Contemporary Photographers*. Eds. Michael Held, Colin Naylor, and George Walsh. New York: St Martin's Press 1982

Larivée, Suzie. *Zones d'extase. Nicole Jolicoeur*. Quebec: VU 1992

Laroche, Joël, directeur de la publication. "La Photographie au Québec." *ZOOM*, Sommaire 77 Paris: 1981

Lawrence, Marilyn. *The Anorexic Experience*. London: The Women's Press 1984

Lecker, Robert. "Introduction" to *Canadian Canons: Essays in Literary Value*. Ed. Robert Lecker. Toronto: University of Toronto Press 1991

Legrady, George, cur. *The Mask of Objectivity/Subjective Images*. London, Ont.: McIntosh Gallery, The University of Western Ontario 1981

Leonard, Linda Schierse. *On the Way to the Wedding*. Boston: Shambhala 1986

Lerner, Loren R. and Mary F. Williamson. *Art and Architecture in Canada: A Bibliography and Guide to the Literature to 1981*. Toronto: University of Toronto Press 1991

Leroy, Jean. *Atget. Magicien du vieux Paris en son époque*. n.p.: Pierre Jean Balbo 1975

Leslie, Mark. *Dying with AIDS/Living with AIDS*. Montreal: The Muses' Company 1992

Levenkron, Steven. *Treating and Overcoming Anorexia Nervosa*. New York: Warner Books 1982

Levenson, Randal. *In Search of the Monkey Girl*. Millerton, N.Y.: Aperture, A New Image Book 1982

Lippard, Lucy R. *From the Center: Feminist Essays on Women's Art*. New York: E.P. Dutton, A Dutton Paperback 1976

Livingston, David. "Robert Bourdeau." In *Twelve Canadians: Contemporary Canadian Photography*. Ed. Jane Corkin. Toronto: Jane Corkin Gallery 1981

Lord, Barry, cur. *La peinture au Canada*. Montreal: Le Pavillon Du Canada, Expo 67 1967

Love, Karen, cur. *Death and the Family*. Vancouver: Presentation House 1995

– cur. *Photoperspectives '85*. Vancouver: Presentation House Gallery 1985

Lyons, Nathan. *Notations in Passing: Visualized by Nathan Lyons*. [Cambridge]: MIT Press in collaboration with Rochester, N.Y.: Light Impressions 1974

– ed. *Photographers on Photography. A Critical Anthology Edited by Nathan Lyons*. Englewood Cliffs, N.J.: Prentice Hall in collaboration with Rochester, N.Y.: George Eastman House 1966

– *Photography in the Twentieth Century*. Rochester, N.Y.: George Eastman House of Photography in collaboration with Ottawa: National Gallery of Canada 1967

– ed. *Toward a Social Landscape: Bruce Davidson, Lee Friedlander, Garry Winogrand, Danny Lyon, Duane Michaels*. New York: Horizon Press and Rochester, N.Y.: George Eastman House 1966

MacKay, Allan, cur. *Suzy Lake: Are You Talking to Me?* Saskatoon: Mendel Art Gallery 1980

Maddow, Ben. *Edward Weston: Fifty Years*. Millerton, N.Y.: Aperture 1973

Madill, Shirley, cur. *Latitudes and Parallels: Focus on Contemporary Canadian Photography*. Winnipeg: Winnipeg Art Gallery 1983

Mahdi, Louise Carus, Steven Foster, and Meredith Little, eds. *Betwixt and Between: Patterns of Masculine and Feminine Initiation*. LaSalle, Ill.: Open Court 1987

Mariani, Phil and Jonathan Crary. "In the Shadow of the West: Edward Said." In *Discourses: Conversations in Postmodern Art and Culture*. Eds. Russell Ferguson, William Olander, Marcia Tucker, and Karen Fiss. New York: New Museum of Contemporary Art and Cambridge: MIT Press 1990

Mastai, Judith. "The Anorexic Body: Contemporary Installation Art by Women Artists in Canada." In *Generations and Geographies in the Visual Arts: Feminist Readings*. Ed. Griselda Pollock. London: Routledge 1996

Mathews, Lawrence. "Calgary, Canonization, and Class: Deciphering List B." In *Canadian Canons: Essays in Literary Value*. Ed. Robert Lecker. Toronto: University of Toronto Press 1991

Max, John, ed. *Montreal Photographers. Image Nation Fourteen*. Toronto: Coach House Press n.d.

– *Open Passport*. Toronto: Impressions Special Double Issue, nos 6 and 7, 1973

Mayer, Marc. "Canadian Irony." In *Canada: Une nouvelle génération. Arden, Bond, Cadieux, Dean, Douglas, Graham, Grauerholz, Lum, Magor, Massey, Racine, Steinman, Sterbak, Wall, Wallace*. Curs. Anne Dary and Jean-François Taddei. Gétigné-Clisson: FRAC des Pays de la Loire; La Roche-sur-Yon: Musée Municipal and Les Sables-d'Olonne: Musée de l'Abbaye Sainte-Croix 1993

McCarthy, Dermot. "Early Canadian Literary Histories and the Function of a Canon." In *Canadian Canons: Essays in Literary Value*. Ed. Robert Lecker. Toronto: University of Toronto Press 1991

McGregor, Gaile. *The Wacousta Syndrome: Explorations in the Canadian Landscape*. Toronto: University of Toronto Press 1985

McKibbon, Millie Richardson, cur. *David Barbour, Scott MacEachern, John Paskievich: Three Manitoba Photographers Exhibition*. Winnipeg: The Winnipeg Art Gallery 1977

McLuhan, Marshall. *Understanding Media: The Extensions of Man*. Toronto: New American Library of Canada, Signet Books 1964

McLuhan, Marshall and Quentin Fiore. *War and Peace in the Global Village*. New York: Bantam Books 1968

Metcalf, John. *What is a Canadian Literature?* Guelph: Red Kite Press 1988

Michael, Magali Cornier. *Feminism and the Postmodern Impulse. Post-World War II Fiction*. Albany: State University of New York Press 1996

Michel, Franck, cur. *Gabor Szilasi. Photographies/Photographs 1954–1996*. Montreal: Vox Populi and McGill-Queen's University Press 1997

Miller, Jane. *Seductions: Studies in Reading and Culture*. London: Virago Press 1990

Minh-ha, Trin. T. "Cotton and Iron." In *Out There: Marginalization and Contemporary Cultures*. Eds. Russell Ferguson, Martha Gever, Trinh T. Minh-ha, and Cornel West. 1990. Reprint. New York: New Museum of Contemporary Art and Cambridge: MIT Press 1994

Mitchell, Juliet. *Psychoanalysis and Feminism: Freud, Reich, Laing and Women*. 1974. New York: Vintage Books 1975

Moi, Toril. "Feminist, Female, Feminine." In *The Feminist Reader. Second Edition*. Eds. Catherine Belsey and Jane Moore. Malden, MA: Blackwell 1997

– ed. *French Feminist Thought: A Reader*. Oxford: Basil Blackwell 1987

– *Sexual/Textual Politics: Feminist Literary Theory*. London: Methuen 1985

Monk, Lorraine, ed. *Between Friends/Entre Amis*. Ottawa: Still Photography Division, National Film Board of Canada 1976

– cur. *Photography 1975 Photographie*. Ottawa: National Film Board of Canada 1975

Morin, Frances. *The Idea of North: Robert Frank, June Leaf, Agnes Martin, David Rabinowitch, Royden Rabinowitch, Dorthea Rockburne, Jackie Windsor*. New York: 49th Parallel Centre for Contemporary Canadian Art 1987

Nadar. "My Life as a Photographer." 1900. Trans. Thomas Repensek. *October 5. Photography: A Special Issue*. 1978

Naef, Weston J. in collaboration with James N Wood. *Era of Exploration: The Rise of Landscape Photography in the American West, 1860–1885*. Boston: Albright-Knox Gallery and New York: Metropolitan Museum of Art 1975

Neuman, Shirley. "ReImagining Women: An Introduction." In *ReImagining Women: Representations of Women in Culture*. Eds. Shirley Neuman and Glennis Stephenson. Toronto: University of Toronto Press 1993

Newhall, Beaumont. *The Daguerreotype in America*. Third edition, revised. New York: Dover Publications 1976

— *The History of Photography from 1839 to the Present Day*. [1949] Revised and enlarged. New York: Museum of Modern Art in collaboration with Rochester, N.Y.: George Eastman House 1964

— ed. *Photography: Essays and Images. Illustrated Readings in the History of Photography*. New York: Museum of Modern Art 1980

Newhall, Nancy. ed. *The Daybooks of Edward Weston. Vol. I. Mexico*. Millerton, N.Y.: Aperture 1973

— ed. *The Daybooks of Edward Weston. Vol. II. California*. Millerton, N.Y.: Aperture 1973

Olsen, Tillie. *Silences*. 1978. Reprint. New York: Dell Publishing, Delta/Seymour Lawrence Edition 1989

Ondaatje, Michael. *In the Skin of a Lion*. New York: Vintage 1987

Orwell, George. "England Your England." In *The Lion and the Unicorn. Socialism and the English Genius*. 1941. Reprint. London: Penguin 1982

Ovenden, Graham, ed. *Hill and Adamson Photographs*. London: Academy Editions and New York: St Martin's Press 1973

Owens, Craig. "Feminists and Postmodernism." In *Postmodern Culture*. Ed. Hal Foster. London: Pluto Press, 1985

Pakasaar, Helga, cur. *Ian Wallace: Clayoquot Protest (August 9, 1993)*. Windsor: Art Gallery of Windsor 1997

Panzer, Mary. "Manifest Destiny." *Afterimage* 13, no. 9 (April 1986): 10–12

Paskievich, John. *A Voiceless Song: Photographs of the Slavic Lands. Un Chant muet. Photographies du monde slave*. Ottawa: National Film Board of Canada in collaboration with Toronto: Lester and Orpen Dennys 1983

Perera, Sylvia Brinton. *Descent to the Goddess: A Way of Initiation for Women*. Toronto: Inner City Books 1981

Petruck, Peninah R., ed. *The Camera Viewed: Writings on Twentieth-Century Photography. Volume I – Photography Before World War II*. New York: E.P. Dutton 1979

— ed. *The Camera Viewed: Writings on Twentieth-Century Photography. Volume II – Photography After World War II*. New York: E.P. Dutton 1979

Pollock, Griselda. "Preface" to *Generations and Geographies in the Visual Arts: Feminist Readings*. Ed. Griselda Pollock. London: Routledge 1996

Pultz, John. *The Body and the Lens: Photography 1839 to the Present*. New York: Harry N. Abrams 1995

Radul, Judy, cur. *Jin-me Yoon: Between Departure and Arrival*. Vancouver: Western Front 1998

Raginsky, Nina. Conversation with author. Ottawa, 1978

Ray-Jones, Tony. *A Day Off: An English Journal by Tony Ray-Jones*. London: Thames and Hudson 1974

Redekop, Magdalene. "Interview with Joy Kogawa." In *Other Solitudes: Canadian Multicultural Fictions*. Eds. Linda Hutcheon and Marion Richmond. Toronto: Oxford University Press 1990

Reid, Dennis. *A Concise History of Canadian Painting*. Toronto: Oxford University Press 1973

— *Photographs by Tom Thomson. Bulletin 16/1970*. Ottawa: The National Gallery of Canada 1970

Reid, Dennis, Philip Monk, and Louise Dompierre. *Visual Art 1951–1993: The Michael Snow Project*. Toronto: Art Gallery of Ontario/The Power Plant 1994

Richmond, Cindy, cur. *Ian Wallace. Masculin/Féminin*. Montreal: Leonard and Bina Ellen Art Gallery, Concordia University 1997

Riis, Jacob A. *How the Other Half Lives: Studies Among the Tenements of New York*. 1901. Reprint. New York: Dover Publications 1971

Roberts, John. *The Art of Interruption: Realism, Photography and the Everyday*. Manchester: Manchester University Press and New York: Room 400 1998

Robideau, Henri. *Big Stories*. Saskatoon: The Photographers Gallery 1998

Rosler, Martha. *3 Works: Martha Rosler*. Halifax: Press of the Nova Scotia College of Art and Design 1981

Rudisill, Richard. *Mirror Image: The Influence of the Daguerreotype on American Society*. Albuquerque: University of New Mexico Press 1971

Russo, Mary. *The Female Grotesque: Risk, Excess and Modernity*. New York: Routledge 1994

Ruwedel, Mark. *Columbia River: The Handford Stretch*. [Montreal]: n.p. 1993

Ryerson Polytechnical Institute, Photographic Arts Department. *Canadian Perspectives: A National Conference on Canadian Photography March 1–4, 1979. Conference Transcript*. Toronto: Ryerson Polytechnical Institute 1979

Said, Edward. "Reflections on Exile." In *Out There: Marginalization and Contemporary Cultures*. Eds. Russell Ferguson, Martha Gever, Trinh T. Minh-ha, and Cornel West. 1990. Reprint. New York: New Museum of Contemporary Art and Cambridge: MIT Press 1994

Salter, Denis. "The Idea of a National Theatre." In *Canadian Canons: Essays in Literary Value*. Ed. Robert Lecker. Toronto: University of Toronto Press 1991

Sander, August. *Men Without Masks: Faces of Germany 1910–1938*. Greenwich, Conn.: New York Graphic Society 1973

Sangster, Gary, cur. *Body Currents: The Recent Work of Geneviève Cadieux*. Cleveland: Cleveland Centre for Contemporary Art 1996

Saul, John Ralston. *Reflections of a Siamese Twin: Canada at the End of the Twentieth Century*. 1997. Reprint. Toronto: Penguin 1998

Sayers, Janet. *Sexual Contradictions: Psychology, Psychoanalysis, and Feminism*. London: Tavistock Publications 1986

Scherman, David E., ed. *The Best of LIFE*. New York: Time-LIFE Books 1973

Schor, Naomi and Elizabeth Weed. *The Essential Difference*. Bloomington: Indiana University Press 1994

Schwartz, Joan M., guest ed. *Canadian Photography*. London and Washington: History of Photography vol. 20, no. 2. Summer 1996

Schwarz-Bart, Simone. *Between Two Worlds*. Trans. Barbara Bray. New York: Harper & Row 1981

Scobie, Stephen. "Leonard Cohen, Phyllis Webb, and the End(s) of Modernism." In *Canadian Canons. Essays in Literary Value*. Ed. Robert Lecker. Toronto: University of Toronto Press 1991

Semchishen, Orest. *Byzantine Churches of Alberta: Photographs by Orest Semchishen*. Ed. Hubert Hohn. Edmonton: Edmonton Art Gallery 1976

Semchuk, Sandra. *Sandra Semchuk: Excerpts From a Diary*. Saskatoon: Mendel Art Gallery 1982

Shuttle, Penelope and Peter Redgrove. *The Wise Wound: Menstruation and Everywoman*. 1978. New revised edition. London: Paladin Grafton Books; Collins 1986

Silverstein, John. *Perceptions: Photographs by Robert Bourdeau, David Hylnsky, Carol Marino, Volker Seding*. Stratford: The Gallery/Stratford 1983

Simon, Cheryl, ed. *The Zone of Conventional Practice and Other Real Stories*. Montreal: Galerie Optica 1989

Simon, Sherry. "Culture and Its Values: Critical Revisionism in Quebec in the 1980s." In *Canadian Canons: Essays in Literary Value*. Ed. Robert Lecker. Toronto: University of Toronto Press 1991

Smart, Patricia. *Writing in the Father's House: The Emergence of the Feminine in the Quebec Literary Tradition*. Toronto: University of Toronto Press 1991

Smith, W. Eugene and Aileen M. Smith. *Minamata*. New York: Alskop-Sensorium; Holt, Rinehart and Winston 1975

Sobieszek, Robert A. and Odette M. Appel. *The Spirit of Fact: The Daguerreotypes of Southworth and Hawes, 1843–1862*. Boston: David R. Godine and Rochester, N.Y.: International Museum of Photography at George Eastman House 1976

Sommer, Frederick. *Venus, Jupiter & Mars: The Photographs of Frederick Sommer*. Ed. John Weiss. Delaware: Delaware Art Museum and Department of Art, University of Delaware 1980

Sontag, Susan. *On Photography*. New York: Farrar, Straus and Giroux 1977

Sourkes, Cheryl. "From the Book of Gates." *In The Zone of Conventional Practice and Other Real Stories*. Montreal: Galerie Optica 1989

Spignesi, Angelyn. *Starving Women. A Psychology of Anorexia Nervosa*. Dallas: Spring Publications 1983

Staines, David, ed. *The Canadian Imagination: Dimensions of a Literary Culture*. Cambridge: Harvard University Press 1977

Stebbins, Joan. *Sorel Cohen: An Extended and Continuous Metaphor*. Lethbridge: Southern Alberta Art Gallery 1984

Steichen, Edward. *A Life in Photography*. Garden City, N.Y.: Doubleday in collaboration with New York: Museum of Modern Art 1963

Stewart, Cathy, cur. *Five Manitoba Photographers: John Paskievich, Michaelin McDermott, Leonard Schlichting, David Barbour, Brian Appel*. Winnipeg: Winnipeg Art Gallery 1979

Stott, William. *Documentary Expression and Thirties America*. New York: Oxford University Press 1973

Surette, Leon. "Creating the Canadian Canon." In *Canadian Canons: Essays in Literary Value*. Ed. Robert Lecker. Toronto: University of Toronto Press 1991

Szarkowski, John. *Looking at Photographs: 100 Pictures from the Collection of The Museum of Modern Art*. New York: Museum of Modern Art 1973

– *Mirrors and Windows: American Photography since 1960*. New York: Museum of Modern Art 1978

Taft, Robert. *Photography and the American Scene: A Social History, 1839–1889*. 1938. New York: Dover Publications 1964

Thériault, Michèle. *Urban Inscriptions: Kim Adams, Claude-Philippe Benoit, Angela Grauerholz, Douglas Walker, Shirley Wiitasalo*. Toronto: The Art Gallery of Ontario 1991

Thomas, Alan. *The Expanding Eye: Photography and the Nineteenth-Century Mind*. London: Croom Helm 1978

Thomas, Ann. "Canadian Nationalism and Canadian Imagery." In *Canadian Perspectives: A National Conference on Canadian Photography, March 1–4, 1979*. Toronto: Ryerson Polytechnical Institute 1979

– cur. *Environments d'ici et d'aujourd'hui. Trois photographes contemporains. Lynne Cohen. Robert Del Tredici. Karen Smiley*. Ottawa: Musée des beaux-arts du Canada 1985

– *Fact and Fiction: Canadian Painting and Photography, 1860–1900. Le réel et l'imaginaire Peinture et photographie canadiennes, 1860–1900*. Montreal: McCord Museum 1979

Todd, Janet. *Feminist Literary History*. New York: Routledge 1988

Torosian, Michael, cur. *Michel Lambeth: Photographer Photographe*. Ottawa: Public Archives of Canada 1986

Townsend, Doug, cur. *Rossiter McEachern Fairfield*. St John's, Nfld.: Memorial University Art Gallery 1986

Trachtenberg, Alan. "The Artist of the Real." *Afterimage* 6, no. 5 (December 1978): 10–13

— *Reading American Photographs: Images as History. Mathew Brady to Walker Evans*. New York: Hill and Wang; Farrar, Straus and Giroux 1989

— "Walker Evans's *Message from the Interior*: A Reading." *October* 11 (Winter 1979): 5–16

Tuer, Dot. "Photographing Against the Grain." In *Le Mois de la photo à Montréal 1999*. Montreal: Vox Populi 1999

Turner, Victor. "Betwixt and Between: The Liminal Period in Rites of Passage." In *Betwixt and Between: Patterns of Masculine and Feminine Initiation*. Eds. Louise Carus Mahdi, Steven Foster, and Meredith Little. LaSalle, Ill.: Open Court 1987

Varley, Christopher, cur. *Eleven Early British Columbian Photographers 1890–1940*. Vancouver: Vancouver Art Gallery 1976

Vernissage. The Magazine of the National Gallery of Canada 1, no. 1 Winter 1999

von Franz, Marie-Louise. *Problems of the Feminine in Fairy Tales*. First revised edition. 1976. Reprint. Irving, Texas: Spring Publications 1979

Vroege, Bas and Hripsimé Visser, eds. *Oppositions: Commitment and Cultural Identity in Contemporary Photography from Japan, Canada, Brazil, The Soviet Union and The Netherlands*. Rotterdam: Uitgeverij 1990

Wall, Jeff. E-mail to author. 26 November 2001.

— *Installation of Faking Death (1977). The Destroyed Room (1978). Young Workers (1978). Picture for Women (1979)*. Victoria: Art Gallery of Greater Victoria 1979

Wallace, Ian. "Image and After-Image II: Roy Arden." *Vanguard* 16, no. 1 (February–March 1987): 24–7

Wallace, Ian and Scott Watson eds. *Ian Wallace: The Idea of the University*. Vancouver: UBC Fine Arts Gallery 1990

Walsh, Meeka, ed. *Diana Thorneycroft: The Body, Its Lesson and Camouflage*. Winnipeg: Bain and Cox 2000

Watson, Scott, cur. *Geneviève Cadieux*. Vancouver: Morris and Helen Belkin Art Gallery and Montreal: Montreal Museum of Fine Arts 1999

Watson, Sheila. *The Double Hook*. 1959. Reprint. Toronto: McClelland & Stewart 1989

Weintraub, Linda. *Art On the Edge and Over: Searching for Art's Meaning in Contemporary Society 1970s–1990s*. Litchfied, Ct.: Art Insights 1996

Weston, Edward. "What is Photographic Beauty?" 1939. Introduction to "Photography – Not Pictorial." In *Photographers on Photography: A Critical Anthology Edited by Nathan Lyons*. Ed. Nathan Lyons. Englewood Cliffs, N.J.: Prentice Hall in collaboration with Rochester: George Eastman House 1966

White, Minor. *Mirrors Messages Manifestations*. New York: Aperture 1969

— cur. *Octave of Prayer: An Exhibition on a Theme Compiled with Text by Minor White*. Millerton, N.Y.: Aperture 1972

Whitford, Margaret. *Luce Irigaray: Philosophy in the Feminine*. New York: Routledge 1991

Whitmont, Edward C. *Return of the Goddess*. New York: Crossroads Publishing 1982

Wiehager, Renate, ed. *Photography as Concept*. Ostfildern: Cantz 1998

Wilks, Claire Weissman. *The Magic Box: The Eccentric Genius of Hannah Maynard*. Toronto: Exile Editions 1980

Williams, Val. "Secret Places." In *The Dead*. Curs. Greg Hobson and Val Williams. Bradford: National Museum of Photography, Film and Television 1995

Wilson, Alexander. *The Culture of Nature: The North American Landscape from Disney to the Exxon Valdez*. Cambridge, Mass.: Blackwell 1992

Winogrand, Garry. *The Animals*. New York: Museum of Modern Art 1969

— *Public Relations*. New York: Museum of Modern Art 1977

— *Women are Beautiful*. New York: Farrar, Straus and Giroux, A Light Gallery Book 1975

Wong, Paul, ed. *Yellow Peril Reconsidered*. Vancouver: On Edge 1990

Wonnacott, Justin, cur. *Messages Sent/Received*. Ottawa: SAW Gallery 1991

Woodman, Marion. *Addiction to Perfection: The Still Unravished Bride*. Toronto: Inner City Books 1982

— *The Owl Was a Baker's Daughter: Obesity, Anorexia Nervosa, and the Repressed Feminine*. Toronto: Inner City Books 1980

— *The Pregnant Virgin: A Process of Psychological Transformation*. Toronto: Inner City Books 1985

Yoon, Jun-me. Conversation with author. Montreal, 1992

Young-Eisendrath, Polly and Florence L. Wiedemann. *Female Authority: Empowering Women through Psychotherapy*. New York: The Guildford Press 1987

Zerbe, Kathryn J. *The Body Betrayed: A Deeper Understanding of Women, Eating Disorders and Treatment*. 1993. Reprint. Carlsbad, CA.: Gürze Books 1995

PHOTOGRAPHIC WORKS

*The following list includes reproductions
of original photographs and paintings,
selected details of artists' books and
photographic installations, and in-site
views of installation works.*

2.1 Karen Smiley (now Rowantree),
Detail from *Check Cashing Identification
Photographs, Star Market Co., Boston* (a
series of 17 pairs of photographs), 1976.
Selenium-toned gelatin silver prints.
16″ x 20″ (40.64 x 50.8 cm) each.
Collection: National Gallery of Canada,
Ottawa

2.2 Angela Grauerholz, *Anne Delson*,
1984. Gelatin silver print. 50.8 x
60.96 cm. Collection: Vancouver Art
Gallery, Vancouver

2.3 Nina Raginsky, *The Kirkpatrick Sisters
in front of the Empress Hotel, Victoria,
British Columbia*, 1974. Gelatin silver
print, sepia-toned and hand-tinted. 17.1 x
11.4 cm. Collection: Canadian Museum
of Contemporary Photography, National
Gallery of Canada, Ottawa

2.4 Sylvain P. Cousineau, *Mr. Fraser,
Ottawa*, 1978. Gelatin silver print. 8″ x
10″(20.32 x 25.4 cm). Private collection

2.5 Michael Schreier, *Street Portraits:
The Anonymous Individual*, 1981. Diptych,
25.2 x 20.1 cm each. Collection: Canadian
Museum of Contemporary Photography,
National Gallery of Canada, Ottawa

2.6 Clayton Bailey, *Dorothy, Joy and Judith*,
1978. Gelatin silver print. 11″ x 14″
(27.94 x 35.56 cm). Collection: Winnipeg
Art Gallery, Winnipeg

2.7 Orest Semchishen, *Exterior, St. Elias'
Ukrainian Orthodox Church, Spirit River,
Alberta*, 1975. Gelatin silver print. 7″ x 9″
(17.78 x 22.86 cm). Collections:
Canadian Museum of Contemporary
Photography, National Gallery of
Canada, Ottawa; National Archives of
Canada, Ottawa; Edmonton Art Gallery,
Edmonton

2.8 Joel Sternfeld, *A Man on the Banks
of the Mississippi, Baton Rouge, Louisiana,
August, 1985*, © Joel Sternfeld, 1985. Dye
coupler print. 40.6 x 50.8 cm. Collection:

National Gallery of Canada, Ottawa;
Courtesy Pace/MacGill Gallery, New York

2.9 Walker Evans, *Country Church near Beaufort, South Carolina*, 1935. Gelatin silver print. 20.8 x 17.3 cm. Collection: National Gallery of Canada, Ottawa

2.10 Edward Weston, *Shell*, © 1981 Center for Creative Photography, Arizona Board of Regents, 1927. Gelatin silver print. 24.6 x 19 cm

2.11 Alison Rossiter, *Pink Soap Bottle*, 1983. From the series *Bridal Satin*. Type C Ektacolor print. 16″ x 20″ (40.64 x 50.8 cm). Collection: Canadian Museum of Contemporary Photography, National Gallery of Canada, Ottawa; Courtesy Art 45, Montreal

2.12 Henri Cartier-Bresson, *Sunday on the Banks of the Marne*, © Henri Cartier-Bresson/Magnum, 1938. Gelatin silver print. 16.4 x 24.5 cm. Courtesy of Magnum Photos

2.13 Walker Evans, *General Store, Selma, Ala.*, 1936. Gelatin silver print. 20.2 x 25.2 cm. Collection: National Gallery of Canada, Ottawa

3.1 Lorraine Gilbert, *Logging Roads on Coyote Ridge Rd., Invermere, B.C.*, 1989. Panoramic Diptych. From the series *Shaping the New West*. Gelatin silver prints. 40″ x 62″ (101.6 x 157.48 cm) overall. Collection: Canadian Museum of Contemporary Photography, National Gallery of Canada, Ottawa

3.2 Lee Friedlander, *Industrial Northern United States*, 1968. Gelatin silver print. 11″ x 14″ (27.94 x 35.56 cm). Courtesy of Fraenkel Gallery, San Francisco

3.3 Michel Campeau, *Autoportrait, Fête pour la paix, Montréal, mai 1983*, © SODART (Montreal), 2001. From the series *La Mémoire du corps*, 1984. Gelatin silver print. 40.6 x 50.8 cm. Collection of the artist

3.4 Tom Gibson, *My Shadow at Comber, Comber, Ontario*, 1970. Gelatin silver print. 11″ x 14″ (27.94 x 35.56 cm). Collection: Canadian Museum of Contemporary Photography, National Gallery of Canada, Ottawa

3.5 Michel Lambeth, *Tchuantepec, Mexico*, 1969. Gelatin silver print. 25.4 x 17.2 cm. Collection: Canadian Museum of Contemporary Photography, National Gallery of Canada, Ottawa

3.6 Michel Lambeth, *St. Lawrence Market, Toronto, Ontario*, 1957. Gelatin silver print. 35.3 x 27 cm. Collection: Canadian Museum of Contemporary Photography, National Gallery of Canada, Ottawa

3.7 Michel Lambeth, *Toronto, Ontario*, 1959. Gelatin silver print. 25.4 x 17.2 cm. Collection: Canadian Museum of Contemporary Photography, National Gallery of Canada, Ottawa

3.8 Jeff Wall, *Dead Troops Talk (A Vision After an Ambush of a Red Army Patrol Near Moqor, Afghanistan, Winter 1986)*, 1992. Colour transparency in lightbox. 229 x 417 cm. Collection: Dr Pincus, Philadelphia

3.9 Jeff Wall, *The Flooded Grave*, 1998–2000. Colour transparency in lightbox. 228.6 x 282 cm. Private collection, Switzerland

3.10 Jeff Wall, *Adrian Walker, artist, drawing from a specimen in a laboratory in the Dept. of Anatomy at the University of British Columbia, Vancouver*, 1992. Colour transparency in lightbox. 119 x 164 cm. Private collection, Barcelona

3.11 Arthur Renwick, *Cage*, 1989. c-prints, letraset. 60″ x 72″ (152.4 x

182.88 cm). Collection: Indian Art Centre, D.I.A.N.A., Hull, Quebec

3.12 Evergon, *Horrific Portrait*, 1983. Colour Polaroid, spray paint, and scratched surface. 20″ x 24″ (50.8 x 60.96 cm). Courtesy of the artist

3.13 Diana Thorneycroft, *Untitled (Snare)*, 1994. Gelatin silver print. 28″ x 24″ (71.12 x 60.96 cm). Collection: Canadian Museum of Contemporary Photography, National Gallery of Canada, Ottawa

3.14 Diana Thorneycroft, *Untitled (Snared)*, 1997. Gelatin silver print. 32″ x 32″ (81.28 x 81.28 cm). Collection of the artist

3.15 Suzy Lake, *Contact Sheet*, 1978. Made in preparation for the series *ImPositions*. Gelatin silver print. 8″ x 10″ (20.32 x 25.4 cm). Collection of the artist

3.16 Vincent Sharp, *Dog Behind Car Window, Toronto*, 1975. Gelatin silver print. 11″ x 14″ (27.94 x 35.56 cm). Collection: Canada Council Art Bank; Bibliotheque Nationale, France

3.17 Richard Holden, *Corner of James and Elgin Streets, Ottawa, Ontario. March 6, 1979*. Cibachrome print. 6″ x 18″ (15.24 x 45.72 cm). Collection of the artist

3.18 Volker Seding, *Kudu, Heidelberg, Germany*, 1989. From the series *The Zoo Portfolio*. Ektacolor print. 17.7 x 22.8 cm. Collection: Canadian Museum of Contemporary Photography, National Gallery of Canada, Ottawa

3.19 Jean-Jacques Ringuette, *Pierre Mouchon se sait observé*. From theseries *De la vraisemblance, autour du personnage de Pierre Mouchon (premier volet)*, 1995–1998. Colour print. 71 x 59 x 3.2 cm. Collection of the artist

3.20 Jin-me Yoon, first card of *Souvenirs of the Self (Postcard Project)*, 1991. 1 of 6 perforated postcards, 4″ x 6″ (10.16 x 15.24 cm) each. 2800 circulated. Courtesy of the artist and Catriona Jeffries Gallery, Vancouver

3.21 Jin-me Yoon, first card, reverse side, of *Souvenirs of the Self (Postcard Project)*, 1991. 1 of 6 perforated postcards, 4″ x 6″ (10.16 x 15.24 cm) each. 2800 circulated. Courtesy of the artist and Catriona Jeffries Gallery, Vancouver

3.22 Vid Ingelevics, Bureau #1 from the installation work *Places of Repose: Stories of Displacement*, 1989/90. Wooden bureau, chromogenic prints, steel frames. Collection: Canadian Museum of Contemporary Photography, National Gallery of Canada, Ottawa

3.23 Charles Gagnon, *sx 70*, 1976. Instant Dye Print (Polaroid). 7.9 x 7.8 cm. Collection: National Gallery of Canada; Courtesy Galerie René Blouin, Montreal

3.24 Lynne Cohen, *Dining Room*, n.d. Gelatin silver print. 16″ x 20″ (40.64 x 50.8 cm) with frame. Courtesy of the artist and P.P.O.W., New York

3.25 Vincent Sharp, *Girl Yawning, Toronto*, 1975. Gelatin silver print. 11″ x 14″ (27.94 x 35.56 cm). Private collection

3.26 Raymonde April, excerpt from *Debout sur le rivage*, 1984. Gelatin silver print. 100 x 100 cm. Collection: Musée d'art contemporain de Montréal, Montreal

3.27 Michel Lambeth, *Royal Ontario Museum, Toronto, Ontario*, 1957. Gelatin silver print. 25.5 x 17.2 cm. Collection: Canadian Museum of Contemporary Photography, National Gallery of Canada, Ottawa

3.28 Michel Lambeth, *Eglinton Station, Yonge Street Subway, Toronto, Ontario*, 1957.

Gelatin silver print. 17.3 x 25.4 cm.
Collection: Canadian Museum of
Contemporary Photography, National
Gallery of Canada, Ottawa

3.29 Irene F. Whittome, *Self-Portrait*,
1976. Sepia-toned gelatin silver print.
120 x 120 cm. Collection of the artist

4.1 Tom Gibson, *Woman Inside and
Outside*, London, England, 1972. Gelatin
silver print. 11″ x 14″ (27.94 x 35.56 cm).
Collection: Canadian Museum of
Contemporary Photography, National
Gallery of Canada, Ottawa

4.2 Charles Gagnon, *New England, 1969*.
Gelatin silver print. 27.8 x 35.3 cm.
Collection of the artist; Courtesy Galerie
René Blouin, Montreal

4.3 Charles Gagnon, *MN: XVI-20-77*, 1977.
Gelatin silver print. 6.9 x 9.3 cm.
Collection of the artist; Courtesy Galerie
René Blouin, Montreal

4.4 Angela Grauerholz, *Mozart Room*,1993.
Cibachrome print. 122 x 183 cm. Collection:
FRAC Franche Comté, Musée de Dole, France

4.5 Carole Condé and Karl Beveridge,
Work in Progress,1908, © CARCC, 1980–81.
Cibachrome print. 16″ x 20″ (40.64 x 50.8
cm). Collection: Camerawork Gallery,
London, England

4.6 Lynne Cohen, *Observation Room*, 1984.
Gelatin silver print. 38.5 x 48.4 cm.
Collection: Canadian Museum of
Contemporary Photography, National
Gallery of Canada, Ottawa

4.7 Lynne Cohen, *Corridor*, 1981. Gelatin
silver print. 40.3 x 50.6 cm. Collection:
National Gallery of Canada, Ottawa

4.8 Michael Snow, *Speed of Light*, 1992.
Phototransparency in altered lightbox.
91.4 x 127 x 15.2 cm. Edition of 2.

Collections: Artists for Kids Trust,
Vancouver; Janet A. Scott, Toronto

4.9 Lionel Lemoine FitzGerald, *From An
Upstairs Window, Winter*, 1950–51. Oil on
canvas. 61 x 45.7 cm. Collection: National
Gallery of Canada, Ottawa

4.10 Christopher Pratt, *Window with a
Blind*, 1970. Oil on board. 48″ x 24″
(121.92 x 60.96 cm). Collection: Norcen
Energy Resources Limited

4.11 Gabor Szilasi, *Portraits/Interiors:
Andor Pasztor*, 1979. Diptych, 33 x 26 cm
each, matt size 49 x 77 cm. Collections:
Musée d'art contemporain de Montréal,
Montreal; Canadian Museum of
Contemporary Photography, National
Gallery of Canada, Ottawa

4.12 Christos Dikeakos, *c̦usnà um –
Location of the Great Marpole Midden*,
1991–93. From the series *Sites and Place
Names, Vancouver*. Colour C Print and Text.
36 x 71 cm. Collection: M.O.C.C.A., North
York, Ontario

4.13 Don Corman, excerpt from the book
Comfort and Cleanliness, 1980. Colour
print. 16″ x 20″ (40.64 x 50.8 cm).
Collection of the artist

TEXT: Here your stay is attended by
personal service and surrounded by quiet
elegance. Call from your bedside and
somebody from the pantry personally
responds to take your order.

4.14 Don Corman, excerpt from the book
Comfort and Cleanliness, 1980. Colour
print. 16″ x 20″ (40.64 x 50.8 cm).
Collection of the artist

TEXT: The system of "every other week"
should be used for turning mattresses.
One week the mattress can be turned
from side to side, the other week from
end to end.

4.15 Susan McEachern, detail of *On Living at Home, Part II-Domestic Immersion*, 1989. 2 images from a grouping of 12. Colour photographs. 16″ x 20″ (40.64 x 50.8 cm) each. Courtesy of the artist

TEXTS: (BAMBOO CURTAIN) Consumption for the home is kept distinct from the economy as a whole.

(BASKET OF FABRIC AND KNITTING) No matter what her obligations are outside of the home, a woman's self-esteem is affected by the cleanliness and orderliness of her home.

4.16 Arthur Renwick, excerpt from the series *Dislocation*, 1988. Panel 6 of 6 panels. Gelatin silver print. 24″ x 96″ (60.96 x 243.84 cm). Collection of the artist

4.17 Jin-me Yoon, *Touring Home From Away*, 1998–99. Installation view; 9 custom fabricated black anodized, double-sided lightboxes, 18 ilfo-chrome translucent prints with polyester overlaminate; Each lightbox 32″ x 36″ x 5″ (81.28 x 91.44 x 12.7 cm). Courtesy of the artist and Catriona Jeffries Gallery, Vancouver

4.18 Geoffrey James, *Looking towards Mexico, Otay Mesa*. From the Series *Running Fence*, 1997. Gelatin silver print. 30″ x 40″ (76.2 x 101.6 cm). Collection: San Diego Museum of Contemporary Art, San Diego

4.19 Claude-Philippe Benoit, *Untitled #3*, 1984. From the series *L'envers de l'écran, un tourment photographique*. Gelatin silver print. 40.6 x 50.8 cm. Collection: Canadian Museum of Contemporary Photography, National Gallery of Canada, Ottawa

4.20 Claude-Philippe Benoit, *Ouverture, échappée*, 1992. Diptych from *CHAPITRE Ô-NU* of the series *LES LIEUX MAÎTRES*. Gelatin silver prints. 138 x 331 cm overall.

Collection: Musée d'art contemporain de Montréal, Montreal

4.21 Roy Arden, excerpt from *Rupture*, 1985. #8 of 9 diptychs. Cibachrome, Gela-tin silver print on paper. 68.6 x 40.6 cm each panel. Collection: Art Gallery of Ontario, Toronto; Gift from the Peggy Lownsbrough Fund, 1989

4.22 Ian Wallace, *Clayoquot Protest (August 9, 1993), VI*, 1993–95. Photolaminate with acrylic and ink monoprint on canvas. 200 x 152 cm. Collection: Vancouver Art Gallery, Vancouver; Courtesy of the artist and Catriona Jeffries Gallery, Vancouver

4.23 Ian Wallace, *Hotel Alhambra, Paris II*, 2000–2001. Photolaminate with acrylic on canvas. 61 x 61 cm. Private collection; Courtesy of the artist and Catriona Jeffries Gallery, Vancouver

4.24 Jeff Wall, *Stereo*, 1980. Diptych. Transparencies in lightboxes. 213 x 213 cm each. Collection: National Gallery of Canada, Ottawa

4.25 Stan Denniston, *Reminder #14, Left: Boulevard de Maisonneuve E.& Rue Alexandre de Sève, Montréal/ Right: Filbert and Mason Streets, San Fransisco*, 1978. Diptych. Gelatin silver prints. 16″ x 20″ (40.64 x 50.8) framed. Collection: Canadian Museum of Contemporary Photography, National Gallery of Canada, Ottawa

4.26 Arthur Renwick, *Landmarks*, 1992–95. Book with various media inserted. 11″ x 8.5″ (27.94 x 21.59 cm) (closed). Collection of the artist

4.27 Jin-me Yoon, detail from September/October 1993 *Ms* magazine photo-essay version of the 1992 photographic installation *Screens*. Courtesy of the artist and Catriona Jeffries Gallery, Vancouver

4.28 Marisa Portolese, *Annullato*, 1993. From the series *Paysage Intranquille*, 1993. Gelatin silver print. 16″ x 20″ (40.64 x 50.8 cm). Collection of the artist

4.29 Michel Lambeth, *New York - Quebec Border through the Dundee Line Hotel, Dundee Line, P.Q.*, 1974. 35 mm colour slide. Collection: Canadian Museum of Contemporary Photography, National Gallery of Canada, Ottawa

4.30 Marlene Creates, excerpts from *Limites municipales, Québec 1997*, © CARCC, 1997. Cibachrome colour print. 200 x 211 cm. Collection of the artist

4.31 André Martin, excerpt from the series *Anagrammes II (Souvenir de Pina Bausch)*, 1987. Chromogenic print. 1 x 1 m. Private collection

5.1 Michel Lambeth, *Union Station, Toronto, Ontario*, 1959. Gelatin silver print. 25.3 x 16.9 cm. Collection: Canadian Museum of Contemporary Photography, National Gallery of Canada, Ottawa

5.2 Michel Lambeth, *St. Lawrence Market, Toronto, Ontario*, 1957. Gelatin silver print. 35.5 x 27.9 cm. Collection: Canadian Museum of Contemporary Photography, National Gallery of Canada, Ottawa

5.3 John Max, *Untitled*, 1972. From the book *Open Passport*. Gelatin silver print. 48 x 32.5 cm. Collection: Canadian Museum of Contemporary Photography, National Gallery of Canada, Ottawa

5.4 Ken Lum, *"What is it Daddy?,"* 1994. Laminated colour print, lacquer and enamel on aluminum. 182.9 x 243.8 x 5.1 cm. Collection: Oakville Galleries, Oakville, Ontario

5.5 Élène Tremblay, from the series *Trous de Mémoire*, 1994. Gelatin silver print.

8″ x 10″ (20.32 x 25.4 cm). Collection of the artist

5.6 Michel Lambeth, *Canadian National Exhibition, Toronto, Ontario*, 1957. Gelatin silver print. 25.3 x 17.2 cm. Collection: Canadian Museum of Contemporary Photography, National Gallery of Canada, Ottawa

5.7 Cheryl Simon, *Lizzie Borden*, 1993. From the series *12 Criminal Women*. Gelatin silver print, wooden mounts, etched glass. 16″ x 20″ (40.64 x 50.8 cm) each. Private collection

5.8 Clara Gutsche, *The Large Parlour, Carmelite Sisters, Trois Rivières*, 1991. From *The Convent Series*, © SODART (Montreal) 2002. Gelatin silver print. 72.5 x 92.5 cm. Collection of the artist

5.9 Michael Semak, *Untitled*, 1976. Gelatin silver print. 8″ x 10″ (20.32 x 25.4 cm). Collection: Canadian Museum of Contemporary Photography, National Gallery of Canada, Ottawa

5.10 Diana Thorneycroft, *Untitled (Cross/Examination)*, 1998. Gelatin silver print. 28″ x 35″ (7.12 x 88.9 cm). Collection of the artist

5.11 George Steeves, *Daisy*, 1994. From the series *Excavations Project*. Selenium toned gelatin silver print. 16″ x 20″ (40.64 x 50.8 cm). Collection of the artist

6.1 Raymonde April, excerpt from Part V of *L'Arrivée des figurants*, 1997. Gelatin silver print. 120 x 100 cm. Collection: Musée d'art contemporain de Montréal, Montreal

6.2 Geneviève Cadieux, *Trou de mémoire, la beauté inattendue*, 1988. Chromogenic print, wood, and burnished mirror. 208 x 472 x 14 cm. Collection: National Gallery

of Canada; Courtesy of Galerie René Blouin, Montreal

6.3 Donigan Cumming, *July 7, 1985*. From the series *Reality and Motive in Documentary Photography, Part 3*, 1986. Gelatin silver print. 201 x 122 cm. Collection: Canadian Museum of Contemporary Photography, National Gallery of Canada, Ottawa

6.4 Sylvain P. Cousineau, *Cicatrice*, 1974. From the series *Mona Nima*. Gelatin silver print. 8″ x 10″ (20.32 x 25.4 cm). Collection of the artist

6.5 Nicole Jolicoeur, *28 juin 1888*. From the installation *Stigmata Diaboli*, 1992. Gelatin silver print, wood, silk, lightbox. 53.3 x 63.5 cm. Collection of the artist

6.6 Janieta Eyre, *Rehearsal #4*, 1993. C Print. 30″ x 40″ (76.2 x 101.6 cm). Collection of the artist

6.7 Diana Thorneycroft, *Untitled (Coma)*, 1998. Gelatin silver print. 32″ x 28″ (81.28 x 71.12 cm). Collection: Canadian Museum of Contemporary Photography, National Gallery of Canada, Ottawa

6.8 Susan Coolen, *Untitled*, 1992. From the series *Exploring the Self*. Gelatin silver print. 3 5/8″ x 5″ (9.19 x 12.7 cm). Collection of the artist

6.9 Stéphanie Beaudoin, *Je suis morte, commémoration, préservation, dissémination*. Detail from the "en repos" section of the installation *préservation*, 1995. Gelatin silver print in a lacquered frame restored with authentic funeral plaque. 4′ x 6′ x ½″ (1.22 m x 1.83 m x 1.27 cm). Collection of the artist

6.10 Paul Litherland, excerpt from the series *Souvenirs*, 1993. Mounted chro-mogenic print. 20.4 x 25.4 cm. Private collection

6.11 Michel Campeau, excerpt from the series *Humus*, 2001 © SODART (Montreal) 2001. Gelatin silver print. 91.5 x 117 cm. Collection of the artist

6.12 Pierre D'Alpé, *Albert*, 1990. Diptych. From the series *Clothesminded*. Gelatin silver print. 10″ x 10″ (25.4 x 25.4 cm)each. Collection of the artist

6.13 Eldon Garnet, *Position 11*, 1979. From the series *Spiraling*. Gelatin silver print and photostat. 19.5″ x 15.75″ (49.53 x 40 cm). Collection of the artist

6.14 Evergon, *Denys in Scarf Bondages*, 1981. From the *Interlocking Polaroid Series*. C-prints from 4″ x 5″ internegatives of Polaroid SX-70. 20″ x 90″ (50.8 x 228.6 cm). Collection: Polaroid International

6.15 Donigan Cumming, *April 10, 1992*. From the series *Pretty Ribbons*, 1993. Colour print. 127 x 86.4 cm. Courtesy of the artist

6.16 Henri Robideau, *Giant Nickel, Sudbury, Ontario*, 1982. Gelatin silver print. 52″ x 29″ (132.08 x 73.66 cm). Private collection

6.17 Chuck Samuels with Sylvia Poirier, *After Weston*, 1991. From the series *Before the Camera*. Gelatin silver print. 24 x 19 cm. Collection: Maison européene de la photographie, Paris

6.18 Sorel Cohen, *An Extended and Continuous Metaphor #6*, 1983. © SODART (Montreal) 2002. Ektacolour prints. 6′ x 15′ (1.83 x 4.57 m) installed. Collection: National Gallery of Canada, Ottawa

6.19 Janieta Eyre, *Twin Manicurists*, 1995. Gelatin silver print. 30″ x 40″ (76.2 x

101.6 cm). Collection: Macdonald Stewart Gallery, Guelph

6.20 Evergon, *The Chowder Maker*, 1986. Colour Polaroid print. 50 x 60 cm. Private collection

7.1 Sandra Semchuk, *Self-portrait, the day I said good-bye to Baba, Meadow Lake, Saskatchewan, April 1976*. Gelatin silver print. 18.8 x 23.8 cm. Collection: Canadian Museum of Contemporary Photography, National Gallery of Canada, Ottawa

7.2 Sandra Semchuk, *Baba's grave, Meadow Lake, Saskatchewan, July, 1977*. Gelatin silver print. 18.8 x 23.8 cm. Collection: Canadian Museum of Contemporary Photography, National Gallery of Canada, Ottawa

7.3 Sandra Semchuk, *Self-portrait (from the kitchen series), RR6, Saskatoon, Saskatchewan, October, 1977*. Gelatin silver print. 18.8 x 23.8 cm. Collection: Canadian Museum of Contemporary Photography, National Gallery of Canada, Ottawa

7.4 Sandra Semchuk, *Self-portrait (from the Self-portraits 1977–1981 series), June 7, 1979*. Gelatin silver print. 18.8 x 23.8 cm. Collections: Canadian Museum of Contemporary Photography, National Gallery of Canada, Ottawa; Glenbow Museum, Calgary

7.5 Sandra Semchuk, *Rowenna and Aunt Elsie at Baba's grave, Meadow Lake, Saskatchewan, July, 1979*. Gelatin silver print. 15.8 x 47.6 cm. Collection of the artist

7.6 Mark Leslie, *Untitled*, 1992. From the series *Dying with AIDS/Living with AIDS*. Gelatin silver print. 8″ x 10″ (20.32 x 25.4 cm). Collection: Estate of the artist

7.7 Mark Leslie, *Sign on the outskirts of Red Deer, Alberta, next to the hotel I stayed at,*

1991. From the series *Dying with AIDS/Living with AIDS*. Gelatin silver print. 8″ x 10″ (20.32 x 25.4 cm). Collection: Estate of the artist

7.8 Henri Robideau, *Acts of God, Panel I*, 1998. Gelatin silver print. 30″ x 20″ (76.2 x 50.8 cm). Collection of the artist

7.9 Mark Ruwedel, *The Road to Hell*, 1996. From the series *Pictures of Hell*. Mounted gelatin silver print with text in pencil. 24″ x 28″ (60.96 x 71.12 cm) overall. Collection of the artist

7.10 Cheryl Sourkes, *The Dream in The Mirror, From the Book of Gates*, 1987. Cibachrome print. 51.1 x 61.2 cm. Courtesy of the artist

7.11 Diana Thorneycroft, *Untitled (Iron Lung)*, 1997. Gelatin silver print. 30″ x 37″ (76.2 x 93.98 cm). Collection: Canadian Museum of Contemporary Photography, National Gallery of Canada, Ottawa

7.12 Diana Thorneycroft, *Untitled (Witness)*, 1998. Gelatin silver print. 32″ x 28″ (81.28 x 71.12 cm). Collection of the artist

7.13 Louis Lussier, *Vases communiquants/Communicating Vessels*, 1995. Diptych. Gelatin silver prints. 169 x 81 cm each. Private collection.

7.14 Lynne Cohen, *Model Living Room*, 1976. Gelatin silver print. 111 x 129 cm. Courtesy of the artist and P.P.O.W., New York

7.15 Richard Holden, *Arctic Panoramics, May 21-June 29-N.W. of Rankin Inlet, N.W.T.*, June 1980. Cibachrome print. 6″ x 18″ (15.24 x 45.72 cm). Collection of the artist

7.16 Paul Litherland, *Fragile Fronts*, 1989. Chromogenic print mounted in sections. 210 x 150 cm. Collection of the artist

7.17 Sylvain P. Cousineau, *Silhouette*, 1974. From the series *Mona Nima*. Gelatin silver print. 8″ x 10″ (20.32 x 25.4 cm). Collection: Canadian Museum of Contemporary Photography, National Gallery of Canada, Ottawa

7.18 Shelley Niro, detail from *Are You My Sister?*, 1994. Photographic installation. Colour photographs, hand-drilled mat board. 101.6 x 640 cm (overall). Collection: Agnes Etherington Art Centre, Queen's University, Kingston, Ontario

7.19 Cyndra MacDowall, excerpt from the series *Some Notes on Ending*, 1987. Gelatin silver print. 11″ x 14″ (27.94 x 35.56 cm). Collection of the artist

7.20 Angela Grauerholz, *Window*, 1988. Cibachrome print. 48″ x 64″ (121.92 x 162.56 cm). Courtesy of the artist and Art 45 Inc., Montreal

7.21 Suzanne Grégoire, *Untitled*, 1995–97. Gelatin silver print. 30″ x 24″ (76.2 x 60.96 cm). Collection of the artist

7.22 Serge Clément, *Coulée, Québec, Québec*, 1996. Gelatin silver print. 33″ x 45″ (83.82 x 114.3 cm). Collection: FRAC Ile-de-France, Pontault-Combault, France

8.1 Donigan Cumming, *July 19, 1985*. From the series *Reality and Motive in Documentary Photography, Part 2*, 1986. Gelatin silver print. 48 x 32.5 cm. Collection: Canadian Museum of Contemporary Photography, National Gallery of Canada, Ottawa

8.2 Anne-Marie Zeppetelli, *Le Mauvais Oeil*, 1998–99. From a series of five prints. Gelatin silver print. 2′ x 3′ (0.61 x 0.91 m) each. Collection of the artist

8.3 Sylvie Readman, *Autoportrait à la fenêtre/Self-portrait at Window*, 1993.

Chromogenic print. 169.5 x 247.5 cm. Collection: National Gallery of Canada, Ottawa

8.4 Geneviève Cadieux, *Parfum*, 1991. Chromogenic print. 152.5 x 579 cm. Collection: Musée départemental d'art contemporain de Rochechouart, France; Courtesy of Galerie René Blouin, Montreal

8.5 Charles Gagnon, *Drugstore – Greenwich Village, N.Y.*, 1968. Gelatin silver print. 35.3 x 27.8 cm. Collection of the artist; Courtesy of Galerie René Blouin, Montreal

8.6 Geneviève Cadieux, *Portrait de famille*, 1991. Installation view. 3 double-faced lightboxes: Cibachrome transparencies and Cibachrome pearl prints. 230 x 230 x 30.5 cm each lightbox. Collection of the artist; Courtesy of Galerie René Blouin, Montreal

8.7 Marisa Portolese, *Untitled*, 2001. From the series *Amuletta*, 2001. Colour print. 20″ x 24″ (50.8 x 60.96 cm). Private collection

8.8 Judith Eglington, *Earth Visions*, 1972. Gelatin silver print. 16″ x 20″ (40.64 x 50.8 cm). Collection of the artist

8.9 Marie-Christine Simard, *Ambre Gris*, 1996. Gelatin silver print. 16″ x 20″ (40.64 x 50.8 cm). Collection of the artist

8.10 Charles Gagnon, *Exit – Montreal*, 1973. Gelatin silver print. 27.8 x 35.3 cm. Collection of the artist; Courtesy of Galerie René Blouin, Montreal

8.11 Charles Gagnon, *Corner of Girouard St. – Montreal*, 1973. Gelatin silver print. 27.8 x 35.3 cm. Collection of the artist; Courtesy of Galerie René Blouin, Montreal

8.12 Charles Gagnon, *Window with X – Montreal*, 1979. Gelatin silver print. 27.8 x

35.3 cm. Collection of the artist; Courtesy of Galerie René Blouin, Montreal

8.13 Charles Gagnon, *Moving Truck, Hydrant, Blocked up Door – Montreal*, 1977. Gelatin silver print. 27.8 x 35.3 cm. Collection of the artist; Courtesy of Galerie René Blouin, Montreal

8.14 Charles Gagnon, *Cleaner, Mailbox, Sign, Plant – Montreal*, 1976. Gelatin silver print. 27.8 x 35.3 cm. Collection of the artist; Courtesy of Galerie René Blouin, Montreal

8.15 Normand Grégoire, *Polyptyque Deux*, 1970. Gelatin silver print. 16.3 x 24.4 cm. Collection: Canadian Museum of Contemporary Photography, National Gallery of Canada, Ottawa

8.16 Normand Grégoire, *Polyptyque Deux*, 1970. Gelatin silver print. 33.5 x 49.3 cm. Collection: Canadian Museum of Contemporary Photography, National Gallery of Canada, Ottawa

8.17 Susan Coolen, *Untitled*, 1993. From the series *Dreaming*. Colour print. 16″ x 20″ (40.64 x 50.8 cm). Collection of the artist

8.18 Élène Tremblay, excerpt from the series *Ne Tueras*, 1992. Type C print. 16″ x 20″ (40.64 x 50.8 cm). Collection of the artist

8.19 Sandra Semchuk, *Self-portrait (from the land location series), RR6, Saskatoon, Saskatchewan, May, 1977*. Gelatin silver print. 18.8 x 23.8 cm. Collection: Canadian Museum of Contemporary Photography, National Gallery of Canada, Ottawa

8.20 George Steeves, *Christmas, "Fallen Bird," Ellen's Wedding Dress*, 1981. From the series *The Pictures of Ellen*. Nelson gold – toned gelatin silver contact print. 8″ x 10″

(20.32 x 25.4 cm). Collection: Canada Council Art Bank, Ottawa

8.21 Hamish Buchanan, detail from *Some Partial Continua, Sequence 6*, ["The Crucifixion", 1921 (subsequently destroyed) by Ludwig Gies, from *German Expressionst Sculpture*, Stephanie Barron, organizer, University of Chicago Press, 1984; detail from "man in a set of standard poses," 1887 by Eadweard Muybridge, from *Behold the Man: The Male Nude in Photography*, Alasdair Foster, Stills Gallery, Edinburgh, 1988; the artist, as a theoretical angel, Bank Street studio building, Ottawa, 1979, photographed by Brian Donnelly], 1991–96. Colour photographs on card. 126 x 20.4 cm. Collection of the artist

8.22 Lynne Cohen, *Flying School*, 1980. Gelatin silver print. 111 x 129 cm. Private collection

8.23 Raymonde April, excerpt from *Une Mouche au Paradis*, 1988. Gelatin silver print. 170 x 120 cm. Collection of the artist

8.24 Douglas Curran, *Concrete flying saucer found in the San Bernardino Hills. Perris, California*, 1979. From the book *In Advance of the Landing: Folk Concepts of Outer Space*, 1985. Gelatin silver print. 16″ x 20″ (40.64 x 50.8 cm). Collections: Canadian Museum of Contemporary Photography; The Walter Phillips Gallery, Banff, Alberta; University of Alberta, Edmonton, Alberta

8.25 Jin-me Yoon, *between departure and arrival*, 1996/1997. Partial installation view, Art Gallery of Ontario. Video projection, video montage on monitor, photographic mylar scroll, clocks with 3-D lettering, audio. Dimensions variable. Courtesy of the artist and Catriona Jeffries Gallery, Vancouver

8.26 Barbara Spohr, *Untitled*, n.d. Type C print. 25.3 x 20.2 cm. Collection: Whyte Museum of the Canadian Rockies, Banff

8.27 Barbara Spohr, *Untitled*, n.d. Ektacolor print with paint. 60.8 x 50.7 cm. Collection: Canadian Museum of Contemporary Photography, National Gallery of Canada, Ottawa

8.28 Thaddeus Holownia, *Jolicure Pond*, 1997. Chromogenic colour contact print. 7″ x 17″ (17.78 x 43.18 cm). Collection: Canadian Museum of Contemporary Photography, National Gallery of Canada, Ottawa

8.29 Andrea Szilasi, *Figure in Lake*, 1998. Two woven gelatin silver prints. 181 x 148 cm. Edition of 3. Collection: Canadian Museum of Contemporary Photography, National Gallery of Canada, Ottawa

8.30 Holly King, *Chamber of Passage*, 1992. Chromogenic print. 158 x 122 cm. Collection: Musée d'art de Joliette, Québec

8.31 Raymonde April, excerpt from Part I of *L'Arrivée des figurants*, 1997. Gelatin silver print. 120 x 88 cm. Collection: Musée d'art contemporain de Montréal, Montreal

8.32 Raymonde April, excerpt from Part I of *L'Arrivée des figurants*, 1997. Gelatin silver print. 120 x 85.5 cm. Collection: Musée d'art contemporain de Montréal, Montreal

8.33 Raymonde April, excerpt from Part III of *L'Arrivée des figurants*, 1997. Gelatin silver print. 120 x 92.5 cm. Collection: Musée d'art contemporain de Montréal, Montreal

8.34 Raymonde April, excerpt from Part III of *L'Arrivée des figurants*, 1997. Gelatin silver print. 120 x 88 cm. Collection: Musée d'art contemporain de Montréal, Montreal

8.35 Raymonde April, excerpt from Part V of *L'Arrivée des figurants*, 1997. Gelatin silver print. 120 x 100 cm. Collection: Musée d'art contemporain de Montréal, Montreal

8.36 Raymonde April, excerpt from Part II of *L'Arrivée des figurants*, 1997. Gelatin silver print; 120 x 175.5 cm. Collection: Musée d'art contemporain de Montréal, Montreal

8.37 Marlene Creates, excerpts from *Entering and Leaving St.John's, Newfoundland 1995* (a series of 15 pairs of cibachrome colour prints), © CARCC, 1995. 11.4 x 16.5 cm each. Collection: Government of Newfoundland and Labrador

8.38 Angela Grauerholz, *Disparition*, 1995. Gelatin silver print. 122 x 183 cm. Collection: Modern Art Museum, Fort Worth

C.1 AA Bronson, Sketch for *AA Bronson August 22, 2000*, 2000. Ebonized wood, plexiglass, black and white photographic print. 2020 x 720 x 500 mm. Courtesy of the artist

Credits

Shelley Niro – L. Ostrom

Geneviève Cadieux – *Parfum*: F. Le Saux; *Trou de mémoire, la beauté inattendue*: National Gallery of Canada; *Portrait de famille*: Georg Rehsteine

Ken Lum – Issac Appelbaum, Oakville Galleries

Ian Wallace – Paul Arbez

Roy Arden – Carlo Catenazzi, Art Gallery of Ontario

Yoon – *Touring Home From Away*: Don Hall; *Screens*: Kim Clarke

INDEX

Engel, Marion, 229; *Bear*, 229

Ereshkigal, 201–2, 205–6

European photography, 7; characteristics of, 35, 46, 62, 237; daguerreotype, response to, 32, 46; death and, *see* death

Evans, Walker, 37, 39, 42, 43, 47, 60, 75, 270; *American Photographs*, 37, 47; "Bedroom Dresser, Shrimp Fisherman's House, Biloxi, Mississippi," 75; "Country Church near Beaufort, South Carolina," *39*; *Fortune* magazine and, 42; "General Store, Selma, Ala.," *46*; "Negro Church," 37; "Wooden Church," 37

Evergon, 66–7, 69, 83, 101, 164, 170, 183, 193, 197, 202, 219, 224, 230, 246, 247–8, 262, 269, 270; *The Anatomy Lesson*, 219; A.P. (Anonymous Printer), 178; *Bondage Scapes*, 66–7, 247; *The Baker*, 183; *Bum Print Edition*, 247; *Caucasians in Birdland*, 247; Cellulose Evergonni, 178; *The Chowder Maker*, *182*, 183; *Denys in Scarf Bondages*, *169*; Egon Brut, 178; *Eve R. Gonzales*, 178; "Gyrfalconmen Mating," 247; "Horrific Portrait," *67*; *Horrific Portraits*, 67; *Interlocking Polaroid* series, 67, 83, 164, 170, 193; *Manscapes*, 101; *Paper and Porcelain Men*, 247; *Peacock and Night Rider*, 247; *Ramboys – A*

Bookless Novel, 247, 248; "Self-Portrait," 83, 246; *The Three Fates*, 202; *Torsos with Light*, 247; Pl. V

Evergonni, Cellulose. *See* Evergon

Excerpts from a Diary (Sandra Semchuk), 189–94, 201, 208, 249, *188*, *189*, *190*, *191*, *192*, *249*

Expo '67, 51

Eye Goddess, the, 202

Eyre, Janieta, 159–60, 179, 245, 270; "Confession," 179; *Incarnation* series, 179; *Rehearsal* series, 159–60; "Rehearsal #4," *159*; "Twin Manicurists," 179; *181*; Pl. XII

"Faking Death" (Jeff Wall), 64, 160, 168

Family of Man, The, 219

Farley, Denis, 211; *Études pour Caleb sèche*, 211

feminine, the, 192, 194, 242; anorexia and, 149–51; Canada and, 163; Jungian definition of, 150; multiplicity of, 178; "soul image" of, 183. *See also* Demeter/Persephone myth; Innana/Ereshkigal myth

feminism, 5

"fence" of civilization, 223–9, 249, 266

FILE magazine, 165

FitzGerald, Lionel Lemoine, 96; "From An Upstairs Window, Winter," 96, *97*

Fitzgerald, Thom, 159; *The Hanging Garden*, 159

"The Flooded Grave" (Jeff Wall), 64, *65*, 191, 271

flying: and Canadian photography, *see* Canadian photography; shamanism and, 238, 249–50, 256, 257

49th Parallel Centre for Contemporary Art, 24

Frank, Robert, 43, 46, 118, 256–7; *The Americans*, 43, 46, 257; "Another World," 256; "Electric Dog in Mabou," 256–7, 258; Mabou collage works, 256–7, 258; "The View From the Canadian Side," 118

Freud, Sigmund, 5, 170, 187

Freudian psychoanalysis, 8

Friedlander, Lee, 16, 57–8, 218, 242; "Industrial Northern United States," *57*; self-portrait series, 57–8, 218

frontier, U.S. notion of, 224–5, 227

Frye, Northrop, 8, 121, 207, 237; *The Bush Garden*, 121

Gagnon, Charles, 53, 58, 62, 76–8, 89–90, 107–8, 110, 115, 117, 126, 176, 192, 213, 233, 238, 241–2, 244–5, 242, 245, 253, 257, 269, 270, 271; "Addington St., Garage Door – Montreal," 238; "Bank Vault with Truck and Man – Montreal," 241; "Broken Plate Glass Window – Soho," 241; "Building with Flag – Ottawa, 1974," 241; "Building with Tree

and Two Persons –
Montreal, 1974," 76;
"Candystore Window,
Bloor St. – Toronto,
1973," 89; "Cleaner,
Mailbox, Sign, Plant –
Montreal," *242*, 242;
"Corner of Girouard St.
– Montreal," *240*, 241;
"Drugstore – Greenwich
Village, N.Y., 1968," *232*,
233; "Exit – Montreal,"
238, *239*; "Ex Situ –
Painted Desert, Arizona
of Ground, 1999," 108;
"Fireplace – New York,
1968," 89; "From a
Hotel Room – N.Y.,
1966," 77; "Funseekers
Intl. – Ottawa,
1968," 89; "Justice
of the Peace: Near
Poughkeepsie, N.Y.,"
241; "Mies Building,
Christmas –
Westmount, Que.," 77;
Minox series, 241; *MN:
XVI-20-77* (Minox
image), *91*; "Motel –
Lake George, N.Y.," 77;
"Moving Truck,
Hydrant, Blocked-up
Door – Montreal," *241*,
241; "National Gallery:
from Outside – Ottawa,
1978," 89; "Near the
Wadsworth Atheneum –
Hartford," 238; "New
England, 1969," 89, *90*,
92, 257; "9:45 p.m. –
Banff, Alberta," 238;
"Painted Animals and
Fence – Maine, U.S.A.,
1979," 77; "Painted
Desert" photographs,
107–8; "Parking Ramp
and Flower – Montreal,"
238; "Parking, 6 p.m. –
Magog, Quebec," 78;

"Pipes, Park, Church –
Montreal," 78; "Plant,
Mount Allison
University, 1973," 76;
"Plants, Montreal
Museum of Fine Arts –
Montreal," 241; "Porch,
Branch and Snow, 1977,"
89; "6th Avenue –
N.Y.C.," 76–7; sx-70
Polaroids, 76, *77*, 89;
"Transformer Access –
Westmount, Que.," 238;
Underpass, Trees,
Chemin de la Côte-des-
Neiges – Montreal,"
238; "Untitled –
Montreal, 1975" ("Blue
Room"), 241; "Window
with X-Montreal," *240*,
241; Pl. VI
Gagnon, Monika (Kin),
175
Garnet, Eldon, 80, 166;
Spiraling, 166; "Position
11" (from *Spiraling*), *166*;
Trembling, 80; *Vanitas*,
80
Gaudard, Pierre, 51, 52,
72; *Les Ouvriers*, 51
Gaudet, Gérald, 214
General Idea, 63–4, 165,
169, 178, 271; AA
Bronson, *see* AA
Bronson; Felix Partz,
63–4 (portrait of), 165,
271; Jorge Zontal, 165,
271
Gibson, Tom, 9, 58, 83, 87,
96–7, 247, 248, 253,
269; "Asilomar,
California," 83;
"London, England,
1974," 96; "My Shadow
at Comber," *59*; "Woman
Inside and Outside," 87,
88
Gilbert, Lorraine, 52;
"Logging Roads on

Coyote Ridge Rd.,
Invermere, B.C.," *52*
Gilbert, Sandra, 177
Gingras, Nicole, 31, 237;
Les images des Autres, 31,
237
Glenbow Museum, 218
Godbout, Jacques, 126–7;
Les Têtes à Papineau, 126
Gohlke, Frank, 104
Goldchain, Raphael, 52
Goldin, Nan, 165, 180; *The
Ballad of Sexual
Dependency*, 180;
"Ectopic Pregnancy," 180
Gonzales, Eve. R. *See*
Evergon
Gould, Glenn, 26
Gowdy, Barbara, 85; *The
White Bone*, 85
Grant, George, 121
Grauerholz, Angela, 27,
90, 148, 163, 169, 269,
270, 215–16, 222, 237,
245, 253, 266; "Anne
Delson," 26; "Clouds,"
254; "Crowd," 169;
"La Conductrice," 216;
"Disparition," *267*;
*Églogue ou Filling the
Landscape*, 266; "Enter-
ing the Landscape,"
266; "Harrison," 169;
"Interior," 90, *91*;
"Leaving the Land-
scape," 266; "Mozart
Room," 90, *91*; "Win-
dow," 90, 215–16, *216*
Great Above, the, 219
Great Below, the, 219
Grégoire, Normand, 72,
235, 244, 245, 247, 271;
Image 7, 244; *Polyptyque
Deux*, 235, 244;
"Polyptyque Deux"
("flying" man), *243*;
"Polyptyque Deux" (man's
back to window), *243*;
Série 4, 72